The Photographer's and Artist's Guide
to High-Quality Digital Scanning

# MASTERING

# Digital
# Scanning

## WITH SLIDES, FILM, AND TRANSPARENCIES

## David D. Busch

# Mastering Digital Scanning with Slides, Film, and Transparencies

Senior Vice President, Retail Strategic Market Group: Andy Shafran

Publisher: Stacy L. Hiquet

Credits: Senior Marketing Manager, Sarah O'Donnell; Marketing Manager, Heather Hurley; Manager of Editorial Services, Heather Talbot; Senior Acquisitions Editor, Kevin Harreld; Senior Editor, Mark Garvey; Associate Marketing Manager, Kristin Eisenzopf; Retail Market Coordinator, Sarah Dubois; Production Editor, Jenny Davidson; Copy Editor, Kezia Endsley; Technical Editor, Michael D. Sullivan; Proofreader, Sandi Wilson; Cover Designer, Chad Planner, *Pop Design Works*; Interior Design and Layout, Bill Hartman; Indexer, Schroeder Indexing Services; Cover photography by David D. Busch and Michael D. Sullivan.

Library of Congress Catalog Number: 2003109333

ISBN: 1-59200-141-6

5 4 3 2 1

Educational facilities, companies, and organizations interested in multiple copies or licensing of this book should contact the publisher for quantity discount information. Training manuals, CD-ROMs, and portions of this book are also available individually or can be tailored for specific needs.

Muska & Lipman Publishing, a Division of Course Technology ■ 25 Thomson Place ■ Boston, MA 02210 ■ www.muskalipman.com ■ publisher@muskalipman.com

# About the Author

**David D. Busch** has been demystifying arcane computer and imaging technology since the early 1980s. A former professional photographer who was later seduced by computer technology, his articles on photography and image editing have appeared in magazines as diverse as *Popular Photography and Imaging, Petersen's PhotoGraphic, The Rangefinder*, and *The Professional Photographer*, as well as computer magazines such as *Macworld* and *Computer Shopper*.

Busch has written more than 70 books since 1983, including the mega-best-sellers *Digital Photography All-In-One Desk Reference for Dummies* and *The Hewlett-Packard Scanner Handbook*. Other recent books include *Digital Photography Solutions* and *Mastering Digital Photography*, both from Muska & Lipman/Course Technology. This is his ninth book on using scanners.

He earned top category honors in the Computer Press Awards the first two years they were given (for *Sorry About The Explosion*, Prentice-Hall; and *Secrets of MacWrite, MacPaint and MacDraw*, Little, Brown), and later served as Master of Ceremonies for the awards.

Technical Editor **Michael D. Sullivan** added a great deal to this book in addition to checking all the text for technical accuracy. A veteran slide photographer, Michael contributed some of the best images in this book, and he volunteered his expertise in Mac OS X for important behind-the-scenes testing of software and hardware.

Mike began his photo career in high school where he first learned the craft and amazed his classmates by having Monday morning coverage of Saturday's big game pictured on the school bulletin board. Sullivan pursued his interest in photography into the U.S. Navy, graduating in the top ten of his photo school class. Following Navy photo assignments in Bermuda and Arizona, he earned a B.A. degree from West Virginia Wesleyan College.

He became publicity coordinator for Eastman Kodak Company's largest division where he directed the press introduction of the company's major consumer products and guided their continuing promotion. Following a 25-year stint with Kodak, Sullivan pursued a second career with a PR agency as a writer-photographer covering technical imaging subjects and producing articles that appeared in leading trade publications. In recent years, Sullivan has used his imaging expertise as a Technical Editor specializing in digital imaging and photographic subjects for top-selling books.

# Dedication

As always, for Cathy.

# Acknowledgments

Once again thanks to Andy Shafran, who realizes that a book about working with color images deserves nothing less than a full-color treatment, and knows how to publish such a book at a price that everyone can afford. It's refreshing to work for a publisher who has *actually written* best-selling books on imaging, too. Also, thanks to senior editor Kevin Harreld, for valuable advice as the book progressed, as well as project editor Jenny Davidson, copy editor Kezia Endsley, layout tech Bill Hartman, proofreader Sandi Wilson, and indexer Sandi Schroeder.

Special thanks to my agent, Carole McClendon, who has the amazing ability to keep both publishers and authors happy.

# Contents

## PART II: MAKING GREAT IMAGES

# Preface

Transport your growing collection of color slides, transparencies, and negatives into the digital world! Your best pictures may not have been captured with a digital camera, but there's no reason why you can't use your computer to view, manipulate, edit, store, or print every image. Inexpensive scanners that can digitize your film images throw open the doors to amazing creative techniques like those discussed in this book.

It doesn't matter whether you're a digital photographer wanting access to an archive of older film-based images, or an active film (or film/digital) shooter yearning to combine the advantages of conventional photography with digital technology. You don't even need to be a computer genius, nor bust your wallet to get the capabilities you need. This book is aimed at everyone who has film images and wants to work with them electronically.

# Introduction

The great enigma of the digital age: what do I do with all my color slides, transparencies, and negatives? According to the Photo Marketing Association's most recent review and forecast, millions of rolls of film are being sold in the United States alone, along with millions more one-time-use film cameras. We're as likely to see filmless photography anytime soon as we are to work in a paperless office.

Even as digital photography becomes the tool of choice for professional and amateur shooters, film remains a wildly popular medium. And even if film cameras were to vanish tomorrow (and they won't!), most photographers have a treasure trove of film-based images they'd love to be able to manipulate, archive, share, or print using their computers, precisely because of the growing popularity of digital imaging. This book tells you, finally, what you can do with your pictures other than paste them in an album or toss them in a shoebox.

*Mastering Digital Scanning with Slides, Transparencies, and Film* covers every aspect of digitizing, managing, and enhancing film-based images. It cuts through the confusion and describes easy and comprehensive answers to questions that every photographer has been asking. Best of all, it approaches the topic from the photographers' viewpoint rather than that of the graphics guru or PC hardware maniac. There's lots of hardware talk here, along with discussions of appropriate software, too, but everything is canted towards the needs of you, the avid picture-taker.

The best news is that this kind of scanning has suddenly come within the reach of everyone. In March, 2003, Minolta introduced its new DiMage Scan Dual III AF-2840 film scanner at a price of $279. Epson's Perfection scanners were among the first flatbed scanners to do an admirable job scanning film from 35mm to 120 rollfilm. Instead of paying $800 to $1500 for a dedicated film scanner, just about anyone who does film scanning regularly can justify a scanner for the job at a cost of a few hundred dollars.

## Why Another Book About Scanners?

There are dozens of books that purport to address the topic of scanning. I've written nine of them myself. Do we really need another book on the topic?

Actually, I continue to write books on various aspects of scanning because I think there is a serious *shortage* of books that cover the kinds of information you really need to know. As far as film scanning goes, there has been nothing at all aimed at the consumers, photo fans, and graphics workers who want to learn how to capture and use images that originate on slides, transparencies, or negatives. Too many of the books on the shelves are aimed at graphics professionals with esoteric needs and big budgets. Others concentrate on the gee-whiz aspects of the technology and other topics that are only peripherally related to photographic aspects.

This isn't an owners' manual for scanners. You won't find detailed instructions for operating any specific device. The manual that came with your scanner probably has lots of great tips on how to turn it on, make basic settings, and capture an image. I'm going to concentrate on what each of your scanner's controls mean to your final photographs, not how to access them. If you're interested in how scanners work, you'll find enough nuts-and-bolts in the first few chapters. The bulk of this book deals with techniques for getting the best scans and ways to manipulate your images after the scan.

What is *not* contained in this book is as important as what you'll find here. The shrewd folks at Muska & Lipman/Course Technology recognize that digital imaging is a huge topic, so the topics I don't address fully within these pages are covered in other books. These include:

*Adobe Photoshop Photographers' Guide.* (ISBN: 1-59200-172-6) This book serves as an introduction to intermediate and more advanced Photoshop techniques, specifically from the photographer's viewpoint. You can apply this information both to scanned images as well as those created with your digital camera.

*Digital Retouching and Compositing: Photographers' Guide.* (ISBN: 1-932094-19-9) Here you'll find everything you need to know to turn your shoebox-reject photos into triumphant prize-winners. It covers both eliminating defects and repairing pictures to more sophisticated techniques for combining two or more images into a realistic (or, if you choose, fantastic) composite.

*Mastering Digital Photography.* (ISBN: 1-59200-114-9) This is a more advanced book on digital imaging with cameras, full of lots of tips and tricks that any photographer will appreciate.

# What You'll Find Here

I've tried to pack this book with exactly the kind of information you need to scan your images as you graduate from snapshooting to serious photography. It's divided into two parts. The first part gives you the background you need to understand the special requirements of film scanning, and ways to get the best scans. You'll learn a little of how scanning works, why so many options, features, and formats exist, and how you can use these to improve your scans. The second part deals with techniques for enhancing, retouching, storing, and distributing your scanned images.

I'm especially proud of the hefty illustrated glossary I put together for this book. It's not just a word list, but, instead, a compendium of definitions of the key concepts of digital imaging. You'll find all the most important terms from this book, plus many others you'll encounter while creating images. I've liberally sprinkled the glossary with illustrations that help clarify the definitions. If you're reading this book and find something confusing, check the glossary, contained in Appendix A, first before you head to the index. Between the two of them, everything you need to know should be at your fingertips.

# Who Are You?

This book is aimed squarely at anyone who has shot film in the past and wants to move their images into the digital age for manipulation, enhancing, and sharing. It's also written for digital camera buffs and conventional film camera photographers, as well as businesspeople who want to continue to shoot film without losing any of the advantages of their computer. Their goal is to get more from their film images, enrich their photographic activities, flex their creative muscles, or do their jobs better.

If you fall into one of the following categories, you really need this book:

- Photo buffs who want to use their prints for more than just display in albums, or to use their slides for something other than projector shows. You want to use the power of the computer to enhance and distribute your images in better, more versatile ways.

- Those who want to produce more professional-looking processed images from film originals for their personal or business Web site.

- Small business owners with more advanced graphics capabilities who want to use photography and images to document or promote their business, and who have a large base of film images to work from.

- Corporate workers who might not have photographic or image-editing skills in their job descriptions, but who work regularly with graphics and need to learn how to use film images for digitally-based reports, presentations, or other applications.

- Graphic artists and others who already are adept in working with digital images, but who need to know how they can apply their skills to images that originate on film.

- Trainers who need a non-threatening, but advanced, textbook on film/slide/transparency scanning for digital photo-editing classes.

# Who Am I?

You may have seen my photography articles in *Popular Photography & Imaging* magazine. I've also written about 2000 articles for *Petersen's PhotoGraphic*, *The Rangefinder*, *Professional Photographer*, and dozens of other photographic publications. First, and foremost, I'm a photojournalist and made my living in the field until I began devoting most of my time writing books.

Most digital imaging and scanning books are not written by photographers. Certainly, the authors have some experience in taking pictures, if only for family vacations, but they have little knowledge of lighting, composition, techie things like the difference between depth-of-field and depth-of-focus, and other aspects of photography that can make or break a picture. The majority of these books are written by well-meaning folks who know more about Photoshop than they do about photons.

*Mastering Digital Scanning with Slides, Film, and Transparencies*, on the other hand, was written by someone with an incurable photography bug. I've worked as a sports photographer for an Ohio newspaper and for an upstate New York college. I've operated my own commercial studio and photo lab, cranking out product shots on demand and then printing a few hundred glossy 8×10s on a tight deadline for a client's presskit. I've scanned thousands of images, dating back to the Stone Age of desktop scanning (in the late 1980s); I've served as photo-posing instructor for a modeling agency. People have actually paid me to shoot their weddings and immortalize them with portraits. I even prepared presskits and articles on scanning technology as a PR consultant for a large Rochester, N.Y. company. My trials and travails with imaging and computer technology have made their way into print in book form an alarming number of times, including nine tomes on scanners and seven on digital photography.

So, what does that mean? In practice, it means that, like you, I love photography for its own merits, and view technology as just another tool to help me get the images I see in my mind's eye. It also means that, like you, when I peer through the viewfinder, I sometimes forget everything I know and take a real clunker of a picture. Unlike most, however, once I see the result, I can offer detailed technical reasons that explain exactly what I did wrong, although I usually keep this information to myself. (The flip side is that when a potential disaster actually looks good, I can say "I meant to do that!" and come up with some convincing, but bogus, explanation of how I accomplished the "miracle.")

This combination of experience—both good and bad—and expertise lets me help you avoid making the same mistakes I sometimes do, so that your picture taking can get better with a minimum of trial-and-error pain.

I hope this book will teach anyone with an interest in computers and/or photography how to spread their wings and move to the next level. This book will reveal the essentials of both scanning and the important aspects of digital technology without getting bogged down in complicated details. It's for those who would rather learn the difference between a flatbed and film scanner, and how it affects their picture taking, than find out which type of image sensor is the best. I do cover both topics, though, because I think it's possible to feed your technology curiosity without neglecting meaty photographic aspects.

# What You Need

A few of you are reading this book to satisfy your curiosity about digital imaging before actually taking the plunge and buying a camera or scanner. The information here may help you decide just how much scanner you need.

However, many of you already own a film-capable scanner and want to know, "Is this book for me?" That's an excellent question, because books that try to do everything invariably provide too little information about any one topic. I'm going to target information for a broad range of the digital picture-taking public, but if you can satisfy a few pre-requisites, you'll find this book will be much more useful to you.

This book assumes that you have a scanner that can capture film images. If not, I'll help you choose one. I'm not going to name specific models in most cases, for the simple reason that model names are irrelevant. One of the scanners I use regularly is an old Epson Perfection 2450 flatbed that is positively ancient. However, in terms of film scanning it performs as well as the Perfection 3200 and other models that replaced it. So, when I am talking about flatbed scanners with 2400×2400 to 3600×3600 sample-per-inch optical resolution (more on *that* later), it doesn't matter exactly which model I am referring to. The basic capabilities are all that is important.

You should also have a computer equipped for basic scanning needs. Although 3GHz Intel or Athlon speed demons and dual-processor Mac G4 or G5 machines are sexy and affordable, you don't really need that much horsepower for scanning or image editing. I've found that any 800MHz computer (Intel or Mac) with 512MB of memory (even more is better) can do the job. Of course, you'll need either a FireWire or USB connection (USB 2.0 is better than USB 1.1 for most scanning applications), and a monitor large enough (17 to 19 inches) to make viewing a pleasure rather than a pain.

You've shown that you have the final thing you need by purchasing this book. Your enthusiasm and interest in digital imaging will help you turn the information you'll find here into great pictures.

# Chapter Outline

I've divided the book into two parts. Here's a concise outline of the contents.

In Part I, "Making Great Scans from Film," the following topics are covered:

- Chapter 1, "Film Scanning from 50,000 Feet," provides an overview of film scanning, covering why we have film positives as an end-product (instead of prints) in the first place; the difference between slides and transparencies; why shooting positives is still a great idea in the digital age; and how film scanning has developed through the years. There is also an overview of what you can do with scanned film, and a brief list of the options that will be discussed in later chapters. This chapter also points towards third-party services mentioned in Chapter 7.

- Chapter 2, "Film and Scanning," includes detailed information on the makeup of film and how that relates to scanning; differences between color transparency/slide film and color negatives; why negatives are more challenging to scan; and black-and-white positives and negatives. Photographers will learn why it's better to scan a negative or a slide than to scan the second-generation original called a print.

- Chapter 3, "Scanner Specifications for Film," expands on the topics introduced in the last chapter. It includes an in-depth explanation of the characteristics needed in a good film scanner; what dynamic range is and why it is more important in scanning film than in scanning prints; why resolution is much more important when scanning film; why the scanner's optical system is more important than the claimed resolution; and what

interpolation is and why photographers must understand it. When you finish this chapter, you'll have a solid understanding of even the more esoteric features of scanners, such as ASF's Digital ICE technology (for dust reduction), oversampling, and other topics. You'll be well-equipped to evaluate scanners.

- Chapter 4, "Choosing a Scanner," lists the types of hardware available, so you can apply what you learned in the last chapter to select a model. It also discusses your purchasing venues, including online stores, retail camera stores, and other channels.

- Chapter 5, "Scanning with Film-Only Scanners," is a how-to outlining the general procedures for scanning film using the various types of film-capable scanners. Topics include all the steps up to and including making the scan, preparing the image, choosing resolution, and selecting the image.

- Chapter 6, "Scanning with Flatbed and Multipurpose Scanners," discusses the techniques for scanning film using flatbed scanners with built-in scanning capabilities. The topics range from preparing the scanner for the scan to the advantages of gang-scanning several images at once.

- Chapter 7, "Using Outside Services," covers the myriad service bureaus that will scan your film when you take it in for processing. You don't have to do the work yourself! Many will also scan your existing slides or negatives, or even prints. The chapter covers the planning you can do to streamline the process when you know in advance you'll be having your film scanned. It also covers Kodak Photo CDs and options for receiving your scanned images online.

- Chapter 8, "Do-It-Yourself Solutions," covers the ways you can scan film *without* having special scanning hardware. If you can't afford a dedicated film scanner and don't have a flatbed that's nominally film-compatible, all is not lost. This chapter covers everything from slide copy attachments for digital cameras (a widely available but almost unknown accessory) to building your own back-light source for your flatbed.

In Part II, "Making Great Images," the following topics are covered:

- Chapter 9, "Introduction to Image Enhancement," covers the options available in scanner software to fine-tune scans, including why it's better to fine-tune in the scanner than in the image editor. The chapter covers the basics of image quality as well.

- Chapter 10, "Fine-Tuning Your Scans," explains how to color-correct scanned images, remove dust and other artifacts, improve the contrast, and enhance sharpness. Even the most carefully-scanned film image won't be perfect. This information applies to every image editor, but common tools like Adobe Photoshop Elements are used for the examples.

- Chapter 11, "Enhancing Scanned Images," explains how easy it is to go beyond fine-tuning to transform scanned images into something special. It provides an overview of some of the topics covered in *Adobe Photoshop Photographers' Guide* and *Digital Retouching and Compositing: Photographers' Guide* so readers will know where to go next for more information.

■ Chapter 12, "Sharing Scanned Images," explains how scanned images can be shared using e-mail, web pages, and online services. Other options, such as making CDs with images, are discussed. For example, Adobe Photoshop Album and several other programs let you create slide shows that can then be burned automatically onto a CD.

■ Chapter 13, "Storing and Managing Images," discusses software, such as Adobe Photoshop Album, that can not only archive images but also provide quick access through keyword, date, or title searches. Slides are traditionally stored in trays for projection, or plastic sleeves for filing. Negatives can be archived in plastic sleeves, in envelopes, or, with newer technologies such as the Advanced Photo System, right in the cartridge used in the camera. Managing digitized images can be much more efficient than any of these traditional systems, however. These products can also be used to create web pages, digital albums, and other products.

■ Appendix A, "Illustrated Glossary of Scanning and Digital Terminology," explains all the scanning, photographic, and digital imaging terms in the book, illustrated by photographs that will help you understand the terms more easily.

M astering digital imaging with slides, transparencies, and negatives involves two processes: producing great scans and enhancing those scans to create great images. The first step in transforming your film image into a digital masterpiece is to make a scan that captures all the detail in the original film. The first part of this book concentrates on the technology and techniques you need to understand to capture film images proficiently. The second step is to manipulate the pixels in your scan to craft the image you knew was hidden in your original photograph. Later on, in Part II, I'll show you what you can do with those images.

# PART I

# Making Great Scans from Film

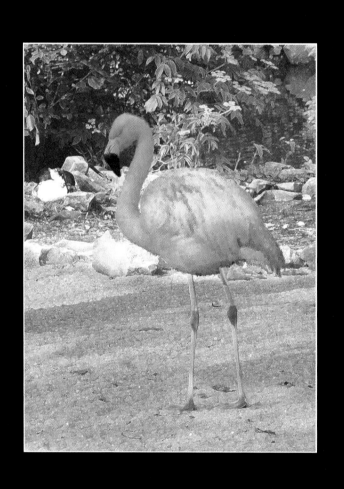

# Film Scanning from 50,000 Feet

When digital imaging first appeared as a promising glimmer on the photographic horizon in the early 1990s, film scanning became the photographer's *Holy Grail*. At that time, few photographers actually expected to *originate* digital photos anytime soon. Digital cameras were horrendously expensive and produced, at best, 1.3-megapixel images that were far below the standards set by film cameras of the time. At the dawn of digital imaging, electronic cameras were the province of photojournalists, catalog photographers, and a few others who needed photos very quickly (for breaking news) or who could benefit from mass-produced digital images (for applications such as catalog layouts).

No, the initial attraction of digital imaging came from the lure of computerized image manipulation (such as retouching photos and removing defects), color correction, and *compositing* (combining several images into one), using miracle-working software such as Adobe Photoshop, which was introduced in 1990. Those of us who had slaved in darkrooms to tweak traditional photographic images slavered at the thought of being able to perform those same manipulations quickly and *reversibly* in the digital darkroom.

The most daunting problem then was *acquiring* digital images. The most versatile and affordable scanners a decade ago were flatbed models that scanned only reflective materials, such as prints. Those devices were sharply limited in what they could do. The first flatbed scanner I owned was able to capture no more than a paltry 16 grayscale tones at a coarse 300 samples per inch—and it cost $2495!

From a photographer's point of view, flatbed scanners have been, at best, no more than a better-than-nothing tool. Shooting images on film, making a print, and then scanning the

second-generation artwork made little sense to photographers. As long as we're shooting film, why not scan the original film? Of course, that exact process has long been followed for images shot for publication. Film scanners had been around since the 1950s, and evolved into sophisticated drum scanners that used laser or photodiode illumination to create ultra-high quality scans and color separations.

However, drum scanners and the computer hardware needed to drive them could have cost up to a million dollars, well beyond the budget of any photographer. Moreover, using a third party to scan images took some creative control out of the hands of the photo's originator. Thanks to Photoshop, photographers began to morph from combination shooters/darkroom technicians into closet computer nerds. Visit any newsroom in the early 1990s and you'd find photographers seated at Macs, fine-tuning their photographs in Photoshop. Many photographers became as skilled at pushing pixels in an image editor as they were in pulling focus. What we really needed was film scanning that could be done by the person whose vision was driving the whole image-creation process.

We've arrived at that point today. Film scanners are available that anyone can afford, and things are only going to get better.

This book is going to delve a little more deeply into digital *photography* than many of the books you may have read. Unlike most of the others on the shelf, this is a *photographers' guide*, designed to leverage the things you already know about photography as you spread your wings in the digital realm. This first chapter is intended to be an overview of film scanning and digital technology, a glimpse from 50,000 feet that provides you with some perspective on where we are, where we're going, and how we got here.

# THE HIDDEN ADVANTAGE

Photographers have become so accustomed to manipulating images in Photoshop that we sometimes take for granted one of the key advantages of digital imaging: *reversibility.* Too many of the special effects and correction techniques used with film are one-shot deals—if you goof, you're stuck with the result. Plunge partially processed film into extreme temperature solutions to achieve a cool reticulation effect, and you might get a cool reticulation effect, or you might end up with emulsion peeling from the film base. Expose developing film to light to create a solarized look, and you could end up with nothing more than fogged film. Underexposed film processed for an extended period of time *might* yield an interesting grain effect, but you might also wind up with a strip of film that's virtually transparent or very low in contrast.

Use digital-image manipulation, instead, and your original slides and negatives remain untouched. You can apply a Reticulation filter, manipulate controls in the Curves dialog box to simulate solarization, or add as much or as little grain as you like. If the effect is not what you wanted, Undo will take you back to where you started. Digital imaging has given photographers unprecedented freedom to scan and modify photos in endless variations.

# How the Technology Got Here

Scanners aren't as new a phenomenon as you might think. Scanning was first proposed in 1850 as a method of transmitting photographs over telegraph lines, giving new meaning to the phrase "dot...dot...dot...". When you realize that photography itself was only a decade or so old, you can understand just how futuristic the idea was at the time.

In 1863, a Catholic priest named Giovanni Caselli achieved the first facsimile transmission when an image was sent between Paris and LeHavre, France. It might be said, then, that the telephone was invented 13 years later so we'd have a way to call somebody up and see if our fax arrived okay. Caselli's *pantelegraph* (a combination of the words *pantograph* and *telegraph*) was a six-foot tall cast iron device. Graphics or text were drawn on a sheet of tin, which was then scanned by the stylus of the transmitter at a coarse resolution of three lines per millimeter (roughly equivalent to 75 samples per inch—not bad!). The signals were sent by telegraph to the destination, where another scanning device wrote a facsimile of the original image. A pair of super-accurate clocks were required to synchronize the process at each end. Figure 1.1 shows the "scanner" portion of Caselli's device.

Another scanning system (the "Nipkow disk") was developed in 1884 as a precursor to television. Then, work by a German physicist in the early part of the 20th Century led to wire photos, introduced to the United States in 1925. The first scanner used to produce color separations for graphic arts applications was developed in 1937. Scanners for the desktop first became available in the late 1980s, and film scanners that cost $4000 or less finally brought capture of slides, transparencies, and negatives within reach of most photographers in the waning years of the 20th Century.

**Figure 1.1** *Napoleon III is shown standing next to Giovanni Caselli's "scanner" in this 1866 engraving.*

Film scanners emerged side-by-side with related technologies, such as reflective artwork scanners and digital cameras. There's been a great deal of overlap in the development of these digitizing technologies. In the 1960s, NASA converted from analog to digital signals for the lunar missions that mapped the surface of the moon because, as you probably know, analog signals can fade in and out, whereas digital information can be transmitted and received virtually error-free. The space program was responsible for the heavy-duty image processing we use today, as computer technology was used to enhance the images returned by NASA's various space probes. The Cold War, replete with spy satellites and various super-secret imaging systems, also helped push the development of digital photography.

Texas Instruments patented the first film-free electronic camera, which, unfortunately, required viewing pictures on a television, in 1972. TV viewing was also an option for the Sony Mavica, introduced in August, 1981 as the first commercial electronic camera. However, the Mavica could also be attached to a color printer. Yet, even the Mavica wasn't a true digital camera; it was more of a video camera that was able to capture and display individual frames. As with scanners, images were captured a line at a time (although very quickly) by these earlier video/electronic cameras. Today, digital cameras capture an entire image in an instant, using an array with rows and columns of tiny sensors.

Scanners, on the other hand, have generally, er, *scanned* to produce an image, using a single-line array that contained sensors across the width of the original being captured. In 1981, I jokingly proposed in a magazine article a scanner built around a dot-matrix printer with a sensor replacing the printhead, thinking that the coarse printers of that day were much too imprecise to actually be used for scanning. Four years later, I found myself the proud owner of a device called *ThunderScan*, which operated in exactly the way I'd joked about, using the Apple ImageWriter as a platform.

My first desktop scanner was slow (requiring many minutes to capture even a small image), captured only black-and-white (not grayscale or color) graphics, and was saddled with relatively low resolution. Although wildly popular for a few years, ThunderScan eventually vanished from the scene as more advanced scanners became available. A typical ThunderScan image is shown in Figure 1.2.

Scanners similar to those we use today followed, but cost $5000 or more in a time when it was possible to purchase a new pickup truck for the same price. Desktop scanning didn't take off until the late 1980s, when Hewlett-Packard introduced the original ScanJet, which could capture

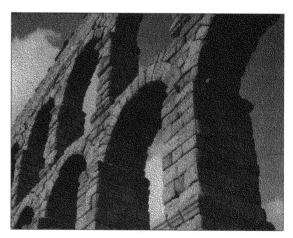

**Figure 1.2** *A typical ThunderScan image.*

up to 16 gray tones, like the image shown in Figure 1.3, and cost only a few thousand dollars. Good-quality grayscale scanning requires more than 16 levels, of course, so HP followed its initial scanner product with the ScanJet Plus, which could capture up to 256 tones.

Eventually, full-color scanners knocked their grayscale counterparts out of the picture entirely, and vendors began quietly developing film scanners with the requisite capabilities (outlined in the next section). Early models were expensive, thanks to a photographic Catch-22. Only a few photographers could afford them, so vendors had to price them high to recoup their costs. Huge price tags perpetuated high prices. Of course, at $5000 or more, not many photographers could be convinced that they even *needed* film scanners. It was only when prices

**Figure 1.3** *This scan has exactly 16 gray tones, yet looks surprisingly natural.*

began to drop below the $2000 level that a large number of graphics professionals realized that they could use these gadgets after all.

Film scanning is no longer the exclusive province of the most sophisticated echelon of graphics professionals. Today, *anyone* can capture digital images from their color slides and transparencies, negatives, and other film originals. You don't need a mega-dollar laser drum scanner to do it. You don't need a $4000 dedicated slide scanner to scan film. Your existing scanner, perhaps supplemented with an accessory, or a low-cost slide scanner that will nick your wallet for less than $300 can do the job. All you need is some inexpensive hardware and the information in this book.

For anyone who's followed scanning technology for more than a few years, this is a strange, unexpected, and wonderful turn of events. Film scanning has long been both the neglected child and darling of the digital imaging world. On one hand, a steady supply of increasingly capable film scanners has been developed and marketed to the well-heeled professionals who need to grab images from slides, transparencies, and negatives on a daily basis. On the other hand, many of us who enjoy shooting film and/or have an extensive library of film images crying out for digital manipulation and storage either couldn't afford the tools we needed, or didn't want to use one of the commercial services that will scan film.

## Computers Up to the Task

So why have film scanners taken so long to come to the personal computer? The main reason for the delay is that graphics of any sort are extremely difficult for computers to handle. Although we think of our PCs as powerful, do-anything devices, their versatility is a brute-force application of their powers to tasks that aren't really suited for raw number-crunching. Indeed, computers can do only one thing really, really well: manipulate numbers. To handle visual information, the analog visual data must be converted (digitized) and stored as numbers, a great many numbers. Ultimately, your computer sees the image you scan as nothing more than a series of binary numbers.

A simple 24×36mm color slide, for example, when scanned at 4000 samples per inch, represents 24 million pixels of information. In raw form, that's more than half a gigabyte of data. Fortunately, the image is squeezed down to a more manageable size using a technique

called *compression* in which long strings of binary 0s and 1s are replaced by much shorter codes that mean the same thing.

So, the first barrier to the development of film scanners has been the need for computers with the raw horsepower to handle all that data. In the early 1990s, I worked with Macintosh computers that required several minutes to apply a simple transformation to an image that weighed in at a few megabytes. To this day, Photoshop includes an option for a helpful "beep" that lets you know when a particular step is finished, dating from a time when it was common to go get a cup of coffee while a Gaussian Blur was applied.

Fortunately, today, we have computers with fast enough processors and sufficient memory to easily manipulate the kind of huge images that film scanning can generate. Indeed, any Mac or PC operating at 800MHz or faster, with 512MB of RAM or more, can be used for film scanning. A faster computer or more memory will make your life easier, but you don't necessarily need the latest big-bucks speed demon to work with images that originate on film.

## Film Scanners Up to the Task

The second roadblock has been the development of film scanners themselves. Designing flatbed scanners for reflective artwork like photographs is almost a no-brainer. Unless you're scanning small, highly detailed originals such as engravings or postage stamps, the same 300 samples-per-inch resolution available from the earliest flatbed scanners is likely to be sufficient. (You'll learn why in Chapter 2.) Capturing full-color at flatbed resolutions is easy, too. Photographs don't include the extremely broad range of tones found in film, so a specification called *dynamic range* (more on that in Chapter 2, also) is less critical for reflective originals.

Now, let's design a scanner for slides, transparencies, or negatives. You'll need much higher resolutions, because the originals are smaller. Instead of an 8×10 print, you may be scanning a piece of film that measures 24×36mm (about 1×1.5 inches). On an original that size, a tiny speck of dust that might blend in with the grain of an 8×10-inch print is enlarged during the scanning process to the size of a gigantic boulder. A hardware or software tool for minimizing dust and other artifacts is essential.

Prints lay flat on the scanner glass, whereas film tends to curve even when confined to a well-designed film holder. You'll need to focus the film scanner, too. It's probably a good idea to design some sort of film-transport mechanism for your film scanner, and a variety of film holders to accommodate the various types of film that must be scanned.

Just when you feel you have everything under control, someone points out that film has a much longer dynamic range, so your scanner's sensor will need to be able to pull detail out of both very dark and very light areas, without compromising the middle tones. There are a few curveballs thrown in for good measure, like the fact that color negative films have a pesky orange-colored mask that you have to compensate for. The mask varies from film vendor to film vendor.

As you can see, inexpensive film scanners had to wait while vendors surmounted the technological hurdles.

## Surmounting Storage Challenges

The third challenge facing designers of film scanners has been the need for sufficient storage to accommodate the massive images that film scanning can produce. Although the capacity of hard disk drives and removable storage options in the mid-1990s remained well ahead of the needs of most users, even those working with graphics, film scanning (along with digital video) has always taxed the capabilities of even the most capacious storage devices.

The 8- to 20GB hard drives of the last generation were barely large enough to store a set of working files for a typical film-scanning project. A 700MB CD-R might have enough space to archive only a dozen or so scanned images. Dial-up connections were laughably slow when it came time to transfer images electronically.

Today, hard drives with 200- to 320GB of storage are commonplace. More photographers own DVD-R, DVD-RW, or DVD+RW drives capable of archiving nearly 5GB of images, and capacities are increasing all the time. My own personal computer has three hot-swappable hard drives, like those shown in Figure 1.4, that can be exchanged for another, so when I want to back up my images, I can pull out one tray and substitute another. Anyone who has struggled with 100MB or 250MB Zip disks appreciates being able to plug in a removable storage device with, say, 120GB of space!

**Figure 1.4** *With hot-swappable 120GB drives, your computer's storage is open-ended.*

## Software Head Start

For the most part, the available software used for film scanning has leapfrogged ahead of the technology. The original Version 1.0 of Photoshop could do much of what needed to be done in terms of editing images, even though later features such as layers, advanced color correction techniques, and sophisticated filters have proved to be indispensable. However, a great many of the improvements in image-manipulation software have been confined to enhancements that make your work faster and easier. Only a tight core of essential features have been developed that have made the final images *better*.

Today, most of the barriers have been knocked down. Inexpensive film scanners and more versatile film-scanning services have welcomed the full range of film images to the wonderful world of digital imaging. This chapter provides a little background on film scanning, explains the key terms, and makes some predictions about where the industry is going.

# A BIT OF PERSPECTIVE

If you want to know just how far ahead of its time Photoshop 1.0 was, consider some of the other products photographers had to work with during that era.

- The fastest Macintosh in 1990 was the Macintosh IIfx, which ran at 40MHz (roughly 50 times slower than today's Macs), had a 160MB hard drive, and cost in excess of $10,000. If you wanted 16.8 million colors instead of 256 colors, you could pay up to a few thousand dollars extra.

- On the PC side, Intel 386 microprocessors running at 33MHz were on the cutting edge. With an 80MB hard drive or two, 8MB of RAM, and a decent monitor, you could expect to spend $7000 or more.

- Windows 3.0 had just been introduced. It was the first widely used PC operating system that easily supported more than 16 colors. Earlier versions of MS-DOS and Windows required shifting into special video modes if you wanted, say, 256 gray tones. Many PC image editors of the time were grayscale only, with no support for color.

- The first pro-quality digital camera, the Kodak DCS-100, was introduced a year after Photoshop, in 1991. Based on a Nikon F3 body, it cost $30,000, had a 1.3-megapixel sensor, and stored its images on an external 200MB hard drive. The whole outfit weighed in at 55 pounds!

- The year 1990 was the Stone Age of the color scanner. Grayscale scanners still predominated, and funky handheld scanners were appearing. But color scanners like the Microtek MSF-300Z flatbed and soon-to-be-introduced Microtek MTS-1850 film scanner were available to those who had thousands of dollars to invest.

# Why Scan Film?

Why would you want to scan film, anyway? Many newcomers to film scanning usually ask this question. Digital cameras are so common these days that film might appear to be on the way out. However, keep in mind that photography didn't replace painting. If anything, there are probably more canvases being slapped with paint today than ever before in history. Artists who work in any medium usually dabble in painting to learn their art before moving on to more refined art forms involving welding and hubcaps. Nor is abstract art the only form of painting today. Most people consider a painted portrait to be a desirable and superior alternative to a more "lifelike" photographic portrait. People pay big a premium for Thomas Kinkade coffee mugs, too.

Photography might have partially supplanted painting and drawing for mundane documentation and illustration, but open any technical manual and you'll still see many hand-drawn diagrams. Photography's greatest impact has come in creating images quickly that couldn't be captured easily by hand, and in giving artistic expression to those who don't have the skills to paint or draw.

# DOES LABOR EQUAL VALUE?

One of the reasons conventional photography will continue to be valued is that the perceived amount of labor—the personal touch, so to speak—put into a piece of art seems to have a bearing on its perceived value. So, paintings are more highly valued than photographs, and Ansel Adams is rarely put on the same pedestal as Pablo Picasso, even though Adams could spend days preparing to take a photo, and Picasso sometimes spent no more than a few minutes on a drawing. The perception is the important thing. Digital photography, because it is "faster," is less likely to be seen as fine art until the public comes to perceive just how much additional time is invested in digital photos during the image-editing process.

Similarly, digital photography is unlikely to eliminate film photography for a long time to come. There are still many things you can do with a film camera that are difficult or impossible to achieve with a digital camera. So, what are the options for photographers who use a traditional camera for some or all of their work? The next section provides a checklist.

## Capturing Prints with a Flatbed Scanner

The traditional way for film images to make the transition to the digital realm has been to scan a print on a *flatbed scanner* (those ubiquitous copier-like peripherals with the lid and glass plate). Indeed, scanning prints has been the only alternative for so long that most of us have forgotten its disadvantages:

■ Prints made directly from negatives have less detail than the original negative. A print is always what we call a *second-generation* product, and loses some of the sharpness present in the film that was exposed in your camera. Detail is invariably lost through a variety of factors, ranging from the added "grain" of the paper the image is printed onto, to the losses in the optical system of an enlarger or automated printer used to make the print.

■ Prints made from slides, especially when an intermediate negative is made, can have *much* less detail than the original slide. If an intermediate negative, or *interneg*, is required, the resulting print is a *third*-generation product, with all the loss of detail that implies. The scan made on your flatbed will be the *fourth* generation.

■ Prints inherently have a much shorter *dynamic range* than film. We'll look at dynamic range in more depth later in this book, but for now it's important to note that the deepest blacks and whitest whites that have detail in a piece of film are invariably blacker and whiter than you can produce with a print. So, an image scanned from film is likely to have a much wider range of tones than one scanned from a print.

■ Prints might not have the correct colors. Color balance is particularly mutable in a color print. When a print is made, the color found in the original film may be "corrected," either using the judgment of the printing machine's operator, or some computer logic built into the device itself. If you've ever shot an impressive, dusky sunset on film, like the one shown at left in Figure 1.5, and received a print that was brightened and/or "fixed" with lots of blue

correction, like the one shown at the right, you'll know what I'm talking about. If you scan a print, there's no telling how close the colors of the print are to the original subject. Scan film, and at the very least you're scanning exactly what the camera saw. The colors in the original film might still be off, but at least the decision about whether to fix them is in your hands.

**Figure 1.5** *Prints are often "corrected" too much!*

There are other disadvantages to scanning prints, but these are the key pitfalls. When you consider them, you might wonder why there are scanners for prints and other reflective art at all. That's a good question, in theory. Flatbed scanners would best be used for originals that don't exist on film in the first place, such as items like postage stamps, printed pieces, paste-ups, Daguerreotypes, or hand-drawn artwork, as well as originals for which the film is lost (those old prints in your shoebox, for example). In practice, reflective art scanners have predominated because they are easy to use, cheap to build (compared to film scanners), and the average user has more prints than negatives tucked away in shoeboxes. Although flatbed scanners might not be the best solution for capturing images that originated on film, for many years they have been the most practical and flexible solution.

## DIGITAL CAMERAS AS SCANNERS

Digital cameras can substitute for a flatbed scanner in a pinch. You can zoom in on a print in close-up mode and capture an image quickly. The resolution won't be as good as with a scanner, lighting the print might be tricky, and the process will require more setup time than you need with an always-ready scanner. But if you only need to capture an occasional print, a digital camera can work in a pinch. You can also use a digital camera to capture slides and other film images, as you'll learn in Chapter 8.

# Using an Outside Service

As you'll discover in Chapter 7, there are many services eager to scan your slides, negatives, transparencies, and prints. You might want to use these services if you have a very few film images to convert, or have a great many. That's not as paradoxical as it sounds. Obviously, if you have only a few special film images you'd like to convert to digital form, it's not worth it to buy hardware to do the job when an outside service can do it for you. At the other end of the scale, if you have a huge stockpile of film to scan, the job could conceivably take months, even if you have the right equipment. It might be better to subcontract the work to a professional service that's geared up for volume work. Once the backlog is taken care of, you can scan other film images as you create them.

An outside service might also be a good idea if you have a regular flow of film images, but don't want to bother with it yourself, or would prefer not to interrupt your regular workflow. Even if you never touch a film scanner, you'll find lots of information about what you can do with your scanned images in Part II of this book.

# What Types of Film Can You Scan?

As much as I love film scanning, writing about it can be tricky because the terminology can be so cumbersome. There's *film*, of course, which encompasses every kind of semi-transparent original described in this book. But there are also *slides*, *transparencies*, and *negatives*, which differ from each other in a lot of ways. In this section, I'm going to define exactly what I mean by each term.

## Film

In this book, *film* means a flexible, semitransparent, (formerly) light-sensitive roll or sheet material that contains an image, after it's been processed. You probably think of film as rolls, cassettes, or cartridges you put in a camera to take pictures. That's a reasonable definition, but the term *film* applies to a much broader range of objects. For example, some kinds of professional cameras use sheets of film, in sizes ranging from 6×9cm to 11×14 inches. This kind of film is used in *view or studio cameras*, which are those large tripod-mounted cameras used for some kinds of illustration and portraiture. (Today, these cameras are as likely to have a digital sensor back-mounted as a film sheet holder.)

Film also includes the material used to produce copy negatives made of prints, duplicates made from slides or negatives, and positive transparencies made from negatives. A piece of film might not even contain an image, although, for this book, when I'm talking about film, I'm always referring to film that has an image aboard.

So, when I use the term *film*, I mean slides, transparencies, negatives, and other originals of the type that can be scanned.

## Transparency

A transparency is a positive image on a piece of film. The most common types of transparencies are color, but black-and-white transparencies are also made. Transparencies can be any size, from 35mm (or smaller) up to 11×14 inches or larger. The gigantic Kodak Colorama that was formerly on display in Grand Central Station in New York City was a special kind of transparency.

Transparencies can be created on rolls of film, or on sheets. Professional cameras like the Hasselblad, Mamiyaflex, and Bronica expose transparencies measuring 6×4.5, 6×6, 6×7, or 6×9cm onto rolls of Ektachrome or Fujichrome film in sizes such as 120, 220, or 70mm. The latter three formats are shown in Figure 1.6. When processed, the transparencies can be left on the roll, or clipped apart into individual images.

Transparencies are also exposed onto sheets of film. The most common size used today (in applications where medium- to large-format film is still being used) is 4×5 inches.

**Figure 1.6** *Common roll film formats include 6×6cm (top left), 6×7cm (top right), and 6×9cm (bottom).*

## Slides

Slides are transparencies that have been placed in a special holder (a *slide mount*) that makes them easier to handle and store, and to use with projector systems. Although 6×6cm transparencies are sometimes mounted and projected, the 35mm transparency is the most commonly mounted film. You'll always receive your 35mm slide film back from the finisher with each frame cut apart and placed in a slide mount unless you specifically note *DO NOT MOUNT* on the work order. When I mention *slides* in this book, I am almost always talking about 35mm color slides. Like other sizes of transparency, slides are produced from films like Kodachrome, Ektachrome, and Fujichrome, which photographers often refer to by the generic term *chromes*. A color slide is shown in Figure 1.7.

**Figure 1.7** *A color slide is a frame of film fixed in a mount.*

## Negatives

Negatives are the inverse image of a positive; that is, all the blacks in the original image appear as white, and all the whites appear as blacks. Intermediate tones are some other inverted tone, with dark grays becoming light grays, and vice versa. Negs are most often original camera film and used to make prints, although *copy negatives* can be made to create a duplicate of an existing negative, and an *internegative* can be made as an intermediate step between a positive original and a print.

Black-and-white negatives contain no color information, and are used to expose positive black-and-white prints (natch). Color negatives, obviously, do have color information and can be used to make full-color prints. You can also use a color negative to make a black-and-white print directly, but special kinds of black-and-white paper must be used for proper rendition of the grayscale tones. Ordinary black-and-white paper isn't equally sensitive to all the colors found in a color negative. Color negatives also contain an orange color-correction mask, which gives them their characteristic overall tint.

Negative films are available in many sizes, from miniature films like the tiny cartridges used in the old 110-format cameras of the 1970s and later, to the more traditional 35mm format. Negative films are available in professional sizes such as 120, 220, 4×5 inches, and larger, too.

When I mention *negative* in the book, I'll generally be talking about original camera film, probably a color negative. When I describe the unique characteristics of a black-and-white negative or color negative, I'll be specific. Figure 1.8 shows a color negative.

Each of these kinds of film requires individual techniques when scanning and enhancing them, and we'll explore all of them later in this book.

**Figure 1.8** *A negative is an inverse image, whereby all the blacks in the original image appear as whites, and all the whites appear as blacks.*

# Why Scan Film, Period?

Earlier in this chapter, we looked at some of the reasons to scan film instead of prints. You might ask yourself, why bother scanning film at all? What can I do with a scanned image after I've captured it? Wouldn't I be better off just forgetting about film and shooting only photos with my digital camera? This section addresses some of those issues.

## Why Shoot Film?

In the 1970s, one of the motion picture industry trade publications printed a story with the headline, "Is Film Dead?". This particular article caused quite a few repercussions within my Rochester, N.Y.-based client, and evoked more than a little nervousness in me, too, because I was making my living at the time writing articles about local television stations who chose to originate their news and documentaries on film rather than adopt what was then called ENG (electronic newsgathering) equipment. Among the topics I wrote about were the "film look" and how it was warmer, more engaging, and otherwise superior to the videotaped image.

Of course, 25 years later, motion picture film isn't dead, although electronic newsgathering has taken over the video newsroom, thanks to tiny cameras, satellite links, and those videophones used so successfully during the Iraqi war. Movies still look richer on film, so most motion pictures are still shot and distributed on film. They might be digitized for the addition of all those spectacular special effects, but movies still start and end with film.

Digital cameras are providing the same sort of threat to the still image on film, but film remains wildly popular (which is a key reason why a book like this one is sorely needed). Film

and digital images should co-exist fairly peacefully for a long time to come. Here are some of the reasons:

- Film cameras are still less expensive than digital cameras with the same capabilities. You can buy a great Nikon or Canon single-lens reflex (SLR) for $300 or less. You can buy a great Nikon or Canon digital SLR for around $1500. You might need a digital camera because you want your pictures immediately, and don't want to scan them. But if you're just looking to save money on film, you can buy a lot of film and processing for $1200.

- Film cameras can do more. If you look at most of the important capabilities found in the best cameras, you'll find that film cameras still can outperform digital cameras in important ways. Need a very wide angle view? Many digital cameras provide only the equivalent of a modest 35mm wide angle on a conventional film camera. Anything wider for a digital model requires an add-on accessory that can be costly. Need a very long telephoto view? Only a few digital cameras have 8X or 10X zooms. The equivalent lens can be borrowed, rented, or purchased for a 35mm camera at a reasonable price. Need fast motor-drive capabilities to capture action? Relatively inexpensive film camera motor drives can capture images at up to eight frames per second. That much speed is found only in costly digital cameras (which are notorious anyway for *shutter lag,* which can delay your action picture for half a second or longer while all the electronics get their act together). Conventional camera films are more sensitive to low light and can produce much finer-grained results than digital sensors. If you're looking for an excuse to use a film camera, the list of advantages is long and enticing.

- Unique tools and capabilities. Some of the tools available for film cameras are unique. These range from specialty films, lenses, and accessories to easier application of techniques such as selective focus. If you want false-color infrared pictures, plan some astrophotography of the Milky Way, or want to manipulate color and tonal values using techniques that simply don't work with digital originals, film is your only choice.

## What Can You Do with Scans?

Once you have a scanned image, there are lots of things you can do with it. Many of the applications described next apply equally to images scanned from film or from prints.

- Capture images for presentations. Whether you're working on a computerized slide show of your family vacation or a presentation for work, a scanner is the perfect tool for turning still photos into digital images that can be merged with text or recorded narrations (using sound capabilities from your PC or Mac) in professional-looking presentations.

- Create images for your own web pages, or those of your company or organization. Your personal web page can include images of your family. A page put together for business can incorporate product photos or other images. A few tasteful images can turn any boring text-only web page from a distraction into an attraction. In addition, you can distribute your images widely. A scanner lets you combine the quality, flexibility, and low cost of traditional cameras and photofinishing with Internet distribution. Figure 1.9 shows a web page with scanned art.

**Figure 1.9**  *Web pages can include scanned artwork.*

■ Capture art for publications. You have a piece of art, such as a logo, cartoon, or chart. You're on a short deadline and need to make some changes to the logo. By scanning and performing some touch-ups in an image-editing program, you'll have the art you need in a few minutes.

■ Capture photographs for placement in a publication. If the final destination of your images is a desktop publication (whether it's a company or personal newsletter, a self-published book of poems, or your holiday greetings), pictures captured by a scanner can enhance any document.

■ Capture low-resolution images for screen display or positioning in publications. Even if you're going to have your film professionally scanned for printing in a slick publication, you can still grab a (relatively) low-resolution version of the image using your scanner, for use as for position only (FPO) artwork. It's easier to visualize layout and finished appearance when you have a rough version of the actual image, instead of a gray or black box on the screen or in your proof printouts.

■ Create a computerized database. Perhaps you have a drawer full of slides of your porcelain collection. Scan them all to create an image-rich database. Dig out those old slides of family vacations and create an electronic family tree.

- Send photos through e-mail. Grabbing scanned images to incorporate in e-mail is fast and easy. What better way to get your message across electronically than with an eye-catching image?

- If you're using a flatbed scanner to capture slides, you'll find the flatbed can do a few things that film-only scanners cannot. For example, you can capture text in optical character recognition (OCR) applications. You'll often find that you have documents in hardcopy form that you'd like to edit using your word processor. These documents can include letters, brochures, newspaper articles, or other printed material. You can also capture images of three-dimensional objects, and scan documents for facsimile transmission with your computer's fax-modem. Flatbed scanners also make great front-ends for home or office photocopying.

- Create original art. Any scannable photograph or drawing can be further manipulated by the computer to produce a beautiful work of art, like the one shown in Figure 1.10.

**Figure 1.10** *Scanned images can become the basis for works of art.*

# Types of Scanners

We won't look at the mechanics of how scanners operate in this chapter. However, you should know that all scanners use a light source, some means of moving the sensor (or a mirror that reflects light to the sensor) over the surface of the artwork (or vice versa), and circuitry to convert the captured information to digital form. Different kinds of scanners usually arrange the components in various ways. You can find more information about how each type of scanner works in Chapter 2, aptly called "Film and Scanning."

## Drum Scanners

At the upper end of the scanner realm are drum scanners, the high-price, high-resolution color separation scanners used in the graphic arts industry in what is called the *prepress* department. (Prepress encompasses everything up until printing plates are made and placed on the printing press.) Drum scanners, as their name suggests, are a prepress department staple that use a rotating drum to scan anything that can be wrapped around the drum. That configuration eliminates scanning of paste-ups on boards, of course, but is ideal for scanning flexible film or prints. As the artwork rotates at high speeds, laser, photodiode, or other precision light source illuminates tiny sections of the original. These scanners can provide highly detailed image files that can be used for sophisticated layout and page composition, electronic retouching, and color separating. High-end scanners can also generate halftone dots electronically while generating output used to create printing plates.

The prices of drum scanners have plummeted sharply from the million-dollar tags of the past. You can pay $80,000 to $140,000 for one of these scanners, but high-performance models costing a lot less are available, too. A large number of drum scanner vendors have gone out of business in the last five years, with buyers turning to favored manufacturers, or opting for super-flatbed scanners described in the next section.

## Prepress Flatbed Scanners

You're probably familiar with the flatbed scanners used by amateurs, photographers, and graphics professionals to grab images for Photoshop. However, there's an entire hidden category of high-end flatbeds used for sophisticated prepress applications. These scanners generally have larger scanning beds (perhaps as large as 12×18 inches) and are designed from the ground up to scan both film and reflective artwork.

Deluxe flatbeds may have two lenses, separate film and reflective scanning beds, superfast performance, and unmatched image quality. Although the price of these flatbeds is only a fraction of the tariff for a drum scanner, the best examples are out of the reach of most users. A typical model in the Agfa DuoScan line costs $9000 or more. Other brands can cost $40,000 and up.

## Conventional Flatbed Scanners

I've termed the kind of flatbed scanner most of us know and love as "conventional." For many good reasons, these are the most popular style of scanner in use today. This configuration provides the best and most flexible combination of features for users who don't need to scan film. A flatbed can scan a variety of originals, including thick originals such as books. If your artwork is too large to fit on a flatbed, you can scan it in pieces. With a special attachment, flatbed scanners can grab images of transparencies or color slides, and an automatic document feeder makes it possible to scan whole stacks of originals unattended. This versatility is hard to match.

**Figure 1.11** *A typical flatbed scanner.*

Flatbed scanners look and work something like a photocopier: You lift the cover, place the original to be scanned face-down on the glass, and press a physical button on the scanner or click a button in your software. Figure 1.11 shows a typical flatbed scanner. The key advantages of flatbed scanners are as follows:

- They can be used with a wide range of non-transparent artwork. Anything that is flat and can fit on the glass platen can be scanned. As with photocopiers that have hinged lids, you can place books, large originals, and thick copy face-down. Images up to 8 1/2×14 inches can be accommodated by the typical flatbed scanner, although some compact models limit you to 11-inch-long documents. As

previously mentioned, very large originals can be scanned in pieces, and then "stitched" together within your image-editing software.

■ You can scan some three-dimensional objects. Keys, watches, human hands, and similar subjects can be captured with a flatbed scanner more easily than with sheetfed models, unless you have a very thin, flexible object. Don't count too much on this capability, however. Results will vary widely, depending on the scanner (the least expensive models do a very poor job of this) and the object being scanned, because the *depth of focus* (the distance above the surface of the glass that is sharp) is limited, and determined in part by the quality of the scanner's sensor.

■ A flatbed's artwork is fairly easy to align. Originals can be placed precisely on the flatbed scanner's scanning bed, using the built-in rulers and alignment guides. Sheetfed models can "drag" the original through slightly skewed, giving you a slightly warped image.

■ Flatbed scanners can handle multiple types of original artwork. Some models are furnished with both a 35mm slide adapter and a 25-page automatic document feeder. Others now include (or have an optional) a device called an active TSA (transparency adapter) that will scan from 35mm up to 5×5-inch transparencies. Some can even scan color negatives.

Flatbed scanners can cost as little as $50 for low-end, low-capability models, to $600 or more for scanners worthy of all but the most demanding applications of graphics professionals. If you're willing to spend about $300, you can get a very fine flatbed scanner, indeed.

## Sheetfed Scanners

Sheetfed scanners, once very popular, are today available only for a few niche applications, such as faxing. I mention them in passing just for completeness. These scanners, which suck up sheets of paper for scanning in much the same way as a fax machine (which itself includes a sheetfed scanner), were valued because of their lower cost at that time, but today flatbed scanners are just as cost-effective (and more versatile). Although there are very few standalone sheetfed scanners still available, you might find some models as part of some "all-in-one" scanner/fax/printing/copying devices, described next.

## All-in-One Devices

All-in-one units are multifunction devices that combine scanning, printing, copying, and faxing capabilities. They were developed to meet the needs of office workers, students, and home users with tight budgets and space constraints. One of these devices might be your best bet for a scanner if versatility is at the top of your wish list.

Units in the lower price range are generally built around a color inkjet printer, which can be attached to your computer and used like any other printer. Some more expensive models, intended for the business market, use a laser printer for output. The vendor adds to the printer a sheetfed or flatbed scanner, which can capture an image of any photograph or document supplied to the device. This simple add-on opens the door to several useful functions.

For example, a multifunction device can serve as a convenient photocopier. If you need a few copies, just enter the number of copies desired into a keypad on the front of the unit, and feed

the sheets through. Many models can enlarge (blow up a 3×5-inch notecard to full-page size) or reduce (squeeze a legal sheet onto an 8.5×11-inch copy you can punch and put in a notebook). The scanner also allows you to capture graphics for your image-editing or desktop-publishing program, and use as a fax machine with either the fax-modem built into the device or your computer's own fax-modem. Most also are furnished with OCR software. As a result, text documents you receive via fax or fed in using scanner mode are translated directly into editable text in your favorite word-processing format.

Multifunction devices often contain their own memory, so you can use them as a copier or fax machine even when the computer is turned off. You can also receive faxes while printing or copying is underway; each job will take its turn.

## Photo Scanners

One useful type of print scanner is the photo scanner, aimed at snapshooters who want to grab images of their small prints, but don't need full-fledged scanning capabilities. These scanners accept snapshot-sized photos, and convert them into scanned images you can manipulate or immediately print with a photo-quality inkjet or dye-sublimation printer.

## Film Scanners

Film scanners, along with flatbeds that have film-scanning capabilities, are the main focus of this book. These are scanners designed specifically to scan 35mm slides, originally for professional applications, particularly for reproduction in catalogs, magazines, or books . You'll also encounter transparency scanners for grabbing images from 6×6cm and larger negatives or transparencies.

# The Future of Scanners

Where are film scanners going in the future? Do I dare make a prediction of that type? Is the only sure thing the fact that I'll probably be predicting the wrong things? After all, futurists of the 19th Century foresaw the invention of the horseless carriage, but didn't have a clue about smog, traffic jams, or road rage. Some seers in the mid-20th Century were certain that, by the millennium, a few gigantic computers measuring city blocks in size would benignly control everything we did. Lasers were destined to become massive death rays that could fry evil-doers from vast distances. None of them realized that virtually every household in the United States would have a toaster oven with more computing power than the systems that took us to the Moon, or that families would gather in front of a laser-based device to watch high-resolution movies on plasma-based displays.

Predictions are easy to make, but, in practice, their chief value lies in the amusement they provide our descendents. In my first scanner book, written in 1990, I predicted 6600×10,200-pixel scanners built into a desktop, capable of capturing full-color 11×17-inch film or print images, viewed on a 27×20-inch color monitor. I figured we might not see such a device until, say, 1995. I thought I was being conservative, because a more highly qualified visionary of the time, Bill Joy (a co-founder of Sun Microsystems), predicted that by the year 2000, we'd have 4000×6000 pixel monitors which would display 24 frames per second, in full 3D!

I'll be covering emerging and future technologies a little in later chapters, but the view from 50,000 feet is clear. Here are some trends to watch:

- Lower prices and more features for film scanners. Minolta's $300 price tag on its entry-level film scanner was a breakthrough that should help create a thriving market for similar units. Prices might go even lower, but film scanners should evolve in a manner similar to their flatbed siblings. Once prices reach a certain level, vendors start adding features to justify the same price. I think you'll see $300 film scanners with 4000 samples-per-inch resolution or built-in sophisticated anti-artifact features like Digital ICE before you'll see $100 film scanners at lower resolutions.

- Storage will get cheaper and more capacious, too. We're already seeing 4GB Compact Flash cards. Since Hitachi purchased IBM's Microdrive division, their emphasis has been on larger and larger miniature hard disks, like the one shown in Figure 1.12. Even these devices are likely to appear to be laughably stingy during the life of this book. (This comes from someone who paid $300 to upgrade to 32,768 *bytes* of memory in 1978, and paid $1000 for a 200 *megabyte* hard drive roughly a decade later.)

**Figure 1.12** *4GB miniature hard disk.*

- Computers will continue to become redundantly powerful, at lower prices. Nobody really needs a 3GHz computer for word processing or to work with spreadsheets. Such muscular machines are nice to have, but not essential for most graphics work. Those editing video or working with 3D modeling and animation can use that much horsepower. Rapid gamers can benefit from wicked-fast computers, too. The lack of a real need for 4- to 6GHz computers won't stop the chip makers from producing them, however. That's great news for those of us who can upgrade to systems that are half as fast, but still gnarly, at ridiculously low prices.

- Online and mail-order services that provide film scanning will become more widely available and less expensive. In the future, you might automatically receive a Photo CD or Picture CD (or DVD) with your film finishing for a built-in fee, complete with built-in software for viewing it on your computer or your home entertainment center's DVD player.

# Next Up

Now that we've looked at scanning from 50,000 feet, it's time to get up close and investigate film and scanning from a practical standpoint. In the next chapter, you'll learn more about film, the challenges of scanning negatives, and explore exactly how scanning works.

# 2

# Film and Scanning

To understand how scanners capture images from film, it's important to know how *film* captures images, and how both processes differ from how our eyes capture those same images. This chapter explains how film works, and how the characteristics of film affect your scans. You'll find a brief discussion of how humans perceive color, too, but if you want a more complete explanation, check out Chapters 9 and 10.

The most important thing to keep in mind now is that film doesn't see images the same way we do (nor do your scanner or digital camera, for that matter). Our brains constantly process the images our eyes receive, making changes that we probably are not even aware of. For example, because of the limitations of our peripheral vision, details of a scene look different when we stare straight ahead than when we peer from the corners. When you're looking eyes-front, the details at either side are blurry; yet, you're not painfully aware of the gradual reduction in sharpness at the periphery of your view. Your brain is concentrating on the scene immediately in front of you and ignores everything else, that is, until it spots a fast-moving object coming at you from the side. Anything that smacks of surprise or danger quickly refocuses your attention automatically, with no conscious effort on your part.

Your gray matter also subtly colors the appearance of what you're viewing, too, quite literally. Our minds automatically modify the colors we see to match our expectations. I once attended a Kodak class in which a narrator told about a trip across country, showing various photos of a train as it progressed from the East Coast to the West Coast. As the views progressed from one to another, the presenter talked about other aspects of the "trip," and didn't call our attention to a subtle change that was unfolding before our eyes. Indeed, nothing at all appeared to be unusual about the train photos that we'd been staring at intensely for five minutes. Then, the narrator showed the first and last photos side by side. One had a strong blue cast, while the other was equally biased towards the red-orange. Each of the intervening photos was slightly more tinted towards the final, reddish image. The eyes of the audience automatically adjusted their perceptions of the photos so that all of them looked "normal."

Something similar happens to you every day. That white shirt you're wearing looks perfectly white outdoors in bright sunlight. Go indoors where the incandescent illumination is very

warm and reddish, and the shirt will still look white. Skin tones may look a little pallid under some kinds of fluorescent lights, but our clever brains filter out most of the greenish tint. Our eyes have a form of the automatic white balance feature found in digital cameras. Our eyes process the things we see so that what we see is what we *think* we should get.

Film has no such automatic compensation. Film has no brain. Greenish, reddish, or bluish illumination produces greenish, reddish, or bluish images. Scanners *do* have a brain in the form of the image-processing software built into them, but their compensation is not as automatic as we'd like. You'll find some explanations of how film perceives images in this chapter. My goal here is to make you more of a film expert than most film scanner users, giving you the information you need to understand exactly what happens to your image *before* you start the scan. That will help you produce better film images, and enable you to use your scanner's correction features more intelligently.

## Making Light Work for You

Light itself is a fairly amazing phenomenon, the subject of multiple books and the center of many puzzling mysteries. Light is usually described as a form of energy, similar to heat, x-rays, radio waves, or television signals. Yet, light has characteristics of matter, too. As energy, it moves in *waves*, like the ripples produced in a pond when you drop in a pebble. As matter, it contains tiny particles called *photons*.

Long ago, scientists thought that light must consist of waves *or* as particles. Sir Isaac Newton, one of the founders of optical science, theorized that light consisted of particles he called *corpuscles*. However, the wave theory seemed to offer a better explanation of the behavior of light until Albert Einstein shook things up at the beginning of the 20th Century. Einstein's work showed that light had dual natures as both wave *and* particle. Although that seems weird, there is no real conflict, because Einstein also demonstrated that energy and matter are really the same thing in a different form, whether used to produce electricity in nuclear power plants or to build houses.

So, as matter, light's photons are free to whack into things, such as the corneas of our eyes or the light-sensitive particles on film, allowing us to see images and capture them in photo-sensitive emulsions. As energy, in wave-form, light can oscillate in different frequencies, both tight bundles of waves with little space between the peaks and troughs, and longer, lazier undulations with longer intervals between them, as you can see in Figure 2.1.

**Figure 2.1** *We see longer wavelengths as red, and shorter wavelengths as blue-violet.*

The frequencies of light let us visualize different colors. For the rather narrow range of frequencies that can be detected by human eyes and digital sensors, we see shorter wavelengths as violet; longer wavelengths are seen as red. Figure 2.2 is a simplified representation of the entire electromagnetic spectrum (not drawn to scale), with the visible wavelengths of light shown as that little sliver of rainbow in the middle.

**Figure 2.2** *Visible light is that tiny rainbow-colored sliver in the middle of the electromagnetic spectrum between ultraviolet and infrared.*

Both natures of light are used in the creation of digital and film images. In a film camera, light passes through the lens, which focuses the light. Then, the photon particles strike particles of light-sensitive material in the film, which react to form a temporary or *latent* image that can be developed into a permanent one. In a nutshell, that's all that's necessary to create a film image.

## How Film Works

Until solid-state technology that gave us computer chips came along, photographic film was one of the most complex products requiring sophisticated production techniques, mass produced and offered at very low cost. Consider that photographic film is only 4 to 7 *thousandths* of an inch thick, and it's coated with up to several dozen emulsion layers. Each of those layers can be only *half of one percent* as thick as the film base itself! Add metallic silver and some complex chemicals that must be frighteningly pure, and then require that the manufacturing process be carried out *in total darkness* under virtually clean-room conditions. Yet, you can buy a roll of this stuff for less than the price of a bag of potato chips or so at most retail stores from Toronto to Tibet. Figure 2.3 shows a simplified cross section of a piece of film, with the film base and photosensitive emulsion layer pictured to scale.

Any film consists of two parts, the emulsion containing the light-sensitive particles that capture the image, and the base material that the emulsion is coated on. In this respect, film technology has changed very little since 1839. Whether the base was a sheet of copper with a thin coat of silver (as in Daguerreotypes), or a piece of tin, glass, paper, or a flexible film coated with silver salts like silver iodide or silver bromide, the concept is the same.

Some images, such as prints, are viewed by reflection, so the base is made of an opaque but reflective material. Film, on the other hand, is viewed by light passing through the base material and filtered by the image present in the emulsion. So, film bases are of necessity transparent and flexible as well, because (other than sheet films) the film is rolled up and moved through a camera one frame at a time. Camera film bases today can be made of cellulose acetate, produced from particles of wood, or from polyester, a synthetic plastic material. (In olden times, film base was also constructed of a material called nitrate, which had the bad habit of deteriorating rapidly as it aged, and burning vigorously when exposed to heat.)

Cellulose acetate is popular as a film base because it's cheap, easy to coat with photosensitive emulsion, and sturdy enough for most camera applications. Polyester film base costs more to produce and is more difficult to layer with light-sensitive gelatin, but is much tougher and resistant to tearing. Polyester is also unaffected by heat or humidity, and thus doesn't change size in harsh environments. These characteristics have made polyester favored for applications like motion picture release prints, which can be shown over and over with only minimal wear and tear. Polyester is also used for photographic films used for still photography. (Glass, which is even more stable than polyester, is still used as a base for films such as those used for scientific applications like astrophotography.)

Of course, film must be sensitized to be of any use in capturing images. That's accomplished by coating the film with layers of emulsion that contain light-sensitive ingredients. The first step is to dissolve pure silver bars in nitric acid, which is then dried to produce silver nitrate crystals. Next, gelatin, extracted from animal hides, bones, and other parts, is dissolved in pure distilled water, and then mixed with potassium bromide and potassium iodide and heated. A silver nitrate solution is added to this mixture. Various miracles of physics happen, and the silver iodide/bromide crystals precipitate out of the solution, where they are suspended in the thickening gelatin, something like gelatin dessert chilled with fruit cocktail in it.

**Figure 2.3** *Film's photosensitive emulsion is unimaginably thin.*

This gelatin emulsion, containing the light-sensitive silver halide crystals, is then coated onto one side of long rolls of film base. An emulsion layer can be as thin as .00006 (6/100,000ths) of an inch thick! Films can have several light-sensitive emulsion layers (to capture red, green, and blue light in color film, for example) and include additional layers that perform other functions. Figure 2.4 shows a simplified cross section of a typical color negative film. Keep in mind that none of the layers is pictured to scale. The layers shown are as follows:

**Figure 2.4** *This film cross section is not to scale, so you can see the individual layers more clearly.*

- *Anti-abrasion layer.* This is an overcoating of clear gelatin that tops the emulsion side of the film. You can usually tell the emulsion side by looking at it: The matte surface (produced by the anti-abrasion layer) is much less shiny than the flip (base) side of the film. In the darkroom (where it was dark and the shininess attribute was invisible) we sometimes would touch the film between our lips; the emulsion side would stick to a lip, whereas the base side would not. This layer protects the fragile layers underneath from scratches and abrasion, but only to a certain extent. Both sides of a piece of film should be treated carefully at all times, particularly when prepping an image for scanning.

- *Blue sensitive yellow dye layer.* This layer absorbs blue light and (in a negative) produces yellow dye in the image areas of the film that contain blue subject matter.

- *Yellow filter layer.* This layer absorbs any remaining blue light, allowing only green and red to pass through to the layers underneath.

- *Green sensitive magenta dye layer.* This layer absorbs green light and (in a negative) produces magenta dye in the image areas of the film that contain green subject matter.

- *Red sensitive cyan dye layer.* This layer absorbs red light and (in a negative) produces cyan dye in the image areas of the film that contain red subject matter.

- *Film base.* This is the semi-transparent substrate onto which the emulsion layers are coated.

- *Antihalation backing.* Light that passes through the film base would reflect back to the photosensitive layers, but is instead absorbed by the dye incorporated in the antihalation backing layer. The dye accounts for the dark appearance of the base side of unprocessed film. Water soluble, it is removed during processing to produce the familiar transparent film image we're accustomed to.

- *Noncurl coating.* All films tend to curl toward the emulsion side, partially because that is the way the film is rolled up before and after exposure, and partially because all those emulsion layers tend to bias the curl in that direction when they swell while immersed in developing fluids. The noncurl coating is a hardened gelatin coating roughly the same thickness as the emulsion itself, and helps counter the natural curl of the film when it is dried.

# OTHER COLORS, OTHER LAYERS

The description of the color layers doesn't take into account images that contain more than just pure red, green, or blue. Most images, of course, contain other hues, as well. In those cases, more than one light-sensitive layer is used to produce an image in a particular region of the film. For example, a subject with yellow tones will be registered by both the red and green sensitive layers, which will produce magenta and cyan dye, which combine to produce a blue color in the negative. Blue, in a negative, prints to yellow, its complementary color. You'll find more detailed descriptions of how red, green, blue, cyan, magenta, and yellow hues relate to each other in Chapters 9 and 10.

Finally, some color films from Fujifilm use the company's proprietary "4th Color Layer Technology," which is actually an additional, cyan-sensitive layer, which supposedly helps render certain shades of green more accurately. This technology is found in the company's professional films, as, supposedly, pros can tell the difference in rendition.

# WHAT'S THAT ORANGE TINT?

The overall orange tint found in color negative films is there for a reason. The dyes used in negative films are far from perfect; in fact, the cyan and magenta dye layers actually absorb certain wavelengths of light that they should allow to pass through. These dyes are satisfactory in all other respects, so film manufacturers add a yellowish tint to the green sensitive layer, and a bit of pink to the red sensitive layer. These tints correct for the slight color cast the dyes produce, and create an overall orangeish mask. The mask is taken into account by your scanning software, and, because different vendors use masks of slightly different colors, you might have to tell the scanner what brand and type of film you are using so its software knows exactly how to tweak the colors.

## What About Color Positive Film?

Color transparency film's emulsion layers are structured in a way that's similar to color negative film, except that the colors and tones aren't reversed. That is, red objects appear as red, not cyan; green objects aren't magenta, and blue objects aren't yellow, as would be the case in a color negative. Nor is an orange mask necessary. Each color-sensitive layer produces dye of its appropriate color, in amounts regulated by the exposure. A positive image should look more or less like the original scene as you photographed it.

That's a significant benefit of color transparency film, both when it comes to printing the film and when making a scan. Color prints made from the same negative can vary wildly in appearance, whether intentionally or unintentionally. We've all experienced this phenomenon when we take previously printed negatives to a different photo lab for reprints. In some cases, we got great prints the first time around and the new ones are decidedly inferior. In other cases, we discover that defects we thought were caused by poor photography turn out to be poor photofinishing by the original lab, as the second set of prints might be much better than the first.

When making prints from color negatives, there can be lots of variations in darkness/lightness, color balance, and other factors. In some cases, the variations are good, as when the photo lab corrects for errors in exposure or color. In other cases, the changes are very bad. The automated printing machinery might not realize you used a bright red background for your picture, and add a frightful amount of cyan in an attempt to compensate. Your backlit silhouette image might come back as washed-out and ugly. Although prints from negatives should be consistent, often they are not.

Figure 2.5 illustrates what can happen in the worst cases. The image at top was intended to show a dramatic skyline silhouette with an angry red sky as a backdrop. Unfortunately, automatic printing machines are likely to filter out the orange cast and "correct" the exposure to produce the version shown at the bottom. Unless you make your color prints yourself, or use expensive custom color printing services, you might not have a lot of control over how your color negatives are printed. Scanning the negatives and making prints yourself might be your only recourse if you want complete creative freedom.

**Figure 2.5** *If you want a dramatic color print from a color negative, you might have to scan the negative and print it yourself. At top, the image as envisioned by the photographer. At bottom, a "corrected" version.*

No such meddling, good or bad, is likely when you shoot transparency film. Only the grossest errors in processing caused by exhausted processing solutions are likely to have any effect at all. If your image is perfectly exposed and properly color balanced, that's how your transparency will look. If you intentionally underexpose or overexpose to achieve an artistic effect, or use colored lighting to be creative, that's what you'll get, too. The flip side is that very large errors can't be easily fixed. Your too-dark slide is simply too dark, although it might also have a tad too much grain and color problems if it is *seriously* underexposed. You might be able to pull some detail out during scanning. It's amazing what you can do by pumping extra light through a dark transparency. But, often, you may not be able to fix the problem.

In short, color negative film is much more forgiving than color transparency film. A wider range of exposures (called *latitude*) can produce an acceptable image. Color transparency films must be more precisely exposed, because the final image is just that, final.

That's why experienced film photographers frequently use a technique called *bracketing* to ensure that at least one image is exposed to produce the exact effect desired. Bracketing is nothing more than giving a little more and a little less exposure to successive shots, producing transparencies that are slightly darker or lighter than the first image taken. If the original image isn't quite right, chances are one of the bracketed shots will be perfect.

Say the recommended exposure determined by your camera's light meter is 1/250th second at f11. If you wanted to bracket in whole f-stops, you could take an additional picture at 1/250th second at f16 (half as much exposure) and one at 1/250th second at f8 (twice as much exposure). In practice, you'd probably bracket much more tightly than full f-stops, using half-stop increments to give you 50 percent, 75 percent, 100 percent, 150 percent, and 200 percent exposures to capture more subtle differences in exposure. Bracketing can be done manually with your camera set to manual mode or fully automatically using your camera's automatic bracketing mode. With most cameras, you needn't even decide whether to adjust the shutter speed or lens aperture. Most let you use Exposure Values, or EV+ and EV– settings, to take a picture at increments that are slightly more or slightly less than the exposure determined by your camera's meter.

The only drawback to bracketing is when your subject is moving quickly, or subject to frequent change. It would be tricky to bracket an action shot (although you could shoot three different photos of similar action at different exposures). If you bracket your people pictures, you may find that the best expression is found in the image with the least desirable exposure. However, for scenics, close-ups, and many other kinds of pictures, bracketing can be a lifesaver. And if you're shooting film for scanning, you'll find that careful exposure techniques and a little bracketing can make your life much easier in the scanning phase.

Figure 2.6 shows a bracketed set of exposures. The nominal correct exposure is the image in the middle. The top and bottom images were underexposed and overexposed by one f-stop, respectively.

**Figure 2.6** *Bracketed exposures, with the middle and bottom versions given 2X and 4X as much exposure as the top image.*

# What About Black-and-White Film?

Conventional black-and-white films are similar in construction to color films, except that there is only one (or sometimes two) photosensitive emulsion layers. All the colors of light are captured by that one layer, producing a monochrome image. In theory, that means the color of the light shouldn't matter to your photo. Pictures taken at dusk or at high noon, indoors or outdoors, should all provide an accurate, grayscale rendition of your image.

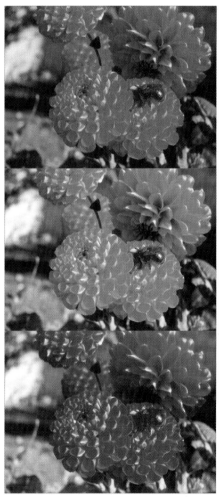

That doesn't mean that black-and-white films are insensitive to the color of light. Nothing could be further from the truth. Some early films were relatively insensitive to red light, which is why women in 1940s and 1950s photographs and films may appear to be wearing black lipstick. The films couldn't record that end of the spectrum very well with these *orthochromatic* films. Motion picture photographers took the special sensitivities of black-and-white film used to make movies into account, choosing makeup and clothing colors, for example, that photographed well. (That's why the television Superman's original super-suit was assembled from materials that were more of a reddish brown rather than the familiar red, blue, and yellow, because the Man of Steel's true colors didn't photograph well in black and white.)

Orthochromatic films (sensitive mainly to green and blue) exist today for specialized graphics applications in which insensitivity to red is important. They were replaced as general-purpose films 50 years ago by *panchromatic* films that imaged all colors realistically (albeit in black and white). Figure 2.7 shows an image of some flowers photographed in full color at top, and then as the same image might appear if photographed using a panchromatic black-and-white film (middle) and orthochromatic film (bottom).

**Figure 2.7** *Full color exposure (top), panchromatic black-and-white (middle), and the orthochromatic rendition (bottom).*

One significant difference between color films and black-and-white films is that, although both grab an image through the use of photosensitive silver halide grains, in color films these grains are removed and replaced by color dyes. In black-and-white films, the actual silver grains that have been exposed are converted to black granules that form the image; the unexposed silver is washed away during processing.

An exception to this is the so-called *chromogenic* black-and-white films, which are actually color films that don't use color dye couplers. Instead, the dyes used to create the image are balanced to produce a neutral gray or black when the film is printed on color paper. Chromogenic films can also be processed in the same chemicals as color negative films.

---

# WHAT'S CHROMOGENIC?

In photography, *chromogenic* refers to images created by replacing silver with color dyes, and doesn't specifically mean a kind of black-and-white film. Other color films and color papers are also chromogenic. The term also has a different meaning outside photography (with a root meaning *chromium* rather than *chroma*, or color), but unless you're a bacteriologist, you probably won't encounter it.

---

There are some neat things about chromogenic black-and-white films, such as the extremely long exposure latitude. Some of these films can be exposed at ISO 50 to ISO 1600, and still produce excellent, fine-grain results. Many photographers have reported that chromogenic films scan more easily and more accurately than conventional black-and-white films. The downside is that, because of the unusual structure of the film, it may be difficult to evaluate a chromogenic negative before it's printed or scanned. If you do a lot of work in black and white, especially if you make prints and don't want to fuss with black-and-white processing, you should check these films out.

## How Pictures Are Made

Early photographers didn't really know how photographic images were produced. All they knew was that when they polished a silver-coated copper plate spotlessly clean, and exposed the plate to iodine fumes, the plate could be exposed to light and then developed with mercury fumes. It all smacks of alchemy, and in some respects, early photography was an arcane art.

Today, photographic scientists know exactly what is going on when an image is captured on film, and have used that knowledge to provide us with better films for conventional photography, and even films better suited for scanning.

### Exposure

Pictures are made in an instant, or, at least, a tiny fraction of a second. Here's a quick description of how images are formed on film.

1. Your camera's shutter speed and lens opening determine the *amount* of light that passes into the camera to reach the film. With a properly focused image, that light will converge at the film plane, where the sensitized film is held flat and tight.

2. The film contains silver halide grains, each of which contains a sensitizer substance on its surface. Photons striking this sensitizer increase the energy of an electron, creating a single atom of silver. When roughly two to four silver atoms in a grain have been converted (out of the billions that might be present in a single grain), that grain is converted to a stable latent-image site. That is, those few silver atoms are enough to allow that particular grain to respond to the development process. A latent image is one that exists on the film, ready to appear when the film is developed.

The number of photons required to create the silver atoms determine the sensitivity of the film. The more photons required, the less sensitive the film. Modern color films require, on average, 20 to 60 photons per grain to produce a latent image. Vendors can create more sensitive films by creating grains that require fewer photons (the best option), or by creating larger grains that can capture more photons by virtue of their increased area. (This produces "grainier" film.) Kodak and Fuji addressed these issues by creating "tabular" and "cubic" grains (respectively) that had larger surface areas that are more sensitive to light.

3. As described earlier, this process of creating the latent image goes on separately in each of the color layers of the film. That's all that's required to create an image. However, the image is still latent, and not visible until the exposed grains have been processed and either converted to black silver grains (in black-and-white film) or replaced with color dyes (in color film). It's important to understand this, because your latent image can be modified by other events prior to processing (when it becomes semi-permanent). For example, extreme heat can convert some unexposed silver halide grains to silver atoms. Simply leaving your film in the camera can have the same effect, as some grains randomly convert to silver as they age. X-ray machines at airports (even the "film safe" varieties) produce enough radiation to eventually fog film, particularly faster films, after they've been x-rayed a number of times (say, on a long trip). For that reason, you should keep your film cool and have it processed as soon as possible after exposure.

# Processing

Processing converts the latent image to a permanent one. That is, the image is as permanent as any image on film can be. Films, particularly color films, are liable to fade over time. The various color layers fade at different rates, so your color pictures are likely to take on a color cast as they change. Fortunately, careful development can eliminate some contaminants that accelerate this process, and films can last decades, or longer. Indeed, your scanner is an important tool in preserving film images after processing, because your digital copies are perfect and potentially immortal.

Conventional black-and-white, color-negative, and color-transparency films are processed in different ways. I'll run through the processes for you quickly.

## Black-and-White Processing

Conventional (non-chromogenic) black-and-white films are easy to process, because they don't contain the multiple photosensitive layers of color films, and the steps are fewer. Here are the steps:

1. In complete darkness, the film is first placed in a solution called the *developer*, which is actually a reducing agent that tries to convert all the silver grains (both exposed and unexposed) into metallic silver. Left unchecked, the developer would give you a very dense, very black image with no detail.

   Fortunately, the exposed silver grains develop much more rapidly than the unexposed grains. The film vendors have calculated exactly how long their films must be processed at a particular temperature to complete the development of the exposed grains, while developing as few as possible of the unexposed grains. So, development is carried out with careful tracking of the time and temperature, along with periodic agitation of the solution to ensure that fresh developer is always available to all portions of the film.

2. Once the film has been properly developed, the development process is halted by rinsing the film in water or a slightly acidic "stop" bath that washes away the developer and neutralizes any that remains present in the film emulsion.

3. Finally, the film is "fixed" by using a chemical (called "fixer," oddly enough) that dissolves only the unexposed silver halide crystals, leaving behind the metallic silver of the image. After this, the film can be safely exposed to the light and can be washed to remove any residual chemicals that remain in the film. This step is important because fixer can itself damage the film if not removed properly.

4. The film is dried and is ready for scanning or printing.

## JUST A LITTLE PUSH

As you might guess, the time/temperature combinations used to calculate development time for black-and-white film usually err on the side of conservativism. That is, some exposed silver grains are sacrificed (by not developing them at all) to help ensure that non-image silver grains aren't developed by mistake. The slightly shorter development time leads to improved images.

However, sometimes we might want to give the film a little push by processing it longer than recommended. The extra development brings out details in images, particularly in the shadows, that would appear pitch-black in prints made from those negatives. Of course, there is also the risk of overdeveloping grains that have already been processed, and of developing grains that weren't part of the image. For that reason, push-processed black-and-white film tends to have a higher contrast and more grain than normally processed film, and highlight details (the dark areas of the negative image) might be too dense, and lack detail they formerly had. In the days when the fastest films of any type were rated at ISO 400, push processing was a valuable tool, and it is still used today. Some photographers use the increased grain as a special effect.

Because of the multiple layers in color films, push processing is a much more dicey proposition, and is used only for special, if unpredictable, effects.

## Color-Negative Processing

Color-negative film is considerably more complex and involves more steps, as befits a process that involves multiple film layers that must each be developed in lockstep with each other. One reason for the complexity is that the processing temperatures must be more tightly controlled. Whereas varying the temperature of the solutions in the black-and-white process by a few degrees may have little or no impact on development, color-processing solutions are commonly kept within half a degree, or less, of optimum at all times. Changes in temperature most definitely can affect how the processed film looks. Here's a brief description of the color-negative film process:

1. As with black-and-white film, the first step is to immerse the color negative film in a developer, which converts the exposed silver halide grains to silver. This process also creates oxidized developer, which reacts with chemicals built into each light-sensitive film layer called *couplers*. The couplers form color dye that corresponds to the latent image, with a different colored dye in the red, green, and blue sensitive layers. As I already mentioned, the red sensitive layers form cyan dye; green sensitive layers form magenta dye, and blue sensitive layers form yellow dye.

   This solution used in this step is called the *color developer*. This step is the most critical, with the chemical kept at 100 degrees Fahrenheit, plus or minus only one-quarter of a degree. Keeping constant temperature is made more challenging by the elevated temperature, as solutions at 100 degrees tend to cool to room temperature if not heated precisely. In contrast, black-and-white films are processed at room temperature (68 to 75 degrees Fahrenheit), so once brought to the proper temperature they aren't as likely to change.

2. The development process is stopped using a stop bath.

3. Bleaching chemicals are used to convert the exposed metallic silver back to a soluble silver halide that can be removed from the film, as it is no longer needed once dye is formed to represent the image.

4. Both exposed and unexposed silver halide grains are thoroughly removed.

5. The film is washed to remove the residual chemicals, and then treated with a solution called *stabilizer*, which performs two functions. Stabilizer prevents any unused magenta dye couplers from reacting with the magenta dye in the new image. It also serves as a wetting agent to reduce spots on the film as it is dried.

6. The film is then dried and ready for scanning or printing.

## Color-Transparency Processing

Color transparencies are developed using yet another process, which is called the *color reversal process* because the latent image in the film is formed as a negative (just like in black-and-white and color negative films) but is converted, or reversed, to a positive image during processing. There are actually several color reversal processes. Kodachrome films incorporate the dyes that form the image into the developers, rather than the films themselves, so a special process is required to process these films. Other films, such as Ektachromes and Fujichromes, use dye couplers, similarly to color negative films, and require a completely different process.

I'm going to ignore the specialized and very complex Kodachrome processing cycle in this section and concentrate on the process used for the more common color transparency films. Here are the steps, in brief:

1. The initial step in processing color-transparency films is the first developer, which is essentially similar to the first developer used for black-and-white and color negative films. Of course, color developer is much more complex than the developer used for black-and-white images. It contains the developing agents, chemicals which provide the needed alkaline environment, preservatives to keep the developer from oxidizing too rapidly, restrainers used to control development in the top, blue sensitive layer of the film, and a silver solvent to dissolve residual silver halide grains in the emulsion. As with color negative films, this is the most critical step in the process, with temperature controlled to within half a degree.

2. Next a short, but enthusiastic, wash is applied to the film to remove excess developer from the film. Further development is carried on during this step, so the amount of wash is carefully controlled.

3. The film is then immersed in a weak acid stop bath solution that halts development completely, and prepares the film for the reversal step.

4. A second wash is used to remove the last traces of the first developer and stop bath.

5. The film, which at this stage looks something like a black-and-white negative, is reversed. The unexposed silver halide (a negative of the image that has been developed so far) was originally reversed by exposure to a strong light. In modern films, this reversal step is performed using a chemical fogging bath instead.

6. Next, a color developer is used to develop the reversed areas of the film to create the colored dyes that form the image.

7. For some types of film, a third wash is used to remove excess color developer.

8. All films then go into a second stop bath, which neutralizes any color developer that remains in the three color emulsion layers.

9. Yet another wash is applied to remove all vestiges of color developer and stop bath, an essential step to eliminate the possibility of staining in the bleach bath that follows. This is often called a "pre-bleach" step.

10. The bleaching step removes all the silver produced by the first developer and color developer, leaving behind only the dyes that make up the image and some residual silver halides.

11. Another wash might be applied, primarily to lengthen the life of the fixing bath that follows, by reducing the chance of chemical contamination.

12. A fixing solution is used to dissolve any silver halides produced by bleaching.

13. A final wash removes any remaining chemicals.

14. Stabilizer is used in a way similar to the stabilizer step in the color-negative process, to prevent contamination of the dyes that have been formed and to eliminate spots on the film as it dries.

15. Once the film is dried, it's ready for mounting, scanning, or viewing.

## Cross Processing

The previous two sections explained how color-processing procedures have carefully been tailored for each kind of color film. Film processing incorporates precise controls and sophisticated developing solutions that ensure the finished color negative or transparency has image characteristics that are exactly what you envisioned when the picture was taken.

All bets are off when you decide to have your film processed in the "wrong" chemicals; that is, color negative films developed in solutions meant for color transparency films, and vice versa. This joyous breaking of the rules is called cross processing. Fortunately, the field of photography has a long tradition of finding a darkroom procedure that isn't broken, and then fixing it anyway. Reticulation, solarization, excessive film grain, and high contrast images are all derived from processing blunders that were magically transformed into desirable effects.

Cross processing has existed for a long time, usually the result of an error. About a decade ago, artsy types decided that the washed-out highlights, pronounced cyan or magenta casts, and overall weird colors looked cool. If you take into account the fact that the goal of photographs used in advertising and some other applications is simply to be noticed, cross-processed images are not only cool but extremely effective. The rich, fantasy colors add a bleeding edge, "with it" look, which is probably why virtually every picture in *Wired* magazine ends up using this technique. Although cross processing is verging on overuse, it still is capable of producing startling, eye-catching images. Figures 2.8 and 2.9 show that some fairly subtle looks can be gained using the wrong processing chemicals; not every photo has to be utterly garish.

**Figure 2.8** *Color negative films developed in transparency processing solutions have a distinctive pastel, pinkish look with lots of grain.*

**Figure 2.9** *Color transparency films developed in color negative processing solutions have washed-out hues with major shifts.*

Color negative films processed in color transparency chemicals all respond in similar ways, even if the response can be unpredictable. But even more delightful is the total lack of consistency that color transparency films display when processed in color negative solutions. Each responds in a different way, giving you a broad range of color casts and other oddball looks to choose from. You'll find different looks from Kodak Ektachromes (both daylight and tungsten versions), to Fuji Provia and Velvia films, Agfa RSX, and others.

Each produces different effects and colors. Some films don't work well with cross processing at all. Some have reported that film that's long past its expiration date works best of all. As with any experimental technique like this, the most fun is in the experimenting to see what works and what doesn't. Then, when you have your cross-processed monstrosity, you can scan it and perform even more manipulations in your image editor.

Achieving good cross-processed results isn't as simple as having your film developed in the wrong solutions. First, films intended for cross processing must be seriously overexposed, by at least two f-stops, for best results. What? You thought those washed-out highlights were automatic? Some films require a little more overexposure; others require a little less. You'll need to experiment.

You can also opt for *overdevelopment* in the processing lab. That's an option because your local MonstroMart is not going to cross-process film for you in their in-store minilab. Some devious souls have tried to repackage their film in a cartridge intended for the opposite kind of film, but modern film cassettes make this difficult, and it's not worth the ire of the minilab owners when your film messes up their processing chemicals.

No, you'll need to have your film cross-processed at a professional film lab, which will be happy to do it for a fee, and even overdevelop ("push") your film for a little bit more. If you're new to cross processing, your best bet is to shoot several rolls of film as a test. Overexpose some of the photos in each roll by two f-stops, and others by three or four f-stops. Then, have one roll cross-processed normally (if the word "normal" can be applied at all), and have another roll cross-processed with overdevelopment. Then examine your finished photos and see which effects you prefer.

# Next Up

Now that you know how the film your scanner will be capturing works, the next chapter looks at how film scanners operate, with particular attention given to important parameters like dynamic range, resolution, interpolation, and other crucial factors that affect the quality of your scan.

# 3

# Scanner Specifications for Film

Scanner specifications such as resolution, dynamic range, and even the number of colors a scanner can capture are subject to a great deal of exaggeration, a healthy dose of smoke and mirrors, and some outright misleading information supplied by scanner vendors. Using listings of specifications to evaluate scanners is not even comparing apples to oranges; it's more akin to comparing apples to plywood because both happen to come from trees. Because some of the criteria used to measure scanner performance are meaningless and others are mythical, understanding exactly how scanners operate, and which parameters are really important, become challenging.

This chapter will help clear up the mystery surrounding scanner specs. I'm going to provide some background on how scanners work and explain the truth behind those mystical numbers listed on the outside of the box.

You can't point a finger at one particular scanner vendor. When a supplier puts banners that scream *3200 dpi resolution!!* on the outside of their box, you can bet that the other vendors will scramble to match this marketing gimmick, even if their current scanners provide a sharper image at "only" 2400 samples-per-inch (spi). Many scanner buyers use the wrong information to make their choices. I'm firmly committed to making sure you have the right information in this chapter and the next one, so you can make an informed purchase decision.

# How Scanners Work

Scanners are similar to digital cameras in many ways. Both devices create images by capturing light reflected by or transmitted through the original subject. A flatbed scanner grabbing an image of a photograph uses the light reflected by the photograph, just as a digital camera takes a portrait or images a scenic view by capturing the light that reflects from the person, mountains, or trees. A scanner digitizing a piece of film uses light that passes through the film. Digital cameras do the same thing when photographing any translucent object such as, say, a stained glass window. From that standpoint, at least, scanners and cameras operate in much the same way.

However, the two devices diverge when it comes time to actually capture the image. Aside from a few specialized studio models, digital cameras grab the entire image in one instant, using a sensor array a given number of pixels wide and a given number of pixels deep (for example, 2048×1536 pixels). Scanners, in contrast, er...*scan*. Their sensors consist of a single row of photosensitive sites that scan one line of samples at once, and then scan successive lines until the entire image is captured.

The difference between flatbed scanners that can scan film and dedicated film scanners is much smaller. Both operate on the same principles, which I'll explain in the following sections, and differ chiefly in how the components are physically arranged inside the scanner.

## Scanner Components

All scanners consist of several basic components, including a holder of some type for the original film or photograph, a light source, optics to focus the illumination from the light source, and the sensor itself. In addition, scanners contain circuitry and intelligence that let them process the scanned information before passing it along to your computer. Here's a quick summary of these components.

### Film/Print Holder

The original being scanned must be firmly positioned in a specific place so the sensor can capture an image. The holder for the film or print varies widely, depending on the type of scanner. With a high-end drum scanner, the original is tightly wrapped around a cylinder, which spins at high speed to allow scanning all portions of the film or print. Of course, this method limits scanning to flexible originals that can be wrapped around the drum. Flat paste-ups are definitely out.

Flatbed scanners use a glass platen or copyboard to hold the film or print flat. Film is generally placed within a frame that blocks most of the light reaching the original, except for the illumination that's intended to pass through the negative or transparency. The artwork to be scanned is sandwiched between the glass platen and a cover, which is, with reflective originals, a plain white surface (often of a spongy texture to allow squeezing the print down firmly on the glass). Flatbeds that can scan transparencies usually include a light source in the lid, so light can pass through.

Dedicated film scanners have special holders for the film sizes they can accommodate. There are usually several: one for 35mm slides, plus one for each size of filmstrip the scanner can handle (from 35mm through 6cm wide rolls). A film scanner can also have a cassette holder for Advanced Photo System film, which, after processing, is returned for permanent storage to the same cassette that was in the camera during exposure. Film scanners also generally have some sort of transport mechanism for moving the film past the sensor.

## Light Source

Scanners all have some sort of light source to illuminate the artwork being captured. Drum scanners often use laser illumination, which is precise and expensive. Flatbed scanners have used an interesting mixture of light sources, including LEDs and fluorescent tubes. Sometimes a single white light source is used with alternating red, green, and blue filters for three separate scans of the same image. Or, three separate red, green, and blue filtered sources might be used. Flatbed scanners that can handle slides might have an additional light source in the lid, or within a substitute lid used only for transparency scanning. The extra illumination can also be built into another attachment that fits over the transparency.

This light source might be movable, traveling along a path as each line of the original is scanned. For scanners in which the artwork moves past the sensor (that is, some sheetfed scanners, such as those found in fax machines, as well as most dedicated film scanners), the light source remains fixed.

Light sources have several attributes in common:

- *Color rendition.* Scanner illumination must have the proper color rendition for accurate scanning. If the light is going to pass through red, green, and blue filters, it starts out as pure, full-spectrum white.

- *Stability.* It's important to have repeatable color and intensity for consistency between scans, so scanner light sources must be stable. That's why some scanners make you wait a few seconds (or minutes) if you haven't made a scan recently so the light source can warm up to its normal operating temperature. Some kinds of light sources are inherently stable, such as the LEDs used in film scanners. Lasers are the most stable light sources of all, of course, but are much too expensive for day-to-day use in consumer-level scanners.

- *Intensity.* The intensity of the light source helps determine how quickly a scan can be made. At low light levels, scans can be unconscionably long. Reduced illumination also provides challenges for the scanner designer, who might have to compensate for less than optimal light levels by using a more sensitive sensor. In general, the more intense a light source, the better, except when the illumination becomes too hot to safely scan originals.

- *Light quality.* Photographers are more aware of light quality than others. Light can be very direct and harsh, or much softer and diffuse, even when both sources produce the same amount of illumination. Light quality is especially important when scanning film, because harsh light accentuates the smallest physical defects in the negative or transparency. Diffuse illumination tends to make scratches and dust less noticeable. On the other hand, direct

light produces a "sharper" image (which is why the scratches show up so readily) and diffuse light creates a less sharp scan. So, light quality must be balanced carefully between the two extremes to provide the best illumination possible.

■ *Longevity*. Light sources used for scanning should not change color or intensity characteristics significantly during their useful life. If they do, you'll find yourself making needless and frequent adjustments as you scan over time. A long useful life is also helpful. Fluorescent tubes last a long time (how often do you change the fluorescent bulbs in your home?) but, when nestled inside a scanner, can be difficult to replace if they ever do go bad. LEDs have even longer lives (when was the last time you saw an LED in a digital clock burn out, even though the clock is on 24/7/365?). Given the rapid evolution of scanners, both kinds of illumination are likely to operate in your scanner long after the scanner itself has become obsolete.

These attributes are all taken into account when designing a scanner. For example, light intensity has an upper limit. More powerful lamps cost more and run hotter. But, more interestingly, as resolution for scanners increases, the possible brightness of the light source runs up against a brick wall. Smaller "pixels" in higher resolution scanners can't "hold" as much light. When the pixels are overexposed by an intense light source, the excess illumination overflows, just like a bucket with too much water. This excess light spills over to neighboring pixels and creates *blooms* or streaks in the image.

## Optics

An optical system of some type is required for most kinds of scanners. The optics focus the light reflected from or transmitted through the original onto the sensor. Optics are required because sensors frequently aren't the same size as the path they are scanning. That is, a scanner that captures an image 8.5 inches wide might not include a sensor strip that is 8.5 inches wide. Instead, the sensor array is smaller, and the full width of the scan is focused down to the actual sensor width. I'll explain more about sensors in a minute.

The important thing to keep in mind is that the optical system in any scanner is one of the most important components affecting image quality. Indeed, the optical system can have more impact on the quality of your finished scan than the sensor itself, or even the resolution you use for the scan. One of the flatbed scanners I own is an older model Hewlett-Packard ScanJet with superior optics. I find that its 600 samples-per-inch scans are far superior to those I get from a newer, 1200 spi scanner, and rival those of an inexpensive 2400 spi scanner when images are enlarged to match the "higher-res" scanner in size.

Some scanners have multiple sets of optics, using one set for standard scans and a second set for higher resolution scans.

## Sensors

Sensors are the devices that capture the light reflected by or passing through the original, registering the intensity at each sample (pixel) position in the sensor, producing information that can be processed to create a finished image. Drum scanners use ultrasensitive photomultiplier tubes. Flatbed and film scanners use silicon chips called charge-coupled devices (CCDs), complementary metal oxide semi-conductor (CMOS) sensors, or contact image

# ISN'T IT DOTS-PER-INCH, NOT SAMPLES-PER-INCH?

You'll frequently see scanner resolution referred to in dots-per-inch (dpi), even by scanner vendors who have caved in to common usage. However, scanner resolution can't really be measured in dots-per-inch for a simple reason—scanners don't make dots! dpi can actually be applied only to devices like printers, which do use dots. You'll see monitor resolution expressed in dpi, too, and computer displays don't image in dots either: They use pixels, so pixels-per-inch (ppi) is a better measure there. (There is one instance in which it's okay to refer to display resolution in dpi. Microsoft Windows uses dpi as a measurement of how large display fonts should be. When you're setting your display for 72 dpi, 96 dpi, or 120 dpi, you're not really affecting monitor resolution at all; you're telling Windows what relative resolution to use when calculating the size of the fonts.)

Scanner resolution is properly measured in *samples-per-inch.* I'm not overly pedantic about the distinction. There's nothing wrong with adapting to common usage. I don't care whether you use dpi or spi yourself, but within the pages of my books I try to be as accurate as possible. So, when you see the term samples-per-inch, you'll know that I am *always* talking about scanner resolution, and if I use the term dots-per-inch, I'm *always* talking about a device like a printer.

sensors (CIS) to capture images. These chips, produced using technology similar to microprocessor-fabrication technology, are efficient light gatherers and are capable of recording both faint and strong amounts of light.

The image is captured as each individual sensor reads the amount of light reflected or transmitted by a small area on the original, and transfers the information in the form of a continuously increasing voltage, proportionate to the number of photons of light that have struck the sensor during its exposure. In many senses, scanner sensors are similar to the light-sensitive silver grains in the emulsion of photographic film, as discussed in Chapter 2.

These sensors can vary in sensitivity, just like fast and slow photographic films, and in "graininess." Like films, the briefer the exposure time or the lower the light level needed to produce an image on film or a scanner sensor, the faster both operate, providing faster scans, shorter exposures, lower light levels, or some combination of all three factors.

Sensors for scanners come in several varieties. The time-tested, high-quality option is the CCD, which is relatively expensive to produce because CCDs can't be fabricated on the same production lines as high-volume chips like RAM. CMOS/CIS sensors, on the other hand, are cheap to produce but have traditionally been associated with lower image quality. (This is changing, and there are now some CMOS/CIS scanners on the market that produce fine results, indeed.)

The two types of sensors manipulate the light they capture in different ways. A CCD is an analog device. Each photosite is a photodiode that has the capability (called *capacitance*) to

store an electrical charge that accumulates as photons strike the cell. The design is a simple one, requiring no logic circuits or transistors dedicated to each pixel. Instead, the accumulated image is read by applying voltages to the electrodes connected to the photosites, causing the charges to be "swept" to a readout amplifier at the end of the sensor array.

A CIS/CMOS sensor, on the other hand, includes transistors at each photosite, and every pixel can be read individually, much like a computer's random access memory (RAM) chip. It's not necessary to sweep all the pixels to one location, and, unlike CCD sensors, which process all their information externally to the sensor, each pixel can be processed individually and immediately.

However, the chief advantage of the technology is that CMOS chips are less expensive to produce. They can be fabricated using the same kinds of processes used to create most other computer chips. CCDs require special, more expensive, production techniques. In most cases, the extra expense is worth it, because CMOS sensors generally produce more noise and artifacts (two kinds of non-image information that can creep into an image), are less uniform, and require larger sensors.

Indeed, the larger sensors help reduce the cost of CIS scanners. Instead of using a long optical path folded with mirrors or prisms (the case with CCD sensors), larger CIS sensors are placed very close to the original being scanned, almost in physical contact with it (hence the term contact image sensor). These scanners don't need a complex and expensive optical system. However, the shorter imaging path means that CIS sensors have much less depth-of-focus (which is like depth-of-field in a camera). If the original or parts of it are even a very tiny amount out of the CIS element's plane of focus, that portion of the original will be blurry. When scanning a piece of paper, something as minor as a wrinkle in the paper can throw the image out of focus. That sensitivity to focus position can be fatal to scans of 35mm slides, which have a natural curvature within their slide mounts.

CCD sensors, in contrast, have bountiful depth-of-focus. Flatbed scanners can even scan small 3D objects. These characteristics make CCD scanners the better choice for all kinds of scanning for the foreseeable future. Your scanner specs will always tell you which kind of sensor is used. Check them before you buy!

# MORE ON CIS

The distance between the sensor and the artwork in a CIS scanner is a few millimeters or less, and the sensor is the same width as the page, whereas the CCD in a non-CIS scanner is only about 1.5 to 2 inches long. A CIS scanner captures the red, green, and blue images using colored LEDs, which flash in sequence as the CIS module moves down the page. Unfortunately, LED illumination is still a bit on the dim side, so scanning can be slow.

In addition to the lower cost to produce CIS scanners, a key advantage is the size of the carriage. A CIS scanning module, with LEDs and sensors included, can be built very small in size, allowing scanners that are themselves not much more than an inch or two thick and roughly the same length and width as the scanning platen itself.

*Electronics*

A scanner also contains a bit of intelligence in the form of the processing electronics that convert the scanned analog signal to digital form, and then parcel it out over the scanner's interface to your computer. Of course, the scanner might perform some other manipulations on the data while the image is still in-house, so to speak. Your scanner software includes controls for adjusting brightness/contrast, color, sharpness, and other parameters during the scan itself. The scanner can also reduce the scanned image from, say, a 48-bit scan down to a 24-bit scan acceptable to your image-editing software. (More on 48-bit, 32-bit, 24-bit, and other "bit depth" topics later in this chapter.)

Although the tendency is to favor simply grabbing a scan and then worrying about fiddling with it later in Photoshop or another image editor, there are some significant advantages to performing corrections while scanning. Hardware-based manipulations (even though the hardware is using built-in software) are faster than making the same changes in your computer using software. Any adjustments you can make in the scanner will happen more speedily because the scanner's software doesn't have to work through the extra overhead of an operating system and a thickly layered software application like Photoshop.

In addition, hardware manipulations can produce better results because the hardware is working with the raw data. By the time a scan reaches your computer, it's already been thoroughly modified during the scanning and analog-to-digital conversion process, so all you have to work with is the information that is left. For that reason, the electronics built into a scanner can be an important factor in your final image quality.

# Grabbing an Image

All the components of a scanner work smoothly together like a well-oiled machine, ignoring for a moment that a scanner rarely (if ever) actually needs oiling. The scan starts when you place a piece of artwork on a flatbed scanner's glass platen, or insert a film holder into the input slot of your film scanner. You might do a preview scan, and then select your other parameters, such as resolution, exposure, and so forth, and then click on the SCAN button in your scanning controller software. At this point, lots of interesting things happen.

If you're using a film scanner, the scanner might refocus on the film in the scanning gate to ensure the sharpest possible image. If the scanner has been idle for a while (and uses a fluorescent tube for illumination), the exposure lamp might be warmed up. After a few seconds have elapsed, the scan begins, giving you ample time to stop any activity, such as jumping around in excited anticipation, that might jar or shake the scanner.

At this point a flatbed scanner's carriage begins to move. It contains a light source and either the sensor array itself or mirrors and an optical system to reflect the scanned data back to the actual array located elsewhere in the scanner. If you're scanning a negative or transparency, the carriage light source will be shut off, and illumination will come from the alternate source *above* the glass platen.

With a dedicated film scanner, the sensor and light source probably aren't going anywhere. Instead, the film is moved precisely between the two of them, as the sensor and illumination are located on opposite sides of the film holder.

As the scan progresses line by line, the information will be processed through the analog/digital converter and stored temporarily in memory included within the scanner itself before the data is directed to your computer. The scanner actually captures three separate images of your original, one each for the red, green, and blue values in the image. (For more on RGB color, see Chapters 9 and 10.)

Over the centuries, or, rather, during the past decade or so that desktop scanning has been popular, several methods for capturing these three images have been used. Some of the original desktop color scanners were three-pass scanners that made three complete passes of the original, each time using a different R, G, or B filter between the artwork and the optical system. Others used three separate red, green, or blue light sources consisting of fluorescent lamps, colored solid-state devices called light-emitting diodes (LEDs), cold-cathode tubes, or other types of illumination. This kind of scanner requires a high degree of accuracy in positioning the scanning elements for the three consecutive scans, and the original has to remain rigidly in place so the three separate scans could be combined (or *registered*) without producing a rainbow-like color fringing effect.

Scanners that capture all three images in a single pass became more popular. The scan can be done with a single CCD array, using three exposures per line, each with a different red, green, or blue light source. More common is a trilinear array, which consists of three duplicate sets of sensors, each with a colored filter coated right on the chip during fabrication. The scanner's optics direct each of three white-light exposures per line to a separate set of CCDs.

Once captured, the processed scan is directed to your computer through the scanner's interface. The first scanners had proprietary interfaces, used SCSI (Small Computer System Interface) connections, or, perhaps, a proprietary SCSI link that worked only with the scanner, and not with any other SCSI component. Some scanners used serial port connections, which meant that you not only had to worry about your serial mouse and modem interfering with each other, but had to contend with conflicts from your scanner, too.

Later, vendors tried to simplify things by giving scanners parallel port interfaces, which let you plug your scanner into the same port used for your printer. That wasn't very smart, because printer ports weren't very good for anything other than printers. In fact, they weren't even that good for printers, which is why most printers today use the USB (Universal Serial Bus) port. Modern scanners all use either USB (preferably the faster USB 2.0) or FireWire connections, and most concerns about linking scanners to personal computers have evaporated. In most cases, hooking up is a plug-and-play deal.

Inside your computer, the scan is saved to your hard disk as a file and is ready for viewing, printing, or manipulating in your image editor.

# Scanner Parameters

At this point, you have a basic understanding of how scanners work. Now it's time to delve a little more deeply into some of the key parameters that govern the quality of your image, such as color depth, dynamic range, and my special love, that mythical quality known as resolution. Understanding these parameters will help you use your scanner more effectively and, when it comes time to purchase a new scanner, might assist you in making a wise purchase. At the very least, I hope you'll avoid the trap of buying a scanner based on a manufacturer's specs for dynamic range and/or resolution alone. As you're about to find out, those figures are very often meaningless!

## Color Depth

Color depth, which is frequently called *bit depth,* is nothing more than a way of representing how many colors a scanner can (theoretically) capture. This parameter is also closely related to dynamic range, because, vendors would have you believe, the more colors a scanner can capture, the greater its dynamic range, and vice versa. The first step is to get this color depth attribute clarified.

As you probably know, computers can't handle continuous analog information very well. A color spectrum represents a continuous progression of colors from deep violet to deep red, with an infinite number of hues in between. The mere concept of infinity gives a computer fits, so the first thing that must happen before your system can handle a full-color image is the conversion from continuous (analog) information to discrete (digital) chunks.

The computer doesn't want to work with an infinite number of reds, greens, or blues or any combination of them. It's happiest with nice binary-based values, such as 256 red tones, 256 green tones, and 256 blue tones. Indeed, most colors can be represented as some combination of those, such as the nice Red: 172, Green: 211, Blue: 115 numbers that result in a soothing medium lime green hue. Although 256 values for each color might not seem like a lot, they represent 256×256×256 different colors, or a total of 16.8 million hues. That's many more than the eye can differentiate!

The *bit depth* part comes from the binary equivalent of the numbers used to represent the colors. In the example above, 0 to 255 (in decimal) actually equals 00000000 to 11111111 in binary, with only eight bits required to represent any color's value, or three sets of eight (24 bits in all) to represent all three colors. That's where the term "24-bit color" comes from. Although 24 bits (three eight-bit bytes) is supremely convenient for programmers to work with, there's no reason to limit color representation to 24 bits and 16.8 million colors.

## DON'T THINK BINARY

The old joke goes, "I've explained binary math to you 10 times, and I'm not going to explain it a third time." In practice, however, you'll never need to understand bits and bytes other than in a general sense when evaluating the color depth of a scanner.

In fact, there are few, if any, "24-bit" scanners sold today. Most claim to record 30, 36, 48, or more bits of information. That's a lot of different colors. A 30-bit scanner, for example, grabs 10 bits each of red, green, and blue, for a possible one billion colors. A 36-bit scanner (12 bits per color channel) can capture an astounding 68.7 billion hues. At 48 bits, the number of colors venture into the Saganesque billions and billions of tones (281 *trillion* to be exact).

In practice, 48-bit color is far more colors than humans can possibly perceive, and quite a few more than most image editors can work with. Until the latest release of Photoshop (which does fully support 16 bits of color per channel, or 48 bits in all), it was necessary to let the scanner convert the image from whatever bit depth it was capable of down to 24 bits for editing. So why bother to capture up to 281 trillion colors in the first place?

---

## EXTENDED COLOR PALETTES ARE POTENTIAL ONLY

Color palettes of 281 trillion (or more) hues are *potential* only, as no image can possibly contain that many colors. Think of it this way: Suppose you had a digital image measuring 3000×2000 pixels. That's six million pixels. If *each and every* pixel in that image were a unique color (which is highly unlikely) you'd need only six million colors, well within the capabilities of the 16.8 million hues possible with 24-bit color. So, higher color depths provide only the potential for more colors, not that many different colors in an actual image.

---

The real value of enhanced color depths is not to provide extra colors to view, but to provide breathing room to compensate for the colors lost during the conversion from analog to digital. All scanners lose some information, thanks to the noise built into electronic systems. With a 24-bit scan having 256 colors per channel, inevitable losses to noise can reduce the number of colors to 128. With half the colors unavailable, it's likely that at least some colors will have to be represented by another color that's close, but not identical. The effect is similar to listening to your car stereo when you roll down the windows, and, with all the wind noise, Jimi Hendrix sounds like he's saying "'Scuse me while I kiss this guy!" instead of "'Scuse me while I kiss the sky!" *Not* the same.

With a 48-bit scan and 16 bits per channel, you can lose half the information and still end up with 8 bits of information per channel and a solid 24-bit image. This extra legroom can be especially important when scanning film and transparencies, because, unlike reflective art like prints, film is likely to have a much longer range of detail, with plenty of useful information in the dark, inky shadows as well as in the bright highlights. As good as CCD sensors are, they lack sensitivity in dark areas and can easily produce false values in the shadow areas of transparencies (or the highlights of negatives), so it's better to have many more hues available than might seem necessary so that, when an image is reduced to 24-bit color and 16.8 million tones, they are the *right* tones and not just a reasonable facsimile.

# Dynamic Range

The capability of a scanner to capture information over the whole range from darkest areas to lightest is called its *dynamic range*. There are many kinds of photos in which you're likely to need an extended dynamic range. Perhaps you have people dressed in dark clothing standing against a snowy background, or a sunset picture with important detail in the foreground, or simply an image with important detail in the darkest shadow, as shown in Figure 3.1.

**Figure 3.1** *Pulling detail out of shadows requires a scanner with a long dynamic range.*

## DANGER, WILL ROBINSON!

Dynamic range is one of those specs that scanner vendors tend to exaggerate. Indeed, some scanners that claim more than 36 bits of color might not actually capture any additional information, even though they claim a dynamic range of 3.4 or 4.8, or some other figure. They're counting on the average buyer not knowing what the values mean, and not understanding that there is no standard definition of what defines "bit depth" or "color depth" as it relates to dynamic range, and many scanners with high bit depth claims might not, in fact, deliver that performance. I explain how dynamic range is exaggerated later in this section.

There *is* a way of measuring dynamic range within the world of scanners, but, as you'll soon see, that method might not produce useful results. Dynamic range can be described as a ratio that shows the relationship between the lightest image area a scanner can record and the darkest image area it can capture. The relationship is logarithmic, like the scales used to measure earthquakes, tornados, and other natural disasters. That is, dynamic range is expressed in density values, D, with a value of 3.0 being ten times as large as 2.0.

As with any ratio, there are two components used in the calculation. These are commonly called *Dmin* (the minimum density, or brightest areas of the film) and *Dmax* (the maximum density, or darkest areas of the film). If you're a photographer, you've probably heard these terms before, as applied to the lightest and darkest useful areas of photographic films.

Dynamic range comes into play when the analog signal is converted to digital form. The analog-to-digital converter circuitry itself has a dynamic range that provides an upper limit on the amount of information that can be converted. For example, with an 8-bit A/D converter, the darkest signal that can be represented is a value of 1, and the brightest has a value of 255. That ends up as the equivalent of a maximum possible dynamic range of 2.4, which is not especially impressive.

This is where bit depth gains some relevancy. A 10-bit A/D converter (for 30-bit color depth) can produce a maximum dynamic range of 3.0; up the ante to 12 or 16 bits in the A/D conversion process, and the theoretical top dynamic ranges increase to values of D of 3.6 and 4.8, respectively. Remember that the scale is logarithmic, so a dynamic range of 4.8 is *many* times larger than one of 3.6.

These figures assume that the analog-to-digital conversion circuitry operates perfectly and that there is no noise in the signal to contend with.

When designing a scanner, the emphasis is always on the Dmax (dark) values, because recording Dmin (bright) values is not that difficult as long as the illumination passing through the brightest area of the film doesn't produce more light than the scanner can handle. That's easy to accomplish by limiting the brightness of the light source.

The dark signals (Dmax) are much more difficult to capture. The weak signals can't simply be boosted by amplifying them, as that increases both the signal as well as the background noise. All sensors produce some noise, and it varies by the amount of amplification used as well as other factors, such as the temperature of the sensor. (As sensors operate, they heat up, producing more noise.) So, the higher the dynamic range of a scanner, the more information you can capture from the darkest parts of a slide or negative.

Extended dynamic range is not particularly useful when scanning prints, because the whitest whites in a photographic print don't reflect all that much light, and the darkest blacks in a print that have detail rarely have a Dmax that exceeds 2.0. It's a whole different kettle of fish with color transparencies, which can easily boast detail in a Dmax that reaches 3.5 to 4.0. You'll want as much dynamic range as possible for scanning transparencies.

Unfortunately, you cannot glean the true dynamic range of a scanner from the specs the vendor supplies. Most of them simply quote the *maximum* potential dynamic ranges. That is, a scanner with a 16-bit A/D converter will be listed as having a dynamic range of 4.8. One with a 12-bit A/D converter will be advertised with a 3.6 dynamic range. In practice, given the noise that creeps into any analog-to-digital conversion process, such scanners are likely to have no better than dynamic ranges of 2.8 to 3.6, regardless of what the vendor claims. Even expensive drum scanners that use virtually noise-free photomultiplier tubes have dynamic ranges no higher than 4.0. The good news is that values of 2.8 to 3.6 are probably high enough for virtually everyone.

The most interesting thing about looking at the fudging of scanner dynamic ranges is that the best measure of how much information the scanner can capture might lie in the signal-to-noise ratio. That is, how much of the scanned information is lost to noise during the analog-to-digital conversion process. No vendor of desktop scanners publishes S/N specifications (wonder why?) and the information would probably be not very useful if it were available. That's because there are as many ways of manipulating that data as there are of fiddling with dynamic range information. For example, at what temperature was the S/N ratio calculated? The hotter the sensor is, the more noise is produced. You can bet that any vendor publishing this information would measure the noise with the scanner inside an icebox. (Thermal noise is not the only kind of noise produced; noise can also be produced mathematically during the process of converting the image from analog to digital form.)

# True Lies About Resolution

The next ox to gore is the mythology surrounding scanner resolution. The two most common questions (after "what's the best scanner?") asked about scanners are:

1. What resolution do I need when buying a scanner?
2. What resolution do I select when making a scan?

If the advertising by scanner vendors is to be believed, the most important specification of any scanner is its resolution, followed by the dynamic range, another number that's subject to accidental or intentional manipulation. As you've seen in this chapter, there are other factors that are a *lot* more important if image quality alone is what you're looking for, and a few that take on major significance when issues like performance (including how long you have to twiddle your fingers while a scan is underway) are crucial. Here's a summary of some of the key points to keep in mind in regard to resolution:

- The optical system of a scanner can have the biggest influence on the quality of the scan, as long as you're using an appropriate resolution. That is, a superb set of optics won't help all that much if you're trying to scan a 35mm slide at 300 spi.

- Qualities of the sensor can be as important as the resolution of the sensor itself. A 3200 spi sensor that's subject to noise, blooming in the image when slightly overexposed, or which can't capture pixels in dim areas of the film won't do as good a job as a 1600 spi sensor with superior qualities.

■ When you're scanning reflective continuous tone artwork, such as photographs, resolution rarely is an issue. You'll find that 300-400 spi is plenty.

■ When scanning film, resolution becomes more important. For most film sizes and most applications, you'll want 2400 spi or higher resolution. Film scanners that offer 4000 spi resolution will do an even better job, but only because *they are better all-around scanners*, not simply because of their resolution.

■ The resolution figures you see quoted for a scanner are not necessarily true or relevant.

I'll explain all these points as we go along.

## What's Resolution?

Earlier, I explained why scanners can't properly be measured in *dots-per-inch*. Each kind of input and output device attached to computers uses different measurements for resolution, appropriate to the kind of device. The resolution of printer and imagesetters is measured in dots-per-inch, which is considered to be the actual dots that the device can apply to paper or film. These dots are generally oval or round, and some devices can actually vary their size.

Specialized printers such as thermal dye transfer printers can even change the intensity of an individual dot. Thanks to the nature of the dyes used, the amount of dye transferred can be varied over a range of 0 (no dye) to 255 (full dye). In all cases, regardless of the variations, these devices are imaging dots and can properly be measured using a dots-per-inch yardstick.

Computer displays are measured using a different yardstick, *pixels*. Monitor resolution can also be confusing, because of terms like *dot pitch* (the distance between two screen pixels of the same color). It's easy to think about pixels-per-inch in terms of a computer display, too, although the number isn't really relevant in the way you think it might be. Your computer doesn't know anything about the number of pixels-per-inch on your display monitor. All it cares about is how many pixels wide and tall the display is. You might have the same monitor set to 1024×768 pixels, 1600×1200 pixels, or (like me) 1920×1440 pixels. The higher resolutions don't make the image you see any sharper. It makes individual elements *smaller*. As you boost the screen resolution, elements such as menus, dialog boxes, and cursors get tinier, providing extra space for other elements, such as pictures. A dialog box that measures, say, 400×400 pixels when your monitor resolution is set to 640×480 might nearly fill up your screen. At the higher 1920×1440 resolution, it will still measure exactly 400×400 pixels and will be no sharper. It will simply be three times smaller.

As mentioned earlier, what fools many people are the settings in Windows for changing your "resolution" to 72, 96, or 120 dpi. Those settings change nothing on your screen other than the size of your fonts, letting you vary them to provide a comfortable viewing size. Non-font images on the screen look exactly the same at any of those "resolution" settings.

# DPI VS. LPI

When dealing with printers and imagesetters, don't be confused by the term *lines-per-inch* as applied to imaging photographs. As you may know, photographs are printed using *halftone screens*. Because most types of output devices can't vary the size of their dots enough to represent all the different tones and colors in a photograph, halftones are used to create an optical illusion. The screen divides portions of the image into tiny dots of various sizes, which the eye blends together to create whites, blacks, pastels, and all the colors in an image. These dots are built up by combining printer dots in various ways, using larger dots in a kind of matrix. For example, if one of these larger dots, called a *cell*, measures 8×8 printer dots on a side, it can contain 0 to 64 dots. When printed on a page, our eyes see any of 64 tones represented by those combinations.

The size of the cell used determines the resolution of the halftone screen, measured in lines-per-inch. Suppose a printer is capable of 1200 dpi. When you divide those 1200 dots-per-inch into cells measuring 8 dots, you find that the maximum number of lines-per-inch that the printer can reproduce is 150 (1200 divided by 8). The lines-per-inch, or *screen ruling*, determines the apparent resolution of the photograph as well as the number of tones that can be reproduced. For example, if you use a larger 10×10-dot cell to give you 100 tones, the resolution drops to 120 lpi. Unless you're working extensively with halftones you probably don't need to absorb all this information, but it helps to avoid confusing dpi with lpi. Figure 3.2 shows you the 16 dot combinations in a printer cell measuring a mere four dots on a side.

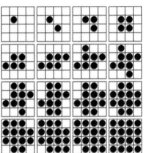

**Figure 3.2** *A printer cell measuring four dots on a side yields 16 dot combinations, plus pure white.*

At the beginning of this chapter, I mentioned that scanner resolution is properly measured in samples (not dots) per inch. Those samples are collected by the sensor array, as outlined earlier in this chapter. The resolution of the scanner in the X dimension (the width of the original) is determined by the number of individual sensors available to capture each line. The number of sensors required is easy to calculate. A 35mm film scanner can capture an image of a slide or negative that's roughly one inch wide. So, a 4000 spi scanner requires exactly 4000 individual sensor elements.

With larger film, the number of sensors needed grows. A film scanner that can accept 6cm wide film (roughly 2 1/4 inches) needs a row of 9000 sensors to grab the image at 4000 spi. Flatbed scanners usually can scan reflective originals up to 8.5 inches wide, requiring 27,200 sensor sites for 3200 spi resolution. Of course, flatbed scanners used for film generally can accept transparencies and negatives that are much smaller than the scanning bed itself, ranging from 1 inch wide 35mm film to 4×5-inch film sheets, so not all the sensors of a flatbed are used for film scanning. As you might guess, designing sensor arrays with so many individual elements is complex.

Resolution in the other direction, the Y dimension (the length of the scanned image), is determined by the distance the sensor moves between lines. This is called the *stepping increment*. A given scanner might not be able to move the sensor array vertically in small enough increments to match the horizontal resolution. That's why you'll see scanners with specs like 2400 spi horizontal/1200 spi vertical resolution. Most of the time, when you see a specification like that, the vendor is being painfully honest. The tendency among manufacturers is to try to make the vertical resolution figure match the horizontal resolution, even if they must fudge the figures a little to do so.

For example, a scanner that claims 2400 spi vertical resolution might not actually resolve that many lines per inch. The sensor array itself is probably wider in that dimension than 1/2400th inch, so the only way to ostensibly move the array such a small increment is to have some degree of overlap between lines. If you think about it, you can see that CCD sensors have one more potential advantage over CIS elements in the Y dimension. When the CCD sensor is smaller than the width of the horizontal scanning swathe, it also tends to be smaller in the vertical direction, too, making small stepping increments practical. A CIS component, on the other hand, is physically larger and therefore more difficult to move vertically in tiny steps.

So, right off the bat, a scanner's horizontal and vertical resolution might not be exactly as claimed. The optics used to focus the image can also have a bearing on resolution, along with the size of the "spot" scanned, and the shape of the sensor.

A truer measure of sharpness is something techies call a *modulation transfer function*, which takes into account the simple fact that optical systems, including those found in scanners, focus each of the primary colors of light at a different point. Scanner designers understand this, and also know that our eyes are more sensitive to certain colors, such as green, than to other colors, such as blue. So, the optics and sensor may be designed to optimize the sharpness in the green channel, while giving up a little in the blue channel, because the overall image will appear "sharper." Indeed, in scanners, up to 60 percent of the image is derived from the green image, 30 percent from the red, and only 10 percent from the blue. These factors all contribute to the sharpness of the final image and are quite separate from the raw "resolution" figure in samples-per-inch (or dots-per-inch) that scanner vendors like to quote.

## TECH ALERT!

If you're really interested in this stuff, or simply want to see all the issues that are involved in calculating the true sharpness of a scanned image, do a Google search (**www.google.com**) for two new ISO (International Standards Organization) specifications designed for scanners. ISO 16067-1 deals with a standard measurement of the resolving power of scanners as applied to reflective originals, whereas those interested in film scanning will be more interested in ISO 16067-2. There's another one, ISO 21550, dealing with dynamic range if you're so inclined. Note that any proposed standards like these must go through working drafts, committee drafts, and several other stages before they become official international standards.

# What's Interpolation?

But wait! There's more. Up to this point, we've been talking about "real" or *optical* resolution (even though it might not be as real as you think). Resolution can also be *simulated* by various mathematical algorithms, producing an apparent resolution that is higher than the figure supplied for optical resolution. This process is called interpolation.

In the bad old days, many vendors would list interpolated resolution as a specification with more emphasis than it should have had. Resolutions were lower in those days (before the advent of affordable film scanners) so the temptation was powerful. So, a flatbed scanner used for grabbing images of photos and such might have a true optical resolution of 300×300 spi. Through the magic of interpolation, that same scanner might be capable of simulating 600×600 spi or even 1200×1200 spi resolution. And that's what the vendor would promote. Gullible buyers might think they were purchasing a 1200×1200 spi scanner when most of the extra sharpness was mathematical smoke and mirrors.

Thankfully, those sorts of shenanigans have been largely abandoned. All vendors list the optical resolution of their scanners as the primary sharpness specification, even though, as you've seen, even optical resolution probably doesn't accurately reflect the resolving power of the scanner. Interpolated resolutions are buried in the other specifications, in a way that is likely to be much less misleading.

Even so, many scanner users don't fully understand interpolation, and either put too much trust in it, or too little. In truth, although interpolated resolutions aren't as good as actual optical resolutions, they still can be useful if applied properly.

Interpolation is nothing more than a process used when changing an image's size (up or down) or color depth to something other than its original size or color depth when captured. Although interpolation can be used to change color information and to make an image smaller than the original, most of the time when we think of interpolation, we are thinking of an image in which new pixels are created to make the final image higher and with more resolution than the original scan. (Interpolation used to make an image smaller is usually called *downsampling* instead.)

Don't confuse interpolation with *scaling*. When an image is scaled up, every pixel is duplicated a certain number of times. To triple the size of an image, each pixel would be duplicated three times. The same is true for scaling an image downward. With simple scaling, reducing an image to one-third its original size means discarding every third pixel (and hoping that the ones that remain bear some resemblance to the original). In either case, the resulting image is likely to have rough edges or "jaggies" in the diagonal lines.

Figure 3.3 *Interpolation creates the new pixels shown in the bottom line between the black-and-white pixels at either end.*

Interpolation is a much more sophisticated process. Instead of just copying pixels, the algorithms used for interpolation examine the neighboring pixels and calculate new pixels that fit in as seamlessly as possible, providing smooth transitions between the old and new. To oversimplify a bit, if an image had a black pixel next to a white pixel, scaling 2X would produce two black pixels and two white pixels. Interpolation would give you the original black-and-white pixels, plus one dark gray and one light gray pixel in between them, as you can see in Figure 3.3.

There are a variety of ways to interpolate images, some of them quite sophisticated. The three most common methods are these:

- *Nearest Neighbor.* This method looks at the pixel immediately adjacent to the pixel being processed, and uses the information about that pixel to create the new pixel. Because only one other pixel must be examined, this method works quickly, but is less precise, and not suitable for most photographic images that contain gradual transitions between areas. With that type image, it produces noticeably more jagged edges. If you're scanning an image that contains hard edges, such as block text or an image that will be saved in GIF format, the Nearest Neighbor algorithm can work well. In those cases, it produces smaller files and preserves the hard edges effectively. Figure 3.4 shows a letter A (a kind of image that works particularly well with the Nearest Neighbor algorithm), whereas Figure 3.5 shows a section of that letter enlarged 600 percent using the algorithm.

Figure 3.4 *Hard-edged images like this one are suitable for Nearest Neighbor interpolation.*

Figure 3.5 *Here's a section of the same letter enlarged 600 percent using Nearest Neighbor interpolation.*

■ *Bilinear*. This method examines the pixels on either side of the pixel being processed. It operates a little more slowly than Nearest Neighbor, and can produce fairly good results with images that contain high contrast components. You can see how this kind of interpolation works in Figure 3.6.

**Figure 3.6** *Bilinear interpolation produces softer edges.*

■ *Bicubic*. The most popular method for interpolation is Bicubic, which examines surrounding pixels to derive information for creating new, interpolated pixels. It's the default method used in many scanners as well as in Photoshop. The latest version of Photoshop adds two variations to the basic Bicubic algorithm—Bicubic Smoother, which does a better job of reducing jaggies when you're enlarging an image; and Bicubic Sharper, which maintains detail when downsampling an image to make it smaller. Figure 3.7 illustrates Bicubic interpolation.

**Figure 3.7** *Bicubic interpolation produces a more realistic result.*

Interpolation is a valid process to use while scanning if you really must have a higher resolution, because the most sophisticated algorithms produce images that do have useful information that wouldn't be found in an unadorned scan. The process can calculate extra pixels with a surprising degree of accuracy, closely mimicking the results you might get at higher resolutions. Interpolation works best with detail-filled images.

Interpolation in some form takes place any time you scan at something other than the scanner's native optical resolution. For example, if your scanner's true resolution is 4000 spi, any time you scan at, say, 2000 spi to reduce file size for noncritical scans, interpolation is used to

generate the final image. Or, if your 4000 spi scanner allows scanning at 8000 spi, interpolation is at work again to simulate the higher resolution. Some scanners interpolate in hardware as the scan is made, whereas others perform this step using software on your computer.

## Does Sharpening Increase Resolution?

The goal of higher resolution is to produce a sharper image, and scanners generally include some sort of sharpening routine in their scanning options, so can sharpening be used to increase the apparent resolution of an image? The safest answer is, "Yes and no."

Sharpening is nothing more than a way to increase the contrast between edges in images, making the edges appear to be more distinct. Figure 3.8 shows a portion of an image that has been sharpened simply by boosting the contrast between the pixels selectively. The most effective kind of sharpening applies the extra contrast only to the edges, leaving the pixels inside the edge boundaries alone. In the simplest kind of sharpening, the scanner's software looks at each pixel, plus the block of pixels that surround it, usually in a 3×3 or 5×5 pixel square. Examining the surrounding pixels tells the software whether the pixel is part of an edge and, if so, the darkness of the pixel can be increased or decreased as necessary to boost contrast. (Blurring, by the way, is this same technique, carried out in reverse to *reduce* the contrast between edges.)

This technique, carried to its most logical extreme, is the process called *unsharp masking*. The process, which doesn't create "unsharp" images, was originally developed in the darkroom. To create an unsharp mask, a film positive is made from the original film negative (or a negative made from the original positive transparency). The reversed film is slightly blurred, which causes the image to spread, exactly as you'd expect from an out-of-focus image. It's this blurred mask that gives the technique its name. When the positive and negative are sandwiched together to create another image, the light areas of the positive

**Figure 3.8** *Increasing contrast at the edges makes an image look sharper.*

correspond very closely to the dark areas of the negative, and vice versa. They effectively cancel each other out to a certain extent. However, at the edges of objects within the image, the blurred areas in the mask don't cancel out, resulting in lighter and darker lines on each side of the edge, generating a sharper-looking image.

Thanks to the miracles of microprocessing, this time-consuming process of creating positives and negatives and unsharp masks can be done electronically, much more quickly and effectively. Scanners offer unsharp masking as one of the options during a scan. By enhancing details found in the original image, sharpening does produce true gains in resolution.

With photographic-type images, the process can only be used to a limited extent, because sharpening invariably increases contrast. Sharpening can also increase noise and grain, and make dust spots, scratches, and other artifacts more obvious in the final scan. You'll want to use sharpening with care.

# Next Up

You now have a good grounding in the most important scanner specifications, so you know what matters and what doesn't. You're also less likely to fall for those phony dynamic range and resolution scams that vendors sometimes try to pull. It's time to move on to some specifics about choosing the best scanner. You'll explore that topic in the next chapter.

# 4

# Choosing a Scanner

Selecting a scanner for your film- and photo-scanning needs is less complicated than it was

only a few years ago. It's not that your choices are limited. If anything, there are many more

scanners that will do the job, many of them at lower prices, than have ever been available

before. The array of scanners to choose from might seem bewildering on first glance, but I'm

confident that you've learned enough from the first three chapters of this book to be able to

sort through the key options. You now understand resolution, bit depth, dynamic range, and

other parameters that affect scanner performance. (If you don't, because you're skipping

around the book, you might want to take some time now to review Chapter 3.)

The reduction in complexity comes from the improvement in scanner and interfacing
technology. You no longer have to decide whether you want a scanner for a PC or a Mac;
virtually all scanners work equally well with both. You don't have to match the scanner's
interface type with the particular interface available with your computer. All newer computers
have a USB port, FireWire port, or both, and scanners today use one or both of these
interfaces. Even installation is easier.

This chapter helps you decide which scanner is right for you. Perhaps you've been scanning
photos and now want to upgrade to a model that scans film, too. Maybe you're contemplating
your first scanner and want a model that handles both. You might even be someone who has
been using a film scanner for a while and is looking to upgrade. Everything you need to know
is in this chapter.

## Simplify, Simplify

When Thoreau wrote "Our life is frittered away by detail... Simplify, simplify, simplify!" he
might have been talking about scanners. He might have followed his own advice, too, and
conveyed the same message without repeating the word "simplify" twice, but there's a lesson
in the author's choice of words. Simplicity isn't always as simple as it seems.

The trend in recent years has been to simplify the design and use of scanners. Scanners have become much smaller, less heavy, and easier to install. At the same time, some of the smaller scanners provide less quality, are subject to vibrations because of their lack of "road-hugging weight," and are less flexible in the way you install them. Some of the simplification came with trade-offs; other improvements had no corresponding drawbacks. This section reviews some of the things you no longer have to worry about, and a few that you do.

## No Problema

Hardware conflicts have been one of the most notorious difficulties that scanner users have faced in the past. The PC architecture was the worse offender, being a motley assemblage of internal system interfaces (including ISA, PCI, AGP, and others), all contending for a limited number of system resources. For example, PCs have only 16 interrupts, called IRQs, that all the devices in the system can use to get the microprocessor's attention, along with a small number of direct memory access (DMA) channels, and a limited number of built-in ports to connect things to. If you've been using Windows-based computers for fewer than five years, you probably don't know what these things are, and don't care. The short explanation is that these limitations made it difficult to connect more than a few devices to your computer without having a few of them squabble over the available hardware resources.

Today, plug-and-play operating systems like Windows mediate these quarrels, allowing devices to share resources when necessary. So, many of the hardware conflicts of the past have become invisible to the average user. Good riddance! Best of all, we have new interfaces like USB and FireWire that allow dozens of devices to peacefully share resources, so it's not necessary to make decisions like "Do I want to use a serial mouse and a modem, or unplug the modem and use my scanner instead?"

---

## MAC CONFLICTS/PC CONFLICTS

Any discussion of hardware conflicts for Windows-based PCs always prompts queries about the equivalent problems on Macintosh computers. The short, if simplistic, answer is this: Macs don't have them. As much as I love and use PCs, I have to admit that the PC architecture is a sloppy conglomeration of compromises (starting with building the original IBM PC as a 16-bit computer that used 8-bit components) generally under the control of no one, expanded in odd directions for odd reasons over the years, and is *still*, more than 20 years after the PC's introduction, dependent on decades-old standards. Mac design, in contrast, has never escaped the iron grasp of Apple Computers, which blithely abandoned obsolete technologies as required (including the recent jump from the old Mac OS to the new UNIX-based OS X) to keep things working logically and smoothly. Hey, Macs crash the same as Windows computers, but it won't be because (as happened to me last week) a built-in modem that I never use decided it didn't like my e-mail client.

Scanners for PCs could use a mixed bag of parallel port, serial port, and SCSI connections, sometimes using dedicated interface cards that worked with nothing else. Sometimes, all the free slots in your computer were filled with adapters for other peripherals, as sound cards, network interfaces, modems, video displays, and other devices that are commonly built into the motherboards of modern computers were installed separately. It was not uncommon to have to pull a card and lose a capability to free up a slot for a peripheral that you needed even more.

The Macintosh world has not been problem-free, either. For many years, Mac scanners used the SCSI interface built into every Macintosh dating back almost to the dawn of time. SCSI is a system-level interface with built-in sharing capabilities. Each SCSI device has enough intelligence to interpret or decode requests from the computer and decide that the signal is in fact meant for it and not one of the other devices on the connection. Because the computer doesn't have to be concerned with the nuts and bolts of operating the peripheral, a SCSI device can be a hard disk, tape drive, CD drive, printer, or scanner. The bus is easily fast enough to handle a scanner's information.

That's the good news. The bad news is that every SCSI device must be set to a unique ID number, and the user must be careful to include a device called a "terminator" at the ends of the SCSI chain. SCSI devices aren't plug-and-play in the strictest sense. Many require special drivers, and all the devices you plan to use must be powered up and available when the computer is turned on. Depending on the type of SCSI interface used, you could be limited to 7 or 15 different devices in one chain. Using SCSI scanners was never as simple as it could be.

More complications came with the drivers for scanners. It was usually necessary to manually install a driver specifically for your scanner, computer, and operating system. Software installation was never pretty, and seldom simple. Today, your operating system might have some built-in support for some digital equipment such as cameras and scanners. At the very least, you should be able to plug in the scanner, reboot, and the operating system will recognize the device and ask you to point it to the appropriate driver. Installation can be much simpler than ever before.

Be thankful that *los problemas* of the past are largely gone and forgotten.

# Defining Your Needs

If you haunt the Usenet newsgroups dedicated to digital imaging for a while, you'll see a common theme popping up in about one out of every five postings. It's a question along the lines of "What's the best scanner to buy?" That question is the digital imaging equivalent of asking "What's the best car?" Do you want to go from 0 to 60 mph in less than six seconds, or would you rather go from Los Angeles to Chicago with fewer than six fill-ups of your gas tank? Do you want a luxury car with every amenity, or an econo-box that costs as little as possible? The compact pickup truck that's the best vehicle for me might be the worst possible choice for an NBA power forward going club-hopping with four of his seven-foot tall teammates.

Before you even begin to shop for the scanner of your dreams, it's a good idea to make a list of your expectations and needs. It doesn't matter whether you're working on a tight budget or

have unlimited funds. The price of the scanner isn't as important as its capabilities. You can spend very little and get a scanner that's perfect for you, or spend a lot and get a scanner that still won't do what you want, or that is so complicated to use you can't put the features you need to work.

Here's a checklist of things to consider before you go shopping for a scanner.

## Will You Be Scanning Only Film?

If all or the majority of your scanning involves film, you definitely should be considering a dedicated film scanner. They do the best job of scanning negatives and transparencies from a quality standpoint, and are generally much faster to use and work with. For example, a film scanner can automatically provide individual prescans or index scans of every image on the film holder, which is much faster than using a flatbed scanner that forces you to work with a gang scan of the whole strip or slide set, and then individually select and scan each image for previewing and making settings changes.

The least expensive film scanners cost about the same as better flatbed scanners, so if you really plan to scan mostly film, you won't be paying much of a cost penalty to upgrade to a dedicated film scanner.

## Will You Be Scanning Photos, Too?

If you have a significant number of photos to scan and have only the occasional need to scan film, a dual-purpose flatbed scanner might be a good choice. Such a scanner can serve double duty. Although you won't get the kind of results you can expect from a film scanner, and your workflow will be a little slower, buying a good scanner that can handle both prints and film can save money, reduce the amount of deskspace taken up by peripherals, and, to some extent, simplify your life. Expect to pay $300 for a scanner that can do both jobs.

Of course, if you have lots of photos and lots of film to scan, and want the best possible results for both, your other alternative is to purchase both a flatbed scanner and a film scanner. Sometimes, having the best of both worlds means you have to embrace both worlds.

## How Will Your Scanned Images Be Used?

This consideration goes hand-in-hand with the previous one. If your film scans are destined for display on a web page, or you plan to make only small prints, the results you get from a flatbed scanner might well be good enough. There's no need to pay for a 4000 spi film scanner if you're going to end up with 600×400 pixel images.

On the other hand, if you use your scanned images to archive valuable transparencies or negatives, or plan to do extensive image editing, you'll probably want the very best scans you can get, which usually means a dedicated film scanner. For the avid photographer, image editing is usually part of the game plan. You might intend to scan your images, and then spice them up with filters, correct their colors, or combine several images to create a whole new picture. If photography is a creative outlet for you, you'll want the best film scans you can get.

# How Much Resolution Do You Require?

Again, web pages, photo ID cards, and real estate listings don't call for a lot of resolution. If you plan to crop your scanned images by extracting tiny portions, make huge prints, or use your scans as "digital negatives" that will serve any foreseeable need in the future, you'll want the best image quality you can get.

Keep in mind the resolution myths mentioned in Chapter 3. When shopping for a scanner, you should know by now that you don't look simply at the number of samples-per-inch, but at the overall optical quality and sharpness of the final image. You might find that a 2400 spi flatbed scanner will perform better than a 3200 spi flatbed, and that a 2820 spi dedicated film scanner will easily outperform both.

Also remember that if you opt for a scanner with less resolving power because your applications today don't demand that much sharpness, you'll be limiting your flexibility in the future. What's good enough today might not be good enough in the future, when you graduate from web page display to full-blown image-editing pursuits. Unless you're positive that you'll never need the extra performance a better scanner can provide, or are willing to upgrade more quickly than you might need to otherwise, check out the model that's the next step up from the scanner you're considering. If the price differential is small, you might save money in the long run and be happier to boot by purchasing more scanner than you think you need now.

# How Many Scans Will You Be Doing at Once?

Making a few scans every day can be a lot of fun. You'll be less enthusiastic when you're faced with 100 film originals to scan. That much work becomes a chore. If you think you'll be scanning lots of film from time to time, the speed and performance of the scanner you buy becomes much more important. (You can also use an outside service to do the work for you; skip ahead to Chapter 7 for more information on this option.)

There are several characteristics of a scanner that can affect its relative performance. Here's a list:

- *Scan speed.* The easiest to measure is the raw speed of the scan at the resolution you want to use. Can it scan a 35mm slide in 30 seconds? Or must you wait three minutes or more, per scan? If you're scanning only a few slides, an extra 150 seconds per scan probably won't mean much. When you have 100 scans to slog through, that's more than *four hours* of additional thumb-twiddling.

  The very fastest scanners generally cost the most, but the slowest aren't necessarily the least expensive. If you're planning on scanning large batches of film, you'll want to check out the scan times for the size image you most commonly scan, at the resolutions you most frequently use. Then weigh that factor against the cost of the scanner and the quality of the final scans. In most cases, saving even significant amounts of time won't be worth reduced quality or outrageous price tags.

- *Setup time.* How much time does it take to get your image ready for scanning? This can include cleaning the film (even if that means a quick dusting with compressed air), as well as inserting the slides or film into a holder and positioning it on/in the scanner. If a scanner

has a difficult-to-use film holder system or if setup is otherwise complicated, you might find that you're spending more time getting ready to scan than actually scanning.

- *Capacity.* The relative effects of setup time can be spread over more images if your scanner can handle multiple frames automatically or semi-automatically. Does your dedicated film scanner have a film transport system that can process an entire roll of film, one after another, or must you cut up your film into strips of four or six frames, and scan each strip separately? Does your scanner have an APS cassette so you can scan all the frames of your Advanced Photo System rolls?

- *Software complications.* Your scanner software can have an impact on the time it takes to make individual scans. The software should be able to identify and isolate each frame, so you can work with one image at a time. The software should provide index scans you can evaluate and manipulate prior to making the final scan. And above all, the scanning application should not be so complicated that you waste a lot of time trying to use its features.

- *Automation.* Sometimes, you'll have a long roll of images all exposed of similar subject matter under similar conditions. If your scanning software can scan each of those images consecutively with little or no intervention from you, so much the better. If the scanning software can work unattended, yet individually analyze each photo and provide rudimentary corrections without your meddling, better yet. When you're scanning lots of film, the more your scanning software can do, and the less you have to do, the more time you'll save.

## Will Your Scanner Be a Long-Term Investment?

Let's be honest. Photographers are even worse gadget freaks than the average bleeding-edge computer nut. There's always a new lens, new filter, new electronic flash, or other accessory beckoning on the horizon. Now that photography and digital technology are converging, new gadgets become even more tempting. It's very likely that the scanner you buy today will be trumped by one that's better, less expensive, and has more features in only a year or two. If you fall into the camp that always lusts after the latest-and-best scanner, the device you buy today probably won't be a long-term investment. In a year or two you'll be ready to pass your scanner along to a family member or, better yet, use it as a backup in case your new scanner abruptly flakes out on you. Or, donate it to a worthy charity. (Although some of the worthy charities I've spoken to tell me they are sick of getting worn-out, obsolete equipment. Consider buying your favorite charity a *new* scanner!)

On the other hand, a significant number of scanner owners aren't interested in having the latest new gadget. They want good quality scans. In that respect, a scanner purchased today should do exactly the same job in three years or five years. If it suits your needs now, it will suit your needs later, assuming your needs don't change.

The wild card in the whole deck, of course, is unforeseen changes in computer hardware and operating systems. That scanner you bought five years ago that uses a particular interface won't work on a future computer that doesn't include that interface. If you think that parallel, standard serial, or SCSI interfaces will never be completely outmoded, consider that computers

are already being sold with no floppy disk drive, few if any PCI slots for plugging in adapter cards, and that most printers today have parallel ports added only as an afterthought.

It's entirely possible that the scanner you buy now will seem hopelessly outmoded sooner than you think. All PC users might abandon Microsoft Windows overnight and switch to Linux, and your scanner vendor won't plan to provide a Linux driver for a discontinued model. Okay, that might be a little far-fetched. However, in the real world, the technical editor of this book discovered that his trusty, expensive UMAX scanner wouldn't operate at all when he upgraded from Mac OS 9.x to Mac OS X. The vendor declined to provide drivers for this older scanner, and the only recourse was to purchase a third-party scanner software package that *was* compatible with OS X for $400.

With luck, though, the scanner you buy today will continue to be useful. If you're a member of the anti-upgrade camp, you should be able to purchase a scanner that does the job for you at a price you can afford, and continue to use it as long as you like.

### Is Size Important?

In the past, scanners, particularly flatbed models, could occupy major allotments of desktop real estate. I'm still using a scanner that eats up 14.5×23 inches of counter space. Its 8.5×14-inch scanning bed makes it useful in an era when most desktop scanners can handle no more than 8.5×12-inch originals.

Other flatbed scanners are smaller, some of them only a fraction of an inch larger than their scanning beds. Most dedicated film scanners are smaller yet, needing only a few square inches of space, plus some clear space in front of them to allow inserting the film holder. If your desktop space is severely limited, you might want to consider scanner size as one of the (minor) points on your shopping list.

## Choosing a Scanner Category

Armed with the information from the checklist, you're ready to choose your scanner. The next step is to decide which category of scanner you want to buy. I outlined the various *types* of scanners (function-wise) in Chapter 1, ranging from high-end drum scanners that perform amazingly well with film (but, of course, cost an arm and a leg), to all-in-one scanner/fax/printers that do just about everything, except scan film.

In most cases, price is a good indicator of the kind of category a scanner falls into. Most of the scanners at a particular price point are fairly similar in features, quality, and capability. But, as you've seen, you shouldn't go by price alone. All the other factors should be taken into account when selecting your scanner category. The following sections outline the major categories you'll be considering.

## Point-and-Shoot Scanners

Yes, the scanner world has the equivalent of the photographic "point-and-shoot" camera model. These are basic flatbed scanner models selling for $50 to $100, or even less with

rebates. They're usually tiny, almost toy-like, and based around CIS components that do an acceptable job of grabbing images from photographs and other documents. Although they may be hyped with 2400 spi resolution or better and claim 48-bit color depth, as you learned in Chapter 3, these specs are likely to be more hype than real. Low-end scanners come with a minimum of software, but are highly automated, virtually a point-and-shoot operation, which is useful for the neophytes who are likely to be first-time scanner users.

In this category, you'll find a large number of scanners from vendors you might never have heard of, as well as "house" brand scanners offered by retailers who put their own label on a generic scanner from some unknown vendor. In truth, most of these low-end scanners are made by a few electronics companies in the Far East and marketed here under the names of a variety of importers. You might have trouble getting your scanner repaired, because the importer might have gone out of business or changed its name. But at these prices, scanners are virtually disposable anyway, so repair is probably not a huge concern.

You might be able to scan transparencies with one of these using a do-it-yourself lighting arrangement like the one described in Chapter 8, but the quality is likely to be so bad that it's not worth the effort. Anyone who wants to scan film should avoid this category of scanner. If you do mostly film scanning and seldom need to scan reflection artwork, a scanner point-and-shoot model *might* be acceptable as a very low-cost accessory.

## Intermediate Scanners

In the $100 to $300 (and up) price range, you'll find intermediate scanners, which includes both better flatbed scanners and the lowest priced true film scanners. These models are aimed at the average consumer and more serious workers who are on a strict budget. The least expensive in this category are flatbeds that scan reflective art only; at the upper end of the price range, you'll find flatbeds that can scan transparencies as well as the simplest dedicated film scanners.

The good news is that many of these scanners come from well-known companies, such as Epson, Canon, Hewlett-Packard, Microtek, Minolta, and others. The claimed specifications for resolution and dynamic range will be as close to truthful as you can expect, and technical support and repair is usually not a problem.

Dedicated film scanners in this category are likely to accept 35mm film only. Flatbeds may scan 35mm to 2 1/4-inch wide film, plus reflective art up to 8.5×12 inches. You probably won't find advanced features like Digital ICE (discussed later in this chapter) at this price level.

The intermediate category includes some well-made CIS-based scanners as well as scanners that use CCD sensors. You'll find that the quality of images captured by scanners from major vendors are comparable, regardless of the type of sensor. However, it's still a good idea to check whether your retailer will let you make some test scans of your own originals to see whether the scanner does the job you expect.

Intermediate scanners are a good choice for those who want high-quality scans of photos and transparencies from their flatbed models, but don't need the absolute best performance and

quality. A flatbed in this category also makes a good accessory and backup for a dedicated film scanner. Purchasing one of these in addition to a film scanner gives you the capability of making scans of reflective art, plus an emergency scanner for your film.

## Advanced Models

Serious graphics workers, professional photographers, and others are the key buyers of flatbed and film scanners priced at $400 to $2000 and more. In this category, you'll find flatbed scanners that do a decent job with film in sizes ranging from 35mm to as large as 4×5 to 5×7 inches. Dedicated film scanners in this group boast 4000 spi resolution, or better, and might accept film up to 2 1/4 inches wide (or more, at the high end).

When you pay this much for a scanner for film, you can expect to get excellent image quality, automated features (such as the ability to scan batches of slides and film frames), and sophisticated correction tools such as Digital ICE. Look for precision autofocus (with user-selectable focus areas), infrared channels to help clean away dust, and a broad range of accessories for specialized scanning needs. The bundled software will be more sophisticated, too. If you're lucky, you'll receive a fully featured scanning software suite like SilverFast Ai.

Advanced models offer the best resolving power and sophisticated optics. Some models might include dual optical systems optimized for both general purpose scanning and high-resolution scanning. Expect the best 16-bit digital-to-analog converters, with low noise, and an extended (not just theoretical) dynamic range.

## Professional Models

For $4000 and up (way up) you can get a professional scanner capable of the very best film or film/photo scanning. If you need one of these and can afford it, you won't be reading this book trying to make a purchasing decision. You'll have gone through all the specs, run tests, perhaps performed a cost/benefits analysis and, determined the return on your investment.

Enough said.

# Digital ICE Suite

Although a discussion of Digital ICE technology in the middle of a chapter on how to choose and buy a scanner might appear to be something of a literary non sequitur, there is reason behind my madness. If you browse the web, scan Usenet newsgroups, or read reviews of scanners, you've undoubtedly heard of Applied Science Fiction's Digital ICE technology. The only dispute I've seen over this suite of technologies is whether it's the greatest thing since sliced bread or, as many scanner owners feel, *much* greater than sliced bread. Digital ICE and Digital ICE[3] (ICE *cubed*. Ha!) are incorporated into many scanner products, both flatbeds and dedicated film scanners, providing unprecedented removal of fingerprints, dust, water spots, tape marks, scratches, and other surface imperfections, plus color correction and contrast management. Some of the technologies are also available as software plug-ins you can use with your own image editor if your scanner doesn't integrate them with its products.

So high is the interest in Digital ICE and other offerings from Applied Science Fiction that I decided that this chapter would not be complete without a discussion of what these products can do for you.

Acquired by Eastman Kodak Company in May, 2003, Applied Science Fiction develops proprietary technologies including the Digital ICE[3] film scanner suite, Digital ICE, Digital ROC, and Digital GEM (all contained in the suite), plus Digital ICE for Photo Prints, Digital ROC plug-in for color restoration, Digital SHO plug-in for revealing details of dark image areas, and Digital GEM plug-in for noise and grain reduction.

This section explains these technologies, and why you need them for your scanner. The key technologies are as follows:

- *Digital Ice.* Removes dust and scratches.

- *Digital GEM.* Minimizes grain.

- *Digital ROC.* Optimizes color.

## Digital ICE

Most scratch- and defect-reduction processes operate by adding a slight amount of blurring to your image, either during the scan itself or afterwards, in your image editor. Blurring removes some of the sharpness, of course, while reducing the contrast of your image. These are all bad things. Sophisticated software scratch- and dust-reduction routines can intelligently look for what appear to be dust and scratches and apply the blurring only to those artifacts. Results can be acceptable, but are never as good as you'd like.

Digital ICE uses technology incorporated into the scanner itself, making it possible to separate the dust and scratches from the rest of the image content, creating a fourth, "defect" channel (D) in addition to the red, green, and blue channels normally collected. Figure 4.1 shows a cross section of film as it might look with numerous dust specks, fibers, and scratches marring the top and bottom surfaces.

**Figure 4.1** *Defects can appear on both the emulsion side of the film (top) and base side (bottom).*

# WHERE'S THE PROBLEM?

Damage to film can occur on the base side (the shiny side) or the emulsion side (the dull side). Dust and fibers can settle on both surfaces, and scratches can be gouged into the emulsion (the worst possible case, because image area is removed) or the film base side (still bad, but less so). Here's how to tell where your damage came from, so you can take steps, if necessary, to prevent it in the future.

- Long, straight, parallel scratches were probably caused as the film ran through your camera or through the lab's processing equipment. You can't check the processing gear, but you can examine your camera to look for a nick in the film path.

- A long parallel scratch on the shiny side of the film was probably caused by dust or a nick on the pressure plate that holds your film in place. It possibly could have been caused by a piece of sand stuck in the lip of your film cassette. Such scratches can show up in your prints as dark lines.

- A long parallel scratch on the dull (emulsion) side of the film might have been caused by dust or a nick in the film gate (the opening that "frames" your picture during exposure). It can also be caused by sand stuck in the lip of your film cassette. Such scratches often show up in your prints as colored lines, because they don't affect all the color layers of the film exactly the same.

- If you get the same pattern of scratches in several rolls over a period of time, the problem is probably with your camera. Sometimes nicks can be fixed with a drop of black glossy paint.

- Irregularly-shaped scratches, half-moon-shaped image defects, or visible bits of dirt embedded in your film were probably caused by mistreatment at the photofinisher.

---

Digital ICE is added to a scanner by including some extra hardware that gleans information about surface defects. Then, proprietary algorithms are applied to the image data, deleting the defect-channel information from the bits, leaving behind only the defect-free image in the normal RGB channels. No blurring effects have to be applied which degrade the image.

Of course, because the RGB information is used to make these calculations, that means that Digital ICE can't be used with conventional black-and-white film. It can be applied to black-and-white chromogenic films processed in color negative (Process C41) chemicals, as long as the image is scanned as a color image. Chromogenic films are available from Kodak, Ilford, Konica, and other vendors. Digital ICE also performs differently with Kodachrome films, because of the unique dyes used in their emulsions. In some kinds of images, detail can be misinterpreted as a defect. ASF uses underwater pictures as an example, but any Kodachrome film image in which the red channel information is weak compared to the blue and green channels can be affected.

Although you can find Digital ICE in many of the higher-end film scanners, it's also available in a special version for flatbeds, such as the top-of-the-line Microtek ScanMaker, and works with color prints, too.

Figures 4.2-4.6 dramatically illustrate how Digital ICE works. Figure 4.2 represents a transparency that has unfortunately acquired a few scratches on the base (non-emulsion) side of the film. Actual image area has not been etched away by the scratches, but the scratches that are visible render the photo totally unacceptable.

**Figure 4.2** *Scratches on the base side of the film make this image unusable.*

Conventional scanning techniques use intelligent blurring to minimize the effect of scratches and dust. I tried using those methods on the image, and then carefully retouched out the remaining scratched areas in the background. The result, shown in Figure 4.3, is terrible. The image is now blurry, and some scratches are still visible.

**Figure 4.3** *Conventional blurring techniques don't really improve images with serious scratches.*

Digital ICE analyzes the image and creates a separate defect channel, like the one shown in Figure 4.4, which includes only the scratches. Overlaid on the original RGB channels, as in Figure 4.5, makes it easy to see which portions of the image belong to the content, and which to the scratches. The final image, shown in Figure 4.6, includes only the content of the slide, and none of the defects.

**Figure 4.4** *A fourth, "defect" channel isolates the scratches.*

**Figure 4.5** *It's easy to differentiate the image area from the scratches.*

**Figure 4.6** *By subtracting the scratch area and retaining only the true image area, Digital ICE is able to re-create the damaged transparency.*

# Digital ROC

Digital ROC is another miracle-working technology that can be included with scanners incorporating the whole Digital ICE suite. It's also available as a plug-in for Photoshop-compatible image-editing applications, so you can add this capability to a scanner that doesn't support Digital ICE itself. Digital ROC restores the density, contrast, and color to faded color images. It can also be used to improve the tonal values of black-and-white images if you scan them in RGB mode.

Nothing is more heartbreaking than finding an old, precious image and discovering that not only are all the available prints faded, but the original negatives or slides have gained an objectionable color cast, too. Faded prints are no big deal if the original film is in good shape, but the dyes in films will fade just as assuredly as those in prints (albeit more slowly). The fading is not uniform, and affects individual color layers, shadows, highlights, and midtones in a different manner.

Digital ROC uses ASF's proprietary algorithms to analyze the color in each film layer and calculate an optimal tonal curve that removes color casts, nullifies tungsten or fluorescent lighting defects, and restores faded images to their original glory (or a reasonable facsimile).

This technology seems to work a lot better than the brute-force method of simply applying different color filters to an image until it "looks right." Although available separately from a scanner, Digital ROC works best when fine-tuned for the characteristics of a specific scanner. Applied at the scanning phase, the technology is fast and fully automated.

I didn't believe what this plug-in did to the image in Figure 4.7. It's the worst faded image I have on hand, and I've used it repeatedly in my books and presentations to illustrate just how bad image fading can get. You'll find it used as a bad example in Chapter 9 of this book, for example.

Then I applied Digital ROC to this hapless image. The plug-in's dialog box is shown in Figure 4.8. It does a good job of choosing its own settings, but you can fiddle with color controls if you like. Figure 4.9 shows the final version, using the automated settings. There's still some fading at the right side of the photo, but the difference is amazing. You can visit Applied Science Fiction at **www.asf.com** and download a tryout version of this plug-in to test. Until you pay for it, your images will have embedded watermarks like those I've deliberately left in the test image.

**Figure 4.7** *The archetype of a badly faded image.*

**Figure 4.8** *Digital ROC can fix the colors automatically.*

**Figure 4.9** *No user input was required to produce this improved (but still slightly faded) version.*

# Digital GEM

No grain, no pain!

Film grain is a fact of life in photography. If you need a bit more sensitivity and use a faster film (ISO ratings 400 and up), an inevitable result is an increase in the apparent graininess of the film. Underexpose your film slightly, and the grain increases. If your image is a tad out of focus and you apply some sharpening during scanning or from within your image editor, guess what happens? More grain. If you're using a medium format camera and decide to switch to a smaller format, such as 35mm, to gain some portability and flexibility, you'll end up with grainier pictures. Strictly speaking, even digital cameras aren't immune to this plague; what we think of as film grains show up in digital pictures as *noise*.

Although emphasized film grain has long been used as a creative tool to provide a minimalist look or to mask detail behind a grainy texture, most of the time it's intrusive and undesirable. Digital GEM, available with scanners or as a Photoshop plug-in, can minimize the effects of grainy film emulsion on your images.

This product works using the same paradigm as Digital ICE. Digital GEM operates something like the sculptor who started with a block of marble and removed everything that didn't look like the statue he had in mind. It analyzes the film and its layers, dividing the data into image information and a grain pattern. Then, it minimizes the grain pattern without affecting the image data. You end up with a sharp, clear image free of those nasty clumps of grain. If you don't want to remove all the grain, Digital GEM allows you to specify how much to leave behind in the image. In some cases, a little grain will produce a more natural appearance. It can be used with both conventional and chromogenic black-and-white films.

Figure 4.10 shows the Digital GEM dialog box. You can control highlight and shadow noise, and clarity, while getting comparison looks at both before and after versions.

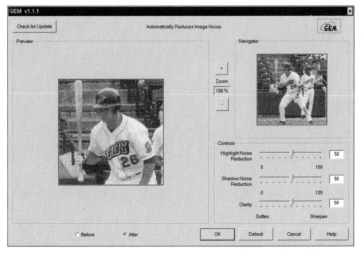

**Figure 4.10** *Eliminate grain using this software digital gem.*

# Digital SHO

Exposure problems cause problems when it's time to scan your film. Digital SHO is another plug-in from Applied Science Fiction that miraculously reveals details hidden in shadows caused by backlighting, shade, or badly used electronic flash. It works on the darker image areas of your photograph to optimize both the exposure and contrast. As a Photoshop plug-in, it works with any image, whether scanned from film, print, or created with a digital camera. The following three figures show the plug-in at work. Figure 4.11 shows a backlit gargoyle that's too dark to even begin the other retouching techniques needed. In Figure 4.12, Digital SHO offers some changes to the shadow brightness and color intensity. The finished version in Figure 4.13 is lightened up and ready for some retouching of the dust spots that remain from the original scan.

**Figure 4.11** *Backlighting is great, but not in this case.*

**Figure 4.12** *Digital SHO lets you lighten up the shadows.*

**Figure 4.13** *Now you can see the gargoyle image has a lot of dust spots that need to be removed!*

# Buying Your Scanner

It's the moment of truth. You fully understand how scanners work and what different types are available for capturing images from film. You know everything about various price points and categories, and have a good understanding of what features to look for. Now, how do you actually purchase your scanner?

One good place to start is with a test drive of the scanner (or scanners) you're considering. You can't base the entire decision on specifications (yes, 4000 spi is good!) or brand name (Nikon and Minolta are great!) or reviews you read in magazines and on the Internet. If you really want to know that a particular scanner is ideal for you, it's a good idea to actually try it out with some pictures of your own. Here are some ways you can do this:

- Find a friend who has the scanner you're considering, and see if the friend will let you come over and try it out.

- Check with business associates and find one with the scanner of your dreams in their workplace. Your colleague needn't actually use the scanner himself/herself. It's good enough to have one on premises, with your friend to vouch for you to get some time on the scanner after hours or during lunch. Don't forget to reciprocate the favor; networking means more than LANs and WANs and WiFi these days.

- See whether a local school or vocational college has a computer lab with the scanner you lust after, and finagle your way to a test session.

- Check out your local copy shop. Places like Kinko's, particularly offices in college towns, rent out computer time, and the larger locations might have a film scanner or two you can experiment with, for a reasonable fee.

- Drop by your local photo retailer and ask for a demonstration. Keep in mind that if your photo store spends time helping you make your scanner decision, the decent thing is to buy your scanner there, too.

## Where to Buy?

Once you've made your final decision on a scanner, the next step is to determine where to purchase the beast. Buying locally is always a good choice, particularly if the retailer is knowledgeable about photography and/or scanners. If you need hand-holding or have problems, you'll know where to turn. Having access to a local expert is certainly worth a few dollars extra that you might pay. However, even if you buy from a local "big box" retailer like Best Buy or Circuit City, you'll at least have a nearby source for warranty help. If the scanner has to be packed up and returned to the vendor, your retailer can handle that for you. Or, they might be able to give you a new/exchange scanner immediately.

Mail order and Internet buying has been popular, too, and offers some of the best bargains. A quick search with Google will yield dozens of sources for buying scanners by phone or online. One source I highly recommend is Publishing Perfection (800-810-1617) at **www.pubperfect.com**. Their prices are good, but one of the key reasons I like this company is that they have *everything*, and they often have it before anyone else. Indeed, more than once

my first clue about the existence of a new scanner or digital camera came when the Publishing Perfection catalog showed up in my mailbox with the goodie's debut on the cover.

And by having everything, I mean *everything*. For example, in addition to a full line of new film and flatbed scanners from Microtek, Pacific Image Electronics, Minolta, Nikon, Epson, and others, the company has discontinued models and factory reconditioned models at significant savings. Publishing Perfection recently offered an older model Minolta film scanner for 35mm to medium format sizes for $299, a drastic price cut from that scanner's original $1999 price tag. This bargain came with a six month warranty, too. I can't list the kinds of scanner close-outs you can find at the company's website because the models change too quickly. If you're looking for hard-to-find scanners, unusual software, and virtually every other product associated with digital imaging, check the company out.

## Buying on eBay

You can also buy a scanner from eBay and probably save a few bucks if you like the thrill of auctions and don't mind a small amount of risk. I've purchased hundreds of items from eBay myself, and, as a seller, have had more than 4000 transactions, virtually all of them good experiences. Here are some tips for buying a scanner from eBay from an auction like the one shown in Figure 4.14:

■ *Confine your shopping to reputable vendors.* These folks will generally have a decent feedback rating (a number that appears next to their name in the auction) with lots of positives and no (or only a few) negatives. Beware of sellers who have no feedbacks, or who have accumulated their feedbacks only as buyers. These numbers are available from the seller's feedback "report card" which you can view by clicking on their feedback rating number.

■ *Look for Buy It Now bargains.* With Buy It Now, you can purchase the item immediately without needing to bid against other eBayers. If the price is right and Buy It Now is offered for that item, click and you're ready to pay for your item. (You must sign up for eBay first if you're not already a member; it takes only a minute or two.)

■ *Price shop to make sure the item you're buying is priced competitively with what you'd pay at other retailers.* I've seen eBayers bid items up higher than list price because they don't know the true value of what they're buying.

■ *Sellers often price items with a very low opening bid (say, $1 for a $500 scanner) knowing that this low price will attract lots of shoppers and will lead to sufficient bids to bring the item up to an expected price.* You as a buyer should realize that a scanner currently bid up to $20 but worth much more is likely to reach a higher price by the end of the auction. Don't expect to steal anything, but don't be surprised if you do get a bargain.

■ *Don't show your hand too early.* It's tempting to place a bid on that $20 scanner right now, but with five days to go in the auction, your minimum bid probably won't remain as high bid for very long. Instead, wait until the last hour of the auction and see what the current price is. If it's still in your ballpark, hang around. Experienced bidders use a technique called *sniping.* That's nothing more than placing your maximum bid just before the auction

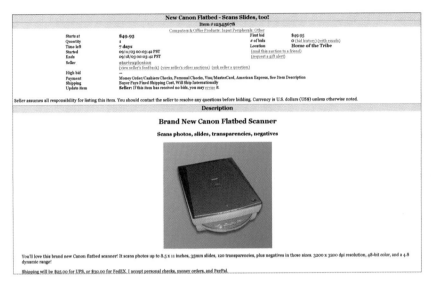

**New Canon Flatbed - Scans Slides, too!**
Item #12345678
Computers & Office Products: Input Peripherals: Other

| | | | |
|---|---|---|---|
| Starts at | $49.95 | First bid | $49.95 |
| Quantity | 1 | # of bids | 0 (bid history) (with emails) |
| Time left | 7 days | Location | Home of the Tribe |
| Started | 09/11/03 00:03:42 PST | (mail this auction to a friend) | |
| Ends | 09/18/03 00:03:42 PST | (request a gift alert) | |
| Seller | atariexplosion | | |
| | (view seller's feedback) (view seller's other auctions) (ask seller a question) | | |
| High bid | -- | | |
| Payment | Money Order/Cashiers Checks, Personal Checks, Visa/MasterCard, American Express, See Item Description | | |
| Shipping | Buyer Pays Fixed Shipping Cost, Will Ship Internationally | | |
| Update item | **Seller:** If this item has received no bids, you may revise it. | | |

Seller assumes all responsibility for listing this item. You should contact the seller to resolve any questions before bidding. Currency is U.S. dollars (US$) unless otherwise noted.

**Description**

**Brand New Canon Flatbed Scanner**

**Scans photos, slides, transparencies, negatives**

You'll love this brand new Canon flatbed scanner! It scans photos up to 8.5 x 11 inches, 35mm slides, 120 transparencies, plus negatives in those sizes. 3200 x 3200 dpi resolution, 48-bit color, and a 4.8 dynamic range!

Shipping will be $25.00 for UPS, or $30.00 for FedEX. I accept personal checks, money orders, and PayPal.

**Figure 4.14** *Online auctions are a good place to look for scanner bargains.*

ends, sometimes in the last minute or so. If your maximum is the highest bid, you'll win, possibly at the expense of inexperienced bidders who didn't bid their maximum and didn't have time to enter the price they were really willing to pay so late in the game. Remember, eBay's automatic bidding system will only use as much of your maximum bid as necessary to win the auction. So, if the current high bid is $200 and you bid $300, your bid will be entered as $202.50 and that's the price you'll pay (unless someone else comes along at the last minute and bids more than $202.50; however, you'll *never* have to pay more than your $300 maximum).

- *Make sure you know exactly what you're bidding on.* Is the scanner new and boxed? Is it used? A factory reconditioned model? How much is shipping and handling? (A $200 scanner might be no bargain if you have to pay $75 for shipping.) If you have questions, the time to ask is *before* you bid. eBay has a provision for asking sellers questions about their wares; use it.

- *Use your credit card to pay, either directly to the seller or through a service like PayPal (www.paypal.com).* If the transaction goes awry, your credit card company might be able to retrieve your money for you.

# Setting Up Your Scanner

The great day is here! Your scanner is safely in your possession and you're more excited than Steve Martin over the new phone book in *The Jerk*. Now what? After you've unpacked your scanner, thoroughly read the manufacturer's setup instructions, and checked to see that you have all the cables, cords, and software required for installation, you're ready to go. This section can help you do it right.

# Where To?

Your first question should be, "Where do I put my scanner?" Scanners used to be big, heavy devices that took up a great deal of desktop real estate. Today they are much smaller, and fit just about anywhere. Here are some considerations to keep in mind:

- *Out of sight?* Out of your mind! Place your scanner somewhere close by. I've seen users who put their scanners a step or two away, which is not a good idea if you do much scanning. Find a location that will let you feed film to your scanner while remaining at your working position. That will save time when you need to load more film into your scanner, clear a jam, or reposition a piece of artwork. If necessary, move something else out of the way. I'd rather move my computer system unit to the floor and have to reach down to insert a CD-ROM than stretch to feed my scanner.

- *Avoid bad vibes.* Small scanners can be affected by vibration, especially during long high-resolution scans. I try to avoid even walking around in my office while a scan is underway. Certainly don't place your scanner on top of your computer or near a printer. A computer's fan and CD-ROM drive vibrate. So does the ink carriage on an inkjet printer. Urban types might live above a subway. I once visited a computer room in an industrial environment that was unfortunately located immediately above a drop forge! You might not be able to afford the floating floor that was installed in that room, but you can use a piece of foam rubber or other vibration insulator to keep your scanner from getting the shakes.

- *Watch the environment.* Minor variations in cold, heat, or moisture probably won't damage your scanner, but environmental fluctuations never do film any good. And dust is one part of the environment film can always do without. Don't place your scanner near your room's heat source or directly in front of an air conditioner or humidifier, and keep dust down a mite, if at all possible.

- *More power!* Plug your scanner into a quality surge protector. An uninterruptible power source (UPS) isn't necessary, because during a blackout being able to continue a scan (even a long one) will be the least of your problems. Power surges can damage a scanner, so use a surge protector. Remember that these protectors are good only for a certain number of surges before they lose the ability to protect your equipment. Repeated small power spikes can eventually wear out the component, so don't count on a three-year old power conditioning device as protection for your $2000 film scanner. When thunderstorms threaten, consider unplugging every device you don't want to use unintentionally as a fuse.

# Installation

It's important to read the vendor's instructions, even if you're using a plug-and-play operating system and you've installed dozens of peripherals before. For example, some scanners require the software to be installed *before* the scanner is connected and powered up. If you plug in the scanner too soon, your operating system might recognize the scanner and try to install driver software that the vendor prefers to install first. With other scanners, it's okay to plug it in now and install the software later.

Once you've reviewed the manufacturer's installation recommendations, review my own set of tips before you get started.

- *Double-check to see whether your linkup complies with the vendor's recommendations.* For example, if you have many USB peripherals, you might have installed a USB hub to give you more than the two or so USB ports found on most computers. Some scanners don't work well with hubs and require that you plug the scanner directly into a USB port on your computer. USB hubs might have a separate power supply, or they might be powered by the computer. The power configuration of the hub can affect how compatible it is with your scanner.

- *Do you have USB Version 1.1 or the newer Version 2.0?* A scanner designed for USB 2.0 will probably work fine if plugged into a USB 1.1 port, but will undoubtedly run more slowly. Now might be the time to purchase a USB 2.0 upgrade card and plug it in.

- *Locate the right cables, in the right length.* One of my scanners is located behind me (within easy reach), but to run the cables around the back of my desk and over to the scanner calls for a 15 foot USB cable. I had to purchase a special cable to accommodate this configuration.

- *If your scanner accommodates both USB and FireWire, use FireWire if you can.* There are several reasons for this. FireWire is theoretically faster (particularly if your computer is stuck in the USB 1.1 time warp) and peripherals that use FireWire are still less common. So, using FireWire when you can gives you better performance and leaves your USB ports free for the zillion peripherals such as printers, mice, memory card readers, and digital camera links. I keep adding USB hubs to my computer every couple of months, but I still have a free FireWire port.

- *If you're using Linux, you'll probably find that connecting a scanner can be more than a little problematic.* Linux support for USB has been spotty, so you'll probably have to stick with scanners that use a SCSI interface. Few scanners ship with drivers for Linux. There are some third-party drivers, such as the software known as SANE. If you're not an experienced Linux user, your best bet is to locate a compassionate colleague who already has a scanner working under the operating system, and rely on their help. Even then, you might have problems getting a film scanner to work. Be patient.

- *If all else fails during installation, reboot.* Many installation problems I've seen are resolved nicely when the computer is rebooted and given the opportunity to re-recognize the scanner it failed to locate the first time around.

- *Make a copy of your installation software disk, and keep it in a safe place.* CD burners were *made* for this sort of protection. Use it.

- *Once you've installed your software, visit your scanner vendor's web page and look for updates.* Even if your scanner is new and right off the shelf, it might have been a month or three since it left the factory, and newer drivers may be available.

# Next Up

You're ready to go. In the next two chapters, I'll be offering some advice as to how to get the most from your dedicated film scanner or flatbed scanner, with a detailed discussion of some of the software controls you'll be using to optimize your images.

# 5

# Scanning with Film-Only Scanners

If you're new to scanning, or have used only flatbed scanners in the past, your first scans with a dedicated film scanner are sure to be a revelation. Film scanners are specialized beasts, optimized to do one thing very well: scan images from transparent originals such as slides or negatives. As such, they require special procedures and, perhaps, a little more attention than their flatbed brethren. That's because film scanners must operate precisely and consistently to produce the best results with the more demanding film originals.

Flatbed scanners are designed to handle either reflective artwork only, or both reflective originals and film, so their operation takes into account the compromises needed to work with such a broad range of originals. You might be able to slap a photo on a flatbed scanner, and not be overly concerned about how clean the glass is or whether the photo is oriented precisely. Any dust or artifacts are likely to be so small that they either won't be obvious in the scan or can be easily retouched out. It's a simple matter to rotate a scanned photo in your image editor to square up its edges, too. Film scanning allows no such sloppiness. The film must be cleaned scrupulously, positioned precisely, the scanner focused, and a scan made at the optimal settings for the intended use. Because your original can be as small as 24×36mm (or smaller if you scan APS format), even slight errors can have a major impact on your finished scan.

This chapter runs you through the basics of scanning with a dedicated film scanner. I'll cover the settings you need to make to correct color, improve tonal rendition, and optimize your image. However, because this fine-tuning can also be done within an image editor, I'm going to relegate the in-depth discussions of using histograms and other controls to Chapters 9, "Introduction to Image Enhancement," and 10, "Fine-Tuning Your Scans." You'll learn why you need these controls in this chapter; to master them, you'll want to study Chapters 9 and 10.

> ## FLATBED OWNERS: THIS CHAPTER'S FOR YOU, TOO!
>
> If you scan your film with a flatbed scanner, you should read this chapter anyway, because I'll be covering some basics of film scanning that apply to your kind of scanner, as well. Indeed, the initial sections, dealing with software, apply equally to film scanners and flatbeds. Likewise, those who work primarily with dedicated film scanners should also read Chapter 6, because, in addition to covering the differences between the two types of scanning, I explore some additional features that apply equally to film-only capture devices.

# Choosing Bundled Scanning Software

If you're new to scanning, you might be surprised at just how many choices you have in scanning software. You can choose from your scanner vendor's standalone scanning application or a module that can be accessed from within your image editor. The vendor might also supply a "quick scan" utility that does little, but does it fast, or (in the case of many flatbed scanners) lets you grab an image by pressing one of a selection of "one touch" buttons on the scanner itself.

Third parties also provide scanner software that works with popular hardware. These applications often make up for a lack of fine-tuning features found in the vendor's own software. If you're unhappy with the scanning software that comes with your device, or are looking for extra features, an application like SilverFast Ai or VueScan will probably do a better job for you. This section outlines your options for choosing bundled software furnished with your scanner, and should help you choose one or more scanning software alternatives that will give you the best results. In the section that follows this one, I describe your options among third-party scanning applications.

## TWAIN or Standalone?

When I began using scanners in the late 1980s, there were no choices for scanning software. You used the scanning application that was furnished with your scanner. Nothing else would work. Sometimes this application was a standalone program that did nothing but scanning. In other cases, the scanning software had some primitive image-editing capabilities. (In those days, even fully-featured image-editing applications with names like Digital Darkroom, PixelPaint, and Picture Publisher weren't all that fully-featured.) Some vendors provided a third-party image editor that had been modified specifically to work with your scanner. Standalone scanning was virtually your only choice.

That's because communicating with a scanner is a complex task, and every scanner uses its own set of commands to control its functions. Vendors weren't willing to lock themselves into a standard set of commands and functions, because doing so might limit them to a set that lacked needed features or, worse, that couldn't grow as new features were developed. So, it was necessary to "hard-wire" all those commands into a single program that was used to do the

actual scanning. The alternative, writing individual interfaces for each scanner and each software application that might want to use the scanner, wasn't practical.

Instead, a consortium of companies convened to develop a standard protocol and application programming interface (API) that would serve as an intermediary between the hardware device (scanner) and the software (any program, including image-editing applications, fax programs, optical character recognition applications, or desktop publishing programs).

The use of protocols and APIs is not unique to scanners, of course. A universal printer driver that includes an API sits between your operating system and your printer, and provides mediation between your word processing program or image editor and the printer when it comes time to make a hardcopy of a document or image. Your printer might still have a driver of its own, but it can be simplified to deal only with the printer's special features. APIs also exist between software applications. For example, anyone who wants to write software that creates eBay auctions can get a license to the eBay API and use its routines to interface with the auction's website.

In 1990, the TWAIN Working Group was formed. (TWAIN either stands for nothing, or Technology Without An Interesting Name, depending on who you believe.) The consortium included Aldus (vendor of PageMaker, later acquired by Adobe), Caere (now better-known as ScanSoft, maker of the optical character recognition program OmniPage), and Kodak, as well as scanner manufacturers Hewlett-Packard and Logitech.

A combination of existing protocols and specifications formed the foundation for TWAIN, which had the following goals:

- *Multiple platform support.* TWAIN works with many operating systems, including all the varieties of Windows and Mac OS.

- *Compatibility with multiple devices.* TWAIN was designed to support slide scanners, flatbeds, digital cameras, image-grabbing peripherals, and other kinds of bitmap capture devices.

- *Widespread acceptance.* TWAIN has been successful because it has been widely adopted and used by a large number of vendors. And vice versa.

- *Extensibility.* TWAIN was written to work smoothly with new features that weren't even imagined when the specification was drawn up, such as hardware/software oriented dust and artifact removal capabilities found in slide scanners.

- *Ease of use.* TWAIN had to be easy to use for both the operator of the scanner or other device, and easy for the programmer to write code for.

- *Multiple format support.* Locking users into one particular image format was not acceptable. TWAIN was designed to transmit the standard data formats available when it was developed, including PICT (a Macintosh format, but supported by many Windows applications) and TIFF (the standard Windows format, also supported on the Mac), as well as a format called DIB (device independent bitmap). Best of all, TWAIN also can work with other kinds of formats, including those that haven't been designed yet.

Now that TWAIN is firmly entrenched, it's virtually guaranteed that the software you use will work with it. And the term "standalone," applied to scanning applications, doesn't have quite the same meaning as it did in the Stone Age of scanning. Each option has its own advantages.

For TWAIN, the advantages are as follows:

- You can scan from within the software application of your choice. That can be an image editor such as Photoshop or Paintshop Pro, an album application such as PhotoImpact Album, a fax program, or an optical character recognition application. (Some programs use an alternative to TWAIN, such as ISIS, for document scanning.) There's no need to load a separate program. If you're working on a project and decide you need to scan an image, just activate the TWAIN capture module and go.

- You install only once. Your scanner's TWAIN driver is installed once, usually when you set up the scanner. Thereafter, you never need to re-install the driver just because you add a new program that can work with it. Many applications recognize installed TWAIN drivers automatically and list them as a choice under the Import or File menus. Others include a Select Source menu item that you must use to explicitly select one TWAIN driver as the default.

- Smooth integration. When you're using a TWAIN driver, the captured image will be imported directly into your image editor. A separate program might need to save the image to a file, or place it on the Clipboard where it can be pasted into a document in your image editor.

Today, a standalone scanning application is one that can be run externally to an image editor or another program. With some scanners, the standalone version and TWAIN driver have identical interfaces; the main difference is that the separate scanning application doesn't require a "host" application to run. In other cases, the standalone application is entirely different. The advantages of using a separate scanning program are as follows:

- *Speed.* If you don't happen to be using an image editor and don't plan to edit your scanned images immediately, a standalone application can be extremely fast. Just fire it up and make your scans. They'll generally be copied to files in a folder you select. When you're finished with a batch, you can view and edit your final scans at any time within your image editor.

- *Compatibility.* Standalone programs can be used regardless of the application that's the destination for your finished scan. Certainly, most applications support TWAIN, but a surprising number do not. You might own a desktop publishing program that can't import files directly from a scanner. Or, you might want to include images in a favorite album program that can't be used with a TWAIN driver to make scans. It's likely that many of your most-used applications that support embedding images don't have scanning capabilities. For example, many people use Microsoft Word as a simple desktop publishing program. The most common versions of this application can use only photos that have been scanned by another application. A standalone scanning program makes a perfect complement to any scanner-challenged application.

■ *Power*. If the TWAIN-compatible scanning application furnished with your scanner doesn't have advanced features, you might find that a more sophisticated standalone program like Hamrick Software's VueScan can help. You might need to use an external program simply to get the features you need.

## Easy or Advanced?

Some scanners are furnished with several scanning applications, an "easy" version that is highly automated and takes care of most of the decisions for you, as well as an "advanced" version that places many different settings at your fingertips. The simple version might run as a standalone application, or you might discover several scanning sources available from within your image-editing application.

For example, the default software installation for Epson flatbed scanners capable of capturing film images places both a TWAIN driver and a limited version of a more advanced program, called SilverFast Epson SE, into the menus of your image editor. Epson users can also choose the Epson Smart Panel, shown in Figure 5.1, either from their OS, or by evoking the application through a press of a "one touch" button on the scanner itself. Epson, like many other scanner vendors, also provides "scan to web," "scan to print," and "photocopier" applications. Only the SilverFast option can truly be called an advanced scanning application, at least, in terms of power and functions.

The differences between the simple and advanced programs/modes can be subtle. Indeed, with some scanner software, the easy and advanced versions are folded into a single application; you choose which mode you want to use from a menu.

**Figure 5.1** *Epson's Smart Panel is a basic application for controlling scanning operations.*

In other cases, the simple version hides most of the user-configurable controls (even choosing such things as resolution for you automatically) but makes them available if you make a change in your preferences. Or, the advanced version can be used in automated mode, with the user selecting only the parameters that need to be changed.

Which mode or application version do you need? If you're wading through the pages of this book you might automatically assume that the advanced mode is always the way to go, but that's not necessarily true. Here are some guidelines to help you choose:

■ If you've just purchased a scanner, you might want to use the easy, automated mode for a while to become familiar with the features of the scanner and its software. When you're not sure exactly what various settings do, or how to operate them, it's good to be able to sit back and watch the software do the work on autopilot.

- If you're scanning a large number of similar originals, the default settings might do a good job with all of them. Say you've taken portraits of 200 elementary school students under the identical lighting setup. If you did your job of arranging the lighting properly, and have exposed the film correctly, your scanner's automated mode can do an excellent job. Alternatively, your software may have the capability of saving scanning settings, in which case you can set up the job once, store the settings, and scan all 200 negatives under automated mode.

- Should you need to apply individual settings to each original scanned, it's a no-brainer: You need the advanced mode.

- You might find that some of the features you need, such as gang scanning or advanced color correction tools, are available only under the advanced mode.

# EASY TO USE OR EASY TO LEARN?

There's often some confusion over the terms *easy to learn* and *easy to use*. The implication is that a sophisticated application that requires an investment in time to learn cannot be easy to use. That's simply not true. Conversely, a simple application that takes no time at all to master can be difficult to use, in terms of the time you must spend to carry out a simple task.

The best analogy I can come up with is the DOS prompt (or UNIX prompt if you're using Mac OS X) compared to a graphical user interface (GUI) like Windows or Mac OS. A command-line interface like the DOS prompt is *very* difficult to learn. There are dozens of commands, with arcane options and switches. To copy a file, you must master command lines like XCOPY C:\*.* D:\myfolder /S. A GUI, in contrast, is relatively easy to learn. Once you've learned how to double-click on files and drag and drop items between folders, you can do just about anything. DOS is hard to learn, and a GUI is easy to learn.

But don't confuse the learning curve with ease of use. Once you've mastered either system, you'll find that the hard to learn mode is *much easier to use*. But that's true *only* if you've taken the time to learn the system.

For example, if I want to copy all the JPEG files in a folder and its subfolders that have been modified to another folder, Windows doesn't provide an easy way to do it. You can't open an Explorer window, readily identify the files you want, and drag them to the destination folder. This happens to be a function I carry out several times a day to back up images I edited, and Windows forces me to use a separate program to do it.

From the DOS command line, I can type **XCOPY C:\Images *.jpg /m /s D:\ImageBackup** and the job is done automatically. I can modify this task on an ad-hoc basis by typing a slightly different command line, or I can create a file of commands called a batch file to perform this task for me.

Easy-to-learn functions and applications can't account for variations in your needs, so many tasks actually take a great deal more time to perform with an "easy" interface. Keep this dichotomy in mind when selecting a scanner application, particularly when choosing a sophisticated program that might be tricky to learn but that will save you a great deal of time in the long run.

# Choosing Third-Party Scanning Software

You're not limited to the software provided with your scanner, of course. Although there were quite a few third-party scanning applications in the past, today your choices have narrowed to a pair of outstanding packages—LaserSoft Imaging's SilverFast Ai and Hamrick Software's VueScan. SilverFast is expensive (around $400), supports just about every scanner feature imaginable (including quite a few that might not even be available in your scanner), and has a rich graphical user interface that's still easy to use. Its chief drawback is that each version is customized for a specific scanner; you must purchase a separate copy for each scanner you operate. For most people who have only one film scanner, that's not much of a problem.

VueScan is extremely inexpensive (less than $100) but natively supports all the popular scanners. Buy it once, and you're equipped to scan with just about any scanner you care to use. VueScan's user interface is more sparse (although you have the option to display more or fewer choices), and its dedicated fans will say that this is all for the good. All the commands and options you need are on a series of tabs, buttons, and drop-down lists. Once you've learned to use the program, scanning becomes as intuitive as writing with a pencil. VueScan is the epitome of the "ease of use" mode I lauded in the previous sidebar. Like the DOS prompt, the application can be daunting to the beginner, but after you've mastered it, nothing gets in the way of fast, efficient, high-quality scanning. Because it can be used with so many scanners, VueScan is arguably the most popular scanning software on Earth.

Both SilverFast and VueScan work fine with both Windows and Mac OS. VueScan, shown in Figure 5.2, also runs under Linux. You'll find more discussion of SilverFast and VueScan in Chapter 9.

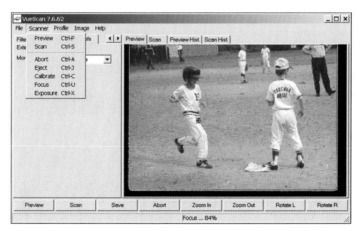

**Figure 5.2** *VueScan's Spartan interface doesn't interfere with rapid, precise scanning operations.*

# Prescanning Festivities

Before you can actually begin scanning, you'll need to prepare your film, load it into a film holder, launch your scanner software, and insert the film holder into the scanner. These steps take longer to describe than perform, but you'll want to review the tips in this section carefully before you take the leap.

## Preparing the Film

The first step in scanning film is to prepare the film. As I've noted a million times already, even the tiniest dust spots or scratches on a piece of film will be enlarged dozens of times by the time you view your scan or make a print. Even if your scanner is equipped with outstanding dust removal features, the best anti-dust measure is not to allow it to collect on your film in the first place. Here are some tips for minimizing dust and scratches on your film:

■ Work in a clean, virtually dust-free environment. Your computer workstation needn't reside in a clean room, but anything you can do to minimize the amount of dust flying around will be a tremendous help. Keep your area dusted, using an anti-static cleaner. Pay special attention to notorious dust-collectors like CRT monitor screens or desktop fans. Clean your air conditioner or air vent filters and ducts. Consider the use of one of those ionizing air cleaners that suck up particles and impurities.

■ Keep your film in the glassine or plastic sleeves they were placed in by the processing lab. Mounted slides should be kept in slide pages or boxes and stored in a cool, dry place not subject to environmental extremes or influxes of dust. Advanced Photo System (APS) film is returned to you in the same protective cartridge you used in your camera. See Figure 5.3 for some recommended storage options.

**Figure 5.3** *Keep your original film in safe storage to preserve your priceless image information.*

- Be careful when removing strips of film from sleeves, or when handling slides. A damaged sleeve might have a rough edge or an embedded piece of dirt that can scratch your film as it is withdrawn. When working with slides, you should never touch the film itself or allow anything else to touch it.

- Slides contained in glass slide mounts (thin glass covers both sides of the film) are protected from dust and scratches, but glass mounts are not a panacea. The glass itself can become grimy or pick up fingerprints. Moisture trapped inside the glass can blossom into mold. Under some conditions, an air gap between the slide and glass can contribute to circular rainbow-colored interference patterns called *Newton's Rings*. Many dedicated slide scanners can't scan glass-mounted slides, so you'll have to remove the slides from the mount before scanning.

If your best efforts fail, you might still find that your film has dust, scratches, or fingerprints on it. You might be able to remove or minimize these prior to your scan. Here are some tips to get you started:

- Get yourself a can of compressed air, and use it. You should be able to remove 99% of the dust on your film using a quick spritz. Be careful not to tilt the can too much, or you can end up spraying a mist of white-powdery propellant instead.

- Sometimes dust can become stuck to the film, or perhaps was slightly embedded in the film during processing. A soft, camel's hair lens brush can sometimes be used to dislodge this dust. As long as the dust isn't stuck in the emulsion itself or doesn't leave behind a trace of its presence, you can usually remove stubborn particles effectively.

- In the past, photographers working in non-digital darkrooms have found that "wet mounting" scratched film using a liquid that fills in the scratches works wonders. This method is still used today with high-end scanners built specifically to accommodate the procedure. Scratches can also be filled in with a *very* light coating of petroleum jelly or other substance. I don't recommend any of these methods for the average scanner user. Your scanner's built-in scratch-reduction features are likely to do a better job with less risk of damaging your film.

- When all else fails, you can try film cleaning products, such as Kodak Film Cleaner, Edwal Film Cleaner, or PEC-12 Film Cleaner. Have a soft, lint-free cloth available to apply and clean up after.

- Northeast Photo-Tech Corp's Hide-A-Scratch comes in a 1 oz. bottle and looks like nail polish remover, but smells like turpentine (which is one of the ingredients). Used with care, it can mask scratches effectively.

- There's not a lot you can do about mold or fungus or insect damage. By the time it shows up, it's probably eaten into the emulsion of your film. If the film image is important, brace yourself for a heavy-duty retouching session in your image editor.

# Inserting in Film Holder

Once your film is clean and ready to scan, you'll need to insert it into a film holder. The holder itself and how film is inserted will vary, depending on your scanner and the type of film. In general, film holders for one type of scanner don't fit another brand, so you should be as careful when handling the holder as you are with the film. Break a film carrier and you're out of business until you can find a replacement. In fact, I recommend purchasing an extra of each kind of film holder you use the most. You'll be able to load your spare carrier with slides or film while the first one is being scanned, plus you'll own a backup if your original film holder is lost or becomes damaged. If the unthinkable happens and your film scanner is discontinued and replacement parts become scarce or expensive, you'll be able to sleep nights knowing that at least one part of your scanner has a backup. Your scanner vendor's support, parts, or repair departments will be happy to sell you an extra carrier.

## Finding the Emulsion Side

One thing each scanner and film variety has in common is that the film should be placed with the emulsion facing the scanning sensor. Generally, that direction is down. The most obvious reason for scanning with the emulsion side of the film facing the sensor is that scans made in that orientation are not reversed or produced in a mirror image. You can easily reverse an image in your image editor, so if you accidentally make a few scans with the emulsion facing the wrong way, you haven't made a fatal error.

However, there is another reason for using the correct orientation. When the emulsion faces away from the sensor, the light exposing the film reaches the emulsion first, and then passes all the way through the film base before striking the sensor. In the correct orientation, the light passes through the base first, and then the emulsion, immediately reaching the sensor as it emerges from the film. If you remember Figure 2.3 in Chapter 2, the film base is *very* thick compared to the emulsion, and the film base is not perfectly clear. It's possible that the image will become slightly diffused if the base is sandwiched between the actual image and the sensor. Moreover, scanners focus on the side of the film facing the sensor, so it will focus on the base side of an inverted piece of film, rather than on the emulsion itself. The quality difference of scanning flipped film may, in fact, be tiny, but why degrade your image if you don't have to?

How do you tell which side is the emulsion side? With strips of film, if you can read the frame numbers and edge markings, the emulsion is facing away from you. For mounted slides, the emulsion side is facing away from you if you can read the film manufacturer's name, the name of the photo lab, or simply the slide number imprinted on the slide. Plastic mounted slides are often a different color on each side. The front or base side might be white, with the emulsion side gray. If you hold the film at an angle, the base side will be shiny, whereas the emulsion side will look dull and might have a raised image on it. Film tends to curl toward the emulsion side, which you can see in film strips and mounted slides. If all else fails, look at the film for lettering: if it's reversed, so is the film. That works only with images containing lettering, of course.

## Working with the Carrier

You'll find different types of carriers for each type of film. Here's some advice on how to work with each. In all cases, wearing a pair of lintless white cotton gloves while handling film is a

good idea, if only to guard against implanting fingerprints on your film. You'll find these gloves at better camera stores.

- *35mm strips.* One type of film holder accepts strips of 35mm film, usually cut into strips of four to six frames, as shown in Figure 5.4. Your scanner may also be able to handle longer, uncut rolls of film, but, usually, you'll be working with cut strips. The best kind of carrier comes in two parts. Remove the top part, insert the film in the holder, and replace the top part. If you handle the film carefully, this kind of carrier eliminates the chance of scratching the film, as the holder grips only edges (the non-image area) of the film. I've seen one-piece holders that have a long channel on either side. The tip of the strip is placed at the entrance to the channel, and then the film is pulled back through. Anytime you pull film through anything there is an opportunity to scratch it.

**Figure 5.4** *Carefully insert your film-strips into the 35mm film carrier.*

- *120/220 70mm film.* These 2 1/4-inch wide film formats aren't compatible with all film scanners, but if your model can accept them, you'll use a holder similar to those offered for 35mm film. If the holder is the channel type, be careful pulling the film through. In any case, try not to crimp or bend the film.

- *Sheet film.* If your dedicated film scanner can scan 4×5 inch or larger sheet film, you'll use a carrier that holds a single sheet.

- *Advanced Photo System film.* Scanners that accept APS film use a special holder/transport mechanism, which might have to be purchased separately. These are as easy to load as a camera; just drop the film in and load the holder into the scanner. Make sure you only insert a cassette of *processed* film! (There's a square opening on the end of the cassette with the numeral 4 next to it. That opening should show white behind it, as shown in Figure 5.5.) The unique light lock on an APS cassette doesn't trap dust the way the old felt cassette lips did, reducing scratching problems.

**Figure 5.5** *Make sure your APS film is exposed and processed by checking the square index hole.*

■ *35mm slides.* Film carriers for slides will either be two-piece affairs, or may have a slot in the side of the carrier which you can use to insert and remove the slides, as shown in Figure 5.6. Usually, you'll need to orient your slides a particular way, with the long dimension of the image area parallel to the long dimension of the film holder. That means your scanner will always be scanning horizontally composed images with the slide rotated 90 degrees, but in practice that's not much of a drawback. All scanning software has a provision for rotating the preview image so you can evaluate it in the correct orientation.

**Figure 5.6** *Slides are inserted into slots in the film carrier.*

# Launching Your Software

Your next step is to launch your scanning software and allow it to initialize the scanner. In most cases, the scanner must not have any film in it when the software is first loaded. Dedicated film scanners transport your film in and out of the scanner using a motor, so before you load the scanner you'll need to turn it on, make sure your operating system recognizes it, and make sure that your scanner software is ready to use it. Usually, just flipping the scanner on does the job. If you've used the scanner before, your operating system will recognize that a device has been added to the USB connection and might show a dialog box telling you that.

The steps you follow go something like this:

1. Make sure the scanner is turned on and has been recognized by your computer. Many film scanners have an LED or indicator light on the front that blinks to indicate that the scanner is powered up and ready to go. If your operating system hasn't recognized the scanner, you'll find that out quickly enough in the Step 3.

2. Double-check to see whether the scanner is configured properly. Most of the time that will involve nothing more than making sure the film gate door is closed so the scanner can initialize itself. Your scanner instructions will list any start-up steps you need to take.

3. Launch your preferred scanner software. If it's a standalone application, you can launch it from the Windows Start menu, from an icon you've placed in the task bar, or by another preferred method. Mac owners can double-click the application on their desktop, in the Apple menu, or using another method. If your software runs from within your image

editor, choose the application from the appropriate place in your editor's menus, usually somewhere such as File > Import. With Mac OS X, the utility window might be hidden underneath your image editor's array of palettes. With Photoshop, you can hide the palettes by pressing the Tab key.

4. As the scanner software loads, you'll usually see a dialog box letting you know the software is searching for your scanner and, then, initializing it when the scanner is found. The blinking light on the scanner may stop blinking and glow steadily to indicate the scanner is now ready to go. If the software is unable to find your scanner, check your cable connections. If this is the first time you've used the scanner you might have to re-install it or the software.

## Loading the Scanner

When the scanner is ready, insert the film carrier into the scanner facing the correct way. You might need to move the film gate door to a specific position before doing this. The scanner probably will grip the film holder and pull it into the scanner a few millimeters. At this point, you're ready to do an index scan or preview scan of the film in the holder.

If your scanner uses an APS adapter, you'll need to insert the adapter into the scanner with its contacts oriented the correct way, and the film gate door moved to the APS setting. Once the scanner recognizes the adapter, it will move the adapter into the scanner. You can then close the film gate door, if your scanner requires that step. The scanner will open the APS cassette, extract the film for scanning, and then automatically rewind the film when finished.

With any type of film carrier, you can eject the film by pressing the Eject button on your scanner, or by selecting Eject from your scanner software. Wait until the film holder is all the way out of the scanner before removing it. You'll need to wait while an APS adapter rewinds the film back into the cassette.

## Starting the Scan

Now it's time to begin making your scan. You'll need to perform a prescan of your image, set the film type and other basic parameters, and then fine-tune the color correction, sharpness, and tonal settings prior to making the actual scan. I describe each of these in this section.

## Prescanning

The first step of the scanning process is to retrieve a preview scan or index scan of the image(s) on the film, like the one shown in Figure 5.7. In your scanner software, find the menu item or button that triggers this prescan, and if the scanner starts transporting your film and making other reassuring noises, you're all set.

The preview will be an initial view of the film in the holder. The scanner software might provide a single view of thumbnails of all the images in the holder, or might give you a close-up view of each of them individually or on separate tabs. Even if you get a gang view of all the thumbnails, you'll still be able to zoom in as you work.

The difference between an index scan and a preview or prescan is simple. An index scan shows all the images on the filmstrip, or all the slides in the slide holder. You can use an index scan when you plan to scan more than one image in a set, or when you need to select a single frame from multiple similar frames in the set. A prescan is a preview of the image to be scanned. You can crop this preview, make corrections, and perform other setup steps prior to making the final scan.

**Figure 5.7** *Create an index scan of all the images in the film holder.*

## Selecting Film Type and Format

Your scanner needs to know what type of film it is looking at, both to set the scan area as well as to set some basic scanning parameters. Your scanning software will have menus or drop-down lists you can use to specify the size and type of film to be scanned. Here are some of the choices you'll need to make:

- *Film format.* With a 35mm film scanner, you might need to select between 35mm and APS formats. The default will usually be 35mm, so if you don't have an APS adapter or never scan APS film, you might never need to choose a film format.

- *Film size.* Scanners that handle larger film types will have choices for the various 120/220 formats (6×4.5 cm, 6×6 cm, 6×7 cm, and 6×9 cm) or other sizes your scanner can work with.

- *Film type.* These can range from color negative, to color positive (transparencies or slides), to black-and-white negative, to black-and-white positive. By telling your scanner what type of film you're working with, the software knows whether to invert the image or to compensate for the orange mask found in color negative films.

- *Film brand.* Some scanner software lets you specify a specific brand of color negative film, such as Fujicolor HQ or Kodak High Definition 200 film. If so, the software will use a customized profile of that film that takes into account the emulsion's particular characteristics, including the balance of its orange mask. Figure 5.8 shows this feature at work. If you're scanning older films, they might not be represented in the profiles.

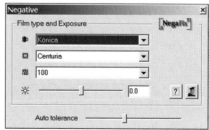

**Figure 5.8** *Select your brand and type of film.*

■ *Custom type.* Your scanner software might let you create custom profiles of particular films. This is handy if you don't like the results your scanner produces with the default profiles, or when a new film comes on the market that isn't supported by your software.

Note that many scanners can automatically detect the film type, particularly when used with APS film.

---

## THAT ORANGE MASK AGAIN!

Orange masks differ from one manufacturer to another and the compensation for each varies. In addition, if you're scanning negative film that does not include an orange mask, you might not want orange mask compensation. For example, if you've cross-processed color slide film in color negative solutions, you'll end up with a negative, of course, but there will be no orange mask. In such cases, you'll want to scan the film as a positive image, and then reverse it yourself if your software doesn't allow reversing an image as a separate option.

---

## Viewing the Prescan

Select a frame or image for your final scan (usually by clicking it in the index scan) and you can view it in more detail, as well as make corrections. (Note that some software lets you select more than one thumbnail in the index scan, and then scan each of those selected images consecutively, either using the same settings or custom settings.) Here are some of the things you can do with the prescan image:

■ *Flip or rotate the preview.* This feature is handy to produce a more naturally oriented preview to work with if your original image was shot rotated 90 degrees from the view shown on the screen, as in Figure 5.8. For example, 35mm vertically oriented photos will generally display in landscape mode in the prescan. You might want to flip the preview horizontally or vertically to produce a mirror image.

■ *Zoom in or out.* You can zoom in to make the preview or a portion of the preview larger, and zoom out to get a view of the entire frame.

■ *Scroll image.* When you're zoomed in, you might be able to view only a portion of the image to be scanned at one time. Your software probably has a grabber tool for moving the image around in the display window.

■ *Crop the image.* If you don't want to scan the entire frame, use the Crop tool to exclude the area you don't need. That will reduce the size of your scanned image and should speed up the time needed to make the scan. If you're scanning APS film, the software probably has a cropping tool that automatically selects the C/H/P (classic, horizontal, and panorama) aspect ratios available with APS cameras.

■ *View all index images at once.* This option shows all the prescan images in one workspace so you can compare them.

■ *Save your prescan or index scans.* Your software might allow you to store the prescan images on your hard disk for review later. This can be a handy way of cataloging your filmstrips or slides.

# Setting Scanner Preferences

Your next stop is to set some of the scanner preferences available with your software, for features like automatic dust removal, auto focus, color correction, exposure, and index scan quality. Check out Figure 5.9.

■ *Automatic dust removal.* Even if your scanner doesn't have the advanced Digital ICE dust and artifact removal tool, it's likely to have some sort of dust-bunny blaster. With the least expensive scanners, this is likely to be a blurring routine that actively searches for random spots and splotches that appear to be dust and removes them by blurring them into their surroundings.

■ *Focus.* Your scanner might use fully automatic focus full time, or might let you use semi-automatic or manual focus. You can set your scanner preferences for automatic or manual focus. The latter is especially handy because the scanner will usually let you manipulate a cursor around the preview area to determine the exact area to focus on.

■ *Automatic correction.* Even sophisticated scanner software usually has a setting for applying automatic color and tonal correction. Use this preference if you have images that aren't particularly demanding, and you're willing to let your scanner do most of the work for you.

**Figure 5.9** *You can set many scanner preferences for general use.*

■ *Auto exposure.* Sometimes automatic exposure is a separate preference. You can let the software determine the exposure, or lock it in for a particular kind of film, such as negatives or slides. You might also be able to preset the area used for autoexposure measurement, handy when you're scanning a batch of images that have similar layouts, such as landscape or sunset photos.

■ *Index scan quality.* You might be able to specify whether your software provides quick-and-dirty index/prescans, or slower, higher-quality previews.

# HIGH-RES IS BEST FOR DUST REMOVAL

Remember that dust-removal routines work best at higher scanning resolutions. At lower res settings, your scanner's dust-buster finds it more difficult to differentiate dust from random pixels, because the dust itself might be no more than a few pixels wide. At higher resolutions, even tiny dust comes into sharp focus, so to speak, and can be tracked down and zapped more precisely. So, if you have an original that's plagued with dust, but won't be deployed in large sizes (say, you plan to put the image on a web page), your first inclination might be to scan at a lower resolution so the dust won't be so sharp. Wrong-o! Scan at the highest resolution you have so your scanner's dust-removal routines can do their job. Then, resample the image to the size you actually need. You'll end up with a sharper image with less apparent dust.

## Mastering Basic Controls

Unless you're scanning on full autopilot, you'll need to apply various exposure, color, and tonal controls next. This section gives you the basics of what each control does. For more detailed explanations of how to correct images, either with your scanning software or using your image editor, see Chapters 9 and 10 in Part II of this book.

### Exposure Controls

Exposure controls adjust the overall lightness and darkness of your image, but make no tonal changes. You can think of exposure controls as the shutter speed and f-stop controls like those found in your camera; the settings that determine the brightness of all the pixels of the image or color channel equally.

The exposure settings, shown in Figure 5.10, let you adjust the brightness/darkness of the entire image (or of the master channel in an image editor), or just the values of the red, green, and blue channels individually. Of course, if you manipulate only one color channel, you're likely to produce a color shift, but I'll address color correction later in this chapter.

Exposure controls are useful for calibrating your scanner to a standard exposure. If you find your scans are consistently too dark or too light, you might want to use the exposure control settings to add or subtract a little from your basic exposure. Scanner software lets you save exposure settings on disk, and recall them later, so you can create customized exposure profiles for your favorite films.

Autoexposure lets the scanner determine the overall exposure of a scan, based on the density of the original. This exposure can be automatically determined for each image scanned, or you can lock in an exposure and use it for a series of scans.

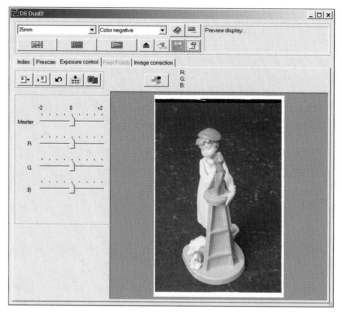

**Figure 5.10** *Exposure controls modify the brightness of an image.*

## Focus

The focus functions of your scanner are useful when the original film is warped or very curled. You can set the focus mode in your preferences and forget about it, or use a different mode while you actually scan. Your scanner software probably has several options, including fully automatic focus, point autofocus, and manual focus, using a tool that lets you view the image and watch it pop in and out of focus as you move a slider.

---

## COMPARE AND CONTRAST

In-focus images look contrasty and sharp; out-of-focus images are blurry and soft. Keep that in mind when determining how to focus your scanner. If your images have large areas with little contrast (say, a plain background or areas of sky), the scanner might have difficulty zeroing in on exact focus. Use point focus to move the point at which focus is determined, or focus it manually.

---

Focusing manually can be difficult, because the eye's memory isn't good enough to tell whether the image was sharper before, or is sharper now. That's why you may focus your camera by jogging back and forth around the point of sharpest focus, or your eye doctor keeps flipping lenses in and out during an examination until you're absolutely sure which one provides the best image. Your scanning software should provide you with aids to use during manual focusing, like the one shown in Figure 5.11.

**Figure 5.11** *Manual focus can be used with problem film.*

# Resolution

Many times you'll want to change the default resolution used to make a scan. You won't always want to scan at the maximum resolution (unless you need to maximize automatic dust removal), because that much detail isn't always necessary; nor will you want to scan at a lower setting all the time. Your scanner's resolution controls let you specify the resolution to be used to make the scan.

Input resolution, usually measured in dpi or dots per inch (even though scanners don't have dots, as I mentioned in Chapter 3), determines the number of samples-per-inch your scanner captures. At the low end, you might be able to choose a few hundred dpi, proceeding up to your scanner's maximum optical resolution (such as 2820 dpi or 4000 dpi). You might also be able to choose one of your scanner's available interpolated resolutions. (For more on resolution and interpolation, review Chapter 3, "Scanner Specifications for Film.")

Your software might also let you select output resolution, which determines the resolution used when the image is sent to a printer (which *does* use dots). You can use this control to enter the resolution of the printer that will be used to create hardcopies of your image.

Related values, like those shown in Figure 5.12, include magnification or scaling, input size (the dimensions of the area to be scanned),

**Figure 5.12**
*Resolution and output sizes can be set prior to the scan.*

output size (the width and height of the final image), and units (whether dimensions are expressed in pixels, millimeters, centimeters, inches, picas, or points). Pixels are a useful measurement if you need to capture an image in a specific pixel size, such as for a web page. Inches, millimeters, and centimeters are units useful for describing the size of an image when printed (choose millimeters or centimeters if you're working with metric paper sizes). Picas and points are units that come in handy in desktop publishing, because type, column widths, and other layout dimensions are expressed using those units.

## Color Matching

Because all devices define their color gamuts differently (see Chapter 10 for more on this), you can frequently get better scans by letting your scanner use available color matching profiles and color spaces. You can activate this option, choose profiles that correspond to your color monitor, printer, and scanner, and choose the color space you want to work within to help ensure consistent color from scan to scan and project to project.

Profiles are often provided by the equipment vendor, although you can calibrate your own equipment and create a personalized profile. Color spaces to work in include sRGB, Apple RGB, Adobe RGB, and others.

# Mastering Correction Controls

As mentioned earlier, most of the correction controls available in scanner software are also available in your image editor. Whether you apply them during scanning or in the editor after the scan is complete is up to you. Ideally, doing as much correction during the scan itself is the best plan, because even the most sophisticated image editor can't retrieve detail or colors that aren't in the scan in the first place.

In the real world, however, you might decide that the gains made in super-fine-tuning your scans aren't worth the extra time it takes. Your scanner software's controls are likely to be less versatile than those offered in your image editor; the dialog boxes probably have fewer options, and because you spend less time working with your scanner software, just about any task will take a bit longer. For work that isn't critical, an excellent scan that you can touch up in your image editor might be preferable to a superb scan that takes twice as long, overall, to produce. The choice is yours.

Because the controls operate in similar ways in both scanner software and image editors, I've relegated the most in-depth discussion of their use for Chapters 9 and 10. This section introduces you to the key controls, and explains why they are important.

## Tonal Controls

Tonal controls adjust the brightness, darkness, and contrast of the blacks, whites, and grays of your image as well as the individual colors. Adjustments at your disposal might include:

- *Brightness/Darkness sliders.* These controls adjust the relative brightness or darkness of every pixel in an image, or only those of a particular color channel. The chief drawback of

this kind of control is that it applies its effects to all the pixels, even those that don't necessarily need modifications. So, if your shadows are too dark, using the brightness control to lighten them will also brighten the highlights, possibly washing them out. Use these controls for slight changes, if at all.

■ *Histograms.* Histograms, like those shown in Figure 5.13 (one for the gray values, one for color), are charts that show you the relative number of tones at each brightness level. You can use the histogram to determine whether the image's pixels are weighted towards the shadows, highlights, or are evenly spread throughout your image. Histogram controls let you choose which pixels are rendered in true black, and which in true white, and then adjust the midtone levels to provide an improved tonal balance.

■ *Curves.* The curves controls show the distribution of tones in an image, and give you complete mastery of the tonal rendition of every pixel. Used on individual color channels, curves are an important color-correction tool, too. Manipulating curves takes some practice, but once you've learned how to use them you can make some amazing corrections to your images. You'll find more on curves in Part II of this book.

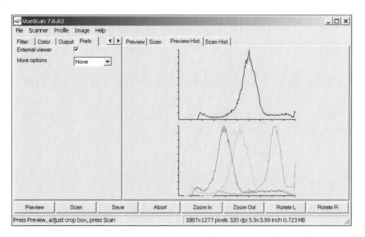

**Figure 5.13** *Histograms provide information about the tonal values in an image.*

# Color Controls

Color controls let you correct the colors of your image, or provide special color effects that don't reflect reality. Your color controls parallel the tonal controls (because tonal controls like curves can also be used to modify color), but you'll find some new tools at your disposal as well. These include:

■ *Variations or ring-arounds.* Many scanner utilities provide a "variations" dialog box that shows you sample previews with different types of color correction. You can visually compare them and choose the one that looks best to you.

- *Color balance or selective color.* Like the Brightness/Darkness sliders, the color balance sliders are an overall control that can be useful when the color changes you need to make are simple. A set of three sliders representing Red/Cyan, Green/Magenta, and Blue/Yellow colors can be manipulated to change the color cast of an image. Small color problems can be fixed with color balance controls. More complex situations might be better addressed with the curves controls.

- *Hue, saturation, lightness.* Sometimes you need to think outside the dialog box. It's easy to think about correcting color by adjusting color casts: making an image more or less blue, more or less red, more or less magenta, and so forth. The HSL controls, like those shown in Figure 5.14, approach color from a different angle, using components other than the color primaries alone. This different angle lets you make changes to one of these components without modifying any of the others. For example, if you want colors to appear richer, adjust the saturation control. To shift all the colors in a particular direction, rather than simply add a bit of that color, use the hue controls. The lightness adjustment adjusts the brightness of all the pixels while keeping the hue and saturation values the same.

**Figure 5.14** *Modify hue, saturation, and lightness values independently.*

# Other Controls

There are a few other basic controls to know about, covered in this section. Not all scanner software has all these controls, but most of the best applications have something like them.

## Sharpness Controls

Scanner software lets you adjust the sharpness of your image during the scan. Most scanners apply some software sharpening during the scan by default. You can opt for a little less sharpening (a good choice if your image is already too contrasty) or up the ante for even more sharpening. You might be able to dial in a little extra crispness, or use a tool like Unsharp Masking (explained in Chapter 9).

## Reviewing Your Changes

Some software enables you to take snapshots of preview states as you apply controls, and then arrange the snapshots side by side for comparison before you make the scan. You also might be able to compare the original image with a final scan and make additional changes before scanning again.

## Saving Files

If your scanner software works from within an image editor, it might dump its scans directly back to your editing application. It might be up to you to remember to save the scan before finishing a session. Alternatively, your scanning software might save your scans directly to a

file. That's a handy option afforded by VueScan, because you can scan for hours without stopping to save a file; it's done for you automatically. VueScan offers a remarkable number of options for saving your scanned files, as you can see in Figure 5.15.

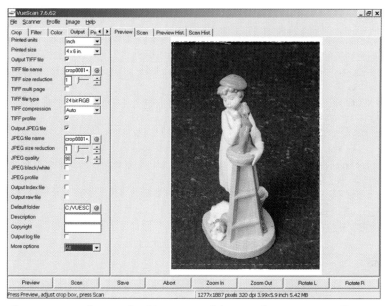

**Figure 5.15** *Choose the file type and format for automatically saved scans in VueScan.*

Most scanner programs let you choose automatic file naming, so the application will select a consecutively numbered filename for each scan. VueScan also lets you choose file type, kind of compression, simultaneous output to a JPEG file (so you'll have a smaller reference file, say, to e-mail to a colleague for approval), JPEG quality level, and other parameters.

## Saving Jobs

If you're lucky, your scanner software will let you save all the settings you make as a job, and then re-use those settings later. Then, if you encounter a similar project later (or if you shoot the same type of image over and over), you can reuse the job and save yourself some setup time.

# Next Up

This chapter provided an overview of scanning film with a dedicated film scanner. The next chapter looks at the same task from the viewpoint of flatbed scanners. Much of the information you need to know is the same, so I won't repeat some of the discussions here in Chapter 6. The emphasis in Chapter 6 is on what's different about scanning film with a flatbed, and you'll be looking at a few advanced features available to both types of scanners.

# 6

# Scanning with Flatbed and Multi-Purpose Scanners

If you're scanning your film with a flatbed scanner that's been modified to scan film, or with a multipurpose scanner (usually a higher-end flatbed specifically designed for both reflective and transparent artwork), you have your work cut out for you.

You need to take some extra care prior to scanning, because not only will you need to clean your film, but you'll want to make sure the glass platen of your scanner is spotless, too. If your flatbed wasn't originally designed for scanning film, you need to make the most of the available resolution. A 3200 spi flatbed isn't really the equivalent of a 3200 spi dedicated film scanner, for reasons explained in Chapter 3.

However, many flatbeds today do a better job of scanning film than was possible with their counterparts only a few years ago. Some more expensive models even include a second set of optics to focus the smaller area of a film scan onto the sensor array, so your scanner doesn't capture images from a 1-inch wide color slide in the same way it grabs an 8×10-inch photo.

## FILM SCANNING, CONTINUED!

This chapter continues the discussion begun in Chapter 5. It explains the basics of scanning film with a flatbed scanner, and explores some of the features available in scanner software available for flatbeds. The advanced features described in this chapter are available to those using dedicated film scanners, too, so you should consider this chapter to be Part II of the film scanning information flow.

# Choosing Your Software

Everything in the previous chapter on selecting scanning software applies to flatbed scanners, too. In fact, packages like SilverFast Ai and VueScan work equally well with either type of scanner. Figure 6.1, in fact, shows VueScan being used with an Epson Perfection 2450 flatbed film scanner. For several illustrations in Chapter 5, I used VueScan with a Minolta dedicated film scanner. That Spartan interface discussed in the last chapter can be expanded to include many, many more options, as you can see in the Figure 6.1.

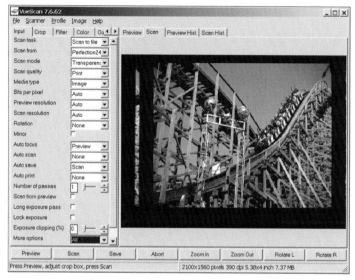

**Figure 6.1** *VueScan's interface can be expanded to include a lot more options.*

Flatbed scanners can use TWAIN-based software or standalone applications, and you can select your scanner from within Photoshop or another image editor just as easily. In fact, my own copy of Photoshop has TWAIN import selections for six or seven different scanners and software applications.

If you do use more than one scanner, it's easy to switch back and forth between them. I alternate among four scanners: two USB flatbed scanners, a USB film scanner, and an old SCSI flatbed. No more than three are active at any one time, as I share a USB cable between one of the flatbed scanners and the film scanner. When I want to use the flatbed, I unplug the USB cable from the film scanner and plug it into the flatbed. I don't need to reboot or do anything special; that's the beauty of a plug-and-play operating system and the USB bus.

Of course, flatbed scanners can do a lot more than scan film. So, the software bundle supplied with your scanner includes a larger variety of applications. In addition to the basic (or perhaps basic and advanced) scanner software, you might also get an upgraded image editor; document-management software like PaperPort that grabs pictures of letter, memos, and other pieces of paper and assembles them into a desktop database of images; software for capturing and faxing documents or photos; optical character recognition (OCR) software for converting documents and faxes into editable text; slide show software for creating presentations; or any of a half dozen other software bonuses. Film images aren't especially suitable for OCR, document management, or perhaps faxing, but you can use them for many of these other applications. Flatbed owners should consider these features welcome extras.

# Prescan Operations

As with dedicated film scanners, flatbeds require some setup and housekeeping before you begin to scan. This section provides a quick overview of the most important steps to follow. Some are the same steps you apply to a scan with a dedicated film scanner, but a few are different (but just as important).

## Prep Your Scanner

Your scanner needs a little preparation before you begin the scan. You can perform many of these tasks in any order, but consider them a checklist you should follow every time you scan.

■ *Prep your light source.* Depending on your flatbed scanner, the film light source might be built into the lid, included in a separate lid, or consist of a module that's placed down on the scanner glass over the film. If the source is built into the lid, as shown in Figure 6.2, you'll usually have to remove a cover that protects the light during scanning of reflective artwork. Some older scanners used a bulky, separate lid with a light source built in. With these scanners you can remove the original lid and replace it with the illumination source lid in a few seconds. Make sure the white diffusion glass of the light source is clean. You might need to plug the lightsource/lid into a special connector on the back of the scanner. The connector supplies power to the light.

**Figure 6.2** *The light source is usually built into the lid of flatbed scanners.*

■ *Clean the scanner glass.* I'm always surprised at how quickly scanner glass becomes dirty. It's also surprising that I'm able to get decent scans of photos when the glass has a fingerprint or two and a modest amount of dust. Film originals are not so forgiving. Before you scan, you'll want to clean the glass with a soft, lint-free cloth. Don't rub hard or vigorously on the glass when it is dry; some pieces of dust are hard enough to scratch the glass. You might need some glass cleaner to remove fingerprints. If you find your liquid cleaner leaves residue or a film, switch to another. (And be careful not to let it drip around the edges and inside the scanner.) Finish off your cleaning with a careful spray of compressed air to remove any remaining dust particles.

■ *Locate and clean your film carriers.* I have so many of these for different scanners that I tend to get them mixed up or mislay them. My solution was to create a file folder for each type of film holder and file them away in a cabinet underneath each scanner. You'll want to make sure the holders themselves don't have dust or grime that can contaminate your film.

■ *Get some clean white, lintless gloves.* As mentioned in the last chapter, white gloves are a good idea for handling film in any case. With a flatbed scanner, they become even more important. Some flatbed slide holders are little more than frames that you drop 2×2 slides into so they rest on the glass, as shown in Figure 6.3. To remove the slides after a scan, you might have to lift the frame and pick up the slides by hand, individually. That's a good way to get fingerprints on the glass and trigger another cleaning session. Slide a clean piece of paper under the slide and use gloved hands to lift it and you'll avoid the fingerprints and other grime that might collect during a busy scanning session.

**Figure 6.3** *Slide carriers for flatbed scanners are little more than a tray that separates the slides.*

## Prepare Your Film

You'll want to clean your film before scanning, as outlined in Chapter 5. Minimize the amount of dust around the scanner, remove the film carefully from its sleeve or other storage place, and use care when handling the film. If you're scanning glass-mounted slides, now might be a good time to remount them in plastic slide mounts. Cardboard slide mounts, although they still exist, are a poor choice for critical work. They can bend, possibly allowing your film to bend, too, and are rabid carriers of cardboard dust and fragments.

Compressed air, soft brushes, film cleaning chemicals, and other remedies described in the previous chapter can all be used to prep your film. Use them carefully.

## Insert in the Film Carrier

Flatbed scanner film holders are typically different from their dedicated slide scanner counterparts. On the plus side, they're simpler to use, less expensive to buy, and don't need to stand up to transport in and out of the scanner. On the other hand, these holders are usually made of thin plastic and are easy to break if you drop and step on one, and too often come in the one-piece variety that requires you to thread the film into a thin channel, possibly scratching the film as you drag it through. Use care when loading your film carrier!

Remember that the emulsion side of the film should face downward, toward the scanner glass. You'll recall from the last chapter that the correct orientation is with the film numbers or edge markings or imprinting on the slide mount reading correctly as you look down on the scanner. Because of the physical thickness of the film holder, the film is positioned a fraction of a millimeter from the scanner glass, so inverting the film and scanning the base side instead of the emulsion side can have a more significant effect on focus and sharpness.

After the film is in the carrier, you can go ahead and put it on the scanner glass. Follow your scanner manufacturer's recommendations for positioning the film holder. Often, the holder will be 8.5×11 inches in size, even if the film being scanned is smaller, so you can place it flush against the top and right edges of the scanner glass. The film being scanned will be positioned in the carrier so the film is in the center of the scanner platen; that's where the light source is most even and the optics do their job better (with a decent quality scanner, the difference between results scanned at the edges and center will be small, but most will perform better in the middle area of the platen).

## Launch Your Software

Next, launch your scanning software so it can locate your scanner and initialize it. If the software doesn't find the scanner, you might have to switch the scanner off and then on again, or perhaps reboot. If the scanner is newly installed, you might have to reinstall the software. If you're using Microsoft Windows, you might have to reinstall the software anyway, just for the heck of it. Windows programs have a habit of over-writing modules needed by other software, or doing other strange things, so if you've been using Windows for a while, or installed some new software recently, don't be surprised if your old software suddenly stops working.

# Starting the Scan

Now it's time to begin making your scan. You'll need to perform a prescan of your image, set the film type and other basic parameters, and then fine-tune the color correction, sharpness, and tonal settings prior to making the actual scan. Each of these steps is covered in this section.

## Perform Initial Scan Setup

The initial scanning setup procedures for flatbed scanners are the same as for film scanners:

■ *Preview/index scan.* The usual procedure is to scan all the film on the platen at once, and then select the frames you want to work with individually.

■ *Select original type.* First choose between reflective and transparent original artwork (a choice you don't have to make with a dedicated film scanner).

■ *Film type.* If you choose negative, many scanner applications also let you select a specific brand of film, such as Kodak, Fuji, or Konica, and the exact film type, so the software will know how to handle the orange correction mask of your particular film. Not all film types will be available in the software's list, however. You may have to wing it when selecting a film type and choose something close.

■ *Film format.* You might not need to specify whether you're scanning 35mm film, 120 film, 4×5 film, or some other format. Generally, flatbed scanners don't care about film size. Anything that fits into the target area on the platen (usually that center strip) is fair game. Figure 6.4 shows a 6×7mm frame's preview scan, along with a space set aside for 4×5-inch film.

■ *Batch scan.* This is a useful feature for TWAIN modules. It lets you send each scan directly to your hard disk (for editing later) or, at your option, back to the image-editing program that invoked the scanning software. If you have lots of high resolution scans to make, you'll find that your image editor can quickly become bogged down trying to load all of them into memory for display. Let the editor hog all your memory and everything else running on your computer slows down. It's better to scan to your hard disk and then load your scans one at a time later.

**Figure 6.4** *A preview scan lets you evaluate the image and apply corrections.*

## Choose the Scan's Bit Depth

With both dedicated film scanners and flatbed scanners, you might have a choice of bit depths to use when scanning. Here are the most common options:

■ *n-bit to 24-bit color.* In this mode, your scanner captures the image using its maximum available bit depth (most commonly 48 bits, or 16 bits per color channel) and then interpolates to a 24-bit image before sending the image to your computer. This is the best choice for non-critical color images.

■ *16-bit to 8-bit grayscale.* The computer captures 16 bits worth of grayscale information (32,767 gray tones) and interpolates down to a 256-bit grayscale image. Again, for non-critical use, this option is fine.

■ *48-bit color.* The scanner sends a full 48-bit file to your computer, with 16 bits of information per color channel. Photoshop 7 had a limited range of functions that it could perform with 16-bit color channels, but the latest versions have no such limitations. If you're finicky about your color and want to do extensive correction in Photoshop, this is reason enough alone to upgrade!

- *16-bit grayscale.* Although not particularly useful for photographs, this mode can provide extra useful information for scans of black-and-white film, or monochrome scans of color slides.

- *1-bit line art.* Use this mode for scanning images that contain black and white only, and no grays. Such originals are encountered most frequently when scanning reflective originals, such as documents, but you can use this mode when scanning litho film or other super high-contrast originals.

## View the Prescan

Your next step is usually to create a selection border around the frame you want to scan, using a selection tool provided by the software. You can select the entire frame, or select only a portion of it to provide cropping. If all you want is an index image of all the frames, you can also select everything and scan that.

Once you've selected a frame, you can flip or rotate the preview image, zoom in, scroll around the image if only a portion is visible, or crop it further. SilverFast and VueScan, for example, will enlarge the prescanned image to give you a better view and an easier image to crop precisely.

# Fine-Tuning the Scan Parameters

You'll spend the bulk of your time prior to making the actual scan fine-tuning the scanner settings. Often, you'll decide to use the scanner's automatic settings and won't invest much effort in this fine-tuning at all. For critical work, you might labor over the preview image for quite a while. The time you spend now can save you time in image editing later. Here are some of the settings you might begin with:

- *Automatic dust removal.* If your scanner includes Digital ICE, you can activate or deactivate its features here. You'll find a longer discussion of Digital ICE's options in Chapter 9. Because Digital ICE is partially a hardware solution, it might not be built into your scanner. In that case, you need to rely on your scanner application's software dust-blurring routines. As noted in the last chapter, such algorithms tend to blur an image slightly, and work best with high-resolution image scans, so the choice to use them or not is yours.

- *Focus.* Your flatbed scanner probably does not have any focus provisions. Flatbed scanners designed for grabbing images of photos and other relatively flat, large-scale artwork tend to rely on the scanner's built-in depth-of-focus to assume that, if the film is loaded into the carrier and placed on the platen properly, it will generally be in sharp focus. (This is one of the reasons a flatbed scanner won't perform as well as a dedicated film scanner at the same nominal resolution.) Or, your scanner might have fully automatic focus or manual focus.

- *Automatic correction.* Your software probably has a setting for automatic color and tonal correction. You might be able to use this most of the time, or you might prefer to always make these settings yourself if you want to fine-tune a scan.

■ *Auto exposure.* Reflective artwork rarely needs "exposure" correction, because the density range of photos is more or less constant. That's not true of film, which can range from dense and dark to light and washed out. A flatbed scanner that lets you adjust exposure, or that offers automatic exposure has an advantage when scanning demanding transparencies and negatives.

■ *Index scan quality.* A scanner can grab quick index/prescans, or provide lower-quality prescans. If you won't be evaluating your prescans extensively, you can save time by opting for the lower-quality initial preview.

## Set Resolution and Scale

You'll find a discussion on setting resolution in Chapter 5. The same recommendations listed there apply to flatbed scanners. The chief difference is that you might want to experiment with interpolated resolutions when scanning small film (35mm or smaller) to see whether your results are better than those you get at the maximum optical resolution of your flatbed scanner.

## Choose a Color Space

You can set your scanner's profiles that define the characteristics of devices like your monitor or printer, create new profiles, and define the color space the scanner will work with. Color spaces include sRGB, Apple RGB, Adobe RGB, and others. You can find more on color matching in Chapter 5, and a more extensive discussion of color and color space in Chapter 10.

# Correcting Your Image

If you elect to correct in the scanner rather than in your image editor, you'll find many of the same controls available. I described the basic controls in Chapter 5. This section looks at some of them in more detail. You can learn even more about how to use them in Chapters 9 and 10.

## Tonal Controls

As noted earlier, tonal controls adjust the brightness, darkness, and contrast of the blacks, whites, and grays of your image as well as the individual colors. Although gross controls over brightness and contrast exist, your primary tools will be the histogram and curves dialog boxes. I'll explain exactly how these work later, but for this overview, here's what you need to know. Although there are other controls, you don't need them for basic scanning.

To adjust the histogram:

1. View the histogram for your image, like the one shown in Figure 6.5. Note the position of the black point triangle/slider (at the left side), the gray point triangle/slider (in the middle), and the white point triangle/slider (at the right side).

2. Move the black point slider toward the right, if necessary, until it coincides with the beginning of a significant number of tones at the left edge of the histogram.

3. Move the white point slider to the left until it meets the tail end of the white tones in the histogram.

4. Slide the gray tone control towards the center. You can view the results of your efforts in the scan preview window. Click OK (or Done, or whatever, depending on your software) when finished.

To adjust the gradation curves, shown in Figure 6.6:

1. View the curves dialog box provided with your scanning software. Use the default value, which provides a single curve for the combined red, green, and blue channels.

2. Move the curve points on the curve by dragging at the grab points to adjust the gradation (you can also manually enter values into a text box provided for each point).

3. Adjust the curve points until the image improves. The lighter values are on the right and the darker values are on the left.

**Figure 6.5** *Histograms can be used to balance the tonal values of an image.*

**Figure 6.6** *Curves are a versatile way of adjusting tones.*

## Color Controls

Color controls let you correct the colors of your image, as described in Chapter 5 and Chapters 9 and 10. The tools provided by scanner software include variations previews, color balance controls, hue, saturation, and brightness controls, and the use of tonal curves for each color channel.

# Special Tools

Your scanner software might have some special tools you can use to fine-tune your scan further. These include:

- *Densitometer.* This tool, shown in Figure 6.7, lets you read the color density values of any portion of your image. It's especially useful when your image will be printed, as it includes an "out of gamut" warning that shows colors that cannot be reproduced using the CMYK (cyan, magenta, yellow, black; see Chapter 10) color model. Densitometry is a complex science. If you're doing professional prepress work, you'll want to polish your skills with this tool.

- *Manual white point/black point/gray point selection.* Advanced scanner applications include tools for manually selecting the areas of an image that should be rendered as black and white and middle gray. Usually, these are "eyedropper" sampling tools, found either within the histogram dialog box or as a separate tool. Simply click the appropriate area in your image preview using the black, white, and gray eyedroppers, and the scanner software will adjust the tonal values to match the points you've set.

- *Multiple sampling.* Noise (random image artifacts) is the bane of any scanner's dynamic range. When attempting to pull detail out of inky black areas of your film, your scanner's sensor may produce noise, which is then falsely interpreted by the software as image data. Multiple sampling can reduce this noise. The scanner will capture each frame multiple times and compare the images. Because noise is random, it will appear in different locations in each scan, whereas true image information will remain constant. The software can then filter out the random noise, leaving a more noise-free collection of pixels behind. Not all scanners offer multiple sampling. If yours does, you might be able to choose 2, 4, 8, or 16 consecutive scans. Each additional scan requires extra time, and lengthens the time needed for the complete scan, of course, but the results might be worth it.

- *Choice of optical resolution.* Some scanners include two sets of optics so you can scan at multiple resolutions. One set of optics is used for normal scanning, whereas the second is used for extra high-resolution scans, usually only within a small vertical strip in the middle of the flatbed platen.

**Figure 6.7** *The densitometer tool can measure density and color anywhere in an image.*

■ *Batch scanning.* Some scanners make it easy to scan batches of images using the same settings. The Canon ScanGear CS software for the Canon scanners, shown in Figure 6.8, asks only that you put a check mark under the frames you want.

**Figure 6.8** *Scanning film in automated batches can save a lot of time with big projects.*

# Next Up

This chapter and the last provided you with everything you need to know to get started scanning film. The last two chapters of Part I tell you about using outside services and some alternative ways to scan film. When you finish them, you'll be ready for Part II, in which you learn how to edit and enhance your scanned photos, plus learn some interesting things you can do with them.

# 7

# Using Outside Services

You don't have to do all the scanning work yourself. There are plenty of third-party services that will scan your film and provide digital images on CD or other media. This chapter explains your options, shows you how to obtain these services, and outlines some planning you can do to streamline the process when you know in advance that you'll be having your film scanned.

Not all of these solutions provide super-high resolution scans. Some of them are best reserved for film images that you want to display on web pages, include in e-mails, or, perhaps, use to make small prints. These applications are well suited to low-cost scans. However, to every scan there is a season, and for every option there is a reason. You'll learn what you need to know to access these scanning services in this chapter.

## Passing the Buck

Much of this book deals with how easy and inexpensive do-it-yourself slide scanning has become. However, doing it yourself isn't your only option, nor is it always your best choice. Why would you want to subcontract this task to a third-party service? Actually, there are quite a few good reasons to let somebody else take care of scanning for you, even if you have film-scanning capabilities of your own. I'll list the rationale for subcontracting your film scanning in this section.

## Reduce Your Expenses

Using a third-party scanning service can sometimes save you money, especially if you don't have many film images to scan, or scan them only from time to time. Indeed, before you invest in a film scanner, you should take a careful look at whether you need one in the first place.

It doesn't matter whether you're a business that must watch every dollar, or an individual who must watch every penny. A film scanner or anything else you buy should be cost-justified before you make the expenditure.

Businesses use a more formal approach. They can calculate their costs to buy and operate a piece of equipment, including depreciation, amortization, deconfabulation, and other esoteric factors. Then, a business can calculate total savings, and come up with various cost-justification and return-on-investment mumbo jumbo figures that I'd understand better if I hadn't barely passed Economics 101 in college.

Individuals are likely to make more informal guesses as to whether the gadget is "worth it," with lots of murky fudge factors (such as the "fun quotient") built in. The decision usually takes the form of an inner dialog. "I really *want* a film scanner!" "But you don't have that many slides to scan!" "I'd have more to scan if I had a film scanner to scan them with!" "You can get a lot of slides scanned at your photofinisher for the $300 a film scanner would cost." "But it would be *fun!*" Then, you make out your check and carry your newest gadget home from the store.

There's a lot to be said for the enjoyment and increased control having your own film scanner offers. But if you're planning to scan only 50 or 100 transparencies in a year, you really can save money by using a third-party service. Anyone who does have a sufficient quantity of work, or those for whom price is no object, should go ahead and buy a scanner. Everyone else should at least consider the other options.

## Delegate Overflow Workload

Sometimes you can't handle all the film you need to scan. Let's say that you like to fine-tune your scans and spend a lot of time tweaking the images so they're perfect. Unfortunately, you've got 100 slides to scan, and it will take you a few days to do even half of them to your satisfaction. Why not use a third-party to scan those slides that are basically sound, but that require some manipulation in Photoshop? A scanning service will do a good job capturing the images, and then you can devote your time to the part of the job that really calls for your skills, experience, and decision-making.

If you're faced with more work than you can handle, throw all your slides on a light table, like the one shown in Figure 7.1, and extract the ones that won't require special handling during scanning. Ship them out to a scanning service, and go back to work on the problem children that

**Figure 7.1** *Examine your slides on a light table to find the ones that can be scanned by an outside service.*

need special attention. You'll not only save time, you won't get bogged down doing scanning that doesn't challenge you. The price you pay the outside service is well worth it.

## Handle Bulk Jobs

Other times, you're faced with a mountain of scans that amount to much more than a simple overflow situation. Perhaps your Aunt Mary discovered 1,000 slides your dearly departed Uncle Joe took on that once-in-a-lifetime trip around the world in 1959. You don't have any personal use for all these images, but Aunt Mary is really looking forward to putting together a PowerPoint presentation she can burn to CD and send to everyone in the family. Do you want to invest umpteen hours scanning these slides yourself?

Maybe you've inherited a worthy but voluminous collection of transparency images that you would like to work with. Or, you're anxious to back up a huge archive of negatives so you'll have duplicates of precious images in case of fire, flood, or deterioration. When a truly mammoth job looms, using a third-party scanning service starts to look better and better.

Subcontracting the job can get the work done faster, more consistently, and with less wear and tear on your nerves. For the relatively modest price you'll pay, you'll be glad you had an option!

---

# WORLD'S LARGEST SCANNING JOB?

Some time ago, I visited the headquarters of a major railroad, based in Omaha, Nebraska, to document what was easily the largest scanning project I ever witnessed. An immense old eight-story building had been converted to a warehouse for millions of paper documents dating back to the 19th Century. The railroad sought to convert them to film for safe, permanent, and more compact storage. So, they bought dozens and dozens of document scanners, and trained a cadre of railroad workers who otherwise were facing layoffs to operate them. As each batch was scanned, the film was checked for quality, and then the old documents went into a chute that led to a railroad hopper car parked at the base of the building. They started at the eighth floor and worked their way down, taking several years to dispose of all those old documents. This was truly the mother of all bulk-scanning jobs!

---

## Require Custom-Quality Scans

There are some situations in which using an outside service to grab your scans can give you better quality than you can get alone. Perhaps your personal film-scanning tool of choice is a flatbed with 3200×3200 dpi optical resolution. As you learned in Chapter 4, flatbed scanners don't produce the same quality as a dedicated film scanner, even at equivalent resolutions. The flatbed works fine for capturing your run-of-the-mill slides, but you'd like a little more quality for some very special images. Or, suppose your personal film scanner has a resolution of 2840 spi, and you feel some film images could benefit from 4000 spi or higher resolution. Maybe there are a few scratches on your transparencies that would be cleared up by the Digital ICE or other special processing that your supplier has, but you don't. Find a scanning service that produces the quality you require and ship them the film you feel could benefit from the improved technology and expertise.

## Require a Special Size

Your film scanner does a great job on strips of 35mm film and 35mm slides. Now you have some 6×7cm transparencies to scan, or, maybe, a heavily retouched 4×5 film negative or transparency, such as the one shown in Figure 7.2. There's no way your faithful film scanner can handle either job, because it's limited to scanning film no larger than 35mm. Time to look for a professional scanning service that can tackle the chore for you at a reasonable price.

**Figure 7.2** *If your film scanner handles only 35mm film, you'll need an outside service to scan a 4×5-inch negative.*

Dedicated film scanners that handle all the sizes you're likely to encounter can be very expensive. Unless you must scan 120/220 rollfilm, 70mm film, and film sheets on a regular basis, it makes sense to turn to specialists. You'll pay more per scan, but you'll save money in the long run.

I did a quick search on the Internet, and found services that will scan 6×4.5, 6×6, or 6×7cm transparencies for $10 (medium resolution) or $15 (high resolution) each, plus $5 per CD to write your scans to optical media. Some of these services offered custom scans using a Scitex scanner for sizes up to 4×5, 8×10, or 11×17 sheets, at up to 8192 spi, priced by the finished file size, and ranging from $20 to $60 per scan. Files can be larger than 200MB, so if you're going this route make sure your computer, RAM, and storage system are up to the task!

## Need to Share Files

If you plan to share your images on the web, it might make sense to use a scanning service like those described later in this chapter. Many of them will post your images in "album" format so your family, friends, or colleagues can view them easily. You save the cost of web space to display the images, and avoid having to upload each of your scans one by one. Even if you have your own film scanner, using a third-party service can make sense when your destination is a web showcase.

# Choosing a Scanning Service

This next section outlines some of your options for choosing and using a scanning service for your film. You'll learn about some of the more popular services available, most of them aimed at consumers and amateur photographers, but all eminently suited for advanced amateur and even some professional applications. You'll learn about the general options most services offer so that your selection can extend beyond the vendors described here.

Please keep in mind that the organizations, their offerings, and even the terminology can change rapidly. For example, Kodak's Picture Center Online was formerly called PhotoNet Online. Fox Photo, which was once owned by Eastman Kodak Company, was purchased a few years ago by Wolf Camera, which in turn was acquired by Ritz Camera. So, today, you'll find that the Ritz and Wolf websites look remarkably similar. During the life of this book, the combined organization might become a single entity. Other suppliers I cite may themselves be acquired, change their names, modify the kinds of services they offer, or otherwise morph in ways I can't predict.

So, read the recommendations that follow with a grain of salt, and don't hesitate to conduct your own searches on the Internet when it comes time to choose your scanning service. Remember, in the digital imaging field, most change is good, so don't blame me for the march of progress!

# Kodak's Massive Umbrella

When I lived in Rochester, N.Y., Eastman Kodak Company was irreverently called the Great Yellow Father. For many picture-takers, the name Kodak has been synonymous with photography, so it's not remarkable that the company has extended its tentacles into so many areas of digital imaging. It's not even a new trend. More than 20 years ago, Kodak was active in machine vision and megapixel sensors (even coining the term), and helped develop some of the earliest multimedia applications for CD-ROMs (as Kodak Photo CDs) and some of the very earliest digital cameras. Some of the best scanners for film were first developed by Kodak for use by photofinishers, at prices that could be justified by operators of those little minilabs in your grocery store.

Kodak still relies heavily on its film and conventional camera business, but its emphasis has always been on pictures and the different ways you can acquire them. Indeed, all the digital imaging options available to you, either directly from Kodak or from more than 40,000 retailers aligned with Kodak, can be confusing. I'll try to help you sort them out, and will mention, in passing, some of the services you can choose from in addition to simple film scanning.

Besides its web-based Kodak Picture Center Online service, Kodak provides equipment and supplies to a variety of retailers so those companies can offer four different disk-based services—Kodak Picture Disk, Kodak Picture CD, Kodak Photo CD, and Kodak Pro Photo CD. These services can be applied to many types of film.

## Kodak Picture Center Online Services

For photographers looking to convert film to digital form, the Kodak Picture Center Online, shown in Figure 7.3, is an entry-level choice. That's because your finished scans are delivered to you over the Internet, and, because of the relatively low speed limits on the Information Superhighway, the images are somewhat lacking in resolution. Picture Center Online is a great choice if you want to share your photos over the Internet, but not so wonderful if you plan on downloading the images to your computer and doing your own editing.

**Figure 7.3** *Kodak's Picture Center Online is a one-stop source for prints, film scanning, and online picture-sharing.*

Here's how it works. Take your unprocessed 35mm or Advanced Photo System (APS) film to any of the zillions of retailers or mail-order photofinishers in the U.S. and request Picture Center Online service. Usually there is a box to check on the order envelope, so all you have to do is check an option and let the lab do the rest. You might, for example, request 4×6-inch prints (to pass around the water cooler), *plus* Picture Center Online services (so you can pass them around the *virtual* water cooler as well).

After your film is processed, the photofinisher will scan your film and upload digital files to the Picture Center Online. You receive your prints or slides back as usual, plus a Roll ID # that corresponds to your online photo pack. You can then log onto the Picture Center, view them in slide show fashion, crop and make corrections, or e-mail a link to friends and colleagues you think might like to view the images. You can also order calendars, greeting cards, and Picture CDs with the digital files, and purchase other items you will like and your photofinisher will love to provide.

Clearly, this is a consumer product that can be very handy for showing off your "new baby" or vacation pictures, but probably not what you're thinking of when you mull over using a third-party to scan your film. Kodak accepts JPEG uploads only, however. I'll describe some even more attractive options soon.

## Kodak Picture Disk

One step up is the Kodak Picture Disk service. This is another entry-level digitization service, although more suitable for pictures that are destined for web pages than those you'll need to

apply some serious image-editing muscle to. The Picture Disk is another one of those options you check when handing over your film for photofinishing. The film is scanned, and you get back a 3.5-inch floppy disk, which can store up to 28 images in 400×600 pixel resolution. That resolution is usable for web display, perhaps a PowerPoint presentation, or viewing on-screen in a slide show application. Don't plan on editing these images, or even making your own prints, unless you have a hankering for some wallet-sized photos.

The Picture Disk includes software you can use to view, print, or share your photos, do some simple cropping and rotating, create screen savers, or make quick-and-dirty presentations. Plus, the Picture Disks are eminently portable and, up until a few years ago, could be accessed almost universally by any computer you might encounter. Today, however, Picture Disks might be problematic for the following reasons:

- The supplied Picture Disk software runs on Windows PCs only. If you have a Macintosh, you'll need to use some other software to view the images, which are in a standard JPG format. Macintoshes that are equipped with floppy drives can usually view Windows-formatted media with aplomb.

- If you own a Macintosh that doesn't have a floppy disk drive, you're in a heap o' trouble. Unfortunately (or, actually, fortunately, considering the relative uselessness of the floppy these days), Macs built since 1998 aren't equipped with a floppy disk drive. If you require one of these dinosaur peripherals, you can usually find an external model that plugs into a FireWire port. There are better ways of exchanging information with Windows PCs (especially since so many PCs and Macs are now equipped with CD drives and burners).

- Don't be surprised to encounter a Windows machine with no floppy drive now or in the near future, too.

- Picture Disks are available only from color negative film, so slide-shooters are out of luck.

## Kodak Picture CD

Kodak Picture CDs are CD-ROMs containing your scanned images, and, like Picture Disks, can be ordered at the time you deliver your film for processing. With the Picture CD, we've left the entry level and reached a more acceptable quality level, with images that measure 1536×1024 pixels. You can do some image-editing in Photoshop or another editor on such images, and even make snapshot-sized prints.

The chief advantages of a Picture CD, shown in Figure 7.4, are the price (around $15) speed (roughly three-day turnaround), and the universal availability of the service from the zillion (actually around 40,000) finishers that deal with Kodak. A big disadvantage is that the service is available only for 35mm and APS color negative film. In

**Figure 7.4** *The Kodak Picture CD provides 1536×1024 pixel resolution.*

addition, the resolution (roughly 1000 spi for a 35mm film frame) is not what most serious photographers are looking for in scanned film images.

Picture CDs work like this: You deliver your film to the finisher and opt for a Picture CD along with your prints. The photos are returned along with your negatives, and a shiny new Picture CD that can be read in any Windows PC or Macintosh. Software for viewing, editing, making slide shows, wallpapers, and so forth, is included for both platforms. You can easily make 4×5-inch prints from the files using your own printer. In-store photo kiosks and the sophisticated printers at your photo-processing lab can usually make fine 5×7-inch prints from Picture CDs.

Each Picture CD contains images from a single roll of film (up to 40 exposures) and amounts to roughly 14MB in a compressed JPEG format. If you have a great many rolls of film (say, you just got back from vacation and exposed 20 or 30 rolls in two weeks), and don't plan on doing extensive editing of your images, Picture CDs are an inexpensive and convenient option. The index print supplied with the package, like the one shown in Figure 7.5, provides thumbnails of each image on the CD, so you can file your images by film roll and always know where to find them.

**Figure 7.5** *The index print inside this package makes it simple to find your images.*

## Kodak Photo CD

Now we're talking! The Kodak Photo CD (now called Photo CD Master) was the original version of Kodak's digital imaging media. Introduced in 1990, the Photo CD was quite a bit ahead of its time, which is a shame, because it was and remains a superior product that should have been adopted as a consumer and professional standard, rather than diluted down to the Picture CD and Picture Disks we have today. At least Photo CD has enjoyed more success than other formats, such as FlashPix, which was promoted by Kodak and then replaced with the Picture CD in the waning years of the last millennium.

The Photo CD was introduced with a lot of fanfare and accompanied by consumer products like players for viewing your pictures on your television. Such products were considered necessary because most personal computers still didn't have CD-ROM drives at that time, and were also doomed to failure, because nobody, then or now, wants to view their snapshots on television. We like passing around packs of photos, enjoy seeing pictures on our computer screens, and can acquire a taste for sending them through e-mail or displaying them on web

pages. But, despite over-enthusiastic focus groups that indicated otherwise, nobody was interested in buying Photo CD players for the home or office, and as a consumer product the format withered on the vine.

Professional photographers loved Photo CD, however, especially when a Pro version came along with encrypting features that help protect the image creator's copyrights. So, the consumer product Photo CD was transformed into a "professional" product. It's a format that's a serious option for anyone who wants digital versions of their film images, with enough image quality to be genuinely useful.

Photo CDs don't contain your garden-variety JPG or even TIFF files. Instead, pictures are stored on the CD in a special proprietary image file format called an Image Pac. The Image Pac concept is very cool. A single file, given a .pcd extension, stores the same image at five levels of resolution (six for the Pro version, described next). The resolutions of the standard Photo CD are 2048×3072, 1024×1536, 512×768, 256×384, and 128×192 pixels. Some sophisticated algorithms are used to derive the various resolutions from a single database of image information, so a particular photo can occupy anywhere from 3.5 to 5MB on the Photo CD, and a whole roll of 36 exposures amounts to about 145MB.

Most image-editing applications can read the PCD format, and will give you a choice of which of the available Image Pac resolutions you want to access when you open the image. Paint Shop Pro, Adobe Photoshop Elements, Microsoft Picture It!, Photoshop, and ThumbsPlus are among the applications that can read the format. When you open a PCD file with an application that accepts PCD file formats, you will see a dialog box like the one shown in Figure 7.6. It enables you to choose the resolution that you need.

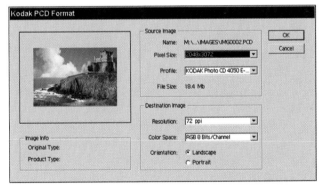

**Figure 7.6** *Your image-editing software's dialog box will allow you to choose the resolution you need.*

Here's a brief list of some of the pros and cons of Photo CDs. The pros are as follows:

■ Photo labs that offer standard Photo CDs accept 35mm and APS film in both negative and color slide varieties. You can use Photo CD as your format for all your 35mm photography.

■ Like Picture CDs, Photo CDs come with an index print that shows thumbnail images of each picture on the CD.

■ Unlike Picture CDs, you can add more photos at any time, so you can return a disk to the photo lab and ask that your next roll of film be included. A Photo CD can accommodate up to 100 pictures. Some labs will even scan and add pictures from film that is already developed, at a cost of $ .50 to $4 per picture.

■ Like Picture CDs, because Photo CDs are created at the time the film is processed, there is less likelihood that the scans will pick up dust and other artifacts that tend to accumulate once the processed film has been delivered to the photographer.

■ Considering the high resolution and flexibility, Photo CDs are not much more costly than Picture CDs. Many labs will supply them for about $25, with a reduced charge when you're adding pictures to an existing CD.

The cons are as follows:

■ Not all photo labs offer them, and Photo CDs can take up to a week or more for processing.

■ Although image editors can read Photo CD format, none of them can *write* the Image Pac format. Once you've extracted an image, at whatever resolution, from a Photo CD, if you make any changes you must save it in a standard file format, such as TIFF, or Photoshop's PSD format. The saved photo, of course, won't have the multiple resolutions of the original PCD file.

■ The standard Photo CD Master disk accommodates only 35mm images. (See the other Photo CD versions described next.)

## Kodak Pro Photo CD

Because it was originally envisioned as a consumer product, the standard Photo CD Master lacks a few features that professional photographers need. The Pro Photo CD is offered in two varieties: Photo CD Portfolio II, and Pro Photo CD Master, which offers an optional sixth level of resolution—an enormous 4096×6144-pixel image! Acceptable film formats for the Pro Photo CD Master include 120/220 film, 4×5-inch film, as well as 35mm. Depending on the film format and the images, the CDs can hold up to 100 images. The Pro Photo CD is also a rewritable CD, so you can continue to add images to the CD until it is full.

Professional photographers like some of the optional features of the Pro Photo CD, such as watermarking and encryption. Watermarking allows overlaying text or a logo on the image to protect it from unauthorized copying, whereas encryption prevents all access to an image unless the user has the special code required to unscramble the image. So, a photographer can

safely distribute a Pro Photo CD to clients, who can view lower resolution, watermarked images. Once they've made a selection and purchased an image, the photographer can supply the code that gives them access to the high-resolution version they'll use in their ad, publication, or other destination.

The Photo CD Portfolio II can include both Photo CD as well as other format electronic image files, and can include audio, text, and other graphics. Image Pacs don't necessarily contain all the possible resolutions, so a Portfolio II disk can accommodate as many as 700 images.

The six Image Pac formats are listed in Table 7.1.

**Table 7.1**  Kodak Digital Image CD Image Sizes

| Image Size | | | Print Size at 200 dpi in Inches | | Print Size at 300 dpi in Inches | |
|---|---|---|---|---|---|---|
| *Pixel Height* | *Pixel Width* | *File Size* | *Height* | *Width* | *Height* | *Width* |
| 128 | 192 | 72KB | 0.6 | 0.96 | 0.4 | 0.64 |
| 256 | 384 | 288KB | 1.3 | 1.92 | 0.8 | 1.28 |
| 512 | 768 | 1.1MB | 2.6 | 3.84 | 1.7 | 2.56 |
| 1024 | 1536 | 4.5MB | 5.1 | 7.68 | 3.4 | 5.12 |
| 2048 | 3072 | 18MB | 10.2 | 15.36 | 6.8 | 10.24 |
| 4096* | 6144 | 75MB | 20.48 | 30.72 | 13.65333 | 20.48 |

*\*Available only on Kodak Pro Photo CD Master*

# Fujifilm—Not Easy Being Green

Although Kodak totally dominated the US market for many years, and has long had a very strong presence in other countries, Fujifilm has been a well-respected supplier of film, cameras, and other products both in the United States and overseas. The familiar green box is found in as many locations as its yellow counterpart and, as you might expect, Fujifilm offers digitizing and online services that correspond fairly closely to Kodak's.

At **www.fujifilm.net**, you'll find a gold mine of information about the company's scanning, printing, and sharing services. You can access them in the same way described for Kodak's Picture Center.

The first step is to drop your film off at a photo retailer for processing. You can check the various options for the services you want, and pick up your order in a day or two. If you like, your film can be scanned and posted online, where you can view, crop, rotate, and edit it, adjusting colors, adding borders, or removing red-eye effects. The usual calendars, coffee mugs, enlargements, mousepads, puzzles, and posters are available. If you request your scanned images on CD, Fujifilm gives you a free copy of Picture It! Express, a simple photo editor you can use to make further enhancements to your images.

Although Fujifilm offers some nice touches (for example, you can display your photo albums on your compatible cell phone), most of its services are consumer-oriented. Lacking a high-resolution Photo CD option, Fujifilm's scanning and online services are distinctly entry-level offerings. Fujifilm has lots of products and services for the professional photographer. You can find out more about them at **www.fujifilmpronet.com**, shown in Figure 7.7.

**Figure 7.7** *Fujifilm offers lots of goodies at its professional photography website.*

# Using Mail-Order Photofinishers

Besides using the services of local photo labs, you can use the services offered by mail-order photofinishers. Many of them offer scanning services and can write your files to a CD-ROM. Most of these are of Picture CD, rather than Photo CD, quality. You can request mail-in envelopes for your film from a mail-order lab by visiting any of the following sites:

- www.agfanet.com
- www.ofoto.com
- www.shutterfly.com
- www.clubphoto.com
- www.photoworks.com
- www.mysticcolorlab.com
- www.yorkphoto.com

Note that web-based services like these come and go, are acquired by other companies, merge, or change their names, so not all of these URLs will be valid for the entire life of this book. I'm including these links because using a mail-order service can save you the aggravation of dropping off and picking up your film at a local photo lab. Simply put your film in a pre-addressed, stamped envelope and put it in your mailbox; you'll receive your CD with scanned images back a week or so later.

# Next Up

If you can't afford a dedicated film scanner, all is not lost. There are some other options you can use to scan your film quickly and easily. I'll show you how to cobble together some digitizing solutions in the next chapter.

# 8

# Do-It-Yourself Solutions

With prices for dedicated film scanners and film-compatible flatbed scanners so low, it's difficult to imagine anyone who can't afford to purchase the hardware they need to scan their slides, transparencies, and negatives. However, if you're in this boat, there *are* some surprising alternatives.

Perhaps you don't scan film often enough to warrant buying special hardware. Or, maybe you have some needs that aren't met by your current equipment. For example, you can scan 35mm film just fine, but have discovered a few 120 rollfilm transparencies you *really* need to scan. What can you do? There are a few gadgets you can buy that will help, and you can also jury-rig some solutions.

The important thing to remember is that some scanners, particularly those with CIS (contact image sensor) components, don't have the depth-of-field required to scan 3D objects (even flat 3D objects like transparencies). So, if your scanner was not designed specifically for scanning film, you'll want to check out its capabilities before attempting to scan slides.

This chapter shows you some of the do-it-yourself solutions, including some low-cost equipment you can buy, as well as a few items you can make yourself.

## Slide Copier Attachments

An easy way to digitize 35mm slides is to use a slide copying attachment or setup with your digital camera. The attachments are nothing more than holders for slides that let you take close-up digital photos of your images. Many digital camera makers offer these for their

cameras. Some are available from third parties, and you can make your own, too, if you have a digital camera that focuses close. Here are the major components you'll be dealing with:

- *Slide mount holder.* The most essential component of a slide copier is a slide mount holder that will grip the slide and keep it steady a fixed distance from the camera's taking lens. The slide must be absolutely parallel with the plane of the sensor; otherwise part of the slide will be out of focus. Ideally, the holder should be movable so you can adjust the distance between the slide and your lens. That will let you adjust the holder at a certain distance when you want to make a copy of the full slide, yet move the holder closer when you decide to crop and copy only a portion of the transparency. The slide should remain parallel to the sensor as it is moved back and forth. Those who have digital SLR cameras can find sophisticated slide copier devices that can do this, like the one shown in Figure 8.1, but they are likely to cost more than the least expensive dedicated film scanners.

Figure 8.1 *Digital SLRs can use the same slide copying gear available for their film SLR counterparts.*

- *Translucent light diffuser.* The light source that illuminates the slide from the back should be soft and diffuse. You can't simply shine a high intensity lamp through the slide. A naked bulb and its filament will create hot spots on the transparency, and might even show up as an image. In addition, raw, direct light is high in contrast and tends to accentuate dust and scratches. If the light first passes through a white diffusing material (such as milky glass or plastic), more even illumination results, and dust is minimized.

- *Close-up lens.* Depending on the capabilities of your digital camera, you might need a close-up lens or some other extra gear to focus closely enough. I'll describe these add-ons in a little more detail later in this chapter.

- *Light source.* A detachable electronic flash placed behind the light diffuser is ideal, but you can also use incandescent lighting if you set your digital camera's white balance properly.

## Buying One

The first place to look is the catalog of your digital camera vendor. Nikon and other manufacturers offer slide copying attachments designed specifically for their equipment. The attachment can include a close-up lens, or might work with your camera's built-in close-focusing capability. Expect to pay $100 or less for a slide copier attachment. The more popular

camera lines are also served by third-party sellers who design, make, or adapt equipment that works with specific camera models. You'll find general-purpose slide copier gear that works with nearly any digital camera, too, like the one shown in Figure 8.2.

Nikon's own CoolPix ES-E28 slide copier attachment fits a variety of Nikon digital cameras, and includes holders for both 35mm transparencies and negatives. Visit **www.specialtyphotographic.com** and you'll discover some versatile add-on slide copiers for Nikon CoolPix, Sony CyberShot, and Sony Mavica cameras. Specialty Photographic also offers an accessory negative carrier, so you can scan negative film as well as slides. If you have only $10 to spend, check out the Pocket Slide Copier at **www.bugeyedigital.com**. This device is little more than a holder/back illuminator for slides or strips of film, so you're on your own for mounting your digital camera and getting close enough (although the vendor does offer a close-up lens kit at additional cost). With this gadget and two AAA batteries, you're on your way.

**Figure 8.2** *A general-purpose slide copier attachment can be simple and flexible.*

# Making One

If you have a light table or light box and a tripod, you have most of what you need to make your own slide-copying setup. Here's what to do:

1. Make a frame out of black cardboard (or spray paint ordinary cardboard black) with an opening just large enough to hold a 35mm slide (or other transparencies that you want to scan).

2. Tape this frame to your light box or light table and mask out the rest of the light surface so glare doesn't spill through. You don't want extra light striking the lens and possibly reducing the contrast of your image.

3. Set up your tripod so the camera can be aimed at the transparency in such a way that the back of the camera is perfectly parallel with the slide. Some tripods let you invert the center post so you can place the tripod above the light box and point the camera downwards.

4. Place the slide in the frame you created, with the emulsion facing the camera. The orientation of the slide doesn't matter, as you'll be able to rotate it, flip it left to right, or whatever, in your image editor later.

5. Arrange your lighting (if necessary).

6. Move the camera and lens close enough to fill the frame with the slide using your camera's macro or close-up setting. Note that some digital camera formats don't correspond exactly to the 1:1.5 aspect ratio of 35mm slides, so if you're copying a slide with such a camera, you'll need to include some of the slide mount in the image, or crop out part of your

picture. Other film formats (such as 6×7cm) might correspond more closely to the image area of your digital camera.

7. Focus carefully on the center of the slide.

8. Use your camera's self-timer to trigger the exposure, to avoid shaking the camera when you press the shutter release by hand. Your camera might also have a remote control or remote release option.

9. Review the image on your camera's LCD display, and take several additional shots at different exposures, if necessary, to produce the optimal image.

## CLOSE-UP GEAR

Those who own digital SLRs have a wider choice of close-up gear to use, but even people with fixed lens digital cameras can add close-up lens attachments to their repertoire. Digital SLRs might be able to use extension tubes, bellows, or special macro lenses to get close enough to image a slide or transparency. Reversing rings enable you to mount your camera's lens so that the front of the lens faces the sensor. With removable lenses that weren't designed for macro photography, reversing the lens can produce sharper results and increase the magnification.

Although your digital camera might get you close, you might want to focus even more closely. That's why you might want to consider a close-up lens, like the one shown in Figure 8.3. Although they are called lenses because they focus light, these add-ons actually look more like clear glass filters with slightly curved lenses.

Close-up lenses fasten to the front of your digital camera's lens. Some cameras use a screw mount in a standard size (27mm, 38mm, 49mm, and so forth), whereas others require a special attachment for using filters and close-up lenses. Close-up lenses are labeled with designations such as #1, #2, or #3, which refer to a measurement of magnification that is called *diopter strength*. You probably don't want to bother with the math, but as a guideline, a lens that focuses down to one meter can focus down to 1/2 meter with a +1 close-up lens, down to 1/3 meter with a +2 close-up lens, and down to 1/4 meter with a +3 close-up lens. The actual magnification depends on the zoom setting of your lens, and the lens' normal close focus range. Close-up lenses can be used in combination to achieve the magnification you want. These lens attachments can provide macro focusing for digital cameras that ordinarily don't focus very close, and extra close focusing for those that do.

**Figure 8.3** *Close-up lenses can bring you to within an inch or two of your slide or other subject.*

# Scanner Light Sources

Another option for those who have a flatbed scanner that doesn't ordinarily have transparency scanning capabilities is to build a light source that can be used from above the scanner glass to transilluminate the slide. This solution can work very well in some cases, even though your scanner's main light source *under* the glass will still be operating during the scan. The key is to use a light source that overpowers the scanner's illumination, allowing the scanner sensor to read the light coming through the transparency.

Some clever solutions have been produced over the years. Figure 8.4 shows a pyramid-shaped gadget produced for Hewlett-Packard scanners that actually reflects the light from the scanner back onto a 35mm slide. The slide is placed on the scanner glass and covered by the mirror gadget. During the scan, the illumination from the moving light tube hits one mirror and reflects off a second mirror onto the slide. This method works surprisingly well, and you might consider building one of your own. These devices work best with Hewlett-Packard scanners, for technical reasons having to do with how the scanner captures light.

**Figure 8.4** *Bouncing the scanner's own illumination back through a slide can work.*

Other external light sources that feature a bright, diffuse light have been built. Figure 8.5 shows an example of a moveable light source that can be placed over slides and used to illuminate them with a flatbed scanner. The key is to have a light that is strong enough to overpower the light from the scanner itself.

**Figure 8.5** *External light sources, either made yourself or purchased commercially, can turn an ordinary flatbed scanner into a film scanner.*

You can also build a light source yourself. Here are some tips:

■ Choose a light source that is diffuse and very strong. A high-intensity desk lamp is not diffuse, and probably not strong enough. Think about using one of those high-powered portable shop/area lights.

■ Use a diffuser, such as milky plastic, that will spread the light evenly over your transparency.

■ Your scanner is probably balanced for daylight color illumination (see Chapter 9 for more on color balance), so any incandescent light you use will produce orangish scans. You can often counter that by placing a blue filter on top of your diffuser. However, it's a better bet to simply use a daylight balanced light source (such as fluorescent lights with 5500 to 6000K bulbs placed very close to the scanner).

■ Use the highest optical resolution available for your scanner. You might want to experiment with interpolated resolutions, too. Scanners not designed for scanning film might not have the resolution required.

# A Special Case

Although the product is a little hard to find, the Lightshow 3D Object Scanning System deserves a special look. At $399 it's not a cheap solution, but it can do so much more than simply scan transparencies that serious photographers will want to know about it.

Lightshow is a combination light source/diffusing hood that fits on top of your scanner glass, providing a versatile source of illuminating for photographing slides, transparencies, and a variety of 3D objects. It actually turns your flatbed scanner into a miniature photo studio, ideal for all kinds of small product photography. It's been tested with scanners from Agfa, Epson, Umax, Microtek, and other vendors. You can find this device, shown in Figure 8.6, at **www.pubperfect.com/fgk.**

**Figure 8.6** *The Lightshow 3D Object Scanning System is perfect for scanning slides and other 3D objects with a flatbed scanner.*

# Next Up

By this time, you should know everything you need to make great scans. The next part of the book shows you how to make great images. I'll kick off the festivities with the next chapter, which introduces you to the concepts that will help you fine-tune your scans.

Now that you've mastered scanning, it's time to turn those great scans into great images. This Part tells you everything you need to know to fine tune your scans, enhance them with special effects, and put them to work on web pages, in your e-mails, and in projects like greeting cards. You'll also learn how to collect your images into albums and share them with friends, either directly or online.

# PART II

## Making Great Images

# 9

# Introduction to Image Enhancement

Scanning film is both a challenge and an opportunity. It's a challenge because you'll obviously want to capture every bit of detail available in an image, in order to preserve the photograph that's hidden somewhere in those grains of silver halide or dye. Scanning is also an opportunity, because the scanning stage is your best chance to fix some of the problems an image displays, in terms of contrast, color, or sharpness.

Obtaining the best scan possible should always be your goal. Image capture always begins in analog mode, which means the scanner has an infinite number of gradations in tone or color available before the photograph is locked into a digital format. It's only within the scanner's software that you have any control over which of those variations is applied to each pixel in the scanned file. After that, you must work with the digitized image and the relationships between pixels that were established in the conversion from analog to digital—for better or worse. So, image enhancement always begins at the scanning stage. Chapters 5 and 6 provided you with some guidelines for scanning film with dedicated film scanners, as well as with flatbed and multipurpose scanners.

However, there's always room for improvement, both in scanning and after the scan when it comes time to work with your image within your favorite image editor. This chapter goes into more detail about some of the parameters you can control in scanning, and provides an overview of some of the most important kinds of changes you can make both during scanning and, later, while refining the image in Photoshop or another image editor. So, the things you

learn here about contrast, color correction, and other aspects of an image apply to the following chapter, "Fine-Tuning Your Scans," too.

# Image Quality Basics

A photographic image looks good because all the components that make up the image are arranged in a pleasing way. Some of the factors, such as composition and subject matter, are within the control of the photographer and are difficult to change later. The way a picture is framed, the subject matter contained within it, and the basic lighting used to illuminate the photo are locked in at the moment the photo is taken. Certainly, you can use heavy-duty retouching and compositing techniques to perform gross surgery on an image. You can modify the effects of the lighting, completely remove your undesirable ex-brother-in-law, or deposit the Eiffel Tower into the center of Times Square, but total transformations like these are the exception, rather than the norm.

Other attributes of an image, including sharpness and the amount of grain (or noise, in the case of digital photos), are most heavily influenced by the film or the characteristics of the sensor. A select few factors, such as brightness, contrast, color, and saturation, are affected by a panoply of causes, ranging from film (or sensor) characteristics, lighting, exposure, and, for film images in the end, how the film is scanned.

## Resolution

Resolution determines how much of the detail in the film is captured in the scan, up to a point of diminished returns. For all film images there is a point at which additional resolution doesn't really buy you much in the way of image quality, so you need to learn just how much resolution you really need for the job at hand.

If you're scanning film on a flatbed scanner equipped for that task, you might want to scan a 35mm slide at 600×600 spi if you're going to use it for nothing more than display on a web page. It's unlikely that extra detail will show up once the image is resized down to a maximum of, say, 600×400 pixels for your website. Figures 9.1 and 9.2 show how a 35mm slide scanned at a higher resolution yields no additional useful information.

If you plan to do serious image editing, cropping, or other manipulations, you'd up the ante to the maximum optical resolution of your flatbed, such as 3200×3200 spi. In some cases, higher *interpolated* scans (you can find out about interpolation in Chapter 2) might be useful.

Dedicated film scanners also give you a choice of resolutions, so you can select a lower-than-max resolution for lower-than-max requirements. After all, resolution also determines the size of the scanned file, so if you truly have no need for a high-res scan, there's no need to waste the time and hard disk space.

**Figure 9.2** *At 2820 spi, all the extra resolution buys you is a closer look at the grain, sharper dust spots, and confirmation that the original photograph was a little out of focus.*

**Figure 9.1** *A scan of this 35mm slide at 600 dpi yields a picture good enough for display on a web page, or for making small prints.*

Higher resolutions, typically up to 4000 spi or higher with film scanners, capture all the details in the film, within limits. Here are some of the factors that can limit the usefulness of a higher resolution:

- *Film grain or dye clusters.* These are the "pixels" of film images and consist of tiny groups of silver halide grains (in the case of most black-and-white films) or collections of cyan, magenta, and yellow dye (in the typical color film). Once you magnify a film image to a point in which these artifacts become visible, boosting the resolution further will provide no additional useful information. With grainy films, that point can come sooner than you might think.

- *Curved film.* If the film isn't perfectly flat in the film holder, and the holder isn't absolutely parallel to the optics, resolution can suffer. Most film scanners are designed with precision holders and rock-steady film paths. However, mounted slides tend to have a curvature that can't be entirely compensated for by the scanner's design or (with luck) generous depth-of-focus. Mounted film tends to "pop" to a more pronounced curve when heated.

- *Intended destination.* If your scanned image will be printed in small sizes, subjected to halftone screening for publication in a book or magazine, or displayed on the web, you probably won't notice the difference between a 2840 spi scan and a 4000 spi scan.

■ *Your scanner's anti-dust/artifact processing.* Low-cost film scanners sometimes have options for reducing the effect of scratches and grain that do little more than slightly blur the image. Obviously, that will affect your true resolution. More expensive scanners include Digital ICE, Digital ROC, or Digital GEM enhancements, and high-end software like SilverFast (with its SF SRD Dust and Scratch Removal features) can also process your image before it is saved on your hard disk. These sophisticated solutions are supposed to retain the original image's resolution, but even the most intelligent algorithms can affect sharpness as they do their job.

# Image Tones

The number of dark to light tones in an image is important. This is true whether we're talking about a black-and-white negative, or a color transparency or color negative. The chief difference is that in a color image, the dark to light tones can be considered for the entire image, or for each of the individual color layers separately. Because, when you're considering brightness only, all values for tones fall into a continuous spectrum between black and white, it's easiest to think of a photo's tonality in terms of a black-and-white or grayscale image.

With film photography, grayscale images like those produced by black-and-white negatives seem to be easy to understand. A negative appears to be a continuous range of tones from black (in the negative's highlights) to white (in the shadows), and all the grays in-between. But, that's not exactly true. The blackest black in any negative isn't a true black, because most films don't block all the light transmitted through them. Hold a negative up to the light and you can see through even the completely "black" edges of the film.

Nor are the clearest parts of the film 100 percent transparent. Even black-and-white film base has a small amount of density in its unexposed parts. In either case, the goal of the photographer is not pure blacks or whites, but, rather, dark shadows that still retain some detail, accompanied by highlights that also have detail and aren't completely washed-out. Plus, you want a good range of tones in-between the two limits.

Of course, once your film image is digitized, it's no longer truly continuous. An analog watch might have a full 360 degree sweep to mark off the seconds, but your digital watch is limited to the values from :00 to :59. The same applies to your scanned image. The grayscale "spectrum" is reduced to 256 tones, ranging from black, with a value of 0, to white, with a value of 255. All the other tones must be assigned to one of the remaining numbers.

So, the number of tones in your scanned image will depend, first, on how many were captured in the original photograph. Exposure, processing, or the characteristics of the film itself help determine the tonal range of the film you will be scanning. After that, the tones captured depend on the dynamic range of your scanner (see Chapter 2 for more on dynamic range), and on the settings you use during the scan.

# Brightness/Contrast

The number of tones is important, but the distribution of them is of equal value. If too many dark tones predominate, the image might appear to be too dark overall. If the tones are

weighted toward the light tones, the image might be too light. Worse, the tones might be arranged in such a way that the contrast of the image is affected. When all the tones are concentrated in one place on the tonal scale, the image has low contrast. When there are fewer tones, spread out, the image might have too much contrast. Contrast isn't always a bad thing, as you can see in Figure 9.3, but you'll want to be able to control it.

**Figure 9.3** *Sometimes contrast can enhance a photo, if you know when to add it.*

# Color

Color is the third factor you can control during scanning. Color is the relationship between the three hues used to produce your image; with a scanner they are the red, green, and blue colors captured by the sensor. Adjusting the relative amount of each of these primary colors isn't enough. There are actually three factors you'll need to be concerned with:

■  *Color proportions*. Full-color images generally contain at least a little of each of the primary colors. The proportions of those colors determine whether the photograph is lifelike, or plagued by a color cast. If you have too much red, the image will appear too warm. If you have too much green, it might look sickly. Extra blue can give a chilly look to a photograph. Other color casts are produced by too much of two of the primary colors, compared to the remaining color. For example, too much red and green produce a sunny yellowish cast, red and blue overdoses tilt things toward magenta, and blue and green create a cyan bias.

■ *Color saturation or richness.* Saturation is how much of the hue is composed of the pure color itself, and how much is diluted by neutral density, or gray. Your scanner software and image editor can help you adjust the saturation of a color by removing the neutral component.

■ *Color brightness and contrast.* As with monochrome images, the brightness and contrast of individual hues can affect an image, with the added dimension of color. If there are only 12 red tones in an image, ranging from very light to very dark, with only a few tones in-between, the red portion of the image can be said to have a high contrast. If you had 60 or 100 red tones, the reds might appear to be relatively low in contrast. The brightness is determined by whether these available tones are clustered at the denser or lighter areas of the image. If 80 percent of your red tones are dark, the reds in your image will be dark, regardless of whether there are 12 of them (high contrast) or 100 of them (low contrast).

# Who's to Blame?

When you have to spend hours correcting color in your scans, you'll probably spend at least a few minutes wondering whom you should kill. Are these color problems your fault? Was it the film? Did the photo lab make a mistake? Is your scanner a lemon?

It might be difficult to determine that an image has color problems if you're working with color negatives, because the colors are reversed and the orange mask tends to disguise the differences. If you're working with transparencies, the problems might be readily apparent, particularly if you're viewing the transparencies on a light table with 5000-5500K (color temperature) illumination and a decent CRI (color rendering index)—see the sidebar that follows for more information about these terms.

Color problems in film images can have several causes, ranging from the film you chose, the light source, or even the lab that processed your film. If you're shooting film now and intending to scan it later, you can save yourself a lot of work by making sure that none of the factors listed next conspire to give you bad color. Follow these guidelines for best results.

## Freaky Illumination

The number one cause of bad color is problems with the illumination. The light might be the wrong color, be mixed, or be missing some crucial portions of the visual spectrum. In any of these cases, the result will be improper color balance. Some of these hitches are easy to prevent or fix. Others are easier to prevent than fix.

### White Balance

No, film cameras don't have the white balance control that digital cameras do, but they experience the same problems with light sources that are too warm or too cold compared to the standard color temperature the films were created for.

Historically, both color transparency and color negative films have been created to expect illumination of a particular color temperature (see the following sidebar for more information

# 5000K AND CRI?

In photographic terms, 5000K means a lot more than a really, really long running event, and CRI is not a television show. Now that you're scanning slides rather than just viewing them with a slide projector, you'll probably want to be more particular about how you view them for evaluative purposes. Color temperature (measured in degrees Kelvin—thus the K) and color rendering index (CRI) are two things you need to know about.

The best way to sort slides and transparencies is through the use of a light box or, if you have a lot of them, a light table. Both consist of a translucent, milky-white diffusing material on which the transparencies rest, illuminated from behind by fluorescent lights. Unfortunately, many fluorescent lights are the wrong color, perhaps too yellow, or too green, or with some other color cast. In addition, fluorescents frequently emit light that is not continuous throughout the entire spectrum. Certain shades of red or other colors may be deficient or missing entirely.

For your viewing pleasure, the illumination should be the right color, generally in the 5000-5500K range that corresponds to daylight. (The Kelvin figures are arrived at by calculating the actual temperature of a mythical object called a *black body radiator* as it progresses from red-hot, perhaps 2000-3000K to white-hot at 11,000K or more.) Daylight illumination not only makes the colors appear to be natural, but also provides a standard we can use to ensure that others who view our pictures use illumination with the same color temperature we did.

A proper color rendering index ensures that the illumination has the right proportions of colors. A light source that looks white to our eyes, but which lacks, say, certain portions of the red spectrum, will portray objects that happen to be those colors inaccurately. That's why you can get a sickly green cast when taking photos under certain kinds of fluorescent lights. CRI values are measured on a scale from 0 to 100, with a light source of 100 having a full spectrum with all the colors. For best color viewing, your light source should have a color rendering index of 90 or more.

on color temperature). Daylight-balanced films are meant to be exposed under ordinary daylight conditions (roughly 5500K) or electronic flash, which has the same color temperature. Back in ancient times there were even "blue" flashbulbs (sort of a one-time-use type of flash) with this color balance.

Other films are balanced for tungsten illumination, which can include ordinary household lamps or, if the photographer wants to use a more precise light source, special photographic tungsten lamps that provide light at either 3200 or 3400K. Professional photographers use these films to avoid having to use daylight film and a filter when exposing under tungsten lights. Available films include Ektachrome 64T, 160T, and 320T Professional (balanced for 3200K), and similar films from Fuji or others. Color negative films, such as Kodak Professional Portra 100T film, are also available with a tungsten balance.

Various Kodachrome films have traditionally been the choice for 3400K illumination, but, sad to say, Kodachrome itself is dying out as a film choice. Many photographers still lament Kodak's decision to discontinue Kodachrome 25 Professional film, which was unmatched for sharpness, fine grain, and accurate colors.

*Figure 9.4  Daylight-balanced films exposed under incandescent lighting end up with an orangish cast.*

Even if you don't plan to set up your camera in a studio and shoot under incandescent illumination, color temperature problems can plague your picture. If you expose your film using light that is "wrong" for your film, a strong color cast is sure to result. Daylight films exposed under tungsten light have a reddish-orange cast, as you can see in Figure 9.4. Tungsten films exposed under daylight have an overpowering blue look. There might not be a lot you can do to correct this problem with transparency films during a scan. Removing the extra red or blue can leave you with a flat, grayish image, for reasons we'll look at in more detail in the next chapter. Color negative films might be correctable. The best option is to avoid the problem in the first place and always use the correct film for your available light. Color-compensating filters can help if you find yourself with changing light sources.

## Mixed Light Sources

Mixed light sources are even more of a nightmare than using light of the wrong color temperature. When you mix light sources you end up with part of your photograph exposed by light of one color, and part by light of another color. This kind of disaster can occur in the following situations:

- You wanted one of those romantic portraits photographed by soft window light, so you positioned your subject near a window. Perhaps you thought you were being clever by using a nearby lamp to fill in the shadows of your subject on the side not illuminated by the window. Instead, one side of your victim's face is bluish, and the other side is reddish.

- You pointed your camera's flash at the ceiling or a nearby wall to get a softer, bounce-flash look that's more attractive than harsh, straight-on direct flash. You didn't notice that the surface has been painted a medium mauve. Mixed with other light in the room, the results are atrocious.

- You used direct flash, but the area behind the subject is too far away to be illuminated by the flash. If the room's ambient tungsten illumination is strong enough, you might end up with a normally exposed and balanced subject standing in a room that's orange- or green-tinted, as in Figure 9.5.

- You shot a portrait at sunset. Your subject looks positively blue compared to the reddish look of the surroundings and sky.

**Figure 9.5** *Exposed by electronic flash, the girl in the foreground is properly color balanced, but the shutter speed was slow enough to let the overhead fluorescent lights produce a green tinge in the rest of the picture.*

- You set up a still life on a table top, carefully placed your lamps, and remembered to use tungsten-balanced film. You forgot about that window in the background, which provides an unwanted blue accent.

Unless you want to claim you were looking for an arty shot, or are prepared to painstakingly color-correct portions of your image individually in your image editor, your best bet is to avoid these situations.

## Fluorescent Light Source

Incandescent light sources and daylight provide a continuous spectrum of colors, even though that spectrum might be biased toward the red or blue ends. That's not necessarily the case with fluorescent lights, which produce their illumination not through their temperature (fluorescents don't burn hotter or cooler) but, rather, by electrons bouncing around causing phosphors coated on the insides of the tubes to glow.

So, the colors found in fluorescent illumination depend primarily on the kinds of light emitted by those phosphors. In many cases, these lights don't produce a full spectrum, but instead emit light that is deficient in certain colors. You might not notice the lack, but your film does. Remember, a "full spectrum" means that *all* colors are present, not just the red, green, and blue used by electronic devices. A fluorescent light might have the right balance of some colors to

*look* white, but might be missing, say, enough yellow to make your still life of a pile of lemons look a little weird.

Fortunately, there are filters that can fully or partially correct for this problem. You can use a general-purpose FL-D (fluorescent-daylight) filter with daylight-balanced film when you shoot. If you know exactly what kind of bulbs are present, so much the better. You can also experiment with various strengths of magenta filter to compensate for an oddball fluorescent light. You might be able to make some corrections during scanning or editing, but the best route is to avoid the problem entirely, as you can see in Figure 9.6.

**Figure 9.6** *Fluorescent lighting and no filter can yield a greenish rendition. Pop on an FL-D filter and reshoot, and colors look natural again.*

# Freaky Photofinishing

It's every photographer's nightmare. You've shot 100 rolls of irreplaceable film, and then something bad happens in the photo lab. Perhaps it's one of those rare events, such as a jam in the processing machine transport that eats a couple rolls of film. The lab might have gotten sloppy with replenishment so all the chemicals aren't up to snuff and your pictures end up with poor color. Or you might find that a particular lab consistently provides process film that is infested with dust or scratches due to sloppy handling.

Not all these events produce bad color, but if any of them happen at your lab consistently, it's time to change labs.

## Mistreatment of Film

If you work at it hard enough, you can ruin your film before you even have it processed. All films are light-sensitive (of course), but can be "exposed" by events other than direct exposure to light. Heat is a major culprit, and another is old age. If you store your film in the glove compartment or trunk of your car for a period of time, you're likely to end up with fogged film and bad colors, as shown in Figure 9.7. If you take a year or longer to finish a roll of film, use outdated film, or don't process your film promptly, the result can be a nasty purple cast, rainbow-hued flares, or fogging. Film can pick up small doses of X-rays each time you pass through a security checkpoint while traveling, and these can accumulate to the point of fogging your film. Checked luggage is also subjected to X-rays, which damage the most sensitive films more quickly. These are the sorts of damage that can't be corrected by the lab, in scanning, or through the most valiant image-editing efforts.

As a photography buff, you are probably careful to avoid disasters like these, but you still might stumble across an old roll of film you forgot to have processed, or be given someone else's film to work with and discover that they were less careful with their images than you usually are.

**Figure 9.7** *Improper storage of unprocessed film can yield fogged images like this.*

## Faded Colors

The dyes used in color transparencies, prints, and negatives aren't entirely stable, and will fade over time. The process is accelerated when the images are exposed to strong light or heat for long periods of time. Hanging a print in a sunny place for a period as short as a few months can produce a faded, magenta-colored oddity (the color cast is caused by the magenta, yellow, and cyan dyes fading at different rates). Color transparencies and negatives can also change color over time, and are also subject to other maladies, such as mold and other nasties that enjoy the taste of the film's emulsion and dyes. Figure 9.8 shows an uncorrected scan of a 25-year-old Ektachrome color slide that has lost a lot of its cyan layer due to fading over time.

Storing your film in a cool, dry, dark place can postpone (although not prevent entirely) the inevitable changes. But when faced with a *fait accompli*, you might be able to fully or partially correct for the fading digitally during scanning or in your image editor. It is sometimes possible to "add" missing colors by reducing the amount of the other colors in the image.

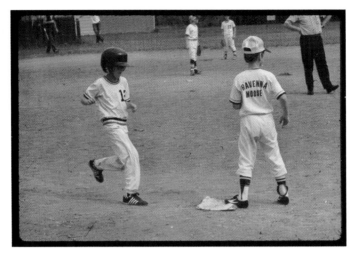

**Figure 9.8** *Although kept in cool, dark storage, this 25-year-old slide has faded.*

# FREEZE!

While exposed and processed film should be stored in a cool, dry place, your unexposed film can benefit from even more special treatment. Professional photographers buy their film in large lots (called "bricks") and freeze it to preserve its characteristics over the long term. Just before use, the film will be thawed and refrigerated. That way, the pro will have a supply of film with predictable colors and speed; if all the rolls are from the same emulsion batch each will be consistent when exposed and processed. The film should be frozen in airtight containers to avoid moisture problems, of course. (The original film packaging should provide enough protection.)

The complication comes from the difference between professional and amateur films. All films begin to age after manufacture, so their characteristics change slightly up to the time they are exposed and processed. Professional films are designed so that they are sold very close to the time when they reach their peak characteristics (and they're refrigerated at the camera store or professional supply house before being sold to the photographer). On the other hand, amateur films are designed to take the normal aging process into account, with the understanding that the films are likely to sit on the shelves at retailers for an average amount of time, and remain in the amateur photographer's possession for a given amount of time before processing. Tiny variations in color and speed are unlikely to be noticed by amateurs. You'd need to take pictures of identical subjects using two different rolls of film (as pros often do) to notice any variations. So, freezing amateur photographic films for storage is unlikely to provide any benefits. Instead, it's a better idea to store amateur film in a cool place to allow the normal aging process to continue. An exception to this would be if the film is approaching its printed expiration date. In that case, amateur films can be successfully frozen to keep them "good" virtually forever.

## Ultraviolet Blue Effect

Some fabrics appear "whiter than white" because they reflect every possible bit of light, including massive amounts of ultraviolet that your film is sensitive to. A garment such as a wedding dress that is supposed to be a glorious neutral white might photograph with a distinct blue cast. Our eyes don't detect the bluish light, but the film records it with alacrity, thanks to the "whiter than white" brighteners put into wedding gown fabrics. Wedding photographers have to deal with this effect all the time. Electronic flash and a white wedding gown can easily produce this undesirable look, as you can see in Figure 9.9.

Fortunately, you can often correct for the blue bias during scanning or later on in your image editor. The fix involves warming up the photo with additional red, but that's rarely a problem with the human subjects who are likely to be wearing the blue-tinged clothing. Human skin often looks healthier with a little added warmth. Certain dyes, including those found in nature, can produce similar false colors. If your floral photos or pictures of road tar (if you're into that) exhibit odd hues, now you know why.

**Figure 9.9** *White garments that reflect ultraviolet light can appear too blue in some situations.*

# What Can You Do About Bad Images?

Fortunately, there are lots of things you can do to fix bad images, as you'll learn in the next two chapters. Some problems can be resolved by re-scanning. Others call for manipulation within your image editor. Many can be resolved easily in a few minutes with tweaks of a few controls. In the worst case, you might find yourself spending hours slaving over an image and wishing that it could simply be re-shot.

The remedies you can apply involve both defects in the film original itself, like those we've discussed in this chapter, as well as problems with how the image was visualized and produced (which includes poor composition). The follow section offers a quick summary of both kinds of problems.

Defects in the film original include:

- *Resolution:* If the problem lies in a scan that doesn't have high enough resolution, you can re-scan. If the film doesn't have the detail you want, you can apply your scanner software's Unsharp Masking tool, or sharpen the image in your editor. Neither option actually provides more detail, but they can make the details that are available more readily visible.

■ *Image tones:* Tonal range can often be improved with your scanner software's histogram or curve controls, or the equivalent tools in your image editor.

■ *Brightness/contrast:* Your scanner or image editor can help you redistribute the tones of images that are too light, too dark, or have too much/too little contrast.

■ *Color:* Unless your image is overwhelmed with a major color cast, you can often make adjustments for tints.

■ *Freaky illumination:* Mixed color or off-color images caused by a bad combination of light sources can sometimes be fixed in an image editor if the problems aren't too extensive. For example, you can crop out the worst parts or select them and apply localized color correction.

■ *Freaky photofinishing:* There's not much you can do about photofinishing that has damaged your film if the result is streaked, scratched, or fogged film.

■ *Mistreatment of film:* Badly treated film is as difficult to fix as film damaged by the photofinisher. Let that be a lesson to you!

■ *Faded colors:* If one or more dye layers have faded slightly, it's often possible to replace the missing color and restore the image to its former glory. Badly faded images are often a lost cause, although they can often be turned into interesting black-and-white photos!

■ *Dust and artifacts:* Your scanner might have special features to reduce dust and artifacts in your images. There are lots of things you can do within your image editor to minimize these problems, too.

Other kinds of defects you can fix using an image editor include:

■ *Bad compositions:* Sometimes a little cropping is all you need.

■ *Damaged photos:* Although scanners do a good job "removing" dust from film, there's little they can do about pinholes in the film, deep scratches in the emulsion, and other kinds of damage. However, image editors have cloning tools that let you paint right over these defects with the surrounding image area, providing a nearly invisible patch.

■ *Unwanted objects:* Trees growing out of heads, uninvited guests in group shots, and a fire hydrant marring an otherwise beautiful picture of your home can also be retouched out if you're willing to spend a little time at it.

■ *Missing objects:* Photo compositing techniques let you *add* objects to photographs that weren't there in the first place, whether one of your loved ones was unavailable during that group shot, or you've fancifully decided to add the Grand Canyon to a vacation photo taken in North Carolina.

■ *Too realistic rendition:* One problem that portraits sometimes have is that they look too much like their subject. Image editors let you strip 20 years from your world-weary spouse's face, or remove those braces from your teenager's teeth.

■ *Blah appearance:* Some pictures just don't sparkle. Fortunately, image editors include a huge selection of filters and other special effects that can turn a shoebox reject into a triumphant prize-winning photo. And performing blatant transmogrifications on images can be a lot of fun, too!

Figure 9.10 is the most blah-looking photo I could find. It was taken with the camera mounted on a tripod in an informal test of the sharpness of a new film I was trying out. (A secondary goal was to show my teenage son why I bought him that paintbrush as a graduation gift.) After a few minutes savaging the photo in Photoshop, I arrived at the image shown in Figure 9.11. It might not be a triumphant prize-winner, but, unlike the original, it might prompt you to stop, look at the photo, and wonder, "What was he *thinking*?"

**Figure 9.10** *Nothing could be more blah than this photo of a peeling post.*

**Figure 9.11** *Special effects can add a certain amount of interest that wasn't there in the original photo.*

# Choose Your Weapons

If you're serious about fine-tuning your images, you should be serious about the software you use. Anyone who wants to perfect their images or perform manipulations beyond simple color corrections and cropping needs to invest a little time in acquiring a suitable image editor and learning how to use it.

Certainly, you don't have to plan on spending hours working with each image. Even dedicated photo hobbyists have many photos that they simply want to scan and use with a minimum of fuss. For those kinds of images, the automated tools built into the software furnished with your film scanner will work fine. Many image-editing applications, like Adobe Photoshop Elements, give you the best of both worlds. They contain wizards that can fix red eye, correct colors, adjust tones, and perform many other simple tasks with little input from you. Yet, under the hood you'll find more powerful tools that let you edit your images more extensively.

This section provides a quick summary of the software that's available, and provides some advice that will let you choose which application is best suited for you.

# Upgrade Your Scanner Software

The software furnished with most scanners is designed to provide you with decent scans with minimum work on your part. The goal is to make the scanner as easy to use as possible for beginners, and let more experienced workers scan quickly and efficiently. After all, if a scanner is very difficult to use, many potential buyers will be put off. Basic scanner software is crafted to help sell scanners, and not necessarily to provide you with the best possible scans.

However, you might be able to upgrade from the basic software to a more advanced application that can do more and do it better. Your software options might already come bundled with your scanner, or can be purchased from a third party at a reasonable cost (considering the features you get).

## A Simple Upgrade

Many scanner vendors provide multiple scanning applications in their scanner bundle, with the option to install one or all of these packages during the initial installation. You can go back and add software later if you find you need it. These applications fall into several neat categories:

- *Basic scanning software.* These packages are provided as standalone programs that can be launched manually or by pressing a button on your scanner. Or, the basic software can be accessible from within your image editor's File > Import menu. In all cases, the package is likely to be wizard-driven, so all you need to do is click a few buttons and let the software perform a prescan, select your image, perform simple corrections, and complete the scan. There might be few, if any, settings for you to fiddle with. Such software is more frequently provided with flatbed scanners rather than dedicated film scanners, and if the flatbed is capable of scanning film there might be no specific features for film scanning.

- *Work center software.* Many flatbed scanners have a work center "all-in-one" scanning application that integrates all the features of the scanner, allowing you to scan to a file, scan an image and direct it to your printer in photocopier-like mode, or send an image to another destination. The application is usually a standalone program that you can launch directly or by pressing one of the "one touch" buttons on the front of your scanner. Although they are handy, these task integrators offer little extra to those who are scanning film.

- *Semi-manual scanning software.* Better flatbed scanners and all film scanners come with a more advanced scanning application that lets you set many parameters on your own, and control any special features (such as dust control) your scanner has. Whether launched as a standalone program or accessed through your image editor's menus (many of these applications can function in both modes), this software will also include automated features for correcting color, choosing a recommended resolution, setting focus (for film scanners), and making other settings. This kind of software will handle most of what needs to be done.

Often, the software provided with scanners will be "lite" versions of full-featured applications you can buy from third parties. Epson, for example, provides SilverFast SE, itself with a lot more power than most scanning apps you'll use. It can be upgraded to SilverFast AI, discussed later, which is truly a professional-level scanning application.

## Third-Party Solutions

A small number of third-party companies make scanning software you can purchase separately from the scanner itself. These include general-purpose scanning applications like Jetsoft Development Company's Art-Scan Pro, and Hamrick Software's VueScan. The latter, for example, works with a long list of reflective and film scanners, including models from Nikon, Minolta, Epson, Canon, and others.

Others are specialized applications that perform a specific function, such as document management, optical character recognition (to convert text documents into Microsoft Word files), and mimicking a photocopier or fax machine. As you might guess from the list of functions, none of these is particularly suitable for film scanners.

At the high end of the third-party scanning applications are programs like SilverFast AI, which offer truly professional capabilities.

## VueScan Professional for Mac OS X, Windows, and Linux

Priced at less than $80, VueScan is inexpensive third-party scanning software that supports many (if not almost all) current film scanners, and several flatbeds too. Visit www.hamrick.com and if your scanner is supported, try the free trial. There are versions for Windows, Mac, and Linux.

VueScan is particularly adept at handling color negatives, and supports advanced features found in film scanners such as autofocus, multiple scans to reduce noise, infrared dust and scratch suppression, and other capabilities. It includes profiles for correcting the orange mask

in more than 200 film types. A standalone program, VueScan is fast (often faster than the software that came with your scanner), both in setup and scanning, thanks to default presets and automated steps. It includes all the sliders you expect to balance color, and a special White Balance setting that compensates for lighting conditions ranging from sodium lamps to sunsets.

As with most scanning programs, VueScan includes no image-editing tools. It's strictly a scanning application with lots of features useful for film scanning. Figure 9.12 shows VueScan in action.

**Figure 9.12** *VueScan supports a long list of film and reflective scanners.*

# SilverFast Ai

SilverFast Ai is the professional-standard scanning application, available for desktop scanners from Canon, Epson, HP, Kodak, LaCie, Microtek, Minolta, Nikon, Umax, and others. SilverFast can also be purchased for high-end scanning equipment from Crosfield, Heidelberg, Howtek, and others. Prices range from around $100 to $600 and up, depending on your scanner, and which features and add-ons you purchase.

If SilverFast SE came with your scanner, you already have one of the most advanced scanner packages available. However, upgrading to the Ai version is well worth it, and gets you sophisticated features like the following.

## SilverFast SRD

SRD (Smart Removal of Defects) is a software-based dust and scratch removal tool with some special features. For example, the program can find and highlight in red what it perceives as unwanted artifacts. You can then interactively increase or decrease the amount of dust and scratches that will be removed, giving you the capability to compromise between those image nasties and the loss of detail that dust and scratch removal often entails. Extremely difficult scratches can be isolated on up to four layers and removed at your command. You can preview Unsharp Masking effects before applying them, too, as shown in Figure 9.13.

**Figure 9.13** *SilverFast lets you preview the effects of Unsharp Masking applied during scanning before the actual scan.*

## Selective Color Correction

SilverFast's Selective Color Correction tool also has as many as four layers, each with independent color correction and masking. The feature is remarkably easy to use. Just click on the color you want to correct, and SilverFast recognizes that hue and provides sliders you can use to correct only that color. The layers and masks let you correct the same color in different parts of the image in different ways.

## Adaptive Color Correction

This capability lets you improve the saturation of faded colors automatically, or using sliders. The feature can be used with the Selective Color Correction tool so you can make saturation modifications only to specific colors. This is the sort of tool you never dreamed existed, but once you use it you'll be glad you found it.

## Selective Color to Gray

This is another one of those unique, life-saving features, which lets you individually change colors to the gray equivalents that will show up best. This avoids the problem often encountered when wildly-varying colors that have similar saturation and brightness levels all convert to roughly the same shade of gray. (It happens a lot!) This solution is light-years ahead of Photoshop's Desaturate command, and more powerful than manipulating individual color channels in a quest for "accurate" grays.

## No Gain, No Grain

SilverFast's GANE feature lets you reduce the grain that frequently appears when high speed films (ISO 800 or higher) are scanned at higher resolutions. The films are inherently grainy in the first place, and a high-res scan only accentuates this. The feature lets you interactively remove grain. It also helps reduce random noise that some older scanners can generate. You can see this powerful feature at work in Figure 9.14.

**Figure 9.14** *Eliminate grain and noise with SilverFast's GANE feature.*

## Other Advanced Features

SilverFast includes a raft of other advanced scanning features, such as an Advanced Color Cast removal tool. Forget what I said about the difficulty of compensating for mixed light sources: SilverFast's MidPip 4 Advanced Color Cast Removal feature can do it. All you need to do is click on an affected area, and view before and after comparisons showing how the correction will look. Modify as needed, and you're all set.

This software also includes improved negative/positive conversion with its NegaFix tool, an advanced Unsharp Masking facility with preview (no trial and error required). If there is a film scanning capability that SilverFast AI doesn't have, it hasn't been invented yet. Keep in mind that not every scanner has every feature that SilverFast supports.

# Upgrade Your Image-Editing Software

Scanners almost invariably are furnished with image-editing software. If you're unlucky, the application will be a cheap throwaway program with few features beyond the bare minimum. If you're luckier, you'll receive a copy of Adobe Photoshop Elements, which has automated features for neophytes, but shares many of its sibling Photoshop's more advanced capabilities. In the good old days, you might have gotten a copy of Photoshop with your scanner, too, but that's a lot less common now.

That's not a tragedy: The Photoshop you received was likely to be last-year's model, or Photoshop LE, a crippled version that was largely displaced by Adobe PhotoDeluxe and, eventually Photoshop Elements. The rationale was that anyone purchasing a scanner expensive enough to bundle a full-version Photoshop undoubtedly already owned Photoshop.

With the cost of film scanners taking such a dramatic drop in recent years, you might be among the new scanner owners who don't already own the image-editing software that's best for you. This section will help you make a decision. Your search will probably take you to one of three levels of image-editing functionality. Prices range from free to big bucks. I'll start at the top, and work down.

## Photoshop: Winner and Still Champion

The good news is that you can do just about all the image editing you could plausibly need to do with several other image editors, so even the most serious amateur image workers can manipulate images without once having to scale the rocky mountain that is Photoshop's learning curve.

However, anyone who works with images professionally, either as a photographer, graphics worker, layout artist, designer, or countless other jobs, doesn't have the luxury of bypassing the Photoshop highway. It's a journey you simply must take if you value your meal ticket.

That's because Adobe Photoshop stands alone as the professional image-editing tool of choice. A professional who doesn't know Photoshop is as rare as a doctor who can't draw blood, or an artist who doesn't know how to mix oil paints on a palette. Your ambitions and interests might lie elsewhere, but there are certain basic tools you must know how to use.

Of course, Photoshop can do virtually everything, from converting files and matching colors for separations to major photographic retouching and enhancement chores. Photoshop can also be used by the artist to paint original illustrations and artwork. There might be better tools for each of these tasks (and for several, particularly painting, there are) but Photoshop can do it all.

You might ask, "If Photoshop is so great, why isn't everybody using it?" Good question, and the answer can be found in the price tag attached to the software (more than $600 for first-time buyers who don't take advantage of an upgrade offer) and the investment in time needed to learn all those features. For those of us who make their living using Photoshop or related tools, cost isn't an issue. I'd gladly pay $600 a year for Photoshop if not obtaining it meant I'd have to look for another line of work.

The learning curve isn't so much a curve as a never-ending process, too. I've been using Photoshop since Version 2.0, and am continually discovering things I can do with it that I didn't know could be done. (Indeed, collecting those discoveries into a couple dozen how-to books like *Photoshop: Photographers' Guide* has kept me busy for quite a while.)

So, what can this Philosopher's Stone of the software realm do that makes it so highly prized? Here's a quick summary:

- *Cross platform/cross format/cross application compatibility.* Photoshop runs on both Windows and Macintosh systems, so professional users can work with it regardless of the platform they are using. It works and plays well with lots of other graphics and design applications, especially those from Adobe, such as PageMaker, InDesign, Illustrator, and GoLive. It can read and write all the industry standard file formats, including a few that you might never have heard of if you're not a graphics professional. Photoshop knows few limitations in terms of the hardware and software it can work with.

- *Optimized programming.* Photoshop is optimized for the latest hardware, and its software routines include features that take advantage of special instructions built into the latest microprocessor chips. Unlike most applications, Photoshop recognizes when a computer has multiple processors and automatically divides its workload among them.

- *Powerful color tools.* Photoshop works equally well with both RGB color space and the CMYK space required for professional printing applications. It can correct and fine-tune colors easily and quickly. Photoshop also adapts to a variety of color management systems. It's compatible with the Pantone Matching System for choosing spot colors. None of the other image-editing options has quite this level of color support.

- *Incredible retouching capabilities.* Photoshop has everything you need for doing minor retouching and performing major surgery on your image. If your photograph needs fixing in any way, Photoshop has the tools to do it.

- *Sophisticated compositing tools.* If you need to combine two or more images or portions of images together to provide a new photograph, Photoshop has precision tools that make this work easy to accomplish. You can select portions of an image quickly, copy those selections to layers of their own, modify the layers, and then recombine all the components smoothly and seamlessly. If Photoshop had been available in the 1960s, several insidious conspiracies would have had much less trouble faking their photographic evidence.

- *Image-bending special effects.* Photoshop has more than 100 special effects built-in that let you apply brush strokes, create lens flares, and produce fantasy looks from mundane

photos. Several times that many additional effects are available from Alien Skin, Andromeda, and others. The all-new Filter Gallery in the latest version of Photoshop, shown in Figure 9.15, provides an easy way to compare effects before you apply them.

■ *Unprecedented support.* Adobe does a great job of supporting Photoshop, but the amazing thing is the amount of support that's available for free or for fee from third parties. You'll find all sorts of information online in Usenet groups filled with canny experts who are willing to answer your questions at the drop of a note. Free tutorials are available on hundreds of websites. Photoshop is taught through seminars, touring road shows, in classes at high schools, vocational schools, and colleges, as well as through videotapes and DVDs. Type "Photoshop" into a search box on **Amazon.com** and, at latest count, you'll come up with 645 titles for your reading and viewing pleasure. Learning Photoshop might require a lot of work, but plenty of help is available.

**Figure 9.15** *Photoshop's new Filter Gallery lets you compare special effects before you apply them.*

# Runners-Up

The image editors in the second level aren't second-rate at all. They're relegated to runner-up status simply because Photoshop is in a class by itself. You shouldn't jump to the conclusion that these image editors lack essential features found in Photoshop. In truth, most of these products can do things Photoshop can't, and many professional graphics workers own an application like Corel Painter or Corel PHOTO-PAINT in *addition* to Photoshop for exactly that reason. A beginning carpenter might try to cut lumber with nothing but a crosscut saw, but those who know their tools would insist on having a rip saw, too (and probably a half-dozen other sawing tools). For the same reason, experienced image manipulators keep Photoshop and a few other pixel-pushing applications in their personal toolkit.

## Adobe Photoshop Elements

Despite what I said earlier, you probably don't need to own both Photoshop Elements and Photoshop, because, aside from a few features like an automatic red-eye elimination tool, there's not a lot that Elements can do that Photoshop cannot. Instead, you should consider Elements as an easy-to-operate "lite" version of Photoshop that serves the needs of photographers who are just getting into image-editing while serving as an easy-to-learn stepping stone, to Photoshop itself. So, if "Photoshop guru" is not in your job description, Elements is the Adobe product you can use for fast, simplified image processing of scanned images. Its paint-by-numbers wizards can lead you through every step in the most common image-tweaking processes.

Many people will be completely happy with Elements, whereas others will eventually outgrow it and graduate to Photoshop. Either way, the $100 asking price for Elements is a bargain for a program that can do as much as this. You can usually find it on sale for $50 or less, too.

Photoshop Elements, shown in Figure 9.16, shares much of the same user interface with Photoshop, including the menu arrangement and floating palettes (along with a handy "well" for storing those palettes). It incorporates most of the basic image-editing tools for image selection, retouching, and painting. It also offers many of Photoshop's most useful filters and accepts the same plug-ins from Adobe and third-party vendors. In fact, if you have an older version of Photoshop, just migrate all the filters over to give yourself a complete set.

**Figure 9.16** *Photoshop Elements provides quick fixes for common problems.*

Elements isn't just a cut-down version of Photoshop. The program includes a few interesting features that Photoshop lacks, such as a Fill Flash command that lets you bring out the detail in an underexposed foreground without washing out the sky. The program has a set of tabs in the toolbar at the top of the main window to provide quick access to many of the program's most-used features, and the automated commands on the Enhance menu make quick work of common image-editing tasks, such as adjusting back-lighting or color cast.

## Corel PHOTO-PAINT

Corel PHOTO-PAINT is the image-editing program that is included in the popular CorelDRAW Graphics Suite package. PHOTO-PAINT, shown in Figure 9.17, is a versatile photo-retouching and image-editing program. It includes a comprehensive set of selection, retouching, and painting tools for manual image manipulations and also boasts some convenient automated commands for common tasks, such as red-eye removal. Like most of the second-level image editors, it includes a large selection of special effects filters, but also accepts Photoshop-compatible plug-ins.

**Figure 9.17** *Corel PHOTO-PAINT works well with CorelDRAW and includes a zillion toolbars.*

# SHARE YOUR PLUG-INS

If you do own Photoshop and another image editor, use the alternate plug-in directory feature found in most image editors so you can share your filters with several compatible programs.

Using a system of menus and dialog box roll-ups similar to CorelDRAW, PHOTO-PAINT is notable chiefly for its (relatively) smooth integration with other applications in the Corel suite, plus some interesting image-processing filters. These filters include most of the effects in Photoshop, plus artistic filters like Smoked Glass, Terrazzo, and Paint Alchemy, a natural-media brush add-on.

## Jasc Paint Shop Pro

Paint Shop Pro wasn't called the Photoshop of shareware for nothing. However, it's long since outgrown its shareware origins and is now dressed up as a slick commercial package you can buy off the shelf in most computer stores, or download from the Jasc Software website (**www.jasc.com**).

Professional artists will appreciate the program's support for pressure-sensitive tablets and sophisticated color optimization capabilities. If you're in a hurry to grab your web graphics and run, Paint Shop has TWAIN support for popular scanners and digital cameras. Plenty of support is also available from Jasc, third-party books, and dozens of websites with Paint Shop tips and tutorials. Whether you are an individual user or choose software for a large organization and need an economical way to provide designers with a powerful image-editing program, Paint Shop Pro has the credentials.

Jasc Paint Shop Pro was originally distributed as a shareware product that you paid for only after you'd had the chance to fully evaluate it, and developed a reputation as a fully-featured "poor man's Photoshop." Now a fully mature product that needn't take a back seat to any other image editor, Paint Shop Pro has its own following who wouldn't use anything else. Selling for around $100, this application is one of the bargains in the second tier of image editors.

Paint Shop Pro boasts a toolkit that includes an impressive array of wizard-like commands that automate the most common tasks, such as scratch repair and red-eye removal. You'll also find multiple levels of Undo, and compatibility with dozens of file formats, including Adobe's native PSD. Its other Photoshop-like features include support for layers, histograms, and color correction, but its complement of selection and paint tools are more limited than those of the Adobe flagship product. Paint Shop Pro, shown in Figure 9.18, has its own collection of special effects, and is compatible with Photoshop plug-ins.

## Macromedia Fireworks

If you plan on using Macromedia Dreamweaver for web development, or want to create Flash animations, you ought to consider the same company's image editor, Fireworks. It's available bundled with other Macromedia software or as a standalone product.

Although Fireworks can handle general-purpose image editing of your scans, it excels at creating web graphics, including imagemaps and banners. It does an excellent job at creating rollover buttons and the HTML and JavaScript code that makes them work. Fireworks, shown in Figure 9.19, also includes the web image optimizing muscle found in Adobe ImageReady (a companion product of Photoshop). As with ImageReady, you can preview the same image at many optimization settings and choose the file format (say GIF or JPEG), color depth (for GIF), and file size parameters that work best for you.

These capabilities are especially convenient for Dreamweaver users to access, as the two programs are integrated enough to allow passing images back and forth smoothly. The chief downsides to Fireworks are its relatively paltry selection of advanced retouching and painting tools, and limited support for file formats beyond the major JPEG, GIF, PNG, and TIFF varieties.

**Figure 9.18** *Paint Shop Pro includes some unique special effects, like this Colored Foil plug-in.*

**Figure 9.19** *Fireworks is a great tool for preparing web graphics.*

## Corel Painter

Why does Corel need a second image-editing program in addition to PHOTO-PAINT? That's simple: There's nothing quite like Corel Painter (nee Fractal Design Painter, MetaCreations Painter, and Procreate Painter). It has always marched down its own path, specializing in an incredible selection of natural-media tools—from paintbrushes to pencils, crayons, chalks, charcoals, and imaginative canvases or textured papers. All these tools are customizable in an infinite number of ways, using an often-bewildering selection of dozens of toolbars, palettes, and dialog boxes.

Painter was created as a way to give traditional artists the tools they needed to "paint" images much as they did in the real world. However, other users soon discovered that Painter could perform amazing transformations of scanned images, and was a powerful way to turn a mundane picture into a prize-winner. Today, serious graphics professionals often own both Photoshop and Painter. If you must choose one, examine the capabilities of each before making your selection. Although Painter matches much of Photoshop's functionality (it is compatible with Photoshop's layers feature), there are some techniques, such as color correction, with which Photoshop is superior. However, Photoshop can't touch Painter's natural-media and web-oriented tools.

The Painter has a built-in facility for creating seamless tiled backgrounds for web pages, more flexible text-creation features, and the capability to "slice" large images into smaller modules that are faster to download. Once an image has been sliced, Painter creates the web page instructions needed to reconstruct it in the visitor's browser after all the pieces have been downloaded. Painter also includes "web-safe" tools that use only colors that can be displayed easily by all browsers, regardless of the color depth set on their video cards. Figure 9.20 displays some of Painter's capabilities.

**Figure 9.20** *No other program has Painter's natural-media effects.*

## Ulead PhotoImpact

PhotoImpact has always been one of my favorite image-editing suites, dating back to the day I adopted the package's Album component as my permanent image-management utility. Although Ulead Systems has attempted to pile on features with each new release, the company has stopped chasing Adobe Photoshop and now is making a run at the real graphics growth segment: web developers. This image editor and its suite of utilities escort you from brewing attractive backgrounds and buttons through optimizing JPEGs to an FTP web publishing tool. Whether you need flaming text or a web-based slide show, this program has an answer.

If your film images are destined for the web, this program deserves a look. You'll find a lengthy list of web-oriented features, ranging from a Java Rollover Assistant for creating interactive buttons, to "image slicing," which lets you cut up images and optimize each part for best display on the web. PhotoImpact can easily create imagemaps from selections, collect all the images on your site (or referenced by a URL) into a browsable album, and add sophisticated frame-transition effects to turn your video files into eye-catching animated GIFs. Despite its low cost, Ulead's pixel-pusher is geared for high-volume web production environments.

PhotoImpact consists of an image editor with most of its web tools built-in, as well as a selection of standalone utilities like PhotoImpact Album and GIF Animator. The image editor is an impressive piece of work on its own, combining some of the natural-media features in Corel Painter with Adobe Photoshop's image-optimization capabilities. It includes filter plug-ins that offer your choice of variation previews on a theme using the selected plug-in, as well as a pair of side-by-side before and after looks that are the easiest and fastest I've ever used.

The editor's automation tools make processing a large number of images a breeze. For example, you can record macros (like Photoshop's Actions) for recycling repetitive tasks, such as reducing a full-color image to a browser-safe palette of 216 hues or adding edge or frame effects. Batch processing can apply one of these user-editable procedures to a whole folder of files consecutively. You can also walk through the macro one step at a time when an image requires some specially tailored attention. Automated tools like the Post-Processing Wizard help correct images grabbed from a scanner or digital camera. An improved version of Ulead's SmartSaver makes it easy to preview before/after images in GIF, JPEG, and PNG formats to select palette, compression ratio, and transparency options.

Even advanced users will need time to absorb PhotoImpact's rich web feature set (most of which are available from an integrated Web menu). For example, the Button Designer creates push buttons from any shape; allows the specification of light source angle and elevation, bevel size, and smoothness; and controls whether the button should appear raised or depressed on your page. The Frame & Shadow Designer offers five styles (such as 2D, 3D, or photographic edges), as well as drop shadows with full control over offset and transparency of the shadow. The results you can get from PhotoImpact are shown in the example in Figure 9.21.

A smooth-working Background Designer pops up with a dozen low-contrast palettes, a dozen and a half customizable textures, and user-editable gradient ramps for those times when you need to blend a specific set of colors into your background. You can also create seamlessly tiling background patterns from any rectangular selection. Artistic texture and particle filter options create effects like rain, snow, or bubbles.

**Figure 9.21** *PhotoImpact's special effects can be applied interactively using before and after preview windows.*

To create an image map, just outline the rectangular, oval, or irregular polygon shape you want to use to define a region in the map, and then select the Image Map Tag menu item. You then choose from client-side, NCSA, or CERN imagemap formats. An integrated HTML Assistant generates the code required to display the current image (or any other image from your hard drive) on your web page using parameters selected from tabbed dialog boxes. Both tools produce error-free tag strings, which you can copy to the Clipboard and paste into your HTML editor.

## Getting Simple

If you don't want to spend a lot of time editing scanned images, you can try out some of the ultra-low-cost (often $50 or less) image editors like Microsoft Picture It! and Roxio PhotoSuite. These programs are incredibly easy to use, with virtually all the most common editing tasks automated or applied through helpful wizards and extra-simple dialog boxes. Most have only limited manual-editing tools for retouching or painting, however.

You can open an image, make some quick fixes with a few mouse clicks, and then immediately print, save, or share your photo. You can use one of these programs as your main image editor, or as a no-brainer alternative to your other editing tools when you're in a hurry or your photo doesn't require extensive manipulation.

## Microsoft *Picture It!*

Microsoft Picture It! is a bargain image editor that beginners can use to get comfortable with modifying scanned pictures before moving on to more fully featured products. Available as a standalone application, Picture It! is also bundled with other products, so you might even receive it as a free gift.

This easy-to-use program automates many fix-up tasks, like removing red-eye effects, removal of dust and scratches, or erasing distracting objects using cloning tools. You can revamp old photos with new looks using painting, distorting, and other capabilities. Built-in wizards lead you through most tasks, including capturing photos from scanners. You can do things such as cropping, rotating, adjusting brightness or color balance, and fixing red eye and scratches. Picture It! also includes a modest collection of effect filters and edge treatments that you can apply to your images. The program even includes some basic painting tools as well as tools for adding text and shapes to your images.

You can crop, rotate, zoom, or flip your images, and combine several photos into a collage. Refine the brightness/contrast and color balance, remove wrinkles, or rotate your images. Picture It! has many more capabilities than you'd expect from an application that is inexpensive and easy to use. If you're just beginning to edit images, you might want to start here. Picture It! is shown in Figure 9.22. Picture It comes in several versions, including a Digital Image Pro edition with a larger array of editing and image-manipulation tools.

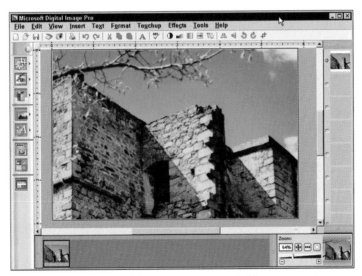

**Figure 9.22** *Microsoft Picture It! is available in several versions, including this Digital Image Pro edition.*

## Roxio PhotoSuite

Roxio PhotoSuite, is inexpensive, very easy to use, and makes an excellent entry-level image editor for those who don't plan to move on to bigger and better things anytime soon. Priced at around $50, the program is uncluttered by toolbars, menus, and palettes. Most of what needs to be done is accomplished by clicking a few buttons and manipulating a slider or two. The program is uncluttered, with a panel on the left side of the screen (shown in Figure 9.23) that has buttons that walk you through each procedure, plus a button-menu at the top that allows you to choose which kind of task you want to perform.

**Figure 9.23**  *Roxio PhotoSuite's interface is non-threatening and as easy to use as clicking a few buttons.*

Still, you'll find a decent selection of image-editing tools, including selection, paint, clone, erase, and fill implements. There's also a special effect brush, tools for drawing shapes, removing scratches, blotting out red eye, and adjusting brightness/contrast and color balance.

If you need help managing and sharing your photos, PhotoSuite can do that too. It has a facility for creating an album, and then sharing photos or the entire album on the web, through e-mail or via a slick-looking slide show. If you like, your slide show can be transformed into a screen saver for constant entertainment. PhotoSuite includes built-in projects that lead you through creating greeting cards, calendars, report covers, and so forth.

# Next Up

This has been your introduction to image enhancement, with descriptions of the key parameters you'll want to control both in scanning and within your image editor. The chapter finished up with a listing of the basic armament you'll want to consider for your image-editing armory. You'll learn about some of the details of the specific kinds of manipulations you can make in the next chapter.

# 10

# Fine-Tuning Your Scans

Even the most carefully scanned film image won't be perfect. This chapter provides an overview of the tools available to you to color-correct scanned images, remove dust and other artifacts, improve the contrast, and enhance sharpness, using common tools like Adobe Photoshop and Photoshop Elements.

The goal here is to familiarize you with basic image editing. In-depth techniques are worth an entire book, and, indeed, there are roughly 24,742 books that tell you how to use Photoshop and Elements alone. If you read this chapter, you'll be equipped to go out and begin gaining the skills you need to manipulate scans yourself.

## How Color Works

You've had the concept of primary colors drilled into you since elementary school, when you learned that yellow and blue crayons can be mixed to produce green. As you became immersed in film photography, you probably learned about the three primary colors of light (red, green, and blue), and the film layers sensitive to each of them. However, there's a lot more to color than that.

## Where Primary Colors Come From

First off, it's important to note that all this business about primary colors derives *not* from the way colors exist in beams of light, but in the biological and electronic mechanisms we use to *perceive* them. Full-spectrum white light, such as daylight, does contain all the "colors" we can see, and many more besides. In addition to the wavelengths we call red, green, and blue, light contains wavelengths we recognize as yellow, orange, purple, mauve, and burnt umber. That's because visible light is a continuous spectrum of wavelengths ranging in size from 400 nanometers (violet) to 700 nanometers (red).

That concludes our physics lesson for today. It's time to move on to biology, if only for a moment. To see such a range of colors, our eyes would have to contain individual cells that are sensitive to each and every wavelength. That's not really possible, for a number of reasons. Instead, human eyes contain two types of vision cells. These include *rods*, which are sensitive to brightness only, and are used for detail and to provide black-and-white vision when there is not much light. Rods can detect light up to a billion times dimmer than daylight. The second type of cells is called *cones* and these come in three varieties, sensitive to red, green, and blue. Cones are located only in a small area behind the eye's lens, which means that our peripheral vision relies entirely on the rods and, even though we never notice, is entirely in black and white! Each variety of cone is sensitive only to one of these primary colors; the red cones peak at 580 nanometers, the green at 545 nanometers, and the blue at 440 nanometers. Our brains are able to combine this information to deduce the amount of non-primary colors within our field of view. If our cones happened to be sensitive to three different colors instead of red, green, and blue, those colors would be our primaries. You can see the color spectrum in Figure 10.1.

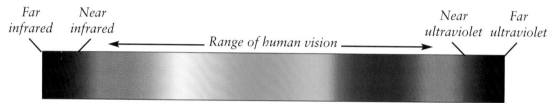

**Figure 10.1** *The visible color spectrum extends from 400 nanometers (violet) to 700 nanometers (red).*

## WHAT'S IN A NAME?

The area of the eye that contains the cones is called the *fovea*. So, now you understand where the name of the Foveon sensor, discussed elsewhere in this book, came from!

Scanners, monitors, color films, digital cameras, and other things that capture or display full color use the RGB model to mimic the way our eyes work. Problems arise because none of these artificial devices record or generate red, green, and blue in exactly the same way that our eyes do, nor does one system match any of the other systems exactly. So, your color slides might not look identical to the same scene in real life. Your scan of the slide might not match the slide very well. The scan might look different when viewed on two different monitors, and the colors can vary still more when printed. Like the "telephone" game, in which a whispered phrase is passed from person to person, the image you start out with may be wildly different from the one that emerges from the far end of the imaging chain.

To make things even more interesting, not only are the colors produced variable, but the colors that *can* be produced can vary from system to system. Some specific colors that you can see cannot be captured on film; other colors that you view on your monitor cannot be reproduced by your printer. The range of colors that can be captured, manipulated, and reproduced by a system is called its *color gamut*.

# Running the Color Gamut

Color gamuts are frustrating things because they never match from system to system. A good starting place is the gamut of colors that humans can see, which was defined in 1931 by the Commission Internationale L'Eclairage (CIE, or International Commission on Illumination in English). It is a scientific color model of the *color space* we can see. Other color gamuts are defined for artificial color systems like scanners, monitors, and printers, and none of them matches the CIE model precisely (or even very closely). Each color system uses three parameters to define the model, such as red, green, and blue; cyan, magenta, and yellow; hue, saturation, and brightness, or other qualities. Expressed as x, y, and z coordinates on a 3D graph, they produce a shape that represents the color gamut of that particular model. A two-dimensional view of the CIE color space is shown in Figure 10.2.

Over the years, new color working spaces have been defined, such as L*a*b and sRGB, in an effort to produce color models that more closely correspond to the actual colors a device can reproduce, as well as to minimize the colors lost when switching from one color system to another (which often happens during image editing).

You really need to learn about only three: RGB (used by scanners and monitors), CMY/CMYK (used by hardcopy devices such as printers), and L*a*b (which is used by image editors such as Photoshop as an intermediate color space).

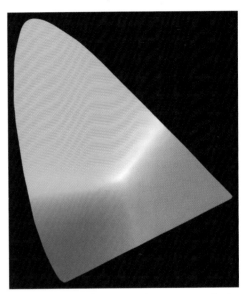

**Figure 10.2** *The CIE color space includes all colors the human eye can perceive.*

## Additive Color

Additive color is produced by combining the red, green, and blue portions of the spectrum to produce all the individual hues. As you'll recall from Chapter 2, scanners capture images using sensors that image red, green, and blue portions of the original subject. Monitors reproduce that color by aiming a set of three electron guns at sets of red, green, and blue phosphors coated on the CRT screen. The phosphors emit photons when struck by the electron beams from the guns. This color system is called *additive* because the red, green, and blue colors are added to produce other colors, such as cyan (green and blue), magenta (red and blue), yellow (red and green), and every intermediate color combination. When equal amounts of RGB are added, we end up with white (at maximum intensity) or gray (when the intensity level is less than maximum). At zero intensity, we get black. Figure 10.3 shows how these colors can be added.

Of course, this two-dimensional model doesn't account for the lightness or darkness of a color. Common representations take care of that by adding a third dimension, shown in Figure 10.4. The color space then becomes a cube, with red, green, and blue colors placed at opposite corners, and their complementary colors inserted between them to occupy the other three corners of the cube. Lightness and darkness are located opposite each other, too. Any hue in the RGB color model can be represented by a position somewhere within the cube.

**Figure 10.3** *Red, green, and blue light combine to produce the other colors, plus white.*

**Figure 10.4** *The additive color model can be represented by a three-dimensional cube.*

# LCDs

Many computer users (particularly those in the Macintosh realm) are switching to LCD (liquid crystal display) monitors. Although some LCD displays are unsuitable for serious image editing (because they are difficult/impossible to calibrate), they do form color similarly to traditional monitors, but use liquid crystal pixels instead of phosphors. Another type of flat display is the OLED (organic light emitting diode) display, which uses LEDs instead of phosphors or LCD elements.

## Subtractive Color

Color can also be produced by starting with white light, and then subtracting portions of the spectrum by absorbing certain colors as the light is reflected through translucent pigments such as ink. The illumination starts out with equal quantities of all colors and looks white to our eyes. The light then passes through layers of pigment, which absorb some wavelengths and

allow the rest to reflect off a substrate (such as paper) and reach our eyes. The hues that have not been subtracted reach our eyes and are interpreted as color.

The pigments that absorb part of the light are cyan, magenta, and yellow. The cyan pigment absorbs only red light and reflects both blue and green, producing the color cyan. Magenta absorbs green illumination and reflects red and blue, producing the magenta hue we see. Yellow absorbs only the blue light and reflects red and green, generating yellow. As counter-intuitive as it might seem for red/green to equal yellow, that's the way it works, as you can see in Figure 10.5.

For printing purposes, black is usually added to the CMY primary colors, producing the CMYK, or *subtractive* color model. (The letter K is used to represent black because B, for blue, was already taken.)

**Figure 10.5** *Subtractive color produces hues by absorbing and reflecting light.*

# WHY BLACK?

If virtually all colors in the RGB model can be produced using only red, green, and blue, why is black a necessary addition for the CMYK model? There are several important reasons for this.

First, it's not easy to produce ink colors that are as pure as the colors that can be generated from light. Cyan ink theoretically absorbs only red light, but in practice it doesn't absorb *all* the red light and might absorb a tad of some of the other colors, too. The same is true for magenta and yellow inks. When you combine all three, instead of the expected black you end up with a sort of muddy brown.

Second, black ink, while canceling out the muddy brown effect, also provides extra detail in the shadow areas that the "brown" ink combo can't duplicate. The result is an image with more contrast, snap, and apparent sharpness.

Finally, combining equal amounts of three colored inks produces neutral density, or gray, that can just as easily be represented by reducing equal amounts of the cyan, magenta, and yellow inks and creating the same neutral density with black ink, which is much less expensive than process color inks to boot. Advanced techniques such as gray component replacement (GCR) and undercolor removal (UCR) take advantage of this concept to provide better images that are less expensive to print.

If you still haven't wrapped your head around the subtractive color idea, you might be wondering why red, green, and blue inks aren't used instead of cyan, magenta, and yellow. After all, inks are available in those colors and are commonly used for spot color printing. Unfortunately, such a scheme has no way to produce any of the other colors. For example, red pigment reflects only red light and absorbs green and blue. Green pigment reflects green light, and absorbs red and blue. Overlap the two, and in the overlap the red pigment absorbs the green and the green pigment absorbs the red, so no light is reflected. We see black. The *subtractive* primaries have to be used to produce all the colors.

The subtractive color system is used by printing presses, inkjet printers, color laser printers, thermal wax printers, and other hardcopy output systems, using minor variations. For example, some color printers use two different strengths of several of the inks, such as a "strong" cyan and a "weak" cyan or a "strong" magenta and a "weak" magenta, so instead of printing with four colors, six or more are employed. That provides many more combinations of colors that can be produced. The only other way to vary the deepness of the color, with most printers, is to enlarge or reduce the size of the printer dot. Thermal dye sublimation printers, though, have the capability of varying the amount of dye transferred to the print over a range of 256 tones for each color. Inkjet printers and offset presses don't have this capability.

## L*a*b Color

L*a*b* color was developed by the CIE as a device-independent international standard. *Device independence* means a system should produce consistent color regardless of the device used to reproduce it.

L*a*b* consists of three components, a luminance or lightness channel, plus a* and b* channels that represent green to red and blue to yellow, respectively. The a* channel describes how red/green a color is; positive values are more red, whereas negative values are more green. The b* channel describes how blue/yellow a color is; positive values are more yellow, negative values are more blue. Don't worry about trying to understand all this thoroughly, you'll never need to work with L*a*b* color directly. Figure 10.6 might help you visualize how this color space works a little more easily.

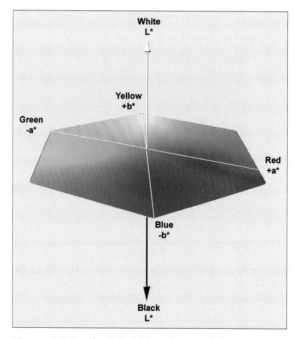

**Figure 10.6** *The L*a*b* color model has a lightness channel (represented by the vertical arrows) and two color channels (represented by the two horizontal axes).*

There are three things you need to remember about L*a*b* color:

■ L*a*b* colors closely reflect how humans actually perceive color.

■ L*a*b* color is able to represent all the colors found in both RGB and CMYK color modes, so it makes an ideal interchange medium between the two.

■ Image editors such as Photoshop actually use L*a*b* mode as their working color space so that images can be converted back and forth between other color spaces (such as RGB and CMYK) with no loss in colors until you save the file in one mode or the other.

## Calibration and Gamma

Photographers who've worked with film know that color is far from absolute. Some films are known for their vibrant, perhaps unrealistically saturated colors. Others are known for muted, or realistic hues. Some films are prized specifically because they produce realistic flesh tones. Indeed, professional films are deliberately designed and advertised as suitable for product photography, because of their higher contrast and rich colors, or for portraits, due to their flattering reproduction of flesh tones.

Color is variable within the digital realm, too. Hues don't match from monitor to monitor, or even with the same monitor over time. Some phosphors, particularly blue ones, change in intensity as they age at a different rate than others, so the image your monitor provides today might not be the same as the one you saw last year. Scanners, too, vary in the colors they capture. Printers reproduce colors in different ways. So, for consistent color, it's common to *calibrate* all the devices in a system. The goal is that, if what you see is not precisely what you get, at the very least what you get is repeatable, because there is a fixed relationship between the colors in the original and your final output.

Unfortunately, calibration is not a matter of just defining Color A as it relates to the original, your scanner, monitor, and printer, and then making adjustments at each step so Color A is equivalent in each. In practice, the response of any color system is rarely linear. When the brightness of tones is defined over a scale of 0 to 255, a value of 64 should represent about 25 percent intensity; 128 should represent 50 percent; 192 should represent 75 percent; and so forth. In the real world, values of 64, 128, and 192 might actually correspond to 20%, 60%, and 80% intensity, instead. The relationship of the actual representation to the ideal is known as a *gamma curve*.

Some devices need gamma correction more than others. Scanners conform to the ideal 45-degree curve rather closely, but monitors often need significant correction. If you know the gamma curve of a particular peripheral, you can create a correction table that compensates for the variation at each point along the curve. Your software can then use the table to adjust the final image.

For best color reproduction, you'll want to use the tools provided by your device's vendor to build a gamma correction table. If you own an Adobe product, the Adobe Gamma application can be used to profile your monitor. Alternatively, you'll find that many vendors provide ICC

(International Color Consortium) *characterization* files for their products. Although canned ICC profiles might not correspond exactly to the characteristics of your peripheral, they will be close enough for all but the most critical applications.

# Balancing Color

As the philosopher Kermit once observed, it's not easy being green. Nor is it easy being orange or purple, but that's what can happen if the color balances of your images are a bit off. In this chapter and the previous one, you learned how color works and what can cause bad color. Now it's time to learn how to solve some of those problems.

Unlike many of the other image-editing skills you have, precise color correction is a complex art and science. Fortunately, basic color correction is something that can be picked up fairly quickly. You'll simply need to apply the concepts in this chapter to your particular image editor.

The original film you scan might have a color cast that you want to get rid of. Or, you might have introduced a color bias during the scan that you want to get rid of. A third possibility is that the color was acceptable, but you want to change the balance for an artistic effect, such as adding blue to turn a daylight winter scene to a nighttime snowscape. Image editors and scanning software all contain color-correction tools that let you make these adjustments.

But before you get started, there is one thing you need to embed solidly in your consciousness: No correction techniques can add color that isn't there. You can only remove color. Color correction works best with images in which all colors are present, but with too much of one hue or another. The extra color can be removed, in moderate amounts, producing a well-balanced picture.

But suppose you have a photo with an extremely strong reddish cast that overpowers all the other colors in the image. If you remove the majority of the red, the few green and blue tones that remain probably won't be strong enough to provide a pleasing color balance. Instead, you'll end up with a grayish photo with little color at all, like the one shown at the bottom in Figure 10.7. Alternatively, you can try to counteract the red by adding massive amounts of cyan (which you'll recall is the "complement"

**Figure 10.7** *Removing the red from this shot leaves very little color behind, as you can see in the version at the bottom.*

of red). In that case, you'll simply end up with a darker photo. Color correction is best suited for minor fine-tuning.

As you learned in Chapter 9, fixing the color in an image involves three steps: adjusting the amount of red, green, and blue to eliminate or minimize color casts; adjusting saturation so the richness of the color is realistic; and modifying the brightness/contrast of the tones. Scanner and image-editing software provide you with sets of dialog boxes for making these adjustments. This section will provide an overview of the most common tools.

# What's Color Correction?

Color correction might more properly be called color *modification*, because not all changes you make to color are intended to correct some defect. In many cases, you might be looking for some special effect. Perhaps you want to add a warm orange-red glow to an image to simulate a sunset. Or, you want to shift colors around to provide a retro-psychedelic look. Producing non-realistic color is actually a lot easier than creating corrected color, because you can play around with various controls as much as you like and when you get something interesting pretend that you meant to do that very thing all along.

Many of the techniques used to distort color are the same as those used to correct it. Either way, you're converting pixels of one brightness value and color to another brightness value and/or color. Change all the red pixels to cyan, blue pixels to yellow, and green pixels to magenta, and you've created a reversed-color image. Make all the dark pixels light, the light pixels dark in the correct way, and you've generated a negative or inverted image. Add a bit of red and the image becomes warmer-looking. The basic concept is quite simple.

# Automatic Color Controls

If you are in a hurry and need only minor corrections, most image editors have automatic color correction controls that will do a good job of making basic fixes to your colors. Many have separate automatic compensation for colors, contrast, and even color saturation. Try these options in your own image editor to see if they work for you.

- Paint Shop Pro: Look in the Effects Enhance Photo menu.
- Photoshop: Try the automated tools found in the Image > Adjustments menu.
- PhotoImpact: Check out Format > Auto-process for some options.

# Color Balance Controls

The most frequently used method for correcting color is to use the color balance controls built into every image editor. Most are easy to find. Here's a roadmap for some common applications:

- Photoshop: The Color Balance dialog box can be accessed by pressing Ctrl/Command+B, or by choosing Image > Adjustments > Color Balance.
- Paint Shop Pro: Use Colors > Adjust > Color Balance.
- PhotoImpact: Choose Format > Color Balance.

- Corel PHOTO-PAINT: Choose Image > Adjust > Color Balance.

- ThumbsPlus: Choose Image > Adjust Colors and then click the Tint tab.

- IrfanView: Choose Image > Enhance Colors.

- Roxio PhotoSuite: Click Touchup > Touchup Filters and then choose Color Adjustment from the drop-down list.

These all work in a similar way, so I'll use Paint Shop Pro's dialog box as an example. These dialog boxes let you adjust the proportions of a particular color, from 0 to 100 percent. You can apply the change to shadows, midtones, or highlights. Some image-editing programs display a before and after preview within the dialog box. Others show you only the final image, after the correction you are making is applied.

You can add one color or subtract its two component colors. For example, moving the Cyan/Red slider to +20 (sliding it toward the red end) has the same effect as moving the Magenta/Green and Yellow/Blue sliders both to the -20 position (towards the left).

Figure 10.8 shows a thistle with a distinct greenish cast. I can remove this green tone by sliding the Magenta/Green control towards the Magenta, which is the opposite, or complementary, color of green. Keeping a close eye on the preview window, the color can be adjusted visually, subtracting green (adding magenta) until the picture looks right. In this case, a value of -78 applied only to the middle tones of the photo (those other than the highlights or shadows) is about perfect. You can also remove green by adding red and blue (thus subtracting cyan and yellow).

**Figure 10.8** *Remove green by adding magenta.*

You'll find these corrections less confusing if you consult a color wheel, like the one shown in Figure 10.9. A given color cast can be removed by:

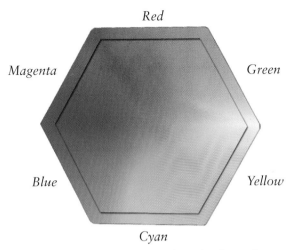

- Adding the color opposite it on the color wheel.

- Subtracting the color itself.

- Subtracting equal amounts of the adjacent colors on the color wheel.

- Adding equal amounts of the other two colors on its color wheel triangle.

**Figure 10.9** *Use this color wheel to calculate which colors to add or subtract.*

The hard part is knowing whether your image has a red or a magenta cast (they can look a lot alike) or a green or cyan cast (ditto). Some image editors, such as Adobe Photoshop Elements, have a special Color Cast dialog box, like the one shown in Figure 10.10, that you can use to remove color bias simply by locating a neutral tone such as black or white. The program then examines the neutral tone and determines whether it has a color cast, and then adjusts the image to suit.

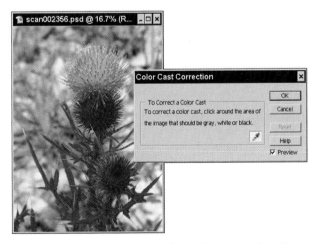

**Figure 10.10** *Some image editors have a Color Cast dialog box like the one found in Photoshop Elements.*

## Adjusting Hue/Saturation/Brightness

Other times, you'll want to change the hue, saturation, or brightness of an image. Image editors have Hue/Saturation dialog boxes that let you make these manipulations for the entire photo, or for individual colors.

The Hue slider represents a trip around the outer edge of the color wheel, up to +180 degrees or -180 degrees. As you move the Hue slider, you can see the color shift through the spectrum towards blue (which resides at +180 and -180 degrees). The Lightness slider changes the brightness or darkness of the color, whereas the Saturation slider fades the color or makes it richer. The Hue/Saturation/Lightness dialog box is especially useful when you want to change the saturation of a color, as it's usually the easiest way to accomplish that change.

Perhaps you have a photo in which the green foliage has picked up a color cast and you'd like to shift all the green values. Or, you might want to brighten up the color dramatically You can do this with the Hue/Saturation/Lightness dialog box, using the sliders like those shown from Paint Shop Pro in Figure 10.11.

**Figure 10.11** *Brighten or mute colors, or change their hue with the Hue/Saturation/Lightness (or Brightness) dialog box.*

## Variations

Photoshop, Photoshop Elements, and some other image editors have a variations mode (which photographers sometimes call a ring-around) that shows you several versions of an image and lets you compare them side-by-side. Choose the one that looks best, and apply the correction to your original image.

Variations dialog boxes are usually arranged something like the one from Photoshop Elements shown in Figure 10.12. Buttons at the left side let you select whether you want to modify the midtones, shadows, highlights, or color saturation. The Color Intensity slider adjusts the amount of change applied, and the Increase.../Decrease preview windows show you what the image will look like with each color added or subtracted. Preview boxes at the top of the window show a "before" view of the image at left, and an "after" image with all the changes you've applied so far. You can click the adjustment buttons at the bottom multiple times to add or subtract colors. When you're satisfied with the way the image looks, click the OK button in the upper right.

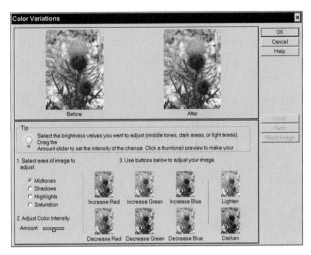

**Figure 10.12** *Choose the variation you want to quickly correct color.*

## Using Brightness/Contrast Controls

You might be able to make minor corrections in brightness or contrast using the sliders of the same name found in every image editor. However, that's usually not your best choice. That's because the Brightness slider lightens or darkens *every* pixel in an image, and the Contrast slider increases or decreases the contrast of *every* pixel. In practice, your images will probably need fixing in specific areas. You might want to lighten the shadows while leaving the highlights alone, for example. For photographs that need that sort of tweaking, you're better off using the Levels command or Curves.

However, despite their limited utility, the Brightness/Contrast sliders, shown in Figure 10.13, are handy, easy-to-understand controls that are a breeze to use. In some cases, you might want to play with these controls to help images that need only minor modifications.

**Figure 10.13** *Use the Brightness/Contrast controls sparingly.*

## Using Levels

A more advanced tool for adjusting tones in an image is the Levels dialog box shown in Figure 10.14 at left. Some image editors also have a Histogram palette, like the one shown at right, with additional information. However, the Histogram palette is used only to provide information. All adjustments are actually made within the Levels dialog box.

**Figure 10.14** *Levels controls allow more sophisticated tone correction.*

The mountain-shaped graph you see in both windows is called a histogram. It consists of 256 vertical lines, each representing the relative number of pixels at each particular gray tone within the image. The taller the line, the more pixels at that brightness level. The far left side of the histogram represents black (you can see a black triangle slider underneath that position), whereas the far right side of the histogram represents white (and includes a white triangle slider). The gray slider in the middle marks the location of the (natch) midtones.

Pictures with lots of dark shadows will have a clump of tall lines at the left (black) end of the histogram; images with detail in the highlights will have tall lines at the right end of the histogram. Because there are only 256 tones that can be used to represent a grayscale image (or each red, blue, or green hue of a full-color image), it's important to make sure that none of these tones is wasted. Levels are a lot easier to use than Curves, and are easier to learn.

## The Histogram Graph

As mentioned, each of those vertical lines represents a gray tone from pure black (at the left of the scale) to pure white (at the right of the scale). Although there are no numbers, there are 256 vertical lines, one for each tone from 0 (black) to 255 (white). The height of the line represents the amount of that tone. A very short line means very little of that tone is in the image. A tall line means that a lot of that tone is in the image. With me so far?

Look at Figure 10.15. This picture is very dark, so all the lines in the histogram are short, meaning there aren't many tones at any of the 256 levels. At the far right (the white end of the histogram) there are no lines at all, indicating that there are no true whites in the image.

## Black Point, White Point, and Midpoint Arrows

Below the histogram in the Levels dialog box are the output sliders, a black triangle on the left, and a white triangle on the right. Moving the black triangle to the right reduces the contrast in the shadows and darkens the image. Moving the right triangle to the left reduces the contrast in the highlights and lightens the image. You can get the same effects by typing a number into the left and right option boxes at the top of the dialog box. When you do, notice that the gray midpoint arrow moves, too.

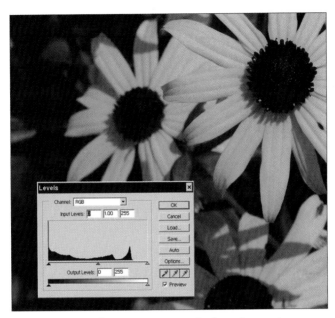

**Figure 10.15** *The picture is too dark and contains no true white pixels.*

These triangles indicate the point that the image editor will use as the pure black, pure white, and midtone gray of your image. When you first view a histogram, the black arrow is located at the far left, the white arrow at the far right, and the midpoint arrow halfway between them. To put wasted tones to better use, you can tell the editor to move its black point to the position where the image does include dark tones, and move its white point to the position where white tones actually begin to have some detail. In this case, just slide the white arrow towards the left, so it aligns with the base of the histogram "peak" at the white end of the scale, as shown in Figure 10.16.

You have a lot of flexibility when using the Levels control. If you feel that some of the black or white tones can be sacrificed, you can move the black or white point arrows even closer towards the center, to provide more of the 256 shades to cover the other tones in the image. Or, you may want to slide the midtone arrow to the right or left to change the relative brightness of the middle shades of an image. The best way to learn to use these tools is to play with them.

The Auto button in the lower-right corner of the Levels dialog box can often speed up making these adjustments for you. This resets the white point and the black point, and redistributes the gray values of the pixels in between. Afterward, the histogram shows that the pixels fill the complete range from white to black. I usually find that setting the black, white, and midpoint tones manually does a better job, however.

**Figure 10.16** *Adjusting the white point slider produces a better image.*

## Adjusting the Midtones

The center (gray) triangle slider in the Levels histogram is used to adjust the midtones, which are called the gamma values. Dragging this triangle to the left lightens the midtones. Dragging it to the right darkens the midtones while leaving the highlights and shadows alone. You can also move the gray triangle by entering numbers from 9.99 to 0.1 in the center option box at the top of the dialog box. The default value, 1.0, lies exactly in the middle of the range.

You might find it convenient to save the adjustments you make to an image, especially if you are processing a batch of photographs that were taken under the same conditions, or if you are retouching a series of video frames. Save your settings by clicking Save and saving them as a file. This file can be loaded later by clicking Load.

## Controlling Output

The final control of the Levels dialog box is the Output grayscale at the bottom. It has black and white point control arrows just like the Input scale. The Output control is used to specify the lightest and darkest pixels that result in your finished image. Move the black triangle to a new value (higher than 0) and the darkest pixels will be no darker than that. Move the white triangle to a value lower than 255, and the lightest pixels will be no brighter than the new value. One thing you can do is invert your image in interesting ways using this control. Just swap the positions of the white and black triangles, or move them to any setting in-between. You can get some interesting effects that wouldn't be possible using only the Invert command.

# Curves

Curves is one of the most advanced tools, offering the user subtle control over the brightness, contrast, color, and gamma levels in an image—control that is far beyond that offered by the Levels and Brightness/Contrast dialog boxes. The Curves dialog box is truly complex, and probably offers control needed by experienced workers and imaging professionals. Less advanced users might want to play with Curves to see what special effects they can achieve. I can give you only a brief introduction to its power here.

The Brightness/Contrast dialog box lets you change an image globally, with no difference between the way the changes are applied to the highlights, midtones, and shadows. The Levels command adds more control, allowing you to change the shadows, highlights, and midtones, separately. The Curves command goes all out and lets you change pixel values at any point along the brightness level continuum, giving you 256 locations at which you can make corrections.

The test photo we've been working with is dark and its contrast reduced. You can correct it using Curves. When you open the Curves dialog box (shown in Figure 10.17), a graph will appear. The horizontal axis of the graph maps the brightness values as they are before image correction. The vertical axis maps the brightness values after correction. Each axis represents a continuum of 256 levels, divided into four parts by gray lines. The lower-left corner represents 0,0 (pure black) and the upper-right corner is 255,255 (pure white).

**Figure 10.17** *The Curves dialog box lets you manipulate tones in powerful ways.*

Whenever you open the Curves window, the graph begins as a straight line at a 45-degree angle from lower left to upper right. That's because, unless changes are made, the input will be exactly the same as the output, a direct 1:1 correlation that can be represented by the 45-degree line. (I can see the eyes of non-math types glazing over already; don't worry, you can play with Curves even without using math.) You can see how the graph works by dragging various points of the line.

Try dragging the middle of the curve up, down, and from side to side to see what happens. Dragging down makes the image darker, whereas dragging up makes it lighter, allowing you to make smooth corrections. When you click on the Pencil icon, you can draw a freehand curve with a pencil tool, producing more abrupt changes. The Eyedropper tools can be used to sample black, white, and gray points in the image. Experiment with Curves often, because you can produce some interesting special effects, and everything you try will teach you more about this tool. For example, the curve shown in Figure 10.18 produces a solarization effect.

**Figure 10.18** *Create a solarized look by bending the curves of your image.*

# Next Up

Fine-tuning is only half the image-manipulation picture. Sometimes you want to do more than just "fix" a photo. At times, you'll want to enhance it dramatically using retouching tools and special effects like those built into all image editors. In the next chapter, I'll show you some of the things you can do.

# 11

# Enhancing Scanned Images

No book about working with scanned images would be complete without a good chapter on image retouching and compositing. Actually, no such book could really be called *complete* without at least a dozen chapters on the topic, because manipulating images after a scan is a complex topic. In fact, there are hundreds of these books available, written specifically for users of Photoshop, Paint Shop Pro, Corel PHOTO-PAINT, and other image-editing applications. If you're looking for one of these, you should consider *Paint Shop Pro 8 Solutions, Photoshop: Photographers' Guide,* and *Digital Retouching and Compositing: Photographers' Guide.* All are available from Muska & Lipman/Course Technology.

Although a comprehensive book will serve you best, I'm going to devote one more chapter to the basics of what you can do with scanned images. Each of these topics is covered in much more detail in the books listed previously, so if you want to explore any of them further, those books are one place to turn.

In the previous two chapters, the emphasis was on color and tonal correction, each of which is an important part of image enhancement. This chapter focuses on other types of changes you can make through retouching, compositing, and the application of special effects with filters.

## What Are Retouching and Compositing?

*Retouching* is the process of manipulating an image to cover up blemishes, remove dust spots, add some hair to a bald head, or reconstruct part of an image that has been damaged. In almost all cases, the goal of retouching is to provide corrections that are invisible to the eye, or nearly so, unless you happen to compare the fixed version side-by-side with the original.

201

*Compositing* is a method of combining images or parts of images to create a new photograph. The combination might involve several areas from the same original, or include parts of two or more different images. In most cases, the blending of images should be seamless enough that the compositing itself is virtually undetectable outside a forensics laboratory. Invisible compositing is usually more difficult to achieve than flawless retouching because the changes are more dramatic. Whereas a retouching chore might involve little more than spotting out a few facial skin problems, compositing can require an entire head transplant!

I've used compositing to create a portrait of my family from the most flattering photos of each, as shown in Figures 11.1 and 11.2. Other times, I've replaced a background to improve an image, or built a fantasy landscape that couldn't possibly exist without my scanner and a tool like Photoshop.

**Figure 11.1** *Mother and daughter don't look their best in this shot, but that's the closest thing to a smile we can coax out of the son.*

**Figure 11.2** *Combining two different shots yields this more satisfactory version.*

In either case, the image manipulation is necessitated by the fact that, sometimes, what you see is not what you want to get. There are often some problems with your scanned image, other than those of color balance, that you'll want to fix using the tools available in your favorite image editor. These defects can usually be categorized as one of two types—physical problems that originated with the film image itself, and appearance defects in your original subject matter that you'd like to correct (whether it was a big nose or an unwanted tree).

## Problems with the Film

Even the best film scanner and its software can't totally eliminate physical problems and damage found in your original slide, transparency, or negative. Nor can even the most fervent retouching completely vanquish all of these. However, many problems can be disguised,

removed, or alleviated, depending on where the damage is on the film, how extensive it is, and what kind of difficulty it presents. Some of the most common film problems include:

- *Pinholes.* It's often difficult to tell where these tiny dots etched into the film emulsion come from. They can be caused by manufacturing defects, air bubbles on the film during processing, and other problems. The result is small round clear areas that must be retouched out.

- *Dust.* Although dust can become embedded in the film during processing, it's more common for the little specks to settle on the film after it is developed. If you can't brush it off or blow it off prior to scanning, most film scanners will minimize the appearance of dust in your scans. The dust artifacts that remain after the scan must be removed with retouching.

- *Scratches.* There are dozens of potential causes of scratching. A tiny nick in the film gate that frames the film during exposure can produce a long horizontal scratch the length of the entire roll. You can get the same kind of scratch from a grain of sand lodged in the felt light trap of a roll of 35mm film. Film can become scratched during processing, whether automated equipment is used or manual film-developing systems are at work. As you've seen, film scanners have powerful scratch and dust removal facilities. Any scratches that are visible post-scan must be removed in your image editor.

- *Reticulation.* Reticulation results when developing film is moved rapidly between chemical baths that have widely varying temperatures. A pattern of wrinkles spreads throughout the entire film, and can't easily be removed by any means (slightly blurring the image might help a bit). Your best bet is to use the reticulation as a special effect. Some images even have a reticulation filter to *add* this look.

- *Fogging, fading, and streaking.* Overall fading can be handled by the color and tonal controls discussed in Chapter 10. Localized problems, including fogging and streaking, can sometimes be retouched out.

## Problems with Your Subject

The best film scanner can't do much about subject matter that is less than ideal, either. As a photographer, you do your best to optimize the look of the things you are picturing on film. You can rearrange some subjects, choose a better angle, or photograph someone from their "best" side. Unfortunately, that's not always possible. Subjects like trees, rocks, and buildings aren't obliging enough to move to new locations. You might be locked into a specific angle or vantage point because there is nowhere else to stand. And, should you be photographing a loved one who makes the Wicked Witch of the West look pretty, you might not be able to *find* their "best" side. (This is particularly distressing when the photo is a self-portrait.) Some common problems include:

- *Unflattering people picture.* The picture was taken too close to the subject with a wide-angle lens or setting and their nose looks huge. Or, perhaps, their nose *is* huge. Bad complexions, imperfect teeth, poor choice of clothing, and other problems can look much worse in the photo than they did in real life when you took the picture.

■ *Unwanted image content.* You didn't notice that tree growing out of your child's head when you took the picture. Or, you did notice your ex-brother-in-law in a family photo, but didn't have the presence of mind to pose him on the very end of the lineup where he could be easily cropped out. When your images contain unwanted content, you can often replace that object with something else, such as the background.

■ *Wanted, but missing, image content.* Slugger Smith was unable to make it to the team photo session, and, although she's only eight years old, her .678 batting average means she really should be included somehow. Don't settle for an inset added to the corner of the team shot. Drop a picture of your star player into the team photo.

Whether you're masking defects in the film or camouflaging problems with your subject matter, the goal of simple retouching is to make the picture look as good as possible. Of course, what's "good" is a subjective quality. A portrait of a teenager trapped within the clutches of puberty might need a great deal of work to produce the silky-smooth skin the youth remembers with nostalgia from pre-teen days. Yet, a 62-year-old corporate chief executive might be proud of the character lines that are evidence of years of hard-won experience.

The amount of time you have to spend retouching a given film image can vary, too. Transforming the image so that it looks "good enough" might not be practical. If the picture is a recent one, such as an informal portrait that can be easily retaken, you might as well call your victim back for another shooting session, rather than spend two hours fixing major problems. On the other hand, if your film image is a treasured old slide from your family archives, or an advertising photo that can't be reproduced without reassembling props, traveling to locations, and collecting a cast of thousands, any amount of time you spend retouching might be well worth it. Figure 11.3 shows a portrait that has been improved through retouching. The original picture at top had a lot of problems, especially around the model's eyes, eyebrows, and mouth. There are some unfortunate shadows, too. Although the retouched photo is far from perfect, some of the problems have been alleviated in the version at the bottom.

**Figure 11.3** *The original portrait (top) needs a lot of work. In the bottom version, the eyes and lips have been fixed, shadows under the eyes lightened, nose reduced in size, and other major work done that might not be obvious. That's the point!*

# The Tools You'll Use

Image editors offer a huge collection of tools you can use to handle virtually every retouching and compositing job. This section introduces you to the major categories of implements at your disposal, and explains how a few of the individual tools work.

## Selection Tools

Of all the features you use, the selection tools are easily the most important, because they define the exact area of the image that you'll be working on. Unless you can select a particular area, it can be difficult to limit your modifications only to that area. You might want to blur or sharpen a specific part of the picture, or copy a new image into a particular area. When you make a selection, your image editor will apply your changes only to the portion of the image within the selection. The kinds of selection tools provided by your application probably include the following:

- *Marquee tools.* These come in rectangular and oval varieties, and let you select squares, rectangles, circles, and ovals by dragging with your mouse. Some editors have "single row" and "single column" selection tools you can use when you need to select only one row or column of pixels.

- *Freehand selection tools.* These include the lasso tool, which lets you draw a freehand line around an object to create a selection, and the polygon tool, used to draw irregular straight-line shapes around the perimeter of the object. You can also use your image editor's vector pen tools to draw curves and lines, and then convert them to a selection.

- *Magic tools.* Some selection tools choose pixels by magic (actually algorithms built into the image editor). Among these are the magic wand, which selects adjacent pixels with similar brightness, and "magnetic" tools that seek out the edges of objects you are selecting and cling to those edges. In Photoshop, this tool is called the Magnetic Lasso; in the latest version of Paint Shop Pro, it's called Edge Seeker. Figure 11.4 shows Paint Shop Pro's Magic Wand tool at work.

- *Range tools.* You'll find selection tools that grab pixels based on their color or brightness values, from anywhere in the image.

- *Paint a selection.* When you need to select a large or very irregular area, you can always paint a selection using tools like Photoshop's Quick Mask mode. This mode works especially well when you need to fade the selection at the edges. In Quick Mask mode, you simply select a brush shape and paint the selection with it.

Selection tools aren't difficult to master, by any means, but using them effectively does take practice. Because selections are such an important part of your image-editing repertoire, you'll want to spend some time learning to use them well.

**Figure 11.4** *Paint Shop Pro has a powerful Magic Wand tool you can use to select portions of an image.*

For example, magic wand-type tools use a parameter called *tolerance* to determine how similar pixels must be before they are selected. You'll get a feeling for how much tolerance to use when selecting areas of similar color and brightness, and this skill will accelerate your selection process significantly. Learn when to use marquee tools to select large areas quickly, and then subtract from the selection using the magic wand or lasso tools. Once you've discovered how easy it is to paint selections using mask modes, you'll use that capability as much as you can. Effective use of selections, working with layers, and accurate tonal/color corrections are the three most important image-enhancement skills you can have.

## Layers

Layers are easily the runner-up in the Most Valuable Tool contest, so you'll find this capability in Photoshop, Photoshop Elements, Paint Shop Pro, PhotoImpact, Painter, PHOTO-PAINT, and other advanced editors. Using layers lets you create a separate overlay for each portion of the image, stack them in the order you wish, and work with them individually.

The non-transparent content of each layer obscures the image content of the layer beneath, so learning exactly how to stack layers and manipulate their transparency can be important. In Figure 11.5, the soccer ball and its shadow are on separate layers so that (in the lower version) the ball can be given an extra bit of blur to add motion to the image. In the version at upper right, the ball has been enlarged dramatically to create a non-realistic, but amusing image.

Layers are not only useful when manipulating parts of an image separately; they can help you when you simply want to retouch a portion of an image separately from other parts. Copy a

**Figure 11.5** *Add some blur to the soccer ball (bottom) or make it huge (upper right), thanks to your image editor's layers capability.*

subject's eyes to their own layer (as I did in Figure 11.3) and then modify their appearance as much as you want. If you decide to cancel all the changes, simply delete the edited layer.

Advanced image editors let you create special types of layers, too. Photoshop, Photoshop Elements, and Paint Shop Pro can work with Adjustment Layers, which allow you to apply brightness and contrast, color, or other types of changes to individual layers (those stacked below the Adjustment Layer), and then change the modifications you've made at any time.

## Cropping, Sizing, and Orientation Controls

Image editors include tools that let you crop the edges of the image so only the pictorial portion you want to include is shown within its borders. They're handy to use, because they have handles you can drag to adjust the borders before you make the final crop, and the portion to be deleted is usually darkened or highlighted so you can visualize the before and after look of the photo simultaneously.

You'll also use the resizing controls that let you rescale portions of an image so you can fit objects more realistically into your photograph (or unrealistically, as I did with the soccer ball in Figure 11.5). You can also change the size and proportions of the entire image if you want,

producing a taller, thinner version that better suits your image, and rotate or flip the image to create a new perspective. In Figure 11.6, the tower at left was given a little extra altitude, and then rotated slightly to the right to add a "leaning tower" feeling.

**Figure 11.6** *Use cropping, sizing, and orientation tools to change the borders of an image, or modify its size or proportions.*

## Painting/Cloning Tools

Whether you want to paint a new image from scratch using natural media tools like those in Painter, or paint over objects while retouching, your image editor's painting and cloning tools are your friends. Perhaps you want to even out a dark blue background, or copy some pixels to hide an unwanted object. Painting and cloning tools use brush tips, patterns, and other options to let you wield your brushes in powerful ways. The key tools that are most brush-like include:

■ *Paint brushes.* These let you paint a solid color or pattern on your image, using soft (fuzzy) or hard-edged brushes as well as brushes with odd-shaped tips. Your image editor will let you blend the color you're painting with the underlying color in a variety of modes, so that your strokes can darken, lighten, or mix in other ways. You can even paint with patterns and brushes that you've created yourself. Some applications, such as Corel Painter, provide

special behaviors for each type of brush, giving them wet tips, dry-flaky bristles, or other characteristics. Painter, for example, is furnished with hundreds of brushes that mimic natural media such as oil and watercolor paints, chalks, pencils, and inks.

■  *Clone tools.* These duplicate parts of an image by copying from one location and painting those pixels down in another location. Cloning is a great tool for covering up unwanted objects, or copying an object from one part of the picture to another part. For example, if your herd of sheep is too sparse, you can copy additional sheep from another part of the photo (or from an entirely different photo) using the clone tool.

■  *Healing and patching tools.* Photoshop added some new clone-like tools that take into account the lighting and texture of the area being painted over. The Healing Brush and Patch tools provide a more realistic rendition when copying pixels. Paint Shop Pro has a Scratch Remover tool that performs a similar function.

## Tonal Controls

When you need to darken or lighten only small portions of an image, you have several options. You can select the area by painting in your image editor's mask layer (called Quick Mask mode in Photoshop) and then using the Levels command or other controls to lighten or darken. If you're in the mood to paint areas lighter or darker, you'll love the Dodge and Burn tools available in Photoshop, Paint Shop Pro, PhotoImpact 8, and other image editors. These terms come from the traditional darkroom techniques that involve holding back (*dodging*) or increasing the exposure of (*burning*) parts of an image when it is exposed under an enlarger.

The Dodge and Burn tools use the image editor's brush features to selectively darken or lighten areas of a photo as you paint with them. You can use them to lighten shadows under eyes, or darken areas such as the partially washed-out side of a barn. Photoshop calls these two tools the Toning tools, and groups them along with a third tool called the Sponge (which soaks up color saturation or increases it as you paint).

Sponge-like tools are available in most image editors. They're called the Saturation Retouch Tool in PhotoImpact and Saturation Up/Down options of the Retouch Brush in Paint Shop Pro. Simply paint over an area to increase the richness of the color in that area only, or to mute the color. This is a great tool for toning down unwanted color casts in part of an image caused by, say, the reflection of colored light from a nearby wall. You'll also find it invaluable for brightening up only parts of an image to create a more distinctive photo.

## Blurring and Sharpening

Selective sharpening can make detail of an image more vivid, especially in contrast to the unsharpened portion of the image that surrounds it. Applying blurring to parts of an image can reduce dust spots without making the entire image fuzzy. Applying blur effects with a brush can be a nifty way to de-emphasize a background that's a little too intrusive for your taste, as shown in Figure 11.7. All image editors have brush-like tools for sharpening, blurring, smudging, or increasing/decreasing the contrast of parts of an image.

**Figure 11.7** *Manually painting with the Blur tool can turn an ordinary seascape into a foggy morning mist.*

The main thing to keep in mind when wielding these tools is to avoid overdoing it. Apply a little too much of the sharpening brush and the area you've worked on can appear grainy or have too much contrast. Excessive blur can be distracting, too. Use just enough sharpening to help your details stand out, and just enough blurring to minimize detail, blend an object in with its surroundings, or make a transition between objects less obvious.

# Filters

Whether your image editor calls them filters, plug-ins, or effects, these mini-programs are among the most useful capabilities in your corrective and creative toolbox. Filters can fix an ailing image, add flair to a good image, and transform a great image into something special. Whether you want to use a filter to mask serious defects in a photo or create a stunning new look, you'll find something useful among the hundreds of plug-ins available for the leading image-editing applications.

Filters are actually miniature applications, complete with their own dialog boxes, preferences, and options. When you activate a filter, your image editor hands off the image layer or selection to the filter, which then processes the pixels in some way and then returns control to your editor. The filter might simply "flip" all the pixels in the image, turning black into white, white into black, dark gray into light gray, and so forth, producing a negative image. Or, the filter might use sophisticated algorithms to brighten or darken certain pixels based on the values of neighboring filters. Others move pixels around, or create entirely new pixels based on mysterious programming commands. The results can be amazing.

But no matter how they operate, filters can be classified into six broad categories, defined by how the plug-in pushes or punishes your pixels.

- *Image enhancement filters.* These are filters that improve the appearance of the image without making obvious changes in its intended content. For example, a sharpening or blurring filter can improve detail or mask dust and scratches without making other dramatic changes.

- *Attenuating filters.* Photographers will recognize this term, often applied to objects placed in front of a light source to change the nature of the illumination or the shadows it casts. These filters act like a translucent material placed between the image and your eye, adding a texture to the image. Most canvas, frosted glass, grain, and similar filters function like this. Depending on the strength of the special effect you apply, the results can be subtle and natural looking, or stronger and more impressionistic.

- *Distortion filters.* These filters operate by moving pixels around in an image, providing distortion of some type, such as a whirlpool, ripple, or pinching effect. Distortion filters are rarely subtle, and are often used to create strong artistic effects.

- *Pixelation filters.* These filters add texture like attenuating filters, but also use the color, contrast, brightness, and other attributes of the pixels being modified to produce the final texture. Instead of simply overlaying a pattern, pixelation filters build the pattern out of your existing image. You'll find pointillist, mezzotint, halftoning, and crystallizing filters in most image editors.

- *Rendering filters.* These filters create new pixels, summoning puffy clouds from nowhere, adding fiery flames where none existed before, casting interesting lighting effects on your subject, or creating apparent 3D images from flat, two-dimensional selections. Filters that simulate lens flares, produce shiny chromium or colored foil effects, and realistic page-curl looks all fall into this category.

- *Contrast-enhancing filters.* Some filters work their magic based on the differences that exist between the boundaries of two colors in an image. Unlike sharpening and blurring filters (which work the same way), these plug-ins can also add color to the edges, change the pixels within boundaries, and produce other dramatic effects. Filters with names like Emboss, Bas Relief, Glowing Edges, Poster Edges, and Ink Outlines work this way.

- *Other filters and plug-ins.* You'll find many more add-ons that don't fit exactly into one of these categories, or which overlap several of them.

## How to Use Filters

Filters are easy to use, but there are some steps you should follow to make sure your filtering experience is a pleasant one. This section provides some guidelines for using filters that apply to just about any image editor you are using.

### Select the Portion of the Image to Be Used

First, make sure the layer where you want to apply the filter is visible and active. A common mistake is to have a layer visible on the screen, but another layer is chosen as the active,

editable layer. The filter you're applying will process the active, highlighted layer, which might not be the one you want.

Choose the portion of the image that the filter will be applied to, using any of the selection tools, including the Marquee, Lasso, and magic wand. Some techniques can be applied only to selections, usually because their effects extend beyond the original selection. If you don't select a portion of an image, the filter will be applied to the entire image. If you're working on a scan that's large (20MB and up), it can take anywhere from a few seconds to several minutes to apply a filter. So, you might want to work with a representative section of the image first before applying the filter to the whole layer.

Although image editors generally have generous Undo features if you make a mistake, it's often smart to copy the entire portion you'll be working on to a duplicate layer and make your selection on a copy. You can play around with different filter effects without modifying your original image. Use several duplicate layers to work with, and you can preserve several versions and compare them.

Remember that many filters won't work on selections or layers that are totally transparent. You might need to fill a selection with a neutral gray fill, or something else so the filter will have something to operate on, even if the contents of the selection will be totally obliterated by the filter itself. Some texture and rendering filters (such as clouds filters) completely ignore the contents of a selection, but still won't operate on a selection that has no contents.

## Choose Your Filter

Some filters are called single-step filters because they have no options or dialog boxes. When you choose the filter, the plug-in immediately applies its effect to the image or selection. These filters are fast to use, but because they have no parameters to fiddle with, offer less control. Filters that do have options will usually be indicated as such in the image editor's Filter menu with a series of dots following the filter name, as with the User Defined... filter in Paint Shop Pro.

Once the dialog box for your filter appears, you can select any of the options you want to use, and preview the image in the dialog box's window. Zoom the preview in or out to see more or less of the image as it will look with the filter applied. Use the preview to select your options and parameters in real-time. If you don't like the look you get, move a slider, click a different radio button, or cancel an option. A typical dialog box, this one taken from PhotoImpact, is shown in Figure 11.8.

Among your options might be a list of *presets*, which are filter settings already configured to produce a certain look with that filter. Your image

**Figure 11.8** *Sliders, preview windows, and other options appear in the typical Filter dialog box.*

editor might supply an extensive library of presets, or you can create your own by clicking the Save button found in many Filter dialog boxes.

### Apply the Filter

Once you're satisfied with the effect, click the OK or Apply button to put the filter to work. The filter might be applied instantly, or it might take a few seconds (or many seconds) depending on the complexity of the filter, the speed of your computer, and the size of the image. Your image editor might have a Beep When Done option that will sound an alert when the processing is finished.

### Evaluate Your Results

When the filter is finished working, be careful not to do anything else, such as move the selection or apply enough filter until you've decided whether or not the effect is the one you want. Although you can always move back in time using your image editor's Undo functions, the process of backtracking is easier if no intervening steps are in the way.

In fact, now is the time to modify the strength of the filter, using any of several options. Photoshop, for example, has a Fade Filter command that allows you to reduce the strength of the filter using percentages. If you copied a selection to a layer of its own, you can also change the opacity of the layer that's been filtered, allowing the original image to show through. The advantage of this method is that you can change your mind at any time (until you save the final image) by adjusting the transparency of the filtered layer.

# A Filter Sampler

In this next section, I'm going to show you a sampling of the kinds of filters you can expect to find in your image editor. I'll include a few from a variety of editing applications, and offer representatives from most of the categories outlined earlier. You'll see that these filters can produce modest changes in your scans, or transform them completely.

## Painting Filters

Painting filters let you apply brush strokes without ever touching a brush. They range from the natural media looks found in Painter and Corel PHOTO-PAINT to wildly creative textures you'll discover in Paint Shop Pro and PhotoImpact. Photoshop and Photoshop Elements have quite a few filter tricks up their sleeves, too.

Painting filters share one attribute: They reduce the amount of information in an image by combining or moving pixels or by adding color. Some overlay an image with a texture or pattern, whereas other plug-ins group similar colors together or transform groups of hues into new tones. The result is an image that has been softened, broken up, selectively increased in contrast, or otherwise "pixelated." These filters seem to have turned a photograph into a painting, transforming harsh reality into a softer look. In truth, of course, the effects mimic the work of an artist, but can't duplicate the artist's sense of exactly where to apply each stroke. You'll find that these plug-ins work best with portraits or landscapes in which fine detail is

not as important as color and shape. They also work well when you want to mask defects in your image.

Figures 11.9 and 11.10 show how the strong stroke effects of these filters can be used to salvage an otherwise worthless image. In Figure 11.9, the floral photos are totally useless as-is. The top image is far too contrasty, and the bottom image is hopelessly out of focus.

**Figure 11.9** *The photo at top is much too contrasty, whereas the one at the bottom is completely out of focus.*

**Figure 11.10** *With Corel PHOTO-PAINT's Scraper Board filter, both images gain some interest from their abstract compositions.*

For Figure 11.10, I took each picture and applied Corel PHOTO-PAINT's Scraper Board filter, and then boosted the contrast and saturation a little. The two worthless photos have been transformed into interesting abstract compositions.

Adding brush strokes can add texture to an image that's too realistic, and make an ordinary photo look more like a work of art. Image editors all have artistic brush filters, like the Dry Brush filter from Photoshop Elements used to produce the image shown in Figure 11.11. At left is the unmodified version of a picture of some pink flamingos. At right, the Dry Brush filter

**Figure 11.11** *Photoshop Elements' Dry Brush filter adds texture to this shot of some pink flamingos.*

brings out the flamingos' natural texture while adding some strokes of its own. Portraits and scenics all can benefit from the application of a little brushwork.

## Sketching/Drawing Filters

You can also apply drawing-like effects, such as pen and ink, using filters that reproduce the outlines or textures of a drawing, while incorporating the content of your original image. These filters can reduce the amount of detail even more than common painting filters, because they emphasize the edges at the expense of the interior portions of each image.

Figure 11.12 shows a lakeside photo of some flowers, not especially notable in any aspect, so I decided to see what I could do using Ulead PhotoImpact's Colored Pen filter. The pen strokes delineated the shapes of the flowers nicely, and gave the image a hand-drawn look, which you can see in Figure 11.13.

The sketching/drawing filters can work for you if your scanned image has bad color, too. Many of them convert color images into charcoal sketches or India ink drawings. You might find that once the objectionable color problems are removed, your image looks more interesting and artistic.

**Figure 11.12**  *These flowers could use some pep.*

**Figure 11.13**  *PhotoImpact's Colored Pen filter provides a hand-drawn look.*

# Emphasizing Edges

Some filters do their work by enhancing the edges found in your images, often producing an abstract effect. They operate by locating rapid changes in contrast or color between pixels, which usually means that there is an edge of some type in the image. Then, they reduce the brightness of the darkest pixels, while increasing the brightness of lighter pixels, accentuating the edge transition. In other cases, the filter might reverse the colors only in the edges, producing a glowing edge effect, or reverse the brightness of all the non-edge pixels. Figure 11.14 uses Corel PHOTO-PAINT's Edge Detect filter to produce an edge-enhanced bouquet. Photoshop's Glowing Edges filter (also found in many other image editors) provides the neon-glow-at-midnight look to a clock tower in Figure 11.15.

**Figure 11.14** *Emphasizing the edges produces this outline-oriented bouquet from Corel PHOTO-PAINT's Edge Detect filter.*

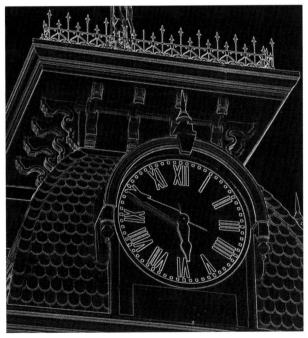

**Figure 11.15** *Neon glows and midnight result from Photoshop's Glowing Edges plug-in.*

Another effect can be had from the common "posterization" filters available in most image editors. These plug-ins find the edges of objects and sketch them in thick, dark strokes while reducing the number of colors in the image. The result is a distinctive poster-like effect. You can use them to create actual posters, or go a step further, as I did for Figure 11.16, and create an old-time postcard of the old Erie Canal (which was transformed at the beginning of the last century into the New York State Barge Canal, and then back to the Erie Canal in an effort to make it more of a tourist attraction).

**Figure 11.16** *Paint Shop Pro's Colored Edges filter gives this image a postcard look.*

Paint Shop Pro's Colored Edges filter provided most of the metamorphosis, but I helped things along a bit by boosting the contrast and saturation, and emphasizing the golden glow in the original photo. The photo was taken by Upstate New York resident Michael D. Sullivan. Mike coincidentally served as technical editor of this book and, as a dedicated color slide shooter, supplied a number of other images found in these pages, including the strawberry and tree branch photos near the end of this chapter.

## Pixelation and Stylizing Filters

These filters are another kind of "artistic" filter, producing pixelation and textures in your images. Some of these filters tend to obscure detail, particularly the "pointillism" and "watercolor" varieties, but a few can enhance your image without totally obliterating your original image. In Figure 11.17, I applied Corel PHOTO-PAINT's Elephant Skin filter (at left) and Photoshop's Facet filter (at right) to an image of some statuary found on the exterior of the cathedral in Leon, Spain. Each filter offers a different effect, but both tend to accentuate the weathered quality of these centuries-old carvings.

**Figure 11.17** *Corel PHOTO-PAINT's Elephant Skin filter (left) and Photoshop's Facet filter (right) add texture to the statues.*

## Distortion Filters

Distortion filters shift pixels around in your image, creating dramatic changes. If you want an abstract look, these filters are a place to start. You can push your image down a whirlpool, add waves and ripples, map the image onto a sphere, or liquefy the image to create a strange fantasy look. Figure 11.18 started out as a simple photograph of an ordinary lamppost until I subjected it to PhotoImpact's Warp With Grid filter. The plug-in overlays your image with a grid pattern, which you can distort by dragging the intersections of the grid lines until you achieve the results you want. I was looking for a lamppost as it might appear on a Saturday morning after a few too many drinks ingested on Friday night.

**Figure 11.18** *PhotoImpact's Warp With Grid plug-in lets you twist and turn your image at will.*

Another good distortion filter is Corel PHOTO-PAINT's Terrazzo plug-in, which produces kaleidoscopic views of your image using your choice of mirroring and blending schemes. If you need an abstract background for a web page, or simply want to create something new and interesting from nothing, you'll want to experiment with this versatile filter. The effect can be applied to the entire image, or just a portion, as was done in Figure 11.19.

**Figure 11.19**  *Corel PHOTO-PAINT's Terrazzo filter creates kaleido-scopic effects.*

## Encase Your Image in Plastic

I'm throwing in two bonus images using a pair of filters that don't quite fit exactly into any of the categories we've been working with. These two filters happen to be favorites of mine, and both are found in Paint Shop Pro. Figure 11.20 takes a delectable still life image of some strawberries, and runs it through Paint Shop's fabulous Enamel filter. This filter finds edges in an image, and then adds a 3D look that seems to separate each section into its own layer.

Another versatile filter is Paint Shop Pro's Soft Plastic filter, which works much like the Plastic Wrap filter found in Photoshop and Photoshop Elements. Both perform an edge-finding number on your image, and then cloak the edges and the areas between them with a shiny plastic look. Adjust the transparency of the filter to achieve looks ranging from total plastic wrap, to an icy covering, to a damp sheen. I chose to apply the filter to some ice-covered twigs to add yet another layer of "ice" and emphasize the frigid fate that had befallen them. You can view the abstract results in Figure 11.21.

**Figure 11.20** *Paint Shop Pro's Enamel filter creates exciting 3D edge effects.*

**Figure 11.21** *Paint Shop Pro's Soft Plastic filter can add a layer of ice to your images.*

# Third-Party Filters

If the filters built into your image editor aren't enough, there are hundreds of other filters available from third parties like Alien Skin Software, Auto F/X, and Andromeda. They are usually organized into suites of 10 or 20 filter plug-ins purchased as a set, so you can gradually expand your collection as your needs and finances dictate. There are too many filters available to tell you about them all, but I can provide a sampler to showcase what's available.

## Auto F/X DreamSuite

DreamSuite comes in three editions: DreamSuite 1, DreamSuite 2, and DreamSuite Gel, each bulging with filters and variations. DreamSuite 1 has dozens of interesting effects. For example, it includes filters with interesting names like Chisel, LiquidMetal, PhotoDepth, Putty, Ripple, Cubism, HotStamp, and Focus.

In DreamSuite 2, you'll find filters for creating frames, film grain, mesh effects, plastic wrap, tile, and the always-interesting Puzzle effect. Just take a favorite photo, apply DreamSuite's Jigsaw effect, make a color print, and then glue to a piece of foam board and cut the puzzle out. DreamSuite Gel includes Gel, GelPainter, Liquid Crystal, GelMixer, and CrystalPainter (shown in Figure 11.22) effects.

Auto F/X also sells AutoEye, which is a great image-enhancement plug-in that can automatically correct many of the color, tonal, and other defects in your scanned images.

**Figure 11.22** *DreamSuite Gel's CrystalPainter filter lets you create crystal edges to any image.*

## Alien Skin Software Eye Candy 4000

Eye Candy offers 23 filters, including Antimatter, Carve, Chrome, Cutout, Drop Shadow, Fire, Fur, Glass, Glow, HSB Noise, Inner Bevel, Jiggle, Motion Trail, Outer Bevel, Perspective Shadow, Smoke, Squint, Star, Swirl, Water Drops, and Weave. Although you can add some of these effects using your image editor's capabilities, you'll never apply any of them as quickly as you can with Eye Candy. In addition, Eye Candy's slider settings can be saved as presets and re-used any time you like.

Figure 11.23 shows Eye Candy's Water Drops filter in action. The controls are typical of the suite's flexibility: You can adjust drop size, amount of coverage, darkness of the drop edges, opacity, amount of color tinting (as well as the color itself), and the degree that the drops refract the portion of your image that lies underneath.

**Figure 11.23** *Eye Candy's Water Drops filter adds realistic moisture to your images.*

## Alien Skin Software Xenofex

Xenofex is another offering from the same company that brought you Eye Candy. It's chock full of interesting filters, many of which are unlike any of those offered in packages from other vendors. You get 16 useful plug-ins, from Baked Earth to Constellation, Crumple, Distress, Electrify, Flag, Lightning, Little Fluffy Clouds, Origami, Puzzle, Rounded Rectangle, Shatter, Shower Door, Stain, Stamper, and Television. Wonder what each filter does? Just look at its name.

Figure 11.24 shows the dialog box for the Baked Earth filter, which creates a cracked surface not unlike the dried mud you'd find at the bottom of a parched, empty lake bed. You can vary the crack length and width, the amount of variation in the cracks, the brightness and sharpness of the highlights, and even the direction the illumination comes from.

**Figure 11.24** *Xenofex's Baked Earth filter offers some interesting textures.*

## Alien Skin Software Splat!

Yet another filter package from Alien Skin is Splat!, which has a few interesting filters, each with a wealth of possibilities. They have names like Border Stamp, Edges, Fill Stamp, Frame, Patchwork, and Resurface. You'll find them useful for creating edges, frames, and textures. One of my favorites in this set is the Patchwork filter, which breaks down your image into neat squares, either using a cross-stitch pattern or the "light pegs" you used to create stunning rear-illuminated art when you were a kid. If you yearn for the days when "art" was created on dot-matrix printers using only ASCII characters, Patchwork has that, too. If you don't know what ASCII characters are, you probably won't be interested in this feature anyway.

**Figure 11.25** *Painting with light is bright when you use Splat!'s Patchwork filter instead of translucent plastic pegs.*

Figure 11.25 shows the interesting results you can get with this filter, using the light peg mode.

## Andromeda Software Filters

Andromeda Software has a very large line of filters, many of them designed specifically for photographers. Andromeda is the Cokin of the Photoshop-compatible plug-in world. Their products include a perspective control plug-in you can use to manipulate the apparent depth of your images, and a "lens doctor" filter to fix the pincushion or barrel distortion effects that

plague some lenses. Andromeda lets you mimic various depth-of-field effects with its variable focus filter, or create multiple images that resemble those you get with high-priced glass filter sets.

The first place to start is with Andromeda's Series 1 set, which bundles together 11 filters. These include the cMulti and sMulti Filters, which generate circular or straight multiple lens and kaleidoscopic effects. The Designs Filter includes dozens of textures and patterns that can be rotated, colored, bent, and warped, providing a 3D-like effect. The Mezzo Line-Screen Filter uses patterned screens to convert your photographs to mezzotint line art. You might also appreciate the Diffract, Prism, and Rainbow Filters for creating spectral effects. A super diffusion tool is found in the Halo Filter, which lets you control the direction, amount of spread, and intensity of the diffusion you apply.

There's also a Reflection Filter for producing realistic pool reflections, and a Star Filter that adds a variety of glints and sparkles to your image. My favorite is the Velociraptor, shown in Figure 11.26. It's a must-have tool for developing realistic motion blurs that extend straight back from your subject, converge to a vanishing point (like Superman or Thermoman zooming into space), or are arranged in diagonals, waves, or arcs.

**Figure 11.26** *Andromeda's Velociraptor gives you remarkable control over homegrown motion blur effects.*

# Next Up

By this time, you should have all the basics of fine-tuning and enhancing images under your belt. Perhaps you're ready to share your best photographs with family, friends, colleagues, and clients. The next chapter introduces some invaluable options for displaying images on web pages, sending them via e-mail, or showcasing them in personal or online photographic albums.

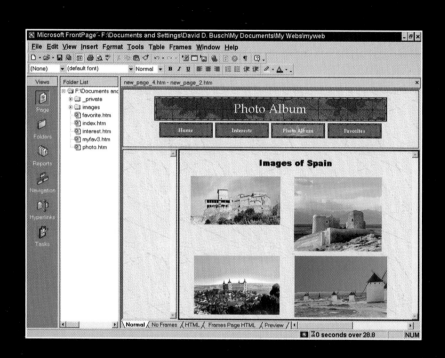

# 12

# Sharing Scanned Images

Let's face it. Half the fun of photography is sharing your images and basking in the glow of the admiration your stellar efforts generate. Whether you're distributing photographs to those who are genuinely interested, subjecting a captive audience to a display of your best work, or soliciting comments or criticism from colleagues or friends, your goal is to make sharing as easy and convenient as possible.

Before the digital age, sharing photographic images could be tricky, particularly if you had a collection of color transparencies that were difficult to view, easy to damage, and were the only copies of the pictures. However, once you've digitized your film images, sharing them automatically becomes a lot easier. Electronic images can be shared in ways that simply aren't possible with traditional pictures that are available only as prints, or, worse, color slides, or, worse yet, only as film negatives.

If you like your photographs and want to have as many people as possible see them, this chapter provides an introduction into all the exciting ways you can share and distribute film images that have been scanned and converted into digital files. We'll be ranging a bit outside the world of scanning, but I think you'll find at least a few ways to share your photography that you might not have known about.

## Whole New Worlds

Historically, it's been tricky to share conventional photographic images and, in fact, many of the most useful innovations in photography have come from developments that make it easier to distribute pictures to a broader viewing audience.

The very earliest photographic images, such as Daguerreotypes, were one of a kind. If you wanted two copies of a portrait of your grandfather, you had to convince the old gent to sit still for two separate photographs (and hope that his frozen expression on each was acceptable). Sometimes copies were made by making a Daguerreotype of a Daguerreotype, but that was less than a satisfactory solution. During the time when each photograph was an original, sharing consisted of passing the one-and-only image around physically, and hoping it didn't become lost or damaged.

Once processes like glass plate negatives and paper prints became available, it was possible to produce copies of images and distribute them, although at extra expense. Today, despite the sophistication of film-based photography, the limitations remain the same. Unless you digitize your images, your options for sharing conventional photographs are these:

- Produce as many duplicate prints as desired and send the extra copies to anyone you'd like to share them with. That can be expensive if you share a lot of photos, even with reprints costing only a few pennies. A typical scenario for this sort of sharing is to allow all your relatives, friends, or colleagues to have a copy of your favorite wedding photos, baby pictures, class reunion shots, snaps from the company picnic, or that product shot that needs to be approved before publication.

- Circulate a single copy of each photograph to everyone. In this case, what you save in not making copies can be eaten up quickly in the expense of physically moving the photos around from place to place. In a business environment, courier fees or simply the cost to move photos around from one company building to another can be significant. You also risk loss or damage to the photos, and make it difficult for two people to view and discuss the same picture at one time. This sort of sharing is typically done in business when an image and perhaps accompanying documents are circulated for approval.

- If you're sharing 35mm slides, the originals or duplicates can be placed in plastic sheets and circulated that way. One big problem with this option is that not every one has a light box, loupe magnifier, or other way to view the slides. Larger transparencies can also be circulated this way, but not much more conveniently.

- You can pop 35mm slides in a tray and share them with a projector, or loan out the tray to those who have projectors of their own. It can be difficult to force people to sit still for a slide show, particularly in a social environment, in which your friends and neighbors can feign sleep or sneak out as soon as the lights are dimmed. In business meetings, if you try to show slides you can almost count on half the people at the meeting suddenly recalling other appointments, remembering cell phone calls they simply must make, and finding other excuses to flee.

- Frame and hang your prints and display them in a gallery. Then, you have to convince people to come and look at your masterpieces.

As you can see, none of the options for sharing conventional photographic images is without drawbacks. Now, digitize your film using the techniques described earlier in this book. Whole new worlds of sharing options are open to you. We already looked at online picture services, like Kodak Picture Center Online, in Chapter 7. Other sharing options include the following:

- Display them as individual photos on your website

- Display them as individual photos on somebody else's website

- Create an online photo album that visitors can page through at their own pace

- E-mail them to friends, relatives, or colleagues

- Copy them to a CD-ROM, and distribute hundreds of sets of as many photos as you want at a cost of a few pennies per set

- Make a computerized slide show

- Make your own PowerPoint presentation and distribute that for viewing at the recipient's leisure

- Collect your photos into a "book" that you can print inexpensively on your inkjet printer

I'll explain each of these options in this chapter.

# Sharing Images via Your Own Web Space

For the ultimate in flexibility in sharing your images on the Internet, you'll definitely want to own and operate your own web space. Certainly, online sharing services like Kodak's Picture Center Online (first mentioned in Chapter 7) make sharing photos as easy as toasting bread, and work with both images scanned for you by the service as well as your own images that you upload.

There are several advantages to using your own web space to distribute photos instead of using the cookie-cutter approach of a third-party sharing service.

- You aren't locked into a fixed type of online album; you can create your own customized display.

- Your own web space can look much more professional, and less consumer-ish, which might be mandatory for a business-oriented enterprise, and more desirable even for home-and-family applications.

- You can use many kinds of displays, including online slide shows, pages with thumbnails and clickable links to the full-sized image, animated shows, downloadable pictures that visitors can use to retrieve your photos for their own use (at a fee, if you want), and many other applications.

- Automated software tools make it easy to create sophisticated displays quickly.

There are also some disadvantages:

- Your own web space might not be free. Although there are lots of free web hosting services (computers which store your web pages and images and serve them to the Internet), others can charge from $5 a year to $24.95 (and up) per month. If you have lots of photos to share or need special services, you might have to lay out some cash for your web presence.

■ You might need to pay for some authoring tools to create your online sharing displays. It's likely that you already have some or most of the tools you need. Photoshop, Photoshop Elements, Photoshop Album, or Paint Shop Pro can handle much of what you need on the imaging side, but you might want to purchase more sophisticated programs for ambitious projects. Applications to create the web pages themselves can be low cost or free (Netscape Composer remains an excellent web page creator). Microsoft FrontPage is furnished in various incarnations with Microsoft Windows and Microsoft Office. Or, you might want to spring for a tool like Dreamweaver.

■ As your plans become more ambitious, you'll probably need to acquire some skills that will help you create and fine-tune your web pages, such as knowledge of HTML (the "language" web pages are written in), or JavaScript (a scripting language that can add movement and interaction to your web pages). These skills are optional and not that difficult to acquire, but still something you should keep in mind.

## Free or Low-Cost Web Hosting

A web hosting service is a company that has its own servers connected to the Internet. Such a service will provide space to you for your own pages. Many of them have web page creation wizards online that allow you to make pages quickly. All you do is follow the instructions in a few dialog boxes. You can choose a theme for your pages, enter text and headlines, upload your images using other dialog boxes, and perform a few customization tasks. The wizard, like the one shown in Figure 12.1, creates the requisite web pages for you automatically.

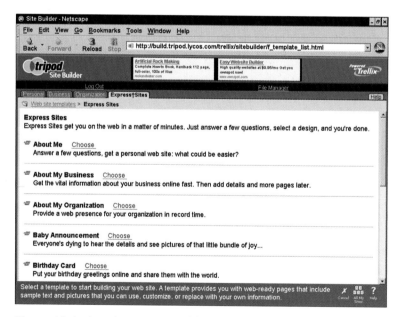

**Figure 12.1** *A web page wizard helps you create web pages quickly.*

Most services like this have quite a few canned themes, formats, and layouts to choose from, but they are just that: canned and prepackaged. You can't fully individualize your web pages. As with any option that's free or very low in cost, you'll have to accept some compromises. These include:

- *Advertisements on your web pages.* The free sites invariably include a few clickable links and other ads on your "free" web pages, so your visitors are subjected to commercial appeals as they browse your photos. Individuals might not find that acceptable. Businesses almost certainly won't. Fortunately, most of the free sites have an upgrade option. By paying a small monthly amount, your web pages are served up without any of the ads.

- *Locked into canned web pages.* Some services require you to use their website creation wizard, which limits your choices to efforts like the one shown in Figure 12.2. Others let you create your own pages without using their wizard. You can design your page using Microsoft FrontPage or another application, and then upload both the HTML pages and pictures to the free hosting site. That option provides maximum flexibility and creativity, if you're inclined to build your web pages yourself.

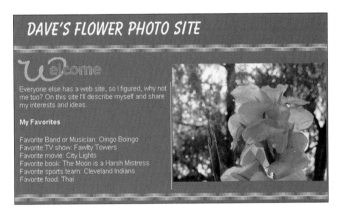

**Figure 12.2** *Don't get locked into canned web pages designed by someone else.*

- *Your web page address, or URL, is likely to be clumsy and provide a definite tip-off that you're using a free service.* For example, your main page might have a URL like **www.reallyfreewebhostingspace.com/member354129/t678219ret4.htm.** That's not a particularly prestigious web address for an individual, and probably the kiss of death for a business' credibility.

- *Inability to serve pictures outside your web pages.* Most of the free web hosting services don't allow links to photographs on their servers except from pages that are also on their servers. So, if a relative or colleague wants to display your photograph on their own web page, or if you want to use one of your shots to illustrate an eBay auction, you might end up with no picture at all on the "foreign" web page or, worse, the logo of your web hosting company.

■ *Limited storage space and/or bandwidth.* Storage space is the amount of hard disk space allotted for your pictures, web pages, and other materials on the hosting computer. Bandwidth is most easily understood as the amount of data transfer to and from the hosting computer. A free service may limit you to 5MB of disk space, which isn't a lot if you have many, many pictures or many of them are large. If your web page is very popular and your images are a bit on the large size, you might bump up against bandwidth limitations, too. A free hosting service might balk when your pages are accessed sufficiently to result in 500 to 1000MB of transfer. Or less.

If you have your heart set on paying little or nothing for your web pages, check to see what your current online service or Internet service provider (ISP) offers as part of their services, or which might be available as an inexpensive upgrade. For example, the Time Warner Roadrunner service in my area provides 5MB of space for their Personal Web Page service. You can create pages using Microsoft FrontPage and even use most of the FrontPage advanced features, including publishing directly to your web space. Like many ISPs, Roadrunner doesn't allow commercial websites. Most other ISPs offer between 5MB and 20MB or more of web space with their basic service package. America Online provides 2MB of space for each of your seven screen names.

Many ISPs offer home page templates, wizards, or even a proprietary or "lite" version of a commercial web page creation tool to help you get your web page up and going. The restrictions of the independent free sites also apply to ISP-hosted web pages, including bandwidth constraints. Make sure your service agreement with your ISP doesn't let them charge you extra fees without warning if your site suddenly becomes popular and attracts a few million visitors.

If your ISP doesn't provide web hosting, and you're still committed to paying next to nothing, use Google (**www.google.com**) to check for free services. These can include sites devoted specifically to photography (photo-sharing communities) as well as "family" web page hosting services, and those that make their money from advertising or fees paid by users who want to exclude the ads from their pages.

These sites come and go with alarming rapidity, but I'm providing a list of providers like GeoCities, shown in Figure 12.3, which have been around for a long time, and which meet the needs of a variety of users.

■ Yahoo! GeoCities—**www.geocities.com**

■ Homestead—**www.homestead.com**

■ iVillage.com—**www.ivillage.com**

■ Familypoint—**www.myfamily.com**

■ Lycos Tripod—**www.tripod.com**

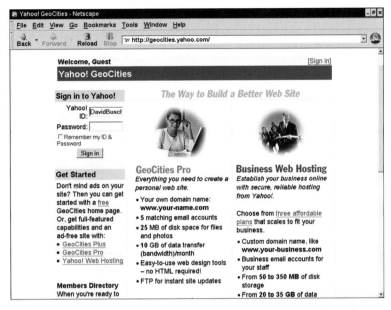

**Figure 12.3** *GeoCities is one of the most well-known of the free and low-cost web hosting sites.*

# Master of Your Domain

A distinct upgrade in terms of classiness, desirability, and flexibility is to host your own domain with the name of your choice, such as **www.dbusch.com**. You'll also pay a little more to go this route, but not necessarily a huge amount. Domains can be surprisingly affordable.

There are a couple of steps involved in setting up a domain of your own. None of them is very difficult and, in fact, some hosting services have automated tools that can do the work for you. I once set up a working domain from scratch in less than two hours, and most of that time was spent waiting for the new domain name to begin "propagating," or become known to the Internet Domain Name Servers (DNS) that help traffic get routed to your site. Follow these steps, and you're in business:

1. First, choose a domain name that isn't already taken. One quick way to check a domain's availability is to use a whois service, like the one at **www.networksolutions.com/en_US/whois/index.jhtml.** Web hosting services also provide these lookups as part of their registration process, so you might be able to skip this step.

2. Register your available domain name with an official registrar. You can locate registrars using Google. They range from small companies to giant registrars like Network Solutions. Some larger web hosting companies, such as Verio, also serve as registrars, as you can see in Figure 12.4. You can register online using your credit card.

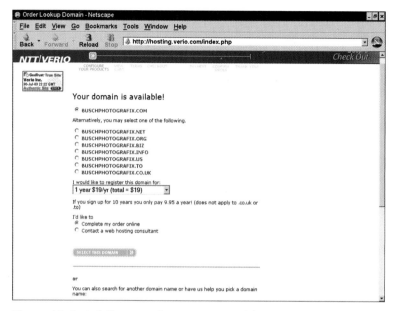

**Figure 12.4** *A full-service hosting service like NTT/Verio can help you find a domain name and register it.*

The main reason to choose your registrar yourself is to reduce costs. Registering with Network Solutions currently costs $35 for one year, or $19 per year if you register for five years. Very small registrars might charge you as little as $7.95 a year. You can choose to register through your web hosting service for convenience, or use a large independent registrar like Network Solutions simply because you want to avoid having to switch registrars every couple of years (which can happen if you select a small company).

3. Sign up for a web hosting service. In many cases, you can skip directly to this step once you've found a web host you like, because most hosting services also help you search for an available domain name and register your domain.

As I mentioned, it might take only a few hours to get your domain up, running, and ready for you to upload your web pages. Your chief concerns in choosing a web host will be cost, capacity, reliability, and its features. Here's a quick breakdown of what these mean to you:

■ Unless you're running a commercial operation, you'll want to minimize cost as much as possible. Web hosting services can cost as little as $25 a year, $5 a month, or as much as $50 and up per month. Cost is generally dependent on the other three criteria: capacity, reliability, and features, which I'll explain shortly.

■ *Capacity* is how much hard disk space you can use to store your pages and images, as well as the bandwidth needed to display them to visitors of your site. Hosting services offer 5MB to 250MB or more of disk space, with options to purchase additional increments at a reasonable price. Bandwidth varies from 1000MB (1GB) to 5GB or more, again with additional capacity available at additional cost.

- *Reliability* is measured in "uptime," or the percentage of the time your web space is available. A figure like 99 percent uptime might look good on the surface, but that translates into downtime of more than three and a half days a year! Most of us look for uptime figures of 99.9 percent or better. Your hosting service will guarantee a specific performance, based on their past experience.

- Features include e-mail accounts you can use to send or receive e-mail (**dbusch@dbusch.com**), technical support, online chat rooms within your web pages, and other goodies. You might not need all these if all you want to do is host photographs, so you should take the available features into account when selecting the price you're willing to pay.

## Comparing Typical Plans

Although pricing for web hosting can vary widely, you might want to compare plans offered by two typical services—NTT/Verio (**www.hosting.verio.com**) and Affordable Host (**www.affordablehost.com**). I selected them because each has a slightly different approach. Although prices can change over the life of this book, both of these providers had fairly stable pricing over the last several years.

### NTT/Verio

Verio's least expensive basic setup is the Bronze Plan. There is a $50 setup fee that doesn't include the separate domain name registration fee ($19 or less, depending on the number of years you sign up for). After that, you pay a monthly fee for the hosting service. A five-year contract will cost you $14.95 a month; contracts of less than a year are $24.95 a month. Other commitments are priced somewhere in between.

Your monthly charge gets you 250MB of disk space, and 7500MB of data transfer (bandwidth), which should cover just about any photo-hosting you want to do. Additional storage and bandwidth is available at reasonable prices. A simple website creation tool, PowerWebBuilder Basic, is included free to help you design your showcase, but you can use your own design software and uploading tools (called FTP software). Those who are heavily into website creation get lots of extras, such as support for CGI scripts (a scripting language widely used to create sophisticated website features), the capability to use databases like MySQL, and secure web server transactions in case you want to set up a shopping cart and accept credit cards.

The rest of us would probably get more use from the 20 standard e-mail accounts, which can be accessed from any e-mail client, including Microsoft Outlook or Outlook Express, as well as from a web browser. You can also forward e-mail to other accounts, and create "autoresponders" that send an automated message in response to inquiries. For example, you can include a notice on your web page along the lines of, "If you'd like to purchase any of these photos, e-mail **iwannabuyit@dbusch.com**" and anyone sending such mail can be sent a canned response. The response can be a pricelist, or a promise to follow up with a personal e-mail, or anything you want.

*Affordable Host*

This company specializes in shared hosting, which simply means that when you buy a server plan, you're also entitled to share all the resources you're purchasing with more than one domain. For example, you could create three domains, **dbusch.com**, **familyphotosbydavebusch.com**, and **buschphotografix.com**, each of which would serve a different audience, customer base, or group.

For $5.95 a month, you can host up to three domains, and create as many as 100 e-mail accounts, with 100MB of hard disk space and 5GB of data transfer. That might be all you need. If not, you can host up to eight domains, create 200 e-mail accounts, and have access to 200MB of hard disk space and 10GB of data transfer for $10.95 a month.

Other plans give you 25 domains, 500 e-mail accounts, 1GB of storage, and 30GB of bandwidth for $25.95 a month. Plans like that are actually designed for web designers and others who want to resell their contracted resources to clients. You can get 10 and 20 percent discounts on any of these plans by prepaying for one or two years.

Although the two example firms I described do a good job, there are many other options available. You can search for other web hosting companies at **www.cnet.com**.

# Nuts and Bolts of Creating Your Own Web Pages

I'm including a short section on the mechanics of creating your own web pages, not because I intend to teach you how to do this, but, instead, as an overview you can use to decide whether you want to get involved in the whole sticky process in the first place. If so, you can find any number of good books on how to create and enhance web pages, such as *Learn HTML 4 In a Weekend, 4th Edition* (Premier Press, 2003).

Of course, at its most fundamental level, web page creation is all about writing HTML code. HTML stands for *hypertext markup language*, which is a fancy term for a text formatting language. That's not as scary as it seems. HTML is nothing more than a set of instructions for your browser and the web server that offers each page for display. The instructions boil down to commands like these (translated into plain English):

*Open a new web page and title it "Dave's Photos." Then display the following headline at a particular size, and some text. Show these images next, centered. If a visitor clicks on any of the images, jump to a page that displays the image in full size. If the visitor clicks on one of these links, go to the linked page."*

In its most basic form, that's all there is to HTML. Of course, there are extensions and add-ons, such as JavaScript, that can provide animations, pages created on-the-fly based on user input, and lots of interactivity. You don't need to learn any of that unless you want to. You don't even need to learn HTML if you'd rather not, because there are many web authoring tools that let you design web pages by dragging and dropping, making selections from menus, or using tool palettes.

If you're curious about HTML, you can probably determine what many of the commands, called *tags*, do just by looking at them. Just launch your browser and visit any web page that you like. With either Internet Explorer or Netscape Navigator, you can view the HTML source code by right-clicking in the page and choosing View Source or View Page Source from the context menu that pops up. You can find some mind-numbingly simplistic HTML code at my family web page at **www.dbusch.com/morekids.htm**. There's nothing scary there at all, as you can see in Figure 12.5.

**Figure 12.5** *Simple HTML is easy to create from scratch.*

Unfortunately, at more sophisticated websites, the code on many pages can be pretty darn ugly stuff if you aren't familiar with HTML (or JavaScript, which also might be present). The good news is that you don't have to know much HTML to do some amazing things—provided that you are using the right tools.

## Using Web Page Tools

Depending on what you are trying to accomplish on a web page, you might not ever have to learn or even look at HTML code. During the last few years, a number of software vendors have worked hard to develop tools that enable users to create web pages through what is known as WYSIWYG (What You See Is What You Get) editors. The idea behind these web page creation tools is that you build your pages exactly as you want them to look in a graphical environment, and the software creates all the necessary HTML code without your even having to look at it.

For example, any version of Microsoft Office, from Office 2000 onward, will work fine for creating web pages. You can use Microsoft Word to create a standard document and then add

a few digital images, titles, various headings, graphics, and even tables. After you complete your work and are happy with the way it looks, you save it as a normal DOC file. Then, after you save the document, you can save it again, only this time you select the Save As menu and, in the dialog box that appears, select Web Page in the Save As Type box. You now have a web page that looks like the Word document that you created.

Another approach is to use Word's web page templates and start by creating a web page instead of a Word document. To get to these templates, select File > New and then click the Web Page tab. Notice that there is even a Web Page Wizard, which will help you select a theme, create multiple pages, and more.

After you see what you can do with Word, you might assume that you can do the same kinds of things in the other Office applications. Your assumption is correct—you can. Creating a web page that looks like a spreadsheet is as easy as creating a spreadsheet in Excel. You also can use PowerPoint to create a slide show that uses your digital images and then have PowerPoint create a web page-based slide show. Even Microsoft Publisher enables you to create web publications.

Macromedia Dreamweaver and Microsoft FrontPage are just two more applications that you can use to create web pages. FrontPage is especially easy to use, but Dreamweaver, designed for professional website designers, has a steeper learning curve.

Figure 12.6 shows a web page being created with one of FrontPage's basic templates. At the bottom of the window, you can see five tabs. Three of them are for conventional views of the

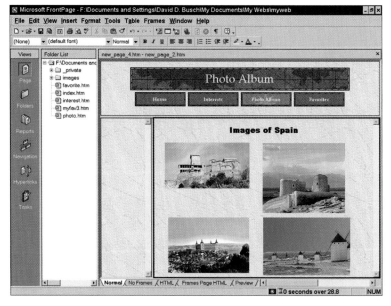

**Figure 12.6** *Microsoft FrontPage includes templates you can use to create web pages.*

web pages—one for Normal view, one for HTML view, and one for Preview. The other two let you view the page without frames (those boxes on the page that separate the content into compartments), and the frames HTML code. These tabs let you switch quickly between views. Start in Normal view, which is the view that you use to insert text and other objects and to change their properties. When you want to see what the page looks like, click the Preview tab. If you need to add, delete, or modify HTML code, click the HTML view or Frames Page HTML view, shown in Figure 12.7. You can create multiple pages, with links between them.

Once you've created your pages, you can upload them to the web space you have acquired. You can use the built-in publishing features of your HTML editor, or work with a separate program called an FTP client. These are the programs that are used to upload and download files between a website and a computer.

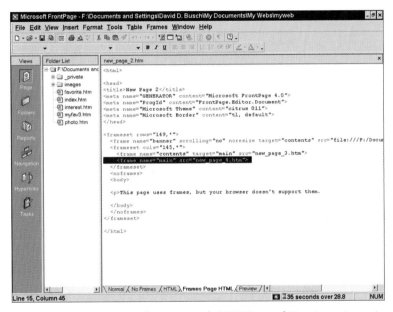

**Figure 12.7** *FrontPage has Normal, HTML, and Preview views, in addition to special views for frames.*

Figure 12.8 shows one such program, FTP Explorer, being used to upload a collection of JPEG images. FTP Explorer is a simple application that works similarly to Windows Explorer. You can open a "window" on your web server, another on your computer, and drag files between them. FTP Explorer is an efficient program that makes the task of transferring files as error-free and quick as possible. You can download this program and other FTP clients from **www.cnet.com.**

**Figure 12.8** *FTP Explorer is a free, easy-to-use application for uploading files to your web space.*

# Sharing Through Photo Labs and Online Services

Chapter 7 looked at photo labs and online services as a way to digitize your images that originate on film. I briefly mentioned that these services also have ways to share your images online. If your web-sharing needs are modest and you don't want to bother with creating your own web pages, one of these services is a viable alternative. Most of them let you upload images that you've scanned yourself, so it's not necessary to send all your film for processing through the photo lab that puts them in the web for you. Your own scans and any digital images from your collection that you want to share can be posted in this way.

As you'll recall from Chapter 7, photo labs and online services can scan and upload your images to the Internet. All you need to do is shoot pictures with a compatible film camera (most services scan only 35mm or APS film), and then select a box on your film order envelope to request the photo lab create digital images and upload them to the Internet at the same time that they develop and make your prints. You can order a Picture CD or Photo CD at the same time. If you make your own scans, you can upload them yourself.

Three of the most well-known services include Kodak Picture Center, described earlier in the book, Ofoto, and PhotoWorks, a service of Seattle FilmWorks. You can find them at **www.kodak.com**, **www.ofoto.com**, and **www.photoworks.com**, respectively. There is also Shutterfly, which has the advantage of being accessible directly from within Photoshop Elements (using the File > Online Services menu choice, shown in Figure 12.9). You can access Shutterfly at **www.shutterfly.com.**

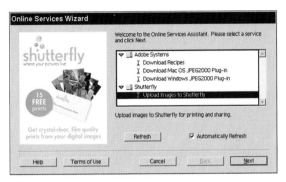

**Figure 12.9** *You can upload to Shutterfly directly from within Adobe Photoshop Elements.*

Sharing photos with these services is fast, simple, convenient, and inexpensive, especially when you think how much it might cost to make a ton of prints and share them in the conventional manner. The services I've mentioned are virtual carbon copies of each other when it comes to the process for sharing photos.

The first step is to convert your images into digital image files. If you're not scanning your own, you can drop your film off at a nearby photo lab or ship it to a mail-order service affiliated with any of the online services. The lab will process and scan the film and upload the digital files to the service's web space, and then notify you that your photos are ready, using the e-mail address you provide. As mentioned, you can also request that the photo lab place the digital images directly onto a CD-ROM or floppy disk.

If you're doing scans yourself, you can upload them to the photo service from your computer. In either case, your images will be ready to be shared. Figure 12.10 shows the screen used to upload photos to PhotoWorks. Note that PhotoWorks also has Uploader Software you can use to upload large batches of images quickly. Keep in mind that some services restrict the kinds of file formats you can upload. The Kodak Picture Center, for example, accepts only JPEG images and you must use either a Microsoft or Netscape browser.

Shutterfly, Ofoto, and the Kodak Picture Center operate almost identically. When you are ready to upload your pictures, you access a screen with text boxes like those shown in Figure 12.10. Type the location on your hard disk of the photo you want to upload, or click the Browse button and navigate to the folder containing the picture. Unless you have an incredible memory for file paths, you'll want to use the Browse option. Some services let you specify as few as three for uploading. Others, like Shutterfly, accommodate 10 or more in one batch.

Once you have uploaded your images to your service, they are available to be shared with others. You can assemble them into albums, or other collections, and then select the album that you want to share. The photo service can send e-mail to your friends, showing them how to access your online album, and inviting them to view your photographs.

When your recipients receive the e-mail inviting them to view your roll of pictures, like the one shown in Figure 12.11, they need to log in to the service to view them, using their own

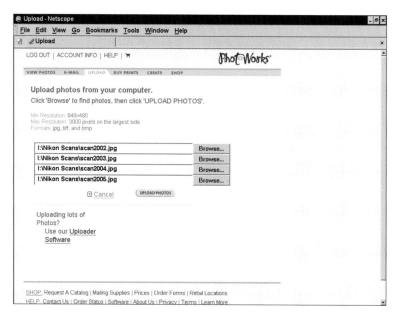

**Figure 12.10** *PhotoWorks has both web-based photo uploading as well as a utility program that uploads batches.*

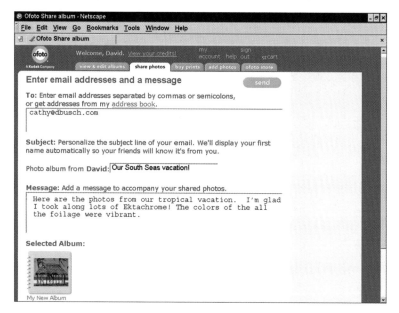

**Figure 12.11** *Once the e-mail invite arrives, the recipient can log on and view your album.*

account, or a free account they can create once. The album is then displayed in their browser, and they can order their own prints, if they like (which is the point of the free online sharing in the first place). These online services are so addictive they should not only be free, but should provide a commission for the photographers good enough to attract print orders!

# Sharing Images via E-Mail

Of course, sharing photos through web pages takes an "if you build it, they will come" approach. There's no need to sit around passively and hope visitors will come to look at your photos. You can be proactive and *send* your pictures for viewing, using e-mail. You don't want to spam unsuspecting folks, of course, but given a willing audience, you can easily send your best shots through standard e-mail. It doesn't matter whether the e-mail is sent or received using standalone e-mail applications, such as Microsoft Outlook or Outlook Express; browser-based e-mail applications, such as Hotmail; your office e-mail systems; or a proprietary e-mail system like that furnished with America Online.

Actually, there's some overlap. Many e-mail accounts can be accessed both through an e-mail client like Outlook as well as through web-based mail access, like that shown in Figure 12.12. If you use America Online at home, you can use the AOL application to send and receive e-mail. However, you can still access your AOL mail from any computer with web access by going to AOL at **http://www.aol.com**. There, the "AOL Anywhere" feature can log you in using your regular AOL screen name and password, and then take you directly to a web page where you can send and receive mail messages.

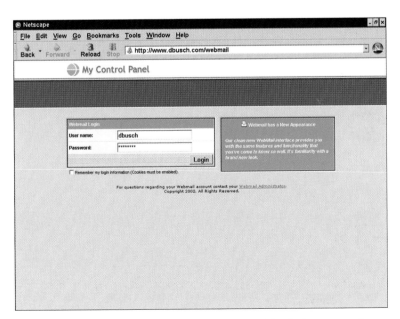

**Figure 12.12** *Some accounts can be accessed both from e-mail clients and web browsers.*

When sending images via e-mail, the size of the image file is even more important than when posting on a web page. After all, if visitors get tired of waiting for a humongous web-based image to download, they can always hit the Back button and flee. However, they may not have activated an option in their e-mail client (if it's available) to not download attachments, so the unwary can end up receiving large images they weren't expecting. This is especially vexing when your broadband connection is down, or you must use a dial-up connection for some other reason, and just want to check and see if that important text message has arrived. It is considered rude to send large image files, unless the recipient has requested that you do so or has agreed in advance that you send them.

So, before you even think about sending images by e-mail, you need to reduce the size of an image (such as from 1280×1024 pixels to 640×480), squeeze down the file size further by using a compressed image file type such as JPEG, or consider not e-mailing them at all. You can always post images to your website and send an e-mail with a link to the photo.

It's important to remember that many e-mail services, including AOL, have strict limits on the size of individual files that can be sent or received, and just about any e-mail system will have a limit to the size of the recipient's mailbox. This restriction can range from less than 2MB to 10MB per mailbox. Some versions send out files in odd formats that recipients may not be able to read, too.

There are three basic ways to share your images using e-mail:

■ You can send an image as an *attachment* to the e-mail.

■ Instead of sending the image file itself, you can e-mail a URL link to the image that points to the web location where the image is posted.

■ If both you and the recipient use HTML-based e-mail applications (and haven't turned off HTML features for security reasons), you can embed the image right in the e-mail.

The first method is the easiest. All you need to do is select Insert > File, or the equivalent command available in your e-mail client. AOL uses an Attach File dialog box, like the one shown in Figure 12.13. (The process may look a little different in later versions of AOL.) After you navigate to the image file or files you want to attach, the e-mail application converts the image to a format that can be sent by e-mail, and then sends the e-mail with the attachment. Equivalent software at the destination converts the image back to its original format. Sometimes the recipient must double-click on an icon representing the image to view the image in their default image viewer. You'll find that some non-e-mail applications have a facility for sending files, too, by automatically launching your e-mail client. Sometimes it may be necessary to put images inside a Zip file to get them to an AOL client.

The second method (e-mailing an URL that recipients can click) is the best choice when you want to send a large image or a group of images without bogging down the recipient's e-mail. Most e-mail programs have a feature for embedding a hotlink in the e-mail that can be clicked to whisk the recipient away (through the good offices of their web browser) to the web

**Figure 12.13**  *AOL's mail system lets you attach a series of files.*

location where the image is stored. This method is especially useful when the recipient has a skimpy mailbox, or might not have a viewing program installed. The web browser serves as the image viewer.

Because the e-mail itself does not contain images, the mail will be compact and fast to download. Your victim will also have complete control over when or if they view the image. You can leave the images on your web space for as long as you want, so people you've sent the link to can view the image for as long as they retain the e-mail or even just the link.

HTML-based e-mail can be problematic, thanks to some security flaws built into components of our best-known operating system (which shall remain nameless). Such e-mail can be filled with colorful graphics and images, but it can also contain off-color graphics and images, as well as pesky pop-ups and nasty virus-like invaders. So, many people have switched off the HTML capabilities of their e-mail clients, or choose to use clients that have no such HTML vulnerabilities.

On the other hand, many more people love HTML-based e-mail, because it can include just about anything you can put on a web page, such as formatted text, graphics, background colors, hotlinks, and textures. It can be created in Microsoft Word, saved with the .htm extension, and then sent like any other e-mail. Many e-mail clients also let you embed images and other HTML content directly. Of course, the recipient must have an application that can display HTML web pages that are received as e-mail, as shown in Figure 12.14.

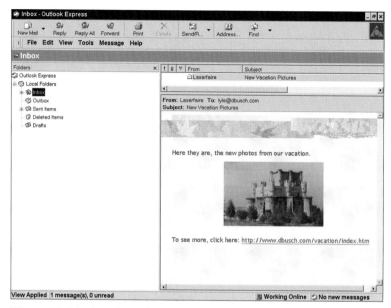

**Figure 12.14** *Anything that appears on a web page can be sent in an HTML e-mail message.*

# Sharing Images via Electronic Postcards and Greeting Cards

Postcards and greeting cards that include your photos are, in one sense, a step up from ordinary e-mail that happens to have a picture or two embedded. If you have a special picture or a special message, consider using an electronic card. They're not limited to special occasions; you can use them any time you want to add emphasis to your message, or create interest in your photography.

You can use Google (**www.google.com**) to locate any of the hundreds of websites that offer postcard and greeting card services. Many of these are free, and make their money from the ads you read while you visit the site, or, perhaps from the sale of related products. Virtually all of them provide photos and other artwork to use in your card. The trick is to find one that will let you upload your own picture and use that as an illustration. One of these is at **www.all-yours.net**. It provides an uploading page, shown in Figure 12.15. Note that you can also provide your own music files that will accompany your card when it is viewed.

The recipient of your e-postcard receives an e-mail message and instructions for reading the card. The e-mail can include an attachment, which can be double-clicked to display the card, as shown in Figure 12.16. This sample, produced with American Greetings' CreataCard application, includes an arrow that's clicked to view the inside of the card. There's also an icon for sending the card to a color printer.

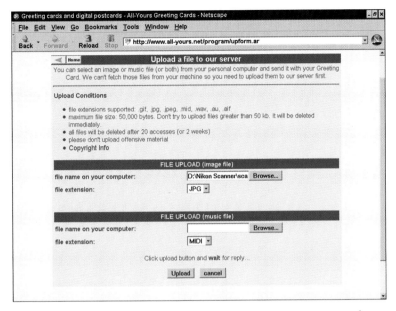

**Figure 12.15** *Upload your own pictures to create your own photo greeting card.*

**Figure 12.16** *An electronic greeting card created with American Greetings' CreataCard.*

# Sharing Images via Instant Messages and Chat Rooms

I've been sending instant messages and haunting chat rooms since 1981 (way before what we now call the Internet became available to the general public). Those of us who were online more than 20 years ago never dreamed that IM applications and chat rooms would become as universal and pervasive as they are today. Of course, always-on high-speed connections had a lot to do with it, but killer features like the capability to exchange graphics and music files have caused this form of electronic communication to really take off.

By mid-2003, AOL was claiming that it transmitted 2.3 *billion* instant messages (IMs) each day, an astounding figure when you realize that fewer than 2 billion telephone calls are made in that time period. Today we have, in addition to AOL IMs, equivalent communications via ICQ, and similar instant messaging services from Yahoo, Microsoft's MSN, and other providers. You no longer need to have a separate IM client for each service you want to use; although the major services still aren't cooperating with each other, applications like Trillian bypass all the fuss and let you log into several different IMs simultaneously.

Even more surprising than the numeric growth of IMs is the expansion from a casual social or entertainment tool to serious personal and business communications channels. IMs are used for customer service, real-time conferences, family reunions, and even to allow "guests" from all over the country to "attend" a wedding. IMs and chat rooms let you talk to anyone who has a computer connected to the Internet. You can build a buddy list of people, so you can see when they're available to talk, or "ping" a person and receive a canned message explaining why they aren't online at that moment.

IMs are a great way to share images and interact in real-time. You send or post to a web page only the images that the recipient asks for—and then you can talk about that image. For example, after taking a trip to Spain to shoot pictures of castles, you could have a chat with one or more friends and share your digital images of the castles with them, as shown in Figure 12.17.

You can post the same sort of links in most chat rooms, too. It's easy to exchange photos with others using instant messages and chat rooms.

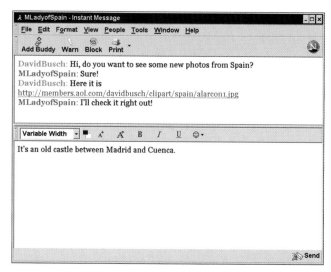

**Figure 12.17** *Send your pictures in real-time with an IM application.*

# Using an Electronic Photo Album to Store and View Images

Electronic photo albums are perfect showcases for your pictures and, as you'll see, are a great deal more flexible than the traditional paperbound album with sticky pages and acetate overlays. Photographers will want to use them to display and distribute their best shots, but photo albums are certainly not limited to a single application. For business use, albums can be used as product catalogs, to document the progress of a project, or to provide a pictorial inventory. Individuals can use them for insurance records, to collect family photos, or to document hobbies. If you collect Lladró porcelain, raise prize-winning canines, or cultivate rare flowers that last for only a few days, you'll want to assemble your best shots in an album, like the one shown in Figure 12.18.

**Figure 12.18**  *Digital photo albums are handy and flexible.*

## Applications for Digital Photo Albums

Of course, unlike their paperbound cousins, digital photo album applications have much more sophisticated features, which take advantage of the power of the computer. You can use them to organize and sort your photos, create online versions for viewing over the Internet, send images by e-mail directly from the album, or create greeting cards. The following sections discuss some of the things you can do with these albums.

## Using an Album with Database Capabilities

Create databases. Applications like Ulead's PhotoImpact Album or Adobe Photoshop Album let you add keywords and descriptions of each thumbnail to fields, like those shown in Figure 12.19. The descriptions provide more information about the image. You can then search and sort based on these fields to help you locate thumbnails or specific record photographs. The best part is that you can define the information fields yourself, so if you want to sort your collection of sports photos by team, year, or playing position, you can create one or more fields that allow you to do that.

**Figure 12.19** *Use predefined data fields or create your own.*

Album applications have album templates with fields already created for you. For example, a Real Estate Portfolio template might have Building Name, Building Style, Location, Number of Rooms, Listed Price, and Sales Representative. You can add to the fields, such as employee number, listing expiration date, and so forth.

Of course, it's a pain to have to enter all that information, but you only have to do it once (plus make updates, as necessary). Once all the information has been entered, it can be exported to a comma-delimited file and imported into other kinds of applications, such as a spreadsheet, another database, or a word processor. This step is as simple as checking the desired fields to export and choosing a menu item to export the information.

You can also search the database. For example, if you want to find all records containing the word "camera," you can use the search capabilities in the sophisticated Search dialog box shown in Figure 12.20. You can also print a color hardcopy of the entire database by using any one of several layout styles, including images and database information.

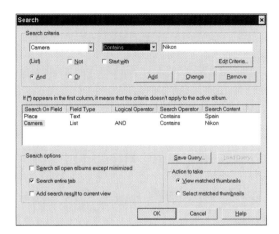

**Figure 12.20** *Search for specific information using a versatile dialog box.*

## Creating a Real Page-Turner

Adobe Photoshop Album is a recent product with lots of interesting capabilities. You can use it to create a book-like photo album with pages that turn, bookmarks, a table of contents, and an index. The program includes wizards that can fashion an album for you in a style that you choose, and then create a Portable Document Format (PDF) file that can be viewed with Adobe Reader (formerly known as Adobe Acrobat Reader). You can print your albums, send them as an e-mail message, burn them to a CD, or order a printed version from Shutterfly.

It's easy. Just choose Album from the application's Creations menu, and drag photos from one or more of your existing picture catalogs to the new album's workspace. Then, click the Start Creations Wizard button to activate Photoshop Album's automated album generating process. Choose from the selection of album styles, like those shown in Figure 12.21.

**Figure 12.21** *Choose an album style from the available templates.*

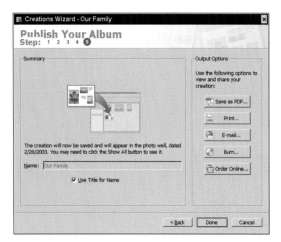

**Figure 12.22** *When you're finished, select your output destination for the album.*

Then proceed to the following screens, which let you enter a title, how many photos you want displayed on each page, and whether you want to include captions, page numbers, or headers/footers at the top or bottom of each page. Preview your album, and when you're happy with the layout and pictures, choose how you want the album output. As you can see in Figure 12.22, you can publish an Adobe Reader document, print the album, send it via e-mail, burn a CD, or order a printed version from an online service.

## Slide Shows

We've all slept through slide shows. We've also watched them with rapt attention. There's a big difference between a single-projector show put on by your next-door neighbor and those multimedia extravaganzas with banks of projectors, mind-numbing sound effects, smoke, and mirrors. There's also a big difference between conventional slide shows and those you can create digitally.

PhotoImpact Album and Photoshop Album have slide-show capabilities that offer images, text, transition effects, audio, and music. However, unlike conventional slide shows, you don't have to pile slides on a light box and rearrange them manually over and over to get the order you like. Instead, you can sort the slides on your monitor, add professional-looking transitions between slides, link the slides to music, or use an audio track to narrate the show. You can even display controls on-screen to advance or reverse a show, repeat it, or skip to a specific slide.

If this sounds a lot like a PowerPoint presentation, you're right. Although PowerPoint is great for shows with lots of bullet points and a bit of animation, Photoshop Album, in particular, is hard to beat for photography-oriented productions. The controls are easy to use, and offer a lot of flexibility, as you can see in Figure 12.23.

**Figure 12.23** *Add music and fancy transitions to your computerized slide shows.*

## Online Slide Shows and Portfolios

An online portfolio or slide show can be created with several applications. Cerious Software, Inc.'s ThumbsPlus, one of the more versatile tools available, contains lots of cool options for creating an online image portfolio. All you have to do is answer a few questions using the Web Page Style wizard shown in Figure 12.24. Use the wizard to select a template, specify the number of rows and columns of pictures shown per page, choose border and image size, and choose the image quality (which is important if some of your visitors have slow, dial-up connections). You can lay out your portfolio in multiple pages, choose to display bandwidth-friendly thumbnails only, or allow links to view a full-sized image.

**Figure 12.24** *The ThumbsPlus Web Page Style wizard can create an online portfolio with one or more pages in minutes.*

The program writes all the HTML code for you. All you have to do is upload the finished files to your web space. What could be easier?

Adobe Photoshop, Photoshop Album, and Photoshop Elements also have Web Photo Gallery tools that produce good-looking web showcases for your photographic efforts. You can select photos and add banners, text, and other features. Each enables you to choose the photos you want to display on your web page, and to specify formats, banners, text, and other goodies. Photoshop Album's gallery creator dialog box, shown in Figure 12.25, has four tabbed pages to let you create banner text, select the size of the thumbnail images, feature larger photos, and implement a custom color scheme.

The finished product is a beautiful full-page web display that features a single large picture with a scrolling strip of thumbnails shown along the bottom or one side of the page. Your visitors can scroll through all the thumbnails and click the ones they want to view a full-sized picture, as shown in Figure 12.26. All the files are saved in folders on your hard disk. If you use FTP Explorer or a similar FTP application, you can drag and drop the files from your disk to your web space.

**Figure 12.25** *Another easy wizard in Photoshop Album streamlines creating a web gallery.*

**Figure 12.26** *You end up with professional-looking pages like this.*

# Next Up

Although the photo album applications discussed in this chapter are a good start, the last chapter of this book looks at ways to manage your scanned images in a little more depth.

# 13

# Storing and Managing Images

There's a 150-year-plus tradition of ways in which film images should or should not be stored, dating back to the invention of the shoebox and extending through the development of climate-controlled storage vaults. You can store your negatives in sleeves, or safeguard them in their Advanced Photo System (APS) cassettes. Slides can be sorted into pages and filed in ring binders or deposited into file folders. Slides also end up in slide trays, ready for projection on a moment's notice. Most of these options emphasize convenience rather than safety, even though film originals are precious commodities, indeed. A related problem is finding the film images once you've managed to store them securely. Storing and managing film images can be complicated.

There are some dramatic differences when it comes to storing, managing, and retrieving your digital scans. For one thing, it's relatively easy to make absolutely faithful exact duplicates of each image, so you can store a copy somewhere safe, while retaining one for fast access. In addition, film images in digital form are much more compact and convenient to store. Anyone who's worked with shelves full of 80-slide or 140-slide trays, or attempted to locate a specific transparency in a drawer full of them knows what I am talking about. Thousands of film images can be archived in a slim stack of CDs or DVDs.

Organizing digital images can be simpler, too. Although I am very careful with my professional film images, others in my family (and perhaps in yours, as well) are less vigilant with their personal negatives, which reside in a giant chest, piled on top of each other in chronological order like fossils at an archeological dig site. The strata are disturbed by infrequent hunts through the pile, and finding a specific negative in all that disarray can be problematic.

Digital images, on the other hand, can be stored in files tagged to keywords, so you can find them in seconds. A lot of information can be contained in picture databases thanks to those

keywords. I'd need a copy of my high school yearbook to identify half my classmates in those old pictures I still have. My kids won't have that problem; they add names and other snippets of information to each of their photos as they update their personal photo databases.

Although digital imaging doesn't yet have a 150-year tradition of methods for storing and managing photos, this chapter will give you a good start in solving your archiving and retrieving problems using slightly newer technology. The key is that you have to *use* the tools at your disposal. Otherwise, you can end up with an unorganized hodgepodge of digital images that's not much more useful than that collection of picture-filled shoeboxes under your bed.

# Physical Storage

The first challenge to tackle is physically storing all those images. If your scans aren't safely ensconced somewhere in digital form, you can't possibly organize or retrieve them. So, deciding exactly how you are going to store your images is the first step. This section helps you get started. You'll learn how to estimate your storage needs (and why anything more precise than an estimate is futile), as well as decide exactly which storage media, or combination of media, is the best for you.

You'll also see that, although digital images don't usually cause many problems from a volume standpoint (hundreds of thousands of images can occupy less space than a paperback book), the *amount* of storage required can still be a big headache. After all, even at a cost of less than a dollar a gigabyte, storing thousands of gigabytes of images can be quite expensive. If you thought scans of prints were storage-intensive, when you began scanning film you learned how large digital files really can be.

Fortunately, storage media comes in two forms, the permanent kind you install in your computer as a hard disk drive, and removable storage such as that provided by Zip disks, CD-R/RW, and DVDs. Permanent storage (which isn't always permanent and can easily be removable) tends to cost more than removable storage options.

## Estimating Storage Requirements

One interesting thing about digital images compared to photographic images is that the storage requirements for a single picture can expand mysteriously and geometrically, beyond all rhyme or reason. When you make a photo on film, say, a color slide, you end up with a known quantity: a color slide that you need to store somewhere. Perhaps you make a copy or two and need to store them, as well.

There are no such assurances for digital images. In fact, the better an original image is, the more likely the storage requirements for the photo are likely to double, triple, or grow tenfold once it's been scanned and converted to digital format. A quick look at how digital images are stored will show you why:

- You can scan a so-so 35mm slide using your flatbed scanner's slide attachment at 1200 spi. A better slide might be worth scanning on a dedicated slide scanner at 2820 spi. A truly stellar example could be worth upping the ante to 4000 spi, or even more. Although the

resolution of the 4000 spi scan is only 3.3 times that of the 1200 spi scan, it will occupy *12 times* as much hard disk space. A really humongous scan of even a tiny 35mm slide can eat up hundreds of megabytes of storage.

■ The storage format you choose can sharply affect how much storage space is required. You can store hundreds of images in a compressed JPEG format in the same space as a single TIFF file at full resolution. But, if you want to be able to edit your images at a later date, you'll be opting for that space-hungry TIFF format, or another format like Photoshop's native PSD, quite often.

■ Photographs proliferate as you edit them. You may be satisfied with an image that weighs in at 10MB and save it under its final filename, such as segoviacastle.tif. But then, you also want to retain the original version in case you decide to go back and edit the picture in a different way. So you save another 10MB file under the name segoviacastleorig.tif. Perhaps you want to create a variation here and there, or edit the image in a new or different way. So, you end up with segoviacastle01.tif, segoviacastle02.tif, and segoviacastle03.tif. Faster than you can anticipate, "final" versions of your 10MB image, like the ones shown in Figure 13.1, are occupying 50 or 60MB of hard disk space.

**Figure 13.1** *Even a few minor variations on a theme can add up to lots of images to store.*

■ Photographs expand with alarming speed as you edit them. Photoshop's ability to divide a working image into individual layers is a blessing for those who are editing images, but the bane of anyone trying to conserve storage space. I was recently working on a scan that clocked in at a modest 4.1MB in its unmodified TIFF form. Then I began to work, selecting and copying various components, pasting them into new layers, and doing other simple modifications. I ended up with a modest six layers, and saved the image as a Photoshop PSD file. The image now had swollen to a massive 39.2MB. It was nearly eight times as large!

Unfortunately, most images can accumulate many more than six layers, producing an even greater disparity. An edited image may evolve into a 20-layer monster in no time. Further, experienced graphics workers get in the habit of saving multiple copies of their work in progress. When you have tweaked a photo a certain way, with the layers in a certain order and each using a particular amount of transparency or other attribute, you don't want to have to write down all those settings. So, it's easier to save the entire PSD file as a version, and then continue to work on the copy. These can proliferate even more hideously than "final" versions. I've found a dozen or more 40MB versions of an original 4MB file haunting my hard drive, long after they were needed for anything.

■ Because we think storage space is so cheap, junk versions of images, and junk images never go away. Your need for segoviacastle24.tif might have evaporated long ago, but the original file remains behind on your hard disk. You've finished another project, but are reluctant to eliminate *any* of the working files. Everyone's mileage varies, but, depending on the amount of editing you do and your working habits, you might have to count on needing 10 to 100MB of space for every megabyte of original image you are actively using. Yipes!

So, how do you estimate your storage requirements, both in terms of permanent hard disk space and removable storage? As you can see, when it comes to permanent storage, the most important factors might simply be your housekeeping habits and how many files you realistically expect to keep at your fingertips. If you don't run a large number of applications, keep your hard disk neat and tidy and free of scratch files and duplications, and don't have your heart set on keeping every file you ever worked on available for instant access, you might be able to get by with a bare minimum (which for graphics workers is likely to be 100GB or more).

If you're sloppy and tend to procrastinate when it comes to cleaning up, or have a very large number of working files, you might need a lot more space. I fall into both categories, so my own system consists of three hard disks—an 80GB drive and two 120GB drives. That's 320GB of storage, and, unfortunately, since I began working with scans of film in various formats, it's not nearly enough.

Your needs for removable storage will more closely parallel your actual input/output, and might actually be measurable. Keep track of how many files, and their sizes, that you offload to removable storage in an average month, and that figure will help you estimate which kind of storage you need, and how cost-effective it will be for you. For example, if you archive less than a gigabyte of images a month, your trusty old Zip drive might be a partial solution, and you can certainly handle the job with a few CD-R/CD-RW discs. If you're looking at dozens of gigabytes, you really should be looking at a DVD-R/DVD-RW/DVD+RW drive. We'll get into each of these options later in this chapter.

Finally, you'll need to take a close look at how many images you absolutely must have stored semi-permanently on your hard drive. Can you live with fetching a disc when you need it, particularly if your removable storage system is well designed and provides easy access? Are you happy browsing through a few CDs? Can you locate your images using a visual album/catalog system fortified with keyword searches? How often do you use older images, or images from projects that are concluded? The trick is finding the optimal balance between the effort required to properly store and manage your images and the benefit you get from having them properly stored.

> **TIP**
>
> When one of the major hard disk vendors, such as Maxtor or Western Digital, introduces a new top-end drive, the previous capacity champ immediately becomes the target for price-cutting and promotions. A while back, when Maxtor began emphasizing its 200-320GB drives, all those skimpy 120GB hard disks suddenly became available for $79 or so, after rebates. I picked up two, one of them advertised as a 100GB drive with 20GB of "free" extra capacity. I'm not making that up.

# Choosing Hard Disk Storage

Your first line of offense in the effort to store your film scans, other data, and programs, is your computer's hard disk drive. This kind of storage, which was called "online" back before the term came to mean something else, is your fastest and easiest to access storage, as well as the repository most exposed to loss of data. In addition, the capacity of your hard disk storage might face some limitations that removable media are not subject to. In this section, I'll outline your options and show you how to minimize limitations or bypass them altogether. I'll start with a discussion of the three most common types of drives in use—ATA, SCSI, Serial ATA—as well as the external Firewire/USB drives.

## ATA/EIDE

ATA (Advanced Technology Attachment) drives, also sometimes known as EIDE (Enhanced Integrated Drive Electronics), are the basic drive type found in virtually all Windows PCs and many Macintoshes. These drives are furnished in several performance levels capable of transferring data at 33, 66, 100, and 133Mbps. The faster drives, also called Ultra ATA, might require a special controller card in your computer to operate at their top speeds.

There are other factors that govern performance of these drives, but the two most important ones to keep in mind when making a buying decision are the rotational speed and built-in memory buffer. With rotational speed, faster is better and costs more. You might find a drive that rotates at 5400 rpm acceptable for storage of image files you don't access daily, but prefer to pay a little more for a 7200-10,000 rpm drive for storage of your programs and files that you're actively working on.

The drive's built-in memory buffer, which usually ranges from 1MB to 8MB or more, determines whether your computer can re-fetch information that it has already worked with recently from the fast buffer or from the slower hard disk. If you don't think this matters much, keep this in mind: Memory speeds are measured in nanoseconds, whereas hard disk performance is measured in milliseconds. The difference between a nanosecond and a millisecond is on the order of saying, "Can you wait a second for your data?" and "Can you wait 32 and a half years?"

## Limitations of ATA

ATA drives have a few pesky limitations. Here's a quick checklist of the worst annoyances:

- Up to four drives are managed by a pair of controllers built into your computer, and the computer can work at full speed with only one drive per controller (either the *master* or the *slave* drive) at once. That means that copying from one drive to another can be a bit slower if both drives are supervised by the same controller.

- With most computers, both PCs and Macs, you can have a maximum of four ATA drives operating at one time. There might be further restrictions on the type of ATA drives installed. For example, certain Power Mac G4 models allow only two Ultra ATA/100 drives plus two Ultra ATA/66 drives.

- Because your CD-R/RW drive also uses the ATA controllers, you might find that you actually can have no more than three ATA hard disks installed at once, unless you add an ATA controller card at extra cost. Most computers don't have that many drive bays anyway.

- ATA drives generally must be installed internally (which is why you need free drive bays), although there are some companies that make adapters that let you connect external ATA drives through a special controller or through a FireWire/USB connection.

- Many computers are limited in the size of the ATA hard disk drives they can accommodate. If you have a very old system, you might bump up against a ceiling at 80GB or lower. Even new machines can choke when presented with hard drives larger than 132GB. To use the full capacity of the drive, you might have to use special software to divide it into *partitions* that are smaller than 132GB. With 160, 200, and 320GB or larger ATA drives already common, that's a heck of a limitation.

## Avoiding Problems

PC owners must be particularly careful when selecting their hard drives, because it can be tricky to upgrade to a larger drive later. I discovered this recently when I went to swap the main drives (the ones the computer boots from) for both my Windows PC and my Macintosh. Here's how the process went for the Macintosh:

1. I connected the new drive to the second hard disk controller in the Macintosh and copied all the files from the old drive to the new one.
2. I went to a Mac OS control panel and instructed the Mac to boot from the system software that now resided on the new drive.
3. I rebooted the Mac a few minutes later. Everything worked great, including all my installed applications.

Later that day I went to upgrade my 40GB boot disk on my Windows 2000 PC to an 80GB drive. The process took quite a few hours, and dozens of steps, which I won't go into here. It involved installing Windows 2000 on a temporary boot disk so I could copy all the system files from my original boot disk to the new one. I also had to make sure user profiles were copied and that my applications, which resided in a different partition (drive F:) on the original boot

disk were also copied to a new partition assigned the same name. Windows doesn't let you move an installed application to another drive (or even another folder) just by dragging and dropping it.

Although there are utilities that will clone a disk and make this process easier, none of them worked for my setup, so I had to do the whole thing manually. The lesson here is to make sure that the main hard disk on your Windows PC is large enough to take care of business for a while. It might not be easy to upgrade it in the future. Keep in mind that I am not one of those militant Mac fanatics; I use my Windows PC about 90 percent of the time. But there are some things that are a lot easier with the Mac architecture than with a PC.

I'm much happier with the way that I partially bypassed the four-drive (actually three) limitation. I installed all my ATA drives in removable carriers, like the one shown in Figure 13.2, which slide into drive bay racks. I have extra carriers and hard drives and can substitute any spare drive for any other just by swapping carriers. If, say, I want to back up data on drive D:, I can replace drive E: with one of my spare drives, copy everything to the extra drive, and then remove it and store it in a safe place. I've even made a copy of my boot drive, so if it should suddenly fail I can pop in the backup drive and be up and running in minutes.

Unfortunately, Windows 2000 doesn't allow these ATA drives to be "hot-swappable." I have to power down, switch drives, and reboot. But the advantages of this system are significant enough that I don't really mind.

**Figure 13.2** *Swappable hard drives give you huge amounts of open-ended storage.*

## WHAT'S IN A NAME?

The proliferation of names for the various types of hard drives partially derives from marketing efforts by the drives' manufacturers. ATA drives are sometimes called IDE or EIDE because that's what some companies, such as Western Digital, call them in order to differentiate their products from other ATA drives. You'll also see the term ATAPI (Advanced Technology Attachment Packet Interface). They all generally mean the same thing.

## SCSI

At one time, SCSI (small computer system interface) hard drives were the darlings of the computer industry. Macintoshes could use nothing else, and anyone who really wanted to own a high-performance Windows PC just had to have one or more SCSI disks installed. Although

SCSI is still a serious option if you want performance, other drive options have taken the forefront. For one thing, ATA drives cost one-half to one-third the price of a SCSI drive of the same capacity. For most users, ATA is about as fast and does just about everything required, so there is little attraction in paying a lot more for what might be seen as marginal SCSI benefits. That's especially true because of the bewildering array of SCSI options, including Wide SCSI, Fast SCSI, Ultra SCSI, Ultra2 SCSI, and Differential SCSI. Now there's Serial Attached SCSI (SAS), too.

Still, there are some advantages to SCSI that you should know about:

- SCSI, particularly Ultra SCSI 160, is fast; potentially a lot faster than ATA.

- Computers can communicate with several SCSI devices simultaneously, further speeding data exchange.

- SCSI controllers can handle 7 to 15 devices, all connected together in "chains."

- SCSI can be used for devices other than hard disks and CD drives. Scanners, Zip drives, and other peripherals can be attached to the SCSI bus. Admittedly, fewer SCSI peripherals are being produced these days, but the capability to attach them remains.

- SCSI devices can be installed either internally or externally. For some SCSI implementations, cables up to 25 meters in length can be used, so distance from your computer is no problem.

If price is no object, but performance is, SCSI deserves at least a look-see.

# Serial ATA

Serial ATA is a variation on the ATA drives mentioned earlier. Conventional ATA drives send their data signals in parallel form; that is, 16 bits of information move along parallel wires simultaneously during one tick of your computer's clock. At higher speeds, interference between the signals in the side-by-side wires is so great that the reliability of the transmission decreases. ATA cables that are 40 or 80 wires wide are relatively expensive to produce, and clumsy to route through the innards of your computer.

Serial ATA sends its data bits down pairs of wires at much higher speeds, with less interference and easier cabling. Don't sniff at the latter advantage. If nothing else, the slim ATA cables allow for much improved airflow within your computer system, so your computer runs cooler.

These new drives also allow running each drive at its full 150Mbps speed at all times. Future versions will run at 300 to 600Mbps. As a bonus, they are potentially hot-swappable, which will be great for those who need to change drives in midstream.

If you plan to upgrade to Serial ATA in the future, you'll find that you can use the new drives with computers that don't have a SATA controller through the use of a parallel-to-serial ATA adapter, which includes circuitry to allow the older controller to accept the serial signal.

# External FireWire/USB

Hard drives are now available in external cases that connect to your computer through FireWire (IEEE-1394) or USB 2.0 cables. These serial devices neatly bypass the limitations of internal hard drives, while offering fast data transfer, the capability to connect dozens of peripherals on a single bus, and a reasonable price. In many cases, FireWire/USB drives are hot-swappable, too.

For a long time, the main difference between these external busses was the speeds they offered. The original USB 1.1 specification provided transfer speeds of 12Mbps (megabits per second), with each device using up to 6Mbps. Up to 127 devices could be attached to the USB bus at once. The more recent USB 2.0 specification increases the data transfer rate to 480Mbps. USB can only be used to transfer data from peripherals from computers.

Meanwhile, FireWire supports data transfer rates of 100, 200, 400, or 800Mbps. It can support up to 63 devices on a single bus, and has the capability to transfer data directly between peripherals, without going through the computer first. USB is less expensive to implement, and is seeing use as a general-purpose interface. FireWire's more flexible capabilities are being applied to high-end applications, such as video transfer.

Hard disks are built around either of these technologies, like the one shown in Figure 13.3, and some drives (and more than a few scanners) include both types of interfaces. These drives make a lot of sense in several situations:

**Figure 13.3** *You can swap FireWire drives between PC and Mac platforms.*

- Your computer's drive bays are filled, or you've already installed as many conventional ATA drives as your controller supports (and you don't want or can't install another controller).

- You'd like to be able to move your data from one computer to another. Simply unplug your external disk and plug it into a compatible drive, and you're all set. This can work between platforms, too. Your PC hard drive can plug into the port of your Macintosh, thus streamlining transfers.

- You're looking for a no-brainer backup solution. Some of these drives have backup software you install on your computer. Thereafter, press a single button on the drive itself, and your data will be backed up automatically.

The chief disadvantage to these drives is that they generally cost about 50 percent more than an internal ATA drive of the same capacity.

# USB 1.1 AND USB 2.0 COMPATIBILITY

You can plug USB 1.1 devices into a spanking new computer with a USB 2.0 port, or use new USB 2.0 devices with a computer that has a USB 1.1 interface. You'll have no problems mixing and matching. All USB 1.1 devices operate at their slower speeds, no matter what type of port they are plugged into. USB 2.0 devices drop down to the lower USB 1.1 speed when plugged into a USB 1.1 port. The fast USB 2.0 peripherals automatically switch into high velocity mode when connected to a USB 2.0 port. That's all there is to it.

For USB peripherals like digital cameras or mice, the type of USB connection you use doesn't make much difference. You might notice slower download speeds with the digital camera designed for USB 2.0 if you use the slower interface, but won't see any difference with a mouse. It's a different story for USB 2.0 peripherals that can really use the faster speed, such as CD and DVD drives, scanners, and hard disks. You'll definitely see increased performance by upgrading to USB 2.0.

# Choosing Removable Storage Media

If hard drives are your main stockroom, your removable media should be considered your storage warehouse. Everything that won't fit on your hard disks should be offloaded to removable storage. Anything that you really don't want to lose should be stored on removable media, too, probably in several copies. Images that you want to physically share with others will probably go on removable media, too.

As you'll see, for compatibility and future expandability reasons, the choices today boil down to CD and DVD. All you need to decide is whether you want to go with the universally available CD format now, or jump right in with DVD and be ready for the future. Which DVD format to select has also been important, but many DVD drives and burners now support several formats, so the choice is less crucial than it used to be.

## Where Have All the Formats Gone?

The list of removable storage formats that have become obsolete in the past few years is about 10 times longer than the catalog of currently viable options. Some media, chiefly magnetic media, that were popular very recently now are as outmoded as the 8-track tape or vinyl record.

Formats do come and go, and if there is a single most important message of this section I want you to absorb, it's that you need to plot your removable storage schemes for the future, as much as you can. If you have libraries of images on streaming tape, but no way to read them, you'll know what I mean. As someone who has lived through the 8-inch, 5 1/4-inch, and 3 1/2-inch floppy eras, suffered through constant Bernoulli Box upgrades from 20MB to 230MB cartridges (at $100 per cartridge!), and struggled to remain compatible with SyQuest, Zip, Jaz, and Clik revolutions, I feel your pain.

Iomega's Zip disk threatened to take over as the new floppy for a while, but today all forms of magnetic media are not much in favor for backing up or archiving. It doesn't make sense to

pay $5 for a 250MB Zip disk when a CD-R that costs a nickel will store three times as much information. I still use my Zip drives, but only for daily incremental backups of text, or to quickly transfer small amounts of information between computers.

Today, optical media like CD and DVD have become the removable storage medium of choice. They are nearly universal. All personal computers can read CDs and most can write to them as well. A great many have DVD readers, too, and a growing number have the capability to write DVDs.

The really great thing about optical technology is that much of it is backward compatible. So, if you opt for a CD burner now and upgrade to a DVD writer in a few years, you will still be able to use your old CDs in your new DVD drive. That virtually guarantees that your new hardware can read CDs for at least 10 more years. What other media format, aside from the 3 1/2-inch floppy disk, can claim a viable lifespan of more than 20 years? (And that's not to imply that the floppy disk has even been viable for the last couple of years.)

# What Formats Are Left?

The playing field now consists of only a few options, so you don't need to agonize over the decision for very long.

## CD-R/CD-RW

The chief difference between the two is that CD-R discs can be written to one or several times until the disc is full. CD-RW discs can be "erased" and written to multiple times. However, with all but the most recent drives, it takes longer to write to CD-RW discs. With CD-Rs costing only a few pennies each, the savings of a CD-RW is not as important as it was in 1995 when I had this bad habit of making $8 coasters out of write-once CD-ROMs.

CDs can hold up to 700MB of information, although some specialized formats, like Plextor's GigaRec, can squeeze as much as a gigabyte of information on a single CD. The oddball formats are slow and cannot be read on many CD drives, so you're better off sticking with the standard format for now. Within the CD realm there is also the "packet-writing" format, which treats a CD as if it were a hard drive, so data can be written quickly, one file at a time, rather than in multi-file "sessions."

You'll find CD-R/CD-RW drives to be the least expensive choice, with decent models available for $50 or less on sale. The media is inexpensive, too. I buy mine during those special rebate deals when you can buy 50 to 100 discs on a spindle for $5 to $12.

## DVD

Currently, the DVD (Digital Versatile Disc) format offers 4.7GB of data storage, with a lot more capacity promised down the road. The only factor that held back the adoption of DVD was the price of the writers (which has now dipped to $150 or less for an internally-mounted drive, but had typically been in the $300 and higher stratosphere), the cost of the media, and the several formats of dubious cross-format compatibility. Today, many drives are compatible with several or all of the formats.

The DVD formats include the following. The last four are the formats used in computer DVD burners:

- **DVD Video**—This is the format used for those DVDs you rent or purchase. It has 17GB of capacity if two layers and both sides are used, so there's plenty of room for those special features.

- **DVD-ROM**—This is a basic format of the disc. It's like the DVD Video disc, but can include computer-friendly features when removed from your set-top DVD player and dropped into your computer DVD drive. Users cannot write to DVD-ROMs. You can think of it as a combination video DVD and extra-large CD-ROM for your computer.

- **DVD-RAM**—This kind of disc can be written to many times (like a CD-RW) in capacities ranging from 2.6 to 9.4GB. These discs are compatible only with DVD-RAM drives.

- **DVD-R**—Developed by Pioneer, this is a write-once recordable disc (like the CD-R), capable of storing 4.7GB on one side or potentially as much as 9.7GB on two sides. It can be played in most DVD players and computer DVD drives.

- **DVD-RW**—This is a rewritable version of the DVD-R format, and is compatible with DVD players and computer DVD drives. It can be played in most DVD players and computer DVD drives.

- **DVD+R**—A 4.7GB (per side) write-once format compatible with DVD players and computer drives.

- **DVD+RW**—Developed by a consortium that includes Mitsubishi, Hewlett-Packard, Sony, Ricoh, Yamaha, and others, this is a rewritable 4.7GB (per side) disc that's compatible with most players and drives.

## Some CD/DVD Storage Tips

Once you've selected your removable media, you'll want to use your storage right. Here are some tips I've collected that will help you get the most from your offline storage.

- Use software like Adobe Photoshop Album to burn your images directly from an album catalog onto a disc. You can save a lot of time, while visually selecting exactly which images you want to archive.

- No matter which method you use for creating a disc, use your album software to create a catalog for that disc. You can review the thumbnails for all the images on the disc and take advantage of the sorting and retrieval capabilities of the software, even if the particular disc doesn't happen to be located in your drive. When you actually do want to work with an image, just pop in the disc and you're set.

- If you have a disc that you haven't cataloged with album software, you can still view thumbnails of each image. In Windows Explorer, choose View > Thumbnails, and Windows will automatically create thumbnails for any folders you navigate through that contain image files. If you're using Windows 98, you must first right-click the folder that contains image files, choose Properties, and mark the Enable Thumbnail View option. Your folder will then look like Figure 13.4.

**Figure 13.4** *Microsoft Windows can be set to show files as thumbnail images.*

■ Use a freeware or low-cost utility such as Midnight Blue Software's SuperJPG for PCs (**www.midnightblue.com**) or Devon Technologies' ThumbsUp for Macintosh OS X (**www.devon-technologies.com**) to create thumbnails in each directory containing images.

■ Alternate between CD-RW and CD-R discs. As you archive images, save them first to CD-RW. Then, when you have enough accumulated, copy the images to different CD-R discs, arranged by categories, for permanent storage. Your CD-RW discs will contain your most current, miscellaneous image files, whereas the CD-Rs will have permanent collections of pictures such as birds, landscapes, seascapes, family, or other appropriate categories. Then when you need a seascape, you can load a single CD and browse through all your images.

■ Make multiple copies of discs. You need backups of your scans.

■ Don't forget to make a special disc with your best images. Quality is a category, too!

■ Be sure to label your CDs using an organized system. You should have both a physical label on the front surface of the disc, and a disc-name label that can be read by your computer.

# Managing Image Files

Now that you have your storage media locked in, you need to develop a logical plan that will enable you to manage all your images efficiently. This section lists some of the different ways you can store, sort, and retrieve those images.

## Organizing a Storage Process

Your first step should be to create a storage process and infrastructure, so to speak, that will work for you. After that, you'll need to implement it. The following sections contain some general tips for getting organized in the first place.

## Organize Your Hard Disk

I see many hard disks that look like a game of 52 PickUp, with all the files and directories arranged haphazardly, as if the files were jumbled in an attempt to create a new William S. Burroughs novel. Image files are deposited in a folder with no regard to much of anything other than the date they were created. If you have a disorganized hard disk, you'll find it hard to find your images and easy to accidentally delete an entire folder of files that you didn't mean to vaporize. Worse, you'll fill up your hard disk with files you *don't* want or need.

Instead, create a hierarchical folder system based on projects, subject matter, or some other criteria. For example, you might have a main folder called Images, which contains subfolders with names like Art Photography, Still Lifes, Portraits, Scenics and Travel, and Sports Photography. Each of those folders contains nested folders of their own, further refining the description of the contents, as you can see in Figure 13.5.

**Figure 13.5** *Hierarchies make it easy to drill down and find the exact image you want.*

With an arrangement like this, you'll find it much easier to locate the exact image you want. The hierarchy can be carried over to your removable storage, too. You might end up with entire CDs that correspond to a single folder on your hard disk. The long filename features built into Windows and Mac OS are your friends. Use names like *Sports Photography Spring 2004*, or *Southern Spain*.

## Create a Schedule for Copying to Removable Media

Hard drives are reliable, so if your disk isn't full you might be tempted to let your image files remain in place for a while. However, for neatness and safety's sake, you should have a

schedule for moving your files over to removable media. It doesn't matter whether you do it daily, weekly, or monthly, it should be a regularly scheduled step so you get in the habit of doing it.

## *Save Your Original Scans on Removable Media Right Away*

Once you've scanned an image, you should save your original scan, before you've done any editing, immediately. I can't count the number of times I've felt I've "improved" an image and saved it as a final version, only to think of yet another way to edit it. In such cases, you might want to start from the original scan, and it's handy to have that scan available.

Your editing skills and the image-editing software available improve over time, too. So, eight years down the road you might be able to manipulate a precious scan in new and exciting ways that simply weren't possible before. You'll be glad you have that original scan available. In many ways, your original digital files are like the negatives for traditional film. The original images contain the best information and the most information possible about the image. Any time that you run filters and digitally enhance an image, it might look better, but you are altering and decreasing the original image in one or many ways.

If you must store your original scans on your hard disk, use the Windows capability of marking them as read-only to protect them from modification. To set a file attribute to read-only, right-click the filename in Windows Explorer. You can Ctrl+click to select more than one file if you want. Then select Properties and on the General tab, click Read-only, as shown in Figure 13.6. After you have set a file's attribute to "read-only," you cannot edit it or save the file with the same name without again changing the read-only attribute. You can, however, save a read-only file under a different name.

With Mac OS 9.x or OS X, select the file in the Finder, choose Show Info from the File menu, and mark the Lock/Locked button.

**Figure 13.6** *Locking a file protects it from modification.*

## Implementing a Backup Plan

Not only is it a good idea to copy files, as mentioned, you should also have a formal backup plan as part of your disaster recovery measures. After all, if you spend many hours scanning and then editing an image, you won't want to reproduce all that work if your hard disk fails.

Windows comes with a simple, yet useful, backup utility called Microsoft Backup, shown in Figure 13.7. If it's not automatically installed on your system, you might have to install it from your original Windows disk. Macintosh users can buy the highly respected Dantz Retrospect (**www.dantz.com**), or choose one of the dozens of free or low-cost backup applications you can find at **www.macupdate.com** (use the Search box and type **backup**).

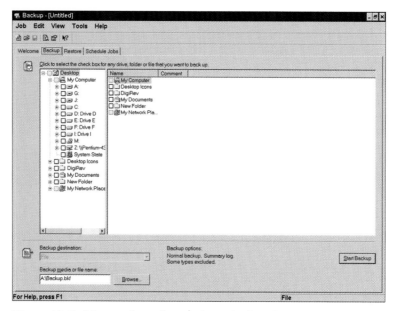

**Figure 13.7** *Microsoft Backup is furnished with Windows.*

You can set your backups as a scheduled task that is carried out at intervals you select. In Windows, you use the Scheduled Tasks utility, usually found in the System Tools menu. Remember to schedule your backups during times when you're not actively using your computer. If you leave your system on all the time, you can schedule the backup for late at night.

Your backup interval is up to you. Just how much information can you afford to lose? In my case, I've implemented a system that backs up *every single data file that has changed* six times a day, so I'm not likely to lose more than a few hours' work.

## Where to Store Your Backups

Backups are of little use if you can't find them, and even more worthless if they are lost or destroyed. If your files are particularly irreplaceable, it's a good idea to have multiple copies, stashed in different locations.

One common scheme rotates a handful of discs, which are used over and over to make incremental backups. Your most recent backup is kept next to your computer. The backup before the most recent backup is placed in a secure location (I have a small, fireproof safe), whereas the oldest might be kept off-site entirely. If loss of your data won't mean the end of life on Earth as you know it, you might simply opt to keep all your rotating discs near your computer.

When you go to make a new backup, re-use the oldest disk, making it your new #1 backup. Your old #1 backup is demoted to secondary status, and the former #2 becomes your oldest. In that way, you have three nominally complete backup copies of your images and data, and if your most recent archive is not available, you still have two reasonably recent copies to access.

# Image-Management Software

You probably own software, or can buy some inexpensively, that can help you catalog and manage your scanned images. We've already looked briefly at album software like Adobe Photoshop Album (available for both Macs and PCs) that you can use to catalog images, and retrieve them using keywords. Tools like this can also be used to browse through images more efficiently and perform other organizational and maintenance tasks. This section lists some of the better applications available.

## Adobe Photoshop Elements

If you need a powerful image editor, but aren't quite ready to devote your life to learning how to use Photoshop, Photoshop Elements is probably right up your alley. It's built on the same underpinnings as Photoshop, and many of the menus, tool palettes, and dialog boxes are remarkably similar. Yet, it's much easier to use, and has wizards, helpful hints, and a brilliant on-screen how-to guide that takes you by the hand and shows you the exact steps to take to solve particular image problems. Elements' File Browser, shown in Figure 13.8, provides thumbnail images plus information about each file you select.

**Figure 13.8** *Adobe Photoshop Elements has a powerful File Browser.*

## Adobe Photoshop Album

I've mentioned Photoshop Album numerous times in this book already, primarily because it is so new, so flexible, and so easy to use. You can tell Photoshop Album to scan your hard drive, and as it does so, it organizes the images by date. That's extremely useful, because so many images are scanned in batches, that arranging them by creation date is a logical, useful choice.

Later, you can use timeline or calendar view to find photos, or add your own keyword tags to help retrieve them using the application's database capabilities.

Like ThumbsPlus, Album has simple tools to fix common problems—errors in contrast, brightness, or color—so you don't have to leave the program to make simple manipulations. I especially like Photoshop Album's archive feature, which lets you copy your images directly to a CD or DVD disc, as shown in Figure 13.9.

**Figure 13.9** *Back up your images directly to CD or DVD using Adobe Photoshop Album.*

# iPhoto for the Macintosh

Sorry, Windows fans, but iPhoto is for the Macintosh only, and, in its latest incarnation, for Mac OS 10.x and up exclusively. The best thing is that it comes free with the operating system, or you can download the latest version directly from Apple's website at **www.apple.com**. It's a powerful image-management tool with all the features you could possibly want. Mac users who don't want to remain penned in the Adobe corral should look no further.

Like Photoshop Album, iPhoto collects and stores photos by creation date, stashing them in the iPhoto Library folder in your Pictures folder. As you're browsing images, it attempts to load the images ahead of time (much like a web browser's "look-ahead" feature for linked pages and images).

A nice touch is a Trash album that retains photos you've deleted from your Photo Library. If you throw away a picture by mistake, you can drag it back to the Photo Library until, as with the Mac's main Trash can, you choose the Empty Trash command to zap the pictures for good.

Also like Photoshop Album, you can back up your photos to CDs or DVDs, and access some simple image-editing tools. Among these are Enhance, which attempts to automatically fix color and mend contrast problems. Retouch can scrub over minor defects to remove scratches and dirt or other problems. If your photo has major problems, you can also set iPhoto to open an image in another application (such as Photoshop or Photoshop Elements) when you double-click it. You can check out iPhoto in Figure 13.10.

**Figure 13.10** *You'll find iPhoto to be one of the most powerful image managers for the Macintosh.*

## Cerious Software Inc.'s ThumbsPlus

ThumbsPlus, which supports more than 70 file formats, looks and works a bit like Windows Explorer, so you won't waste a lot of time learning how to use it. As you can see in Figure 13.11, it displays the contents of your hard disk using a hierarchical tree of nested folders. You can view thumbnail images of any graphics file in the directory on the right side, and then navigate through the folders by clicking them to expand or contract the display. The window at the bottom left of the screen is the Task window, which shows when tasks, such as scanning a folder, are underway.

ThumbsPlus can scan your entire hard drive looking for images, and mark with a color code all folders that contain them. The program is especially useful for managing CDs. You can browse through thumbnails of a cataloged disc looking for images, and insert the actual disc only when you find an image you want to work with.

**Figure 13.11** *ThumbsPlus can scan your entire hard drive looking for images.*

This versatile application can also rename files to your specifications, add watermarks to images, and create contact sheets (a task that Photoshop and Photoshop Elements also excel at). You can even do some limited image editing with this tool.

# Next Up

That's all, folks! You're now fully equipped to plan, scan, fix, retouch, combine, store, and retrieve your film scans. I've guided you through the annals of digital imaging history, shown you how to choose and use your film scanner, and revealed some helpful tips for enhancing your images. The last few chapters have shown you some of the exciting things you can do with your photos. The rest is up to you. I hope you'll apply what you learned to combine your interests in photography and digital imaging.

# Illustrated Glossary of Scanning and Digital Terminology

The world of scanners embraces a broad range of image-capture and image-manipulation technologies, from CCD sensors to the unsharp masking process performed by the scanner or within your image editor. But don't panic if these terms are unfamiliar to you. This glossary is a comprehensive, illustrated compendium of the words you'll encounter when taking pictures, capturing scans, or manipulating your scanned photos in an image editor. You'll find complete explanations of most terms in the chapters in which they first appear, but if you encounter an unfamiliar concept while browsing through the book you can jump to this glossary for a basic definition, or use the index to locate the longer description in the text. By the time you finish reading, I guarantee you'll have an impressive image-capture/editing vocabulary!

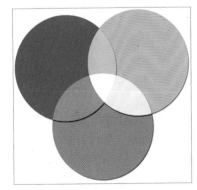

Figure A.1 *The additive primary colors, red, green, and blue, combine to make other colors, plus white.*

**additive primary colors** Red, green, and blue (RGB), used alone or in combinations to create all other colors you capture with your scanner or digital camera. Your computer monitor and image-editing programs like Photoshop work with RGB. See also *CMYK*.

**Advanced Photo System (APS)** A roll film format, slightly smaller than 35mm, in which the film is permanently stored in a cassette. Film scanners can use a special adapter to access this kind of film for scanning.

**airbrush** Originally developed as an artist's tool that sprays a fine mist of paint, the computer version of an airbrush is used both for illustration and retouching in most image-editing programs.

**ambient lighting** Diffuse nondirectional lighting that doesn't appear to come from a specific source but, rather, bounces off walls, ceilings, and other objects in the scene when a picture is taken.

**angle of view** The area of a scene that a lens can capture, determined by the focal length of the lens. Lenses with a shorter focal length have a wider angle of view than lenses with a longer focal length.

**anti-alias** A process in image editing that smoothes the rough edges in images (called *jaggies* or *staircasing*) by creating partially transparent pixels along the boundaries that are merged into a smoother line by your eyes.

**Figure A.2** *Diagonal lines that have been anti-aliased (left) and "jaggy" lines that display the staircasing effect (right).*

**artifact** A type of noise in an image, or an unintentional image component produced in error by a scanner or digital camera during processing.

**aspect ratio** The proportions of an image as printed, displayed on a monitor, or captured by a digital camera. An 8×10-inch or 16×20-inch photo each has a 4:5 aspect ratio. Your monitor set to 800×600, 1024×768, or 1600×1200 pixels has a 4:3 aspect ratio. When you change the aspect ratio of an image, you must crop out part of the image area, or create some blank space at top or sides.

**autofocus** A feature that provides the correct focus of the slide or negative in a film scanner (also used with other devices, such as cameras).

background  In photography, the background is the area behind your main subject of interest.

back-lighting  A lighting effect produced when the main light source is located behind the subject. Back-lighting can be used to create a silhouette effect. You'll often have to work with backlit subjects when scanning negatives or slides. See also *front-lighting, fill lighting, and ambient lighting.*

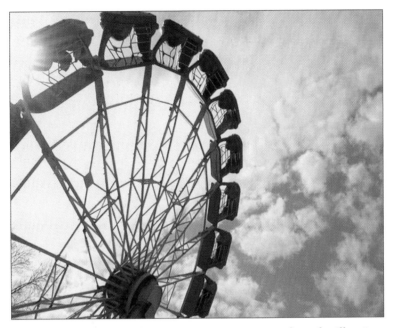

**Figure A.3** *Back-lighting can create interest in a photo by illuminating and emphasizing the outer edges of a subject.*

balance  An image that has equal elements on all sides.

bilevel image  An image that stores only black-and-white information, with no gray tones. Many scanners can capture black-and-white images of originals such as line art or text.

bit  A binary digit—either a 1 or a 0—used in computers to measure the color depth (number of different colors) in an image. For example, a grayscale 8-bit scan can contain up to 256 tones ($2^8$), whereas a 24-bit scan can contain 16.8 million colors ($2^{24}$).

bit depth  The number of bits used to represent colors or tones.

bitmap  In Photoshop parlance, a bitmap is a bilevel black/white-only image. The term is also widely used to mean any image that represents each pixel as a number in a row and column format.

black  The color formed by the absence of reflected or transmitted light.

**black point** The tonal level of an image where blacks begin to provide important image information, usually measured by using a histogram. Scanner software frequently has a histogram you can use before making the scan to optimize the image. You'll usually want to set the histogram's black point at the place where these tones exist.

**bleed** An image that continues to the edge of the page.

**blend** To create a more realistic transition between image areas, as when retouching or compositing in image editing.

**blowup** An enlargement, usually a print, made from a negative, transparency, or digital file.

**blur** In scanning, blur, a softening of the image by reducing contrast between pixels, is often used during the capture to reduce the appearance of dust on the original, or to disguise halftone dots. In photography, to soften an image or part of an image by throwing it out of focus, or by allowing it to become soft due to subject or camera motion. In image editing, blurring is the softening of an area by reducing the contrast between pixels that form the edges.

**Figure A.4** *The black triangle in this film scanner software histogram should be set to the point on the histogram where black pixels begin in the image, shown at left in this dialog box.*

**bounce lighting** Any kind of light bounced off a reflector, including ceiling and walls, to provide a soft, natural-looking light.

**bracketing** Taking a series of photographs of the same subject at different settings to help ensure that one setting will be the correct one. Many digital cameras will automatically snap off a series of bracketed exposures for you. Other settings, such as color balance, can also be "bracketed" with some models.

**brightness** The amount of light and dark shades in an image, usually represented as a percentage from 0 percent (black) to 100 percent (white). Most scanner software includes controls to let you adjust the brightness of the scan.

**burn** A darkroom technique, mimicked in image editing, that involves exposing part of a print for a longer period, making it darker than it would be with a straight exposure.

**calibration** A process used to correct for the differences in the output of a printer or monitor when compared to the original image, particularly as captured by a scanner. Once you've calibrated your scanner, monitor, and/or your image editor, the images you see on the screen more closely represent what you'll get from your printer, even though calibration is never perfect.

**cast** An undesirable tinge of color in an image.

CCD  Charge-Coupled Device. A type of solid-state sensor used in scanners and digital cameras.

center-weighted meter  A light-measuring device that emphasizes the area in the middle of the frame when calculating the correct exposure for an image.

chroma  Color or hue.

chromatic aberration  An image defect, often seen as green or purple fringing around the edges of an object, caused by the optics of a scanner or the lens used in a camera failing to focus all colors of a light source at the same point.

chromatic color  A color with at least one hue and a visible level of color saturation.

chrome  An informal photographic term used as a generic for any kind of color transparency or slide, including Kodachrome, Ektachrome, or Fujichrome.

CIE (Commission Internationale de l'Eclairage)  An international organization of scientists who work with matters relating to color and lighting. The organization is also called the International Commission on Illumination.

CIS (Contact Image Sensor)  A type of sensor used in scanners and digital cameras. While CIS sensors have been used only in the cheapest scanners in the past, the technology is improving the quality available from these devices.

close-up lens  A lens add-on that allows you to take pictures at a distance that is less than the closest-focusing distance of the lens alone.

CMOS (Complementary Metal-Oxide Semiconductor) A type of sensor used in scanners and digital cameras.

CMY(K) color model  A way of defining all possible colors in percentages of cyan, magenta, and yellow, and frequently, black. Black is added to improve rendition of shadow detail. CMYK is commonly used for printing (both on press and with your inkjet or laser color printer). Photoshop can work with images using the CMYK model, but converts any images in that mode back to RGB for display on your computer monitor.

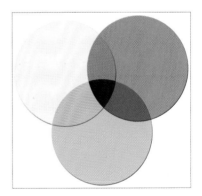

**Figure A.5** *Cyan, magenta, and yellow colors combine to form the other colors, plus black.*

color correction  Changing the relative amounts of color in an image to produce a desired effect, typically a more accurate representation of those colors. Color correction, which can be done in the scanner or within an image editor, can fix faulty color balance in the original image, or compensate for the deficiencies of the inks used to reproduce the image.

**comp**  A preview, also called a letterpress dummy, that combines type, graphics, and photographic material in a layout.

**composite**  In photography, an image composed of two or more parts of an image, taken either from a single photo or multiple photos. Usually composites are created so that the elements blend smoothly together.

**composition**  The pleasing or artistic arrangement of the main subject, other objects in a scene, as well as the foreground and background.

**compression**  Reducing the size of a file by encoding, using fewer bits of information to represent the original. Some compression schemes, such as JPEG, operate by discarding some image information, whereas others, such as TIFF, preserve all the detail in the original, discarding only redundant data. See also *GIF, JPEG,* and *TIFF.*

**continuous tone**  Images that contain tones from the darkest to the lightest, with a theoretically infinite range of variations in between.

**contrast**  The range of difference in the light and dark areas of a photo. Scanner software includes controls to let you adjust contrast.

**contrasty**  Having higher than optimal contrast.

**crop**  To trim an image or page by adjusting its boundaries. After you perform a *prescan* of an original to show the entire subject area, you might want to crop so that only the relevant area is actually captured during the final scan.

**Daguerreotype**  An early type of photograph made on copper plates coated with photosensitive material.

**densitometer**  An electronic device used to measure the amount of light reflected by or transmitted through a piece of artwork, used to determine accurate exposure when making copies or color separations. Scanner software sometimes includes densitometer-like features that let you measure the light being transmitted through or reflected by your original.

**density**  In photography, the ability of an object to stop or absorb light. The less light reflected or transmitted by an object, the higher its density.

**depth-of-field**  A distance range in a photograph in which all included portions of an image are at least acceptably sharp.

**depth-of-focus**  In scanning, the distance range over which the original can be shifted at the scanner glass and still remain in sharp focus; often misused to mean depth-of-field. The larger the depth-of-focus a scanner has, the better it is able to scan three-dimensional objects. Also see *depth-of-field.*

**Figure A.6** *Scanner software sometimes includes a densitometer dialog box you can use to measure colors.*

desaturate  To reduce the purity or vividness of a color, making a color appear to be washed-out or diluted.

diaphragm  An adjustable component, similar to the iris in the human eye, that can open and close to provide specific sized lens openings, or f-stops.

diffuse lighting  Soft, low-contrast lighting.

diffusing  Softening the details in an image.

diffusion  The random distribution of gray tones in an area of an image, producing a fuzzy effect.

Digital ICE  A technology from Applied Science Fiction that automatically removes surface defects such as dust and scratches from an image during scanning. Unlike conventional techniques, Digital ICE doesn't blur or soften the details of an image; it uses patented processes to remove only the unwanted artifacts.

dither  A method of distributing pixels to extend the number of colors or tones than can be represented. For example, two pixels of different colors can be arranged in such a way that the eye visually merges them into a third color.

dodging  A darkroom term for blocking part of an image as it is exposed, thus lightening its tones. Image editors can mimic this effect by lightening portions of an image using a brush-like tool.

dot  A unit used to represent a portion of an image, often groups of pixels collected to produce larger printer dots of varying sizes to represent gray or a specific color.

dot gain  The tendency of a printing dot to grow from the original size to its final printed size on paper. This effect is most pronounced on offset presses using poor quality papers, which allow ink to absorb and spread, reducing the quality of the printed output, particularly in the case of photos that use halftone dots.

dots per inch (dpi)  The resolution of a printed image, expressed in the number of printer dots in an inch. You'll often see dpi used to refer to monitor screen resolution, or the resolution of scanners. However, neither of these use dots: The correct term for a monitor is pixels per inch (ppi), whereas a scanner captures a particular number of samples per inch (spi).

**Figure A.7** *Our eyes merge halftone dots together to provide continuous tones and colors.*

**drum scanner**  A professional scanner, often equipped with a laser light source, used for high-resolution scans of film and reflective art as part of the color separation process for printing.

**dummy**  Also called a comp, a rough approximation of a publication, used to evaluate the layout.

**dye sublimation**  A printing technique in which solid inks are heated and transferred to a polyester substrate to form an image. Because the amount of color applied can be varied by the degree of heat (and up to 256 hues for each color), dye sublimation devices can print as many as 16.8 million colors.

**emulsion**  The light-sensitive coating on a piece of film, paper, or printing plate. The emulsion side of film should be facing the scanner sensor during a scan. In addition, it's important to know which side is the emulsion side when making prints, so the image can be exposed in the correct orientation (not reversed). Image editors such as Photoshop include "emulsion side up" and "emulsion side down" options in their Print Preview features.

**Exif**  Exchangeable Image File Format. Developed to standardize the exchange of image data between hardware devices and software. A variation on JPEG, Exif is used by most digital cameras, and includes information such as the date and time a photo was taken, the camera settings, resolution, amount of compression, and other data.

**existing light**  In photography, the illumination that is already present in a scene. Existing light can include daylight or the artificial lighting already present in the scene, but not electronic flash or additional lamps set up by the photographer.

**export**  To transfer text or images from a document to another format.

**exposure**  The amount of light allowed to reach the film or sensor, determined by the intensity of the light, the amount admitted by the iris of the lens, and the length of time determined by the shutter speed.

**eyedropper**  An image-editing and scanner software tool used to sample color from one part of an image, so it can be used to paint, draw, or fill elsewhere in the image. Within some features, the eyedropper can be used to define the actual black points and white points in an image.

**fill lighting**  In photography, lighting used to illuminate shadows.

**film holder**  A carrier that holds filmstrips or slides for scanning. In traditional photography, a film holder contains sheet film used in a camera.

**Figure A.8** *The film holder carries negatives or transparencies into the film scanner for capture.*

filter  In scanning, a translucent colored material used to convert white light to red, green, or blue. In photography, a device that fits over the lens, changing the light in some way. In image editing, a feature that changes the pixels in an image to produce blurring, sharpening, and other special effects.

FireWire (IEEE-1394)  A fast serial interface used by scanners, digital cameras, printers, and other devices. It was designed by Apple with support from IBM for data transfer at up to 800Mbps (megabits per second). See also *USB*.

flat  An image with low contrast.

flatbed scanner  A type of scanner that reads one line of an image at a time, recording it as a series of samples, or pixels.

focal length  The distance between the film and the optical center of the lens when the lens is focused on infinity, usually measured in millimeters.

focus  To adjust the lens to produce a sharp image.

focus lock  A camera feature that lets you freeze the automatic focus of the lens at a certain point, when the subject you want to capture is in sharp focus.

four-color printing  Another term for process color, in which cyan, magenta, yellow, and black inks are used to reproduce all the colors in the original image.

framing  In photography, composing your image in the viewfinder. In composition, using elements of an image to form a sort of picture frame around an important subject.

frequency  The number of lines per inch in a halftone screen.

front-lighting  Illumination that comes from the direction of the camera. See also *backlighting* and *sidelighting*.

f-stop  The lens opening or aperature.

full-color image  An image that uses 24-bit color; 16.8 million possible hues. Images are sometimes captured in a scanner with more colors, but the colors are reduced to the best 16.8 million shades for manipulation in image editing.

gamma  A numerical way of representing the contrast of an image. Devices such as monitors typically don't reproduce the tones in an image in straight-line fashion (all colors represented in exactly the same way as they appear in the original). Instead, some tones are favored over others, and gamma provides a method of tonal correction that takes the human eye's perception of neighboring values into account. Gamma values range from 1.0 to about 2.5. The Macintosh has traditionally used a gamma of 1.8, which is relatively flat compared to television, but which can provide improved definition and tones. Windows PCs use a 2.2 gamma value, which has more contrast and is more saturated.

**gamma correction**  A method for changing the brightness, contrast, or color balance of an image by assigning new values to the gray or color tones of an image to more closely represent the original shades. Gamma correction can be linear or nonlinear. Linear correction applies the same amount of change to all the tones. Nonlinear correction varies the changes tone-by-tone, or in highlight, midtone, and shadow areas separately to produce a more accurate or improved appearance.

**gamut**  The range of viewable and printable colors for a particular color model, such as RGB (used for monitors) or CMYK (used for printing).

**gang scan**  A procedure in which several pieces of artwork are scanned at once to reduce the number of individual scans.

**Gaussian blur**  A method of diffusing an image using a bell-shaped curve to calculate the pixels that will be blurred, rather than blurring all pixels, producing a more random, less "processed" look.

**GIF (Graphics Interchange Format)**  An image file format limited to 256 colors that compresses the information by combining similar colors and discarding the rest. Condensing a 16.8-million-color photographic image to only 256 hues often produces a poor quality image, but GIF is useful for images that don't have a great many colors, such as charts or graphs. The GIF format also includes transparency options, and can include multiple images to produce animations that can be viewed on a web page or other application. See also *JPEG* and *TIFF*.

**grain**  The metallic silver in film that forms the photographic image. The term is often applied to the seemingly random noise in an image (both conventional and digital) that provides an overall texture.

**grayscale image**  An image represented using 256 shades of gray. Scanners often capture grayscale images with 1024 or more tones, but reduce them to 256 grays for manipulation by Photoshop.

**halftone**  A method used to reproduce continuous-tone images, representing the image as a series of dots.

**high contrast**  A wide range of density in a print, negative, or other image.

**highlights**  The brightest parts of an image containing detail.

**histogram**  A chart used to measure the number of tones in an image at each density level.

**hue**  The color of light that is reflected from an opaque object or transmitted through a transparent one.

**indexed color image**  An image with 256 colors, as opposed to a grayscale image, which has 256 shades of the tones between black and white.

**infinity**  A distance so great that any object at that distance will be reproduced sharply if the lens is focused at the infinity position.

**interchangeable lens**  Lens designed to be readily attached to and detached from a camera, a feature found in more sophisticated digital cameras.

**interpolation**  A technique scanners, digital cameras, and image editors use to create new pixels required whenever you resize or change the resolution of an image, based on the values of surrounding pixels. Devices such as scanners and digital cameras can also use interpolation to create pixels in addition to those actually captured, thereby increasing the apparent resolution or color information in an image.

**invert**  In image editing, to change an image into its negative; black becomes white, white becomes black, dark gray becomes light gray, and so forth. Colors are also changed to the complementary color; green becomes magenta, blue turns to yellow, and red turns to cyan.

**Figure A.9** *An inverted image (left) and a positive image (right).*

**iris**  The adjustable opening of the eye or a camera lens, which limits the amount of light entering.

**ISO (International Standards Organization)**  A governing body that provides standards, including those used to represent film speed, or the equivalent sensitivity of a digital camera's sensor.

**jaggies**  Staircasing effect of lines that are not perfectly horizontal or vertical, caused by pixels that are too large to represent the line accurately. See also *anti-alias*.

**JPEG (Joint Photographic Experts Group)**  A file format that supports 24-bit color and reduces file sizes by selectively discarding image data. Digital cameras generally use JPEG compression to pack more images onto memory cards. You can select how much compression is used (and therefore how much information is thrown away) by selecting from among the Standard, Fine, Super Fine, or other quality settings offered by your camera. The original JPEG specification may be supplanted by JPEG 2000, which provides better compression and multiple resolutions. See also *GIF* and *TIFF*.

**landscape**  The orientation of a page in which the longest dimension is horizontal, also called wide orientation.

**latitude**  The range of camera exposures that produces acceptable images with a particular digital sensor or film.

**lens**  One or more elements of optical glass or similar material designed to collect and focus rays of light to form a sharp image on the film, paper, or a screen. Scanners can contain a lens to focus the image captured by the sensor.

**lens aperture**  The lens opening, or iris, that admits light to the film or sensor. The size of the lens aperture is usually measured in f-stops. See also *f-stop* and *iris*.

**lens shade**  A hood at the front of a lens that keeps stray light from striking the lens and causing image flare.

**lens speed**  The largest lens opening (smallest f-number) at which a lens can be set. A fast lens transmits more light and has a larger opening than a slow lens. Determined by the maximum aperture of the lens in relation to its focal length; the "speed" of a lens is relative: A 400mm lens with a maximum aperture of f/3.5 is considered extremely fast, whereas a 28mm f/3.5 lens is thought to be relatively slow.

**lighten**  A Photoshop function that is the equivalent to the photographic darkroom technique of dodging. Tones in a given area of an image gradually change to lighter values.

**lighting ratio**  The proportional relationship between the amount of light falling on the subject from the main light and other lights, expressed in a ratio, such as 3:1.

**line art**  Usually, images that consist only of white pixels and one color, represented in Photoshop as a bitmap.

**line screen**  The resolution or frequency of a halftone screen, expressed in lines per inch.

**lithography**  Another name for offset printing.

**lossless compression**  An image-compression scheme, such as TIFF, that preserves all image detail. When the image is decompressed, it is identical to the original version. See also *TIFF*.

**lossy compression**  An image-compression scheme, such as JPEG, that creates smaller files by discarding image information, which can affect image quality. See also *JPEG*.

**luminance**  The brightness or intensity of an image, determined by the amount of gray in a hue.

**LZW compression**  A method of compacting TIFF files using the Lempel-Ziv Welch compression algorithm, an optional compression scheme offered by some digital cameras.

**macro lens**  A lens that provides continuous focusing from infinity to extreme close-ups, often to a reproduction ratio of 1:2 (half life-size) or 1:1 (life-size).

**Figure A.10** *When carried to the extreme, lossy compression methods can have a serious impact on image quality.*

**macro photography**  The process of taking photographs of small objects at magnifications of 1X or more.

**magnification ratio**  A relationship that represents the amount of enlargement provided by the macro setting of the zoom lenses, macro lens, or with other close-up devices.

**maximum aperture**  The largest lens opening or f-stop available with a particular lens, or with a zoom lens at a particular magnification.

**mechanical**  Camera-ready copy with text and art already in position for photographing.

**midtones**  Parts of an image with tones of an intermediate value, usually in the 25 to 75-percent range. Many image-editing features allow you to manipulate midtones independently from the highlights and shadows.

**moiré**  An objectionable pattern caused by the interference of halftone screens, frequently generated by rescanning an image that has already been halftoned. Scanners can reduce this effect by blurring the image slightly, or by scanning at an angle. Image editors can also be used to reduce the effect.

**monochrome**  Having a single color, plus white. Grayscale images are monochrome (shades of gray and white only).

**negative**  A representation of an image in which the tones are reversed: blacks as white, and vice versa. Film scanners can handle both negative film and positive film (such as slides or transparencies).

**negative mask**  Color negative films include an extra orange mask that provides color correction.

**neutral color**  In image-editing's RGB mode, a color in which red, green, and blue are present in equal amounts, producing a gray.

**noise**  In an image, pixels with randomly distributed color values. Noise in digital photographs tends to be the product of low-light conditions, particularly when you set your camera to a higher ISO rating than normal.

**normal lens**  A lens that makes the image in a photograph appear in a perspective that most closely matches what the eye sees in the original scene, typically with a field of view of roughly 45°. A quick way to calculate the focal length of a normal lens is to measure the diagonal of the sensor or film frame used to capture the image, usually ranging from around 7mm to 45mm.

**Figure A.11** *Color negatives are characterized by their orange correction mask.*

**orthochromatic**  Sensitive primarily to blue and green light.

**overexposure**  A condition in which too much light reaches the film or sensor, producing a dense negative or a very bright/washed-out print or slide (or digital image).

**panning**  Moving the camera so that the image of a moving object remains in the same relative position in the viewfinder as you take a picture. The eventual effect creates a strong sense of movement.

**palette**  A set of tones or colors available to produce an image.

**panorama**  A broad view, usually scenic. Advanced Photo System negatives can be shot in a panorama mode, which requires a special adapter for film scanning. Panoramas can also be created with some 35mm point-and-shoot cameras, specialty cameras, or with digital cameras (by stitching several images together).

**perspective**  The rendition of apparent space in a photograph, such as how far the foreground and background appear to be separated from each other. Perspective is determined by the distance of the camera to the subject. Objects that are close appear large, whereas distant objects appear to be far away.

**Photo CD**  A special type of CD-ROM developed by Eastman Kodak Company that can store high-quality photographic images in a special space-saving format, along with music and other data.

**pixel**  The smallest element of an image.

**pixels per inch (ppi)**  The number of pixels that can be displayed per inch, normally used to refer to pixel resolution from a scanned image or on a monitor.

plug-in  A module such as a filter that can be accessed from within an image editor to provide special functions.

point  Approximately 1/72 of an inch outside the Macintosh world, exactly 1/72 of an inch within it.

portrait  The orientation of a page in which the longest dimension is vertical, also called tall orientation. In photography, a formal picture of an individual or, sometimes, a group.

positive  The opposite of a negative; an image with the same tonal relationships as those in the original scenes. For example, a finished print or a slide.

posterization  Reducing an image to a limited number of colors, causing a poster-like effect.

prepress  The stages of the reproduction process that precede printing, when halftones, color separations, and printing plates are created.

prescan  A low-resolution scan that produces thumbnail images of all the frames in a film holder. You can crop the prescan to select a specific frame to capture, or use the prescan for preliminary corrections.

**Figure A.12** *A prescan, like this one of an image of a spider web, provides a preview image that can be evaluated and corrected prior to the final scan.*

process color  The four color pigments used in color printing: cyan, magenta, yellow, and black (CMYK).

**RAW**  An image file format offered by many digital cameras that includes all the unprocessed information captured by the camera. RAW files are very large, and must be processed by a special program after being downloaded from the camera.

**red eye**  An effect from flash photography that appears to make a person's eyes glow red (or yellow, green, or white in animals). It's caused by light bouncing from the retina of the eye, and is most pronounced in dim illumination (when the irises are wide open) and when the electronic flash is close to the lens and therefore prone to reflect directly back. Image editors can fix red eye through cloning other pixels over the offending red or orange ones. It can be minimized by increasing the room light, using the pre-flash option built into some cameras, or, with removable flash, moving the flash to a point farther away from the lens.

**reflection copy**  Original artwork that is viewed by light reflected from its surface, rather than transmitted through it.

**reflector**  Any device used to reflect light onto a subject to improve balance of exposure (contrast). Another way is to use fill in flash.

**register**  To align images.

**registration mark**  A mark that appears on a printed image, generally for color separations, to help in aligning the printing plates. Photoshop can add registration marks to your images when they are printed.

**reproduction ratio**  Used in macro photography to indicate the magnification of a subject.

**resample**  To change the size or resolution of an image. Resampling down discards pixel information in an image; resampling up adds pixel information through interpolation. See also *interpolation*.

**resolution**  In scanning, the number of samples captured per inch of the original subject area. In image editing, the number of pixels per inch, used to determine the size of the image when printed. That is, an 8×10-inch image that is saved with 300 pixels per inch resolution will print in an 8×10-inch size on a 300 dpi printer, or 4×5 inches on a 600 dpi printer.

**retouch**  To edit an image, most often to remove flaws or to create a new effect.

**RGB color mode**  A color mode that represents the three colors—red, green, and blue—used by devices such as scanners or monitors to reproduce color. Photoshop works in RGB mode by default, and even displays CMYK images by converting them to RGB.

**saturation**  The purity of color; the amount by which a pure color is diluted with white or gray.

**scale**  To change the size of a piece of an image.

**Figure A.13** *Fully saturated (left) and desaturated (right).*

scanner  A device that captures an image of a piece of artwork and converts it to a digitized image or bitmap that the computer can handle.

Secure Data memory card  Another flash memory card format that is gaining acceptance for use in digital cameras and other applications.

selection  In image editing, an area of an image chosen for manipulation, usually surrounded by a moving series of dots called a *selection border*.

selective focus  Choosing a lens opening that produces a shallow depth-of-field. Usually this is used to isolate a subject by causing most other elements in the scene to be blurred.

sensitivity  A measure of the degree of response of a film or sensor to light.

sensor array  The grid-like arrangement of the red-, green-, and blue-sensitive elements of a digital camera's solid-state capture device.

shadow  The darkest part of an image, represented on a digital image by pixels with low numeric values or on a halftone by the smallest dots or absence of dots.

sharpening  Increasing the apparent sharpness of an image by boosting the contrast between adjacent pixels that form an edge.

sidelighting  Light striking the subject from the side relative to the position of the camera; produces shadows and highlights to create modeling on the subject.

single-lens-reflex (SLR) camera  A type of camera that allows you to see through the camera's lens as you look in the camera's viewfinder. Other camera functions, such as light metering and flash control, also operate through the camera's lens.

slave unit  An accessory flash unit that supplements the main flash, usually triggered electronically when the slave senses the light output by the main unit.

slide  A photographic transparency mounted for projection.

slide mount  A plastic (or sometimes metal, cardboard, and glass) holder for transparencies. Slide mounts allow handling the slide without the need to touch the film itself, and also are used to transport the slide in and out of a slide projector.

SmartMedia  A type of memory card storage for digital cameras and other computer devices.

smoothing  To blur the boundaries between edges of an image, often to reduce a rough or jagged appearance.

**Figure A.14** *A slide mount holds transparency film for projection or scanning.*

soft focus  Produced by use of a special lens that creates soft outlines. Filters are more popular than lenses as they are more economical and flexible.

**soft lighting**  Lighting that is low or moderate in contrast, such as the illumination present on an overcast day.

**specular highlights**  Bright spots in an image caused by reflection of light sources.

**spi**  Samples per inch; the resolution of a scanner.

**spot color**  Ink used in a print job in addition to black or process colors.

**subtractive primary colors**  Cyan, magenta, and yellow, which are the printing inks that theoretically absorb all color and produce black. In practice, however, they generate a muddy brown, so black is added to preserve detail (especially in shadows). The combination of the three colors and black is referred to as CMYK. (K represents black, to differentiate it from blue in the RGB model.)

**telephoto**  A lens or lens setting that magnifies an image.

**thermal wax transfer**  A printing technology in which dots of wax from a ribbon are applied to special paper when heated by thousands of tiny elements in a printhead.

**threshold**  A predefined level used by a device such as a scanner to determine whether a pixel will be represented as black or white.

**thumbnail**  A miniature copy of a page or image that provides a preview of the original. Film scanners provide thumbnail views in their index or prescan modes.

**Figure A.15** *Thumbnails provide previews of images being scanned.*

TIFF (Tagged Image File Format)  A standard lossless graphics file format that can be used to store grayscale and color images, plus selection masks.

time exposure  A picture taken by leaving the lens open for a long period, usually more than one second. The camera is generally locked down with a tripod to prevent blur during the long exposure.

tint  A color with white added to it. In graphic arts, tint often refers to the percentage of one color added to another.

tolerance  The range of color or tonal values that will be selected, with a tool like the Photoshop's Magic Wand, or filled with paint, when using a tool like the Paint Bucket.

transparency  A positive photographic image on film, viewed or projected by light shining through film.

transparency scanner  A type of scanner that captures color slides or negatives, usually a dedicated device or an attachment for a flatbed scanning unit.

tripod  A three-legged supporting stand used to hold the camera steady. Especially useful when using slow shutter speeds and/or telephoto lenses.

tungsten light  Light from ordinary room lamps and ceiling fixtures, as opposed to fluorescent illumination.

TWAIN (Technology Without An Interesting Name)  A software interface that allows scanners to communicate with a computer, especially with image-editing software.

underexposure  A condition in which too little light reaches the film, producing a thin negative, a dark slide, or a muddy-looking print, or a similar look in digital images.

unsharp masking  The process for increasing the contrast between adjacent pixels in an image, thus increasing sharpness, especially around edges. Scanners can apply this process to an image during scanning automatically, or you can use the technique within your image editor.

USB (Universal Serial Bus)  A high-speed serial communication method commonly used to connect scanners, digital cameras, and other devices to a computer. The earlier USB 1.1 interface has been replaced by the USB 2.0 version, which is theoretically faster than FireWire, with a top speed of 480Mbps (megabits per second), although not necessarily so in practice. For scanner users, both USB 2.0 and FireWire are more than fast enough to transfer information from the scanner to the computer, and are preferred over slower USB 1.1, parallel, and other serial interfaces used by earlier devices. See also *FireWire*.

viewfinder  The device in a camera used to frame the image. With an SLR camera, the viewfinder is also used to focus the image if it's focusing manually. You can also focus an image with the LCD display of a digital camera, which is a type of viewfinder.

vignetting   Dark corners of an image, often produced by using a lens hood that is too small for the field of view, a lens that doesn't fully cover the image field of the film or sensor, or generated artificially using image-editing techniques.

white balance   The adjustment of a digital camera to the color temperature of the light source. Interior illumination is relatively red; outdoors light is relatively blue. Digital cameras often set correct white balance automatically, or let you do it through menus. Image editors can often do some color correction of images that were exposed using the wrong white balance setting.

white point   In image editing, the lightest pixel in the highlight area of an image.

wide-angle lens   A lens that has a shorter focal length and a wider field of view than a normal lens.

zoom   In image editing, to enlarge or reduce the size of an image on your monitor. In photography, to enlarge or reduce the size of an image using the magnification settings of a lens.

# Index